LUCIAN FREUD

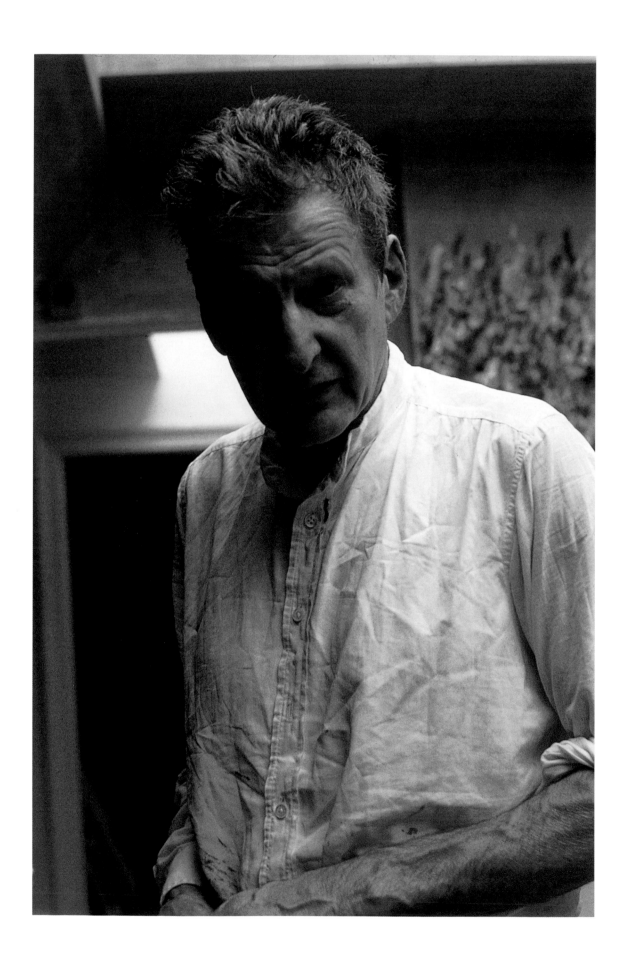

William Feaver

LUCIAN
FREUD

Tate Publishing

Exhibition at Tate Britain sponsored by

✴ UBS Warburg

Published by order of the Tate Trustees
by Tate Publishing, a division of Tate Enterprises Ltd,
Millbank, London SW1P 4RG
www.tate.org.uk

© Tate 2002
Essay by William Feaver © William Feaver 2002
Text by Frank Auerbach © Frank Auerbach 2002

This catalogue is published to accompany
the exhibition at Tate Britain
20 June – 22 September 2002
and touring to
Fundació "la Caixa", Barcelona
22 October 2002 – 12 January 2003
The Museum of Contemporary Art, Los Angeles
9 February – 25 May 2003

British Library Cataloguing-in-Publication Data
A catalogue record for this book is available from the
British Library

ISBN 1 85437 399 4 (pbk)
ISBN 1 85437 439 7 (hbk)

Distributed in North and South America
by Harry N. Abrams, Inc., New York
ISBN 0 8109 6267 5 (hbk)

Library of Congress Cataloging-in-Publication Data
Library of Congress Control Number: 2002105078

Designed by Dalrymple
Colour origination: DawkinsColour Ltd, London
Printed in Italy

Cover: *Frances Costelloe* 2002 [no.155]
Back cover: *Fingers* 1943 Private Collection
Frontispiece: *Lucian Freud* photo: William Feaver

Measurements of artworks are given in centimetres,
height before width, followed by inches in brackets

Contents

9 Foreword

11 Acknowledgements

13 Lucian Freud: Life into Art
William Feaver

51 On Lucian Freud
Frank Auerbach

CATALOGUE

219 List of Exhibited Works

225 Chronology

229 Bibliography

Sponsor's Foreword

IT IS WITH PRIDE and pleasure that UBS Warburg continues its support of contemporary art at Tate with the sponsorship of this exhibition of the work of Lucian Freud at Tate Britain.

A retrospective of such a long and prolific career offers us a perspective on an artist whose work has transcended fashion and who has built up a formidable reputation as one of the most important contemporary figurative painters.

We are reminded that while advances in technology offer us endless opportunities to capture and communicate images, we still celebrate a painter who helps us observe, often in arresting close-up, the people around us. Even for the digital, often cynical twenty-first century consumers, the humanity of his portraits leaves a striking impression.

It's a special pleasure for us that, thanks to UBS PaineWebber, our organisation has been able to lend an important piece to this exhibition, *Head of a Naked Girl I*, and contribute in a small way to its unprecedented scope.

I very much hope you enjoy this exhibition.

MARKUS GRANZIOL
Chairman, UBS Warburg

Foreword

THIS EXHIBITION PRESENTS a selection of Lucian Freud's work from 1939 to 2002. There have been a number of important previous shows of his art in London – retrospectives at the Hayward Gallery in 1974 and 1988, a substantial gathering of recent work at the Whitechapel Art Gallery in 1993 and a smaller one at the Tate in 1998 – but the range of this new project is unparalleled. In his eightieth year, Freud's ouput continues with undiminished, even heightened, vigour, and future exhibitions will no doubt reveal progressively more of the artist and his place in the history of art. Meanwhile, Tate Britain is immensely proud to be staging this survey of his work to date, curated by the writer and critic William Feaver.

The opportunity afforded by this exhibition to see so much of Freud's work in the distinctive context of Tate Britain's collections has come about through the artist's great generosity in collaborating closely and tirelessly with us in all respects. I would also like to extend warm thanks to Bill Feaver for shaping the show with such incisiveness and insight, for writing such engaging texts, and for working so hard on our behalf. Nicholas Serota, meanwhile, has character-istically given wise advice and practical help throughout, at all levels from the macro to the micro. And Tate Curators Mary Horlock and Lizzie Carey-Thomas, preceded in the early stages by Virginia Button, have met the challenges of organising and co-ordinating all dimensions of the project with great assur-ance and intelligence: their contribution has been fundamental and it should be much admired. Amongst many other staff who have helped decisively in various ways I would like to thank Krzysztof Cieszkowski, Suzanne Freeman, Richard Humphreys, Sarah Hyde, Sophie Lawrence, Paul Moorhouse, Judith Nesbitt, Andy Shiel, Chris Stephens and, notably, Mary Richards of Tate Publishing for the particular care and flair with which she oversaw the creation of this catalogue. It has been designed, in my view exquisitely, by Robert Dalrymple.

We are indebted too to Frank Auerbach, not only for his poignant contribu-tion to the catalogue but also for advising on the installation of the exhibition, to William Aquavella for his support and guidance, and to Duncan MacGuigan and Matthew Marks for assistance and encouragement in many respects. As ever, the exhibition has depended absolutely on the many owners of the works of art it comprises. Their generosity has been truly exceptional. Perhaps I may offer particular thanks to Christopher Frayling at the Royal College of Art, London, and Julian Treuherz at the Walker Art Gallery, Liverpool, for arranging special dispensations to enable their works to join the exhibition's second and third

venues in Spain and the USA. In this respect I should add that it has been a great pleasure to work with colleagues at the Fundació "la Caixa" in Barcelona and the Museum of Contemporary Art in Los Angeles on the organisation of the tour; special thanks here are due to Imma Casas, Elena Celorio, Isabel Salgado, Jeremy Strick, Stacia Payne, Paul Schimmel and Rebecca Morse.

In London the exhibition has been sponsored by UBS Warburg, who also supported the Warhol exhibition at Tate Modern earlier this year. We are delighted with this new and productive relationship, and thank them for such whole-hearted commitment to Tate's ambitious exhibitions programme.

STEPHEN DEUCHAR
Director, Tate Britain

Acknowledgements

MANY PEOPLE have helped to make this exhibition possible and we would like to acknowledge them. Firstly, and above all, thanks to Lucian Freud for his vigilance and ready encouragement. We are also most grateful to Frank Auerbach for his advice at various stages and for his eloquent words in this catalogue.

We have benefited from the advice of Nicholas Serota, Stephen Deuchar, Judith Nesbitt and her predecessor Sheena Wagstaff. Many other members of Tate staff should be singled out for their contribution: Virginia Button, formerly senior curator at Tate Britain, helped shape the exhibition in its initial stages, and Lizzie Carey-Thomas also worked on this project from the outset and her good humour and sharp mind helped ease it to fruition. We also owe a special thank you to Suzanne Freeman. Other members of staff who worked on the exhibition must also be acknowledged: Sarah Hyde, curator of interpretation; Gillian Buttimer, exhibitions registrar; Piers Townshend, Rosie Freemantle and Jacqueline Ridge, Tate conservators; David Dance and Mark Edwards, who managed the building work; the team of art handlers led by Andy Shiel with Mikei Hall, who installed the exhibition; and also Tate Photography whose generosity was appreciated.

This catalogue has been designed by Robert Dalrymple with admirable skill and we thank him, and Mary Richards, Sophie Lawrence and Fran Matheson in Tate Publishing. We are also grateful to Krzysztof Cieszkowski who has contributed a detailed bibliography and Lizzie Carey-Thomas for researching the chronology.

Of course, an exhibition of this scale and ambition would not have been possible without the support of the many lenders, both public and private. We owe them all an enormous debt of gratitude. We are also pleased to acknowledge the help of: William Acquavella; Jake Auerbach; Julia Auerbach; Felicity Belfield; Ivor Braka; the late Bruce Bernard; John Bodkin; Kai Boyt; Richard Calvocoressi; Stephane Connery; Thomas Dane; Erica Davies; David Dawson; Andrew Dempsey; Clare Ellen; Bella Freud; Thomas Gibson; Peter Goulds; Philip Harley; James Holland-Hibbert; Jay Jopling; James Kirkman; the Hon. Edward Lambton; Samantha Lewis; Thomàs Llorens; Duncan MacGuigan; Matthew Marks; Philip Miles; Lucy Mitchell-Innes; the late Richard Mosse; Richard Nagy; Geoffrey Parton; John Riddy; Deborah Rogers; Norman Rosenthal; Andrea Rose; Ruth Ur; Virginia Verran; Robin Vousden; Cheyenne Westphal and Henry Wyndham. Special thanks also to Diana Rawstron.

WILLIAM FEAVER AND MARY HORLOCK

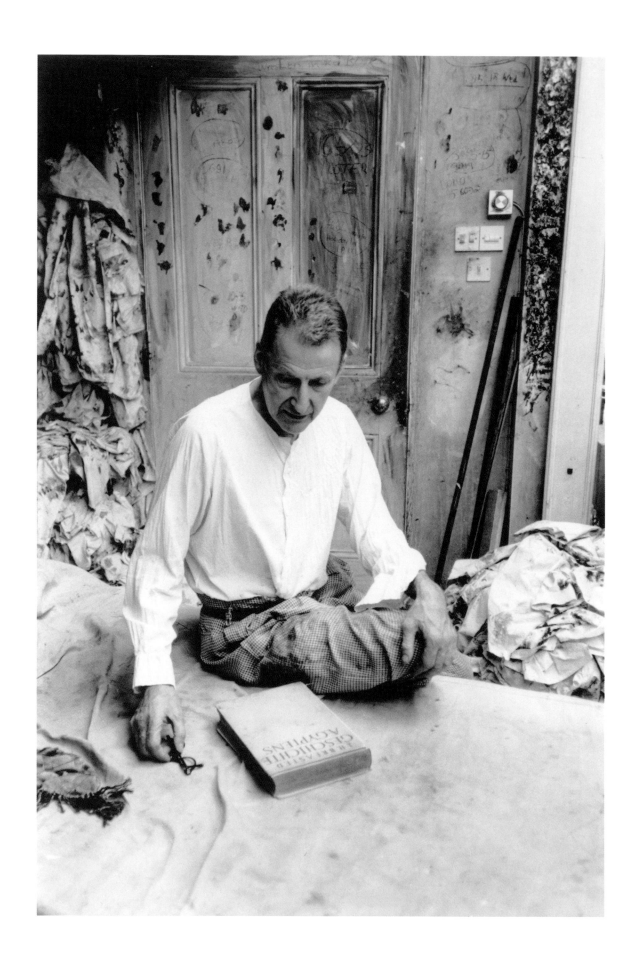

WILLIAM FEAVER

Lucian Freud: Life into Art

'A work grows as it will and sometimes confronts its author as an independent, even alien, creation.' Sigmund Freud, *Moses and Monotheism*, 1939

LUCIAN FREUD'S SINGULARITY, his pre-eminence indeed, arises from a wilful determination persistently exercised. Painting, for him, is an enlivening process. 'Making the paint do what you want it to do.' His paintings take on more than the look of whoever, or whatever. They are 'factual not literal': actual facts, acutely realised. 'I don't want them to be sensational ... but I want them to reveal some of the results of my concentration.'[1]

A PHOTOGRAPH OF FREUD in his studio, taken by Julia Auerbach in the late 1980s, shows him sitting on the edge of a bed on which lies *Geschichte Aegyptens*, a picture-book with an introduction by the renowned Egyptologist J.H. Breasted, published by the Phaidon Press, Vienna, in 1936.[2] The book could be Freud's patient. Much handled, spine broken, it falls open at plates 120–1: two plaster faces with preoccupied eyes and bashed noses unearthed at El-Amarna shortly before the First World War in what was identified as the workshop of Thutmose, chief sculptor to Akhenaten.

Who were they? More to the point: who are they? The one on the left – 'Head of a Man' – could be Amenhotep III, whose son, Amenhotep IV (1372–1358 BC), was reckoned by Breasted to be 'the most remarkable of all the Pharaohs and the first individual in human history'.[3] Amenhotep IV renamed himself Akhenaten after Aten, the sun god, whose cult he created and at whose prompting ('Aten led me here')[4] he closed down Thebes and established El-Amarna, the capital of a civilisation that lasted twelve years.

Long-nosed, thin-lipped, Akhenaten certainly looked more individual than any of his predecessors. A monotheist and poet, he commissioned images of himself seen – as no Pharaoh had been shown before – dandling his children and treating his wife Nefertiti as an equal. It is her painted bust in the Amarna room of the Egyptian Museum in Berlin that has served to place her on every list of the world's most beautiful women ever. Akhenaten's innovations, an insistence on naturalism in art among them, provoked reaction: after the brief reign of his young son-in-law Tutankhamun, polytheism and high formality resumed. The names Aten, Akhenaten and Nefertiti were chiselled off palace walls and El-Amarna crumbled into oblivion.

Lucian Freud, London, *c*.1989
Photo: Julia Auerbach

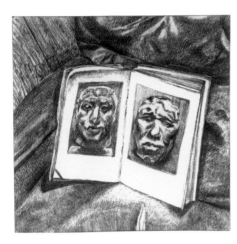

The Egyptian Book 1994 (Private Collection)

The style and individuality of the heretical Pharaoh make him sympathetic. 'I read about him,' Freud says. 'The terrific loneliness of the king. Not many mono- theists around: all these little gods and then one god only.' Equally moving, the ancient faces reproduced in plates 120 and 121 of *Geschichte Aegyptens*, the brown- ish rotogravure softening the dark of their eyes, are no less vivid and poignant for being the faces of persons unknown. Indeed, identification would be a distrac- tion. Freud has used them twice in paintings (*Still Life with Book* 1991–2 and 1993 [no.123]) and in an etching (*The Egyptian Book* 1994). 'By painting them I didn't have to go very far afield. I thought about those people a lot. There's nothing like them: they're human before Egyptian in a way. When you find things very moving, the desire to find out more lessens rather. Rather like when in love with someone, you don't want to meet the parents.'

GESCHICHTE AEGYPTENS has been Freud's pillow book, his painter's companion – his bible, it could almost be said – for sixty years. He was given it soon after he began at the East Anglian School of Painting and Drawing in June 1939. Coincidentally, in March that year, nine months after arriving in London and six months away from death, his grandfather Sigmund Freud published *Moses and Monotheism*, de- scribing it as 'quite a worthy exit'.[6] In it he suggested that an official called Tuthmose (not the sculptor) at the court of Akhenaten was the Moses who led the Jews out of Egypt, the Exodus being 'like a true trauma in the history of a neurotic individual'[6] and Moses, like Akhenaten, an intermediary between the one and only God and the chosen people.[7] 'My grandfather didn't endear himself to the Jews by suggesting that Moses was an Egyptian, an Egyptian floating down the river. An outrageous book: his final kick at the Talmud.'

'Memory-trace' – Sigmund Freud's term – lingers in myth, distinct yet impre- cise, like an after-image on the retina. Whether seen in reproduction, or in the Egyptian Museum in Berlin, the El-Amarna 'portrait-masks' are substantial ob- jects, true images, not apparitions from three millennia ago. They are whoever they are, irrespective of context, not mere relics or illustrations. Anonymity dig- nifies them. They are, in Lucian Freud's phrase, 'an intensification of reality'. He often says, 'I don't want mystification.'

ON SATURDAY 25 JUNE 1938 Lucian and his elder brother Stephen went to see their grandfather, who had arrived from Vienna three weeks before. Setting *Moses and Monotheism* aside for the afternoon, he showed them round the garden of the house at 39 Elsworthy Road, off Primrose Hill, where he lived that summer before moving into 20 Maresfield Gardens and surrounding himself with his cherished Greek and Egyptian antiquities. His old friend Princess Marie Bonaparte, who had accompanied him from Paris on the last leg of his journey from Vienna to London, filmed the three Freuds – Stephen blurry, Lucian deferential – edging along the rockery, pausing to examine the goldfish pond.

'THE PICTURE IN ORDER to move us must never merely *remind* us of life, but must acquire a life of its own, precisely in order to reflect life,' Lucian Freud wrote in 1954.[8] 'Mustn't be indulgent to the subject-matter,' he added recently. 'I'm so conscious that that is a recipe for bad art.'

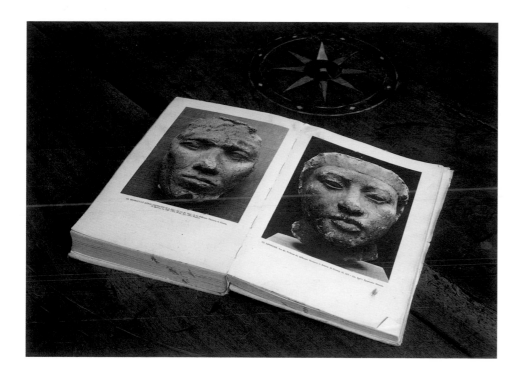

Freud's copy of J. H. Breasted, *Geschichte Aegyptens*, Phaidon Press, Vienna, 1936

THE EPIGRAPH TO Christian Morgenstern's *Galgenlieder* ('Gallow Songs') – nonsense poems with titles such as 'Bim Bam Bum', 'The Knee', 'The Aesthetic Weasel', many of which Freud learnt by heart – is Nietzsche's 'The Child is hidden in the Man: and it wants to play.'[9]

Aesthetic weasels are quick to relate Freud to Otto Dix and Christian Schad and other painters of the Weimar period. It is assumed that he was brought up on them, or predisposed to feel an affinity with them. But he was only 10 in 1933, when he came to England from Berlin, and by the time he became aware of Neue Sachlichkeit mannerisms he was more or less immune to them. Nor did he ever go to the Egyptian Museum. His grandmother, Eliza Brasch, preferred to take him to the Charlottenburg Palace, just across the road, where the Rembrandts struck him as 'brown and disgusting'.

The art that stimulated Freud as a child was altogether more graphic: the daylight naturalism of Dürer's drawing of a clump of grasses, a print of which hung in the Berlin apartment, and Dürer's drawing of his mother, reproduced in a book of ballads that Freud's mother used to read to him. There was also Morgenstern, whose most graphic poem, 'Fishes' Nightsong', consists of hyphens and brackets arranged on the page to resemble plopping waters.

Sigmund Freud came to Berlin every so often to receive treatment for cancer

Wilhelm Busch, from *Max und Moritz*, 1865

Freud (far right) playing the Young Mariner in the Dartington Eurhythmic Players' production of 'The Rime of the Ancient Mariner', 1934

of the jaw. He gave Lucian *The Arabian Nights*, elegantly illustrated by Edmund Dulac ('lovely fat book with what seemed to me pretty good watercolours') and prints of Bruegel's *Seasons: Hunters in the Snow*, the dogs trailing over the hill and skaters far below (Lucian used to skate in the Tiergarten) and *The Return of the Herd* with cattle lumbering homewards ('there are no bottoms like them'). They both liked 'Max and Moritz', the Wilhelm Busch comic strips dating from the elder Freud's childhood in the 1860s: robust drawings of two brats landing themselves in grotesque trouble, getting coated in dough and baked, for instance, or being ground into flour and devoured by ducks. Another illustrator who impressed him was his cousin Martha. She made a name for herself as Tom Seidmann-Freud with elaborate novelty books which had some success. 'Things you could pull and things disappeared and red and blue papers where, if you passed them across the drawings, people disappeared.' She killed herself, following the suicide of her husband, when Lucian was seven. His own drawings from around then include many done during summers spent on the island of Hiddensee, drawings of the ferries, flowers, birds and goblins which he sent home to his mother. 'This is good, take care of it,' he wrote on one. She kept them all.

In Berlin the Freuds lived near the Tiergarten in a large apartment in Regentenstrasse with cook, maid and nanny and an office for Ernst Freud's architectural practice, later in another apartment nearby in Matthauskirchplatz. Lucian went to the local school in Derflingerstrasse and, being the smallest, quickest and most willing in his gang, was voted the one to nick chocolate from shops. Like the other two Jewish boys in the school he was ineligible for Hitler Youth but was told he wasn't missing much, though the sausages were good. He saw Hitler once, in Matthauskirchplatz. 'He had huge people on either side of him; he was tiny.'

The Freuds left Berlin in the late summer of 1933 not as refugees but as émigrés, still permitted to take their possessions with them. Lucian and his brothers, Stephen and Clement, were sent to Dartington Hall in Devon. Classes were not compulsory. 'I got up at five or six and helped Bob the farmer milk the goats and so on. After milking the goats I smelt so much I was avoided. I was quite pleased about that. I used to ride nearly every day and got further and further behind.' He did well at Agility, however, and played the Young Mariner in the Dartington Eurhythmic Players' production of 'The Rime of the Ancient Mariner'. He remained at Dartington after his brothers went on to more conventional schools, not for long though. 'It was obvious to take me away because I didn't go into school at all.'

At Bryanston, where he ended up, Freud joined the Oil Painting Club and also tried his hand at pottery and sculpture, but his ambition was to be published in *Punch* alongside Pont cartoons detailing the English character and Fougasse's nippy draughtsmanship. 'The one I loved by Fougasse was of a man haring through the zoo shouting "There's a moose loose!" and a man asks "Are you English or Scots?"'

16

The joke, peculiarly exquisite to someone not long fluent in conversational English, was typical Fougasse: zoo keeper going flat out and seated man with thermos and neatly bitten sandwich.[10] For sheer alacrity, Fougasse could hardly be bettered. 'Formula figures,' he wrote, 'are easily idealised in the memory and moulded to the reader's own satisfaction; they do not, like naturalistic features, remain obstinately defined and "factual".'[11] Freud did not necessarily agree with that, but Fougasse certainly sparked him. 'Might have been influenced by that tiny comma nose.' When he submitted a cartoon he received an encouraging rejection: 'Good try. Try again. E. V. K(nox).' He tried again, and again, without success.

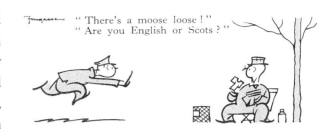

Fougasse, *Punch*, 20 January 1937

Another stimulus, rich in images, was Stefan Lorant's *Lilliput*, the pocket magazine founded in 1937, the chief feature of which was paired photographs presenting striking comparisons. Bald head and poached egg or grinning Gracie Fields and smirking gothic angel. Nude photo studies were slipped in among them and famous paintings were reproduced, starting in the first issue with Correggio's *Venus, Mercury and Cupid* and Hogarth's *The Graham Children*. Walter Trier (a German émigré known to Freud for having illustrated *Emil and the Detectives*) designed the covers, invariably featuring a man and a woman and their Scottie dog. *Lilliput* presented a repertoire of affinities. Meanwhile, at the Tate during the holidays, he had come upon Seurat's *Bathers at Asnières* and van Gogh's *The Painter's Chair* ('very much made me want to paint') and, at the National Gallery, Uccello's *Rout of San Romano*.

Gracie Fields and Gothic Angel, *Lilliput*, October 1937

Freud finished at Bryanston in late 1938, expelled not, it so happened, for having redirected a pack of foxhounds into the school hall and up the stairs ('all flapping round') but as a consequence of being dared to drop his trousers in a Bournemouth street. His stone carving of a horse secured him a place at the Central School of Art. There, in January 1939, he began a general course. The Dominion cinema in St Giles Circus was a distraction ('Westerns: anything with horses in'), as was the ping-pong table and social life in and around Charlotte Street where Lawrence Gowing first encountered him, a Fougasse figure keen to impress, 'already spoken of as a boy-wonder … fly, perceptive, lithe, with a hint of menace'.[12] With Toni del Renzio, a young designer whom he met in the Coffee An', an all-night café, he talked of starting a surrealist magazine, to be called *Bheuaau* ('Boo'), but the idea fizzled.

Freud did not get caught up in the Central. 'A very depressing sub-Academician taught painting. "If you can't draw hands, indicate them", he said, which even then I thought wrong.' After just over a term he left. A girl in the Coffee An' recommended the East Anglian School of Drawing and Painting at Dedham in Essex, a glorified summer school founded a couple of years earlier by Cedric Morris and Arthur Lett-Haines. 'No teaching much but there were models and you could work in your own room. In a funny way it was a bit like the Parisian art schools.' By 1939 Morris was 50 and no longer the promising painter, the stylishly

Man and Horse 1940 (Private Collection)

tart friend of Christopher Wood that he had once been. Freud admired his candid, often mocking, portraits and his vigorous paintings of birds and flowers, worked from the top downwards in a distinctly post van Gogh manner. 'He'd do the background and the eyes and then he'd do the whole thing in one go and not touch it again. I thought Cedric was a real painter. Dense and extraordinary. Terrific limitations.'

One morning, not long after starting at Dedham, Freud was awakened by flames across the road from the pub where he had a room. The art school was ablaze. He and a friend, David Carr, had been smoking in the studio the evening before. 'The Chief Constable of Essex came and looked and said it was a fuse, but I wondered.' The school moved to Pound Farm, Higham, where Morris and Lett-Haines lived. The war began and three weeks later, on 23 September, Sigmund Freud died. 'There was a sort of hole in his cheek like a brown apple: that was why there was no death mask made, I imagine. I was upset.'

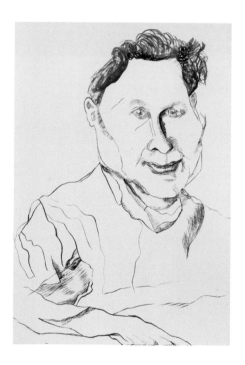

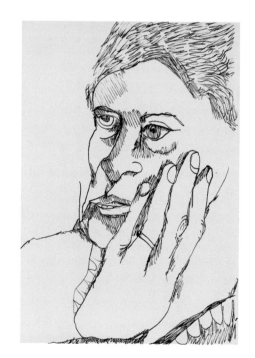

left to right:
Cyril Connolly 1940 (Private Collection)
Stephen Spender 1940 (Private Collection)
The Painter's Mother 1940
(Private Collection)

That autumn Freud and David Kentish, who had been at Bryanston with him and was also at the art school, stayed in a miner's cottage at Capel Curig in North Wales with the intention of working uninterruptedly. Freud took several pictures with him to finish, among them *Box of Apples in Wales* [no.1]: Pound Farm apples set down in a treeless landscape, the crate tilted like the walls in the views from the window of van Gogh's cell at St Remy.

Towards the end of the three months in Capel Curig, Stephen Spender joined them. Twice their age and a celebrated poet, he brought as a present a publisher's dummy which he and Freud filled, during long evenings in the front parlour, with

the innuendo-ridden dealings of a fantasy business, Freud & Schuster. Spender was involved in setting up a new literary magazine, *Horizon*, edited by Cyril Connolly. One of Freud's drawings of himself from the dummy was published in the April 1940 issue, in which Clement Greenberg's essay on 'Avant-Garde and Kitsch' also appeared.

'It was very important to me to make friends or otherwise enemies. I didn't want anything neutral at all.' Indisputably the most helpful friend to be had was Peter Watson, heir to a margarine fortune, backer of *Horizon* and patron to many. Before the war he had lived mainly in Paris; he owned paintings by, among others, Klee, Juan Gris, de Chirico and Poussin; now, stranded in London, he could cultivate local talent only; he bought, for example, in May 1940, the picture that came to serve as a frontispiece to British neo-romanticism: Graham Sutherland's *Entrance to a Lane*. Freud used to go to Watson's flat in Palace Gate to see the paintings and look through the art magazines. Watson even offered to pay his art school fees. 'Money was secondary to him; he was tremendously generous. He helped me very much, looked at my pictures and bought things and gave me money and books.' It was Watson who gave Freud *Geschichte Aegyptens*.

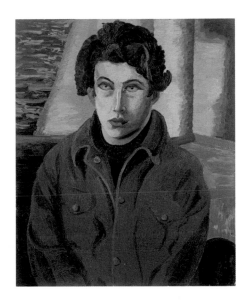

Cedric Morris, *Lucian Freud* 1941 (Tate)

The book had its effect. Freud drew Cyril Connolly as another Prince Shepseskaf (plate 20 in *Geschichte Aegyptens*); he painted *Self Portrait* 1939 resembling one of the Amarna plaster masks plus the lips of Nefertiti (colour plate III). When Cedric Morris reopened the school in April 1940 at Benton End near Hadleigh in Suffolk, Morris painted Freud looking very much a Suffolk Akhenaten, while Freud painted Morris (cf. plate 166: 'Head of a Man' in green slate) chewing a clay pipe and sizing up the young spark [no.2].

Freud's proficiency developed through trial and error. He heard that Picasso used Ripolin enamel paint but not that he drained the oil off. Hence the curdled sky in *Landscape with Birds* [no.3], completed in July 1940. 'I realised that painting in house paint over house paint would be a disaster. So the birds were ordinary paint. Learning to paint is literally learning to use paint.'

Whimsical though *Landscape with Birds* was, it had a bearing on Freud's immediate ambition which was to get away. Anywhere. Ideally New York. The subject came from a rhyme in *The Poet's Tongue*, an anthology used at Bryanston as a textbook, much of which he had learnt by heart.[13]

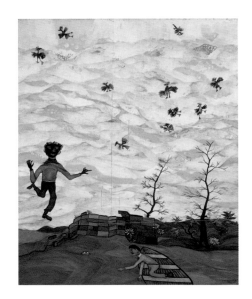

Landscape with Birds 1940 [no.3]

> I skipp'd over water, I danced over sea
> And all the birds in the air couldn't catch me.

In February 1941, using prize money won in a fabric design competition set by the designer Allan Walton ('horses with a repeat of jumps'), Freud went to Liverpool and hung around the docks trying to secure a berth on a ship. 'I liked the idea of adventure – the Ancient Mariner – but I was soon pretty desperate.' Eventually he succeeded in being signed on as an Ordinary Seaman on the SS Baltrover for an Atlantic convoy that sailed in March, leaving a blitzed Merseyside but itself com-

ing under attack from the air far out to sea. The crew did not know what to make of him. Off-watch in the forecastle he ingratiated himself a little by doing tattoos for them in Indian ink: birds and fish, hearts and arrows, 'love' and 'hate'. He drew a bit when he could: crew members, a patch of sea.

In Halifax, Nova Scotia, Freud was questioned by an immigration official who noticed that his passport (birthplace: Berlin) was dated 1939, a time when none were being issued officially. 'He said I was an odd bird and what was I doing on board ship?' The explanation was that Marie Bonaparte had wangled naturalisation for the family over lunch with the Duke of Kent. 'The suspension was unsuspended in our case.' The return voyage took over a month. It was desperately cold, submarines attacked the convoy and Freud developed tonsilitis. 'I was useless. The crew thought I was deliberately "swinging the lead", they said, but I was doing my absolute best.' Back in Liverpool the ship's doctor signed his release and the voyaging was over. 'It wasn't very long, it just seemed long; it was so unlike my life, it stuck out in a particular way.'

His mother visited him in the Emergency Medical Services Hospital at Ashridge where he had his tonsils out. 'It was good because I had such strong sedatives I was asleep when she came.' Then he returned to Benton End and painted *Hospital Ward* 1941 [no.5]: a patient resembling Peter Watson – and Amenhotep III – firmly tucked in. The water plant on the coverlet came from Cedric Morris's garden. 'One of those tough slimy things: really beautiful.'

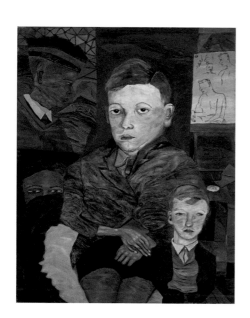

The Village Boys 1942 [no.7]

Working from life, Freud needed models prepared to sit for him. *Evacuee Boy* 1942 [no.6] was a stray, possibly consumptive, specimen with the bad teeth and narrow chest of a Neue Sachlichkeit underdog. With him within spitting distance, Freud began to paint the feel of the shoulder and the disparities of ears and eyes. *The Village Boys* 1942 [no.7] – 'very weedy, nasty but strange' – he fitted out like a crowded corner-shop window. The combination of different sorts of figures in several sizes owed as much perhaps to Thomas Henry's illustrations to the *Just William* books – Richmal Crompton's English suburban schoolboy 'Max and Moritz' stories – as to 'Egyptian things that are not made up'.

In 1942 Freud found himself stuck for somewhere to live. Peter Watson arranged for him to have a room at 14 Abercorn Place, St John's Wood, where John Craxton, another protégé, was already installed. The Janus head in *Still Life with Chelsea Buns* [no.9] belonged to Craxton. Monkey corpses from Palmer's Pet Stores served as models. 'I set certain rules for myself: never putting paint on top of paint. Never touching anything twice. And I didn't want the things to look arty, which I thought of as handmade.'

Dead or asleep: stillness was the prerequisite. His drawing of a sleeping baby, the daughter of Nicholas Moore, a poet friend, was reproduced in *Horizon*, where Graham Sutherland saw it. Sutherland suggested that he and Craxton try the life class at Goldsmiths College, which they did briefly; he also took them to Wales,

introducing them to the Pembrokeshire that was, to him, an inspirational cul-de-sac. To Freud the norms of neo-romanticism – bared souls in hard places and perpetual inky weather – were increasingly ridiculous. Better to be thorough than glib. 'I was always very conscious of the difficulty of everything and thought that by will power and concentration I could somehow force my way, and depending simply on using my eye and my will power overcome what I felt was my lack of natural ability.' In Scotland for a week in 1943, he spent several days with a mapping pen filling in the detail of *Loch Ness from Drumnadrochit* [no.8], the view from a hotel room. Faintly but distinctly in this self-imposed holiday task the middle distance and slopes beyond echo *The Rout of San Romano*.

After a year or so in Abercorn Place, Freud moved to a flat in Delamere Terrace by the canal in Paddington, just west of Little Venice. 'Delamere was extreme and I was conscious of this. A completely unresidential area with violent neighbours. There was a sort of anarchic element of no one working for anyone.' His mother ventured down from St John's Wood Terrace occasionally to deliver food parcels. In the move Freud took with him *The Painter's Room* [no.10] – 'like I took *Box of Apples* to Wales'– unfinished but well set: palm, couch and zebra head put together like components of a charade. 'A bit out-of-Miró: *Harlequin's Carnival*. Its marvellous elation.' The zebra head ('my prize possession'), dandified with stripes turned red, came from Rowland Ward, taxidermists in Piccadilly. One afternoon in the summer of 1944, the window of Freud's room was shattered by the blast from a v1 doodlebug but the painting, wet on the easel, was undamaged. It's a boxed sonnet. 'Full of life and hope. No horrors of war there.'

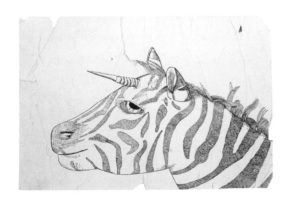 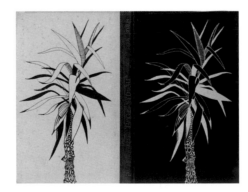

THE COMMON CORMORANT or shag, Lays eggs inside a paper bag.
(Anon., from *The Poet's Tongue*)

The Glass Tower, poems by Nicholas Moore, drawings by Lucian Freud, Editions Poetry London 1944

The image of an egg, that wartime rarity, nestling in a paper bag – an image derived, presumably, from *The Poet's Tongue* – was restored to poetry in *The Glass Tower*, a book of poems by Nicholas Moore, with drawings by Freud.[14] Like the dead monkeys and imaginary exotic birds and fish, the egg in a paper bag was an existing drawing. Freud used these as illustrations wherever he spotted an

opening. One word was enough: egg, monkey, gulls, shell. A unicorn? Not having one in stock, he added a horn to the stuffed zebra head. After all the trouble he took over title page, dust jacket and binding (the palm tree from *The Painter's Room*, yellow on black for the front, black on yellow for the back) he was furious when – besides the 'funny wartime paper, shiny lavatory paper' – several drawings were cropped and one was upside down. 'It's got an "I've got four hands and none of them work and only one eye and I nearly did it" sort of look.'

John Piper wrote in *The Listener* about Freud's first one-man show, at the Lefevre Gallery in November 1944. 'His youthful mannerisms add up to a personality. Too many forms are depressed by having to deliver unimportant literary messages but he has a cultivated feeling for line, when he can be bothered with it, and a natural feeling for colour.' Michael Ayrton, in *The Spectator*, wrote as one who considered himself an accomplished draughtsman. 'The human form defeats him because he does not observe it as he does dead birds.'

Freud resented being regarded as a child of nature or Freudian stripling: 'I thought some pictures were no good because they were too infantile. It irritated me when people talked about them being "primitive". They mistook an inability for an affectation.'

Edmund Dulac said he liked the show, but then he was a family friend and it was family and friends who rallied round and bought nearly half the twenty-seven drawings and paintings on the opening night. *The Painter's Room* was bought for £50, the top price, by Lorna Wishart.

Having supplanted the poet Laurie Lee in Lorna Wishart's affections ('I see no mercy or solicitude in her,' Lee lamented), Freud for his part was greatly taken with her.[15] 'The first person I got keen on. Everyone liked her, including my mother.' She had given him the zebra head, and the dead heron was another of her finds, brought up from the country. He laid the heron out like an emblem – dowsed phoenix, slain albatross – embellished in the Egyptian style, bedraggled plumage exquisitely amended [no.16].

Woman with a Daffodil [no.14] and *Woman with a Tulip* [no.15], from the spring and early summer of 1945, were Freud's first expression of emotional intensity in paint. 'In a way they're devised. I was more concerned with the subject – she was very wild – than I had been before, so it was a more immediate thing.' They are portrait miniatures enlarged and aggravated, expressions drained, frozen with grievance. Soon afterwards Lorna Wishart, who had embraced Catholicism, found some letters and there was a violent falling out. 'Lorna said "I thought I'd given you up for Lent but I've given you up for good".' In Paris a year later he lit candles for her.

Dead Heron 1945 [no.16]

AFTER THE WAR Freud was eager to skip the country. 'I longed to go to France and couldn't, so went to the Scilly Isles.' He and Craxton tried stowing away on a Breton fishing boat but were foiled, so they stayed instead on the Scillies, Anne Ridler's 'tropic in a northern sea / where palm joins gorse'.[16] Scillonian palm and gorse were adequately exotic motifs, also the puffins and rocks and dark blue sea of almost abroad. By the summer of 1946 it was easier to get to Paris. Peter Watson provided introductions and a weekly advance from the London Gallery.[17] There the printmaker Javier Vilato introduced Freud to his uncle, Pablo Picasso. Later in the summer he went to Greece at the suggestion of Craxton, who was already in Athens, and they took rooms for some months in a house on Poros. Freud painted lemons and tangerines, horns and sea thistles in the sharp Aegean light, and two self-portraits, affectedly austere, partly a consequence of having been to the Byzantine Museum in Athens.

Still Life with Horns 1946–7 [no.18]

When he returned to London, in February 1947, Freud took up with Kitty Garman, daughter of Lorna Wishart's eldest sister Kathleen Garman and Jacob Epstein. His portraits of her progressed from *Girl in a Dark Jacket* to *Girl with a Kitten* and *Girl with Leaves* [nos.19, 20, 22] and then his first masterpiece, in 1948, *Girl with Roses* [no.21], a painting that establishes his ability to sustain emotion while making every detail play its part. Seated slightly off-centre, told to sit up, shoulders squared with some degree of confidence, Kitty has her head turned extra full face above the dark of the stripy jumper and the swirl of the velvet skirt. 'I was arranged,' she said. Newly pregnant, cautioned to stillness, clutching one rose above the thorns and resting the other on her lap, she has landed the role of Virgin of the Annunciation, apprehensively iconic, the birthmark a neat blemish. He and Kitty were married in spring 1948. A daughter, Annie, was born in July. They had a house in Clifton Hill, St John's Wood, and Delamere served as a studio.

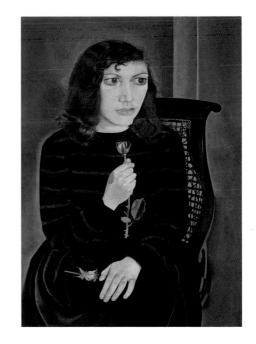

Girl with Roses 1947–8 [no.21]

Pet-shop sparrowhawks, successors to the cage birds that he had bought in Paris and pigeons from the Club Row market in the East End, were Freud's familiars for a while in the late 1940s. 'I was always excited by birds. If you touch wild birds it's a marvellous feeling.' He shot rats on the canal bank to feed the sparrowhawks, using a Luger that had come his way. Kitty, however, objected to an additional buzzard and it had to be returned, in a box on his bike, to the shop. Marriage provoked evasive action, or inaction. Kitty, under stress, was liable to take to her bed. The etching *Ill in Paris* 1948 [no.24] was done in a hotel room. 'I bit it in the basin. One dip. Really quick and dangerous.'

At the same time, in late 1948, Freud drew Christian Bérard, the epicurean 'Neo-Humanist' painter and stage designer, laid up (actually lying back until they could go to lunch), his beard flecked with grey and offset by peltish towelling, his eyes glassy: no sign of the henna tints from not so long before [no.25]. The drawing is a feat of exactitude, the head weighty on the paper. Less than two months later Bérard had a stroke and died.

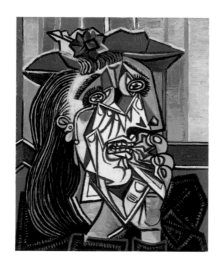

True expression (not to be confused with formulaic Expressionism) demands intensity to an obsessive degree. One day Roland Penrose asked Freud to take one of his Picassos, *Weeping Woman* 1937, down to Brighton for an exhibition. He put it on the seat opposite him in the railway carriage and looked at nothing else the entire journey. 'I was so amazed that the bright sunlight in no way made it any worse or more garish or weaker or more painty. It was as powerful and strong as possible.' Here was a portrait that surpassed likeness. The woman was Dora Maar, but a Dora Maar so transfigured that her name was immaterial. A painting could be as substantial as any person, as real as any incident, more so indeed. 'You can use your intent to make anything seem like anything: Picasso's a master in being able to make a face feel like a foot.'

IN 1949 FREUD was invited by William Coldstream to teach part time at the Slade. Initially most of the students were not much younger than him and although he established rapports, particularly with Michael Andrews, six years his junior, the tutor's role made him desperately nervous. He resorted to being seen but not waylaid – a Fougasse dash. 'I went round to see if I liked the look of anyone. Went through all the rooms three times, at enormous speed, wondering what I was doing there.' He remained a visiting tutor at the Slade, on and off ('but mostly off'), for many years.

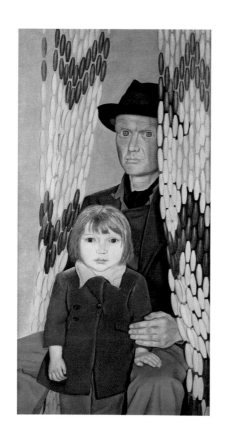

Father and Daughter 1949 [no.27]

A NEIGHBOUR INTRIGUED Freud, not least because the first time he met him he was poking with his stick in the dung heap in front of the house where the coal man lived. 'Good morning,' he said. 'I wonder if you've seen my false teeth anywhere?' In *Father and Daughter* 1949 [no.27] that neighbour, Henry 'Bo' Milton, stares through the parted bead curtain, hat and cravat worn with an air of class-consciousness and mouth firmly shut. Milton was 'a draughtsman and a gentleman, incredibly poor because he was too disorganised to get the dole'. He boasted a family connection with Anthony Trollope, the Victorian novelist of social vicissitudes; his daughter, standing between his knees, is more at ease than he in the painter's room. The painting is reminiscent of a Balthus, *Joan Miró and His Daughter Dolores*, but it is closer to *The Village Boys* from seven years before: the challenge of separate gazes. The bead curtain came from the Galeries Lafayette in Nice, acquired on one of Freud's trips to France, his frequent resort around this time. The swish of a bead curtain was livelier perhaps, where he was concerned, than the School of Paris. Francis Gruber, painter of straightened circumstances, was dead and Dubuffet's glib brutalism did not appeal to him. Balthus, whose early work he admired, particularly the illustrations to *Wuthering Heights*, seemed preoccupied with being grand and producing pictures to match. 'I thought it all came out of Courbet and nothing like as good.' Yet there was Picasso and, behind Picasso, Cézanne. And, more immediately, there was Giacometti: 'very fierce and

24

humorous, his invented proportions for humans as convincing as Ancient Egypt'. His studio in the rue Hippolyte-Maindron was hazed with plaster dust. 'It took almost a mental discipline to distinguish between the paintings, the drawings and the sculptures. It seemed all the same activity. Everything was white.'

Interior in Paddington [no.31], worked on through the winter of 1950–1, is a London painting attuned to Paris, a painting in which the miserabilism of Francis Gruber yields to the stronger presence of Giacometti's sitters. The interior, overlooking the Grand Union Canal, reflects Matisse's paintings of the corner of his studio above the Quai Saint-Michel: *Interior with a Goldfish Bowl* 1914 and *The Painter and his Model* 1917, for example. Canvas (still in short supply) was provided by the Arts Council, Freud being one of sixty painters invited to produce an unusually large picture, by post-war standards, for exhibition during the 1951 Festival of Britain.

He decided on a double portrait: man and palm. Portraits of each with more to them than the *Standing Forms* that Graham Sutherland was then producing on the Côte d'Azur in his bid to develop an International style. Harry Diamond, whom Freud had first met in the Coffee An' years before, stood by the window. He complained that Freud made him hold the unlit cigarette in his left hand, though it is the clenched fist that bears the stain of the heavy smoker. Another thing that he resented: Freud wouldn't let him look at his watch. 'I thought it's my time as much as yours. I've got as much right as you to know what it is.'[18]

Freud was stimulated by Harry Diamond's stroppiness. 'He said I made his legs too short: the whole thing was that his legs *were* too short. He was aggressive as he had a bad time being brought up in the East End and being persecuted.' Four years later he would have qualified as the popular image of an Angry Young Man. The painting breathes resentment. Drained of colour (apart from the specially bought junk-shop red carpet), defiantly precise, it cold-shoulders the whole cheery notion of the Festival of Britain. The odd one out among the fewer than sixty entries (Bacon destroyed his), it was one of the five awarded a £500 purchase prize.

Girl with a White Dog 1950–1 [no.33], the tense counterpart to *Interior in Paddington*, was painted at 27 Clifton Hill. Kitty is resigned to her role, her wedding-ring hand placed on the mattress on the floor, the draped grey blanket enclosing her a little. The bull terrier resting his head on her thigh was a wedding present, one of a pair. Freud had preferred the other one, which was black, but before he finished the painting it was run over so he altered black pelt to white.

'THE ONLY POINT OF TITLES on the whole is to distinguish one picture from another, rather like a Fugue in C Major (Moonlight).'

No.2 in Freud's Hanover Gallery exhibition of May 1952 was *Girl with a White Dog*. No.3 was *Francis Bacon* 1952. Normally, Freud (like Bacon) provided titles

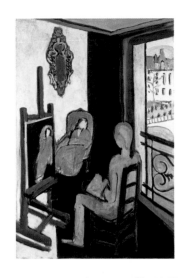

Henri Matisse, *The Painter and his Model* 1917 (Musée National d'Art Moderne, Paris, France)

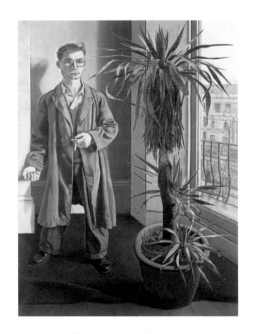

Interior in Paddington 1951 [no.31]

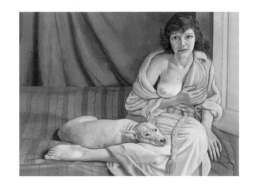

Girl with a White Dog 1950-1 [no.33]

that gave nothing away. Names-to-faces begged questions; uninformative titles meant that the work stood for itself. The *Francis Bacon* represented a known fellow painter (as did the *John Minton* of 1952 [no.35], glassy-eyed and agonised),[19] and it was originally intended to hang in Wheelers, the Soho fish restaurant that Bacon used daily. Not to have named Bacon, a celebrity already, would have been as pointless as conferring anonymity on a patron saint.

Freud had been told about Bacon by Graham Sutherland towards the end of the war. 'I said, rather tactlessly, to Graham "who do you think's the best painter in England?" He said "Oh, someone you've never heard of; he's like a cross between Vuillard and Picasso; he's never shown and he has the most extraordinary life; we sometimes go to dinner parties there."' Freud first met Bacon, by arrangement, at Victoria station, when both went to stay with the Sutherlands for a weekend in early 1945. 'Once I met him I saw him a lot.'

Bacon was for many years the person to whom Freud turned for stimulus, for provocation, for dash. 'His work impressed me but his personality affected me.' Bacon showed him how to wing it through life, how to court risk, tempt accident and scorn the norm. 'He talked about "the sensuality of treachery".' When in 1951 Bacon first painted Freud, he made no pretence of working from him; he used instead a snapshot of Kafka. Far from regarding this as wrongful, or a betrayal, Freud recognised that the painting was indeed a portrait of sorts. 'It isn't very good but it's lively.'[20]

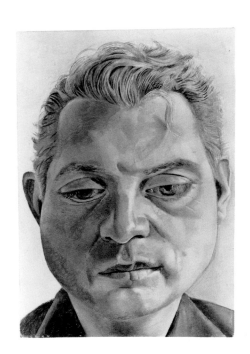

Francis Bacon 1952 (Tate)
Present whereabouts unknown

Freud's *Francis Bacon* 1952[21] was done in two or three months. 'He grumbled a bit but sat well and consistently.' They sat knee to knee, Bacon looking downwards, abstractedly, his head filling the small copper plate as the Amarna plaster mask fills plate 121 in *Geschichte Aegyptens*. Bacon himself was to produce many self-portraits over the years, similarly close but invariably evasive, the steam on the mirror, as it were, obscuring everything but the jowls, the forelock, the hangover and the stare. Freud's Bacon is quietened down. He has come off it, for once, and allowed himself to be seen without the usual chaff. He was, of course, extraordinarily image-conscious. When Freud drew him one evening at Clifton Hill, Bacon said 'I think you ought to use these', easing his trousers off his hips [no.34]. Use of the hips, of what later would be termed 'body language', was typical of Bacon's manner: different strokes for different features. Painterly swipes. Freud concentrated on what he saw; Bacon got by on inspired guesses. The friendship continued until the late 1970s.

IN 'SOME THOUGHTS ON PAINTING' published in the magazine *Encounter* in July 1954, Freud talked of self-indulgence as a discipline through which the painter 'discards what is inessential to him and so crystallises his tastes'. Self-indulgence, in this light, becomes focus.

'Painters who use life itself as their subject-matter, working with the object in

front of them, or constantly in mind, do so in order to translate life into art almost literally, as it were … The painter makes real to others his innermost feelings about all that he cares for.'[22]

Though far from confessional, illustrative still less, Freud's paintings are, of course, open to interpretation. 'Everything is autobiographical, and everything is a portrait.' The end of one marriage and the onset of another is detectable. The span of relationships can be seen, from adoration to unease in three or four pictures. 'The way he moved: like quicksilver,' Anne Dunn said of Freud. She sat for *Portrait of a Girl* [no.30] in 1950, the year she married Michael Wishart, son of Lorna and Ernest Wishart, cousin of Kitty; she subsequently married Rodrigo Moynihan, by then no longer married to Eleanor Bellingham Smith (*A Woman Painter* 1954 [no.42]. Over time complications become pattern and successive paintings become company for one another.

Caroline Blackwood was the new face of 1952: *Girl in Bed* [no.38] and *Girl Reading* [no.37]. Her mother, Maureen, Dowager Marchioness of Dufferin and Ava, did her utmost to thwart the affair. In 1953, when Freud stayed with Ann and Ian Fleming in Jamaica, Caroline was despatched to Spain to be out of the way and to avoid the Coronation, for which, to her mother's mortification, she had not been chosen to be a maid of honour. Nevertheless, when divorce from Kitty came through later that year, they married. Caroline was 22. *Hotel Bedroom* 1954 [no.40] was *Ill in Paris* revisited, strained circumstances, Freud himself looming against an array of open and closed shutters across the street.

Hotel Bedroom was completed in time to be shown at the 1954 Venice Biennale where Freud shared the British Pavilion with Francis Bacon and Ben Nicholson. Introducing him to the Continental audience, Herbert Read described Freud as 'the Ingres of Existentialism', his way of suggesting that perversity could not be more wilfully pursued. Douglas Cooper, reviewing the Biennale for *The Burlington Magazine* with characteristic scorn, pooh-poohed Freud. 'His faulty draughtsmanship and his modernistic distortions (contrasting oddly with the naturalism of his pretty-pretty flower and fruit still-lives) produce paintings that are affected rather than forceful.'[23]

'I myself was dismayed, others were mystified as to why he needed to paint a girl, who at that point still looked childish, as so distressingly old,' Caroline Blackwood wrote in 1993. 'It is interesting to remember that the many portraits he painted in the forties and fifties, in what is now considered his most romantic and gentle style, at the time were seen by many as shocking and violent and cruel.'[24]

'The stiffness, eccentric virtuosity and staring imagery of the great self-taught painter', as Robert Melville described it, was a young man's manner.[25] Freud realised that there was every reason for him to loosen up. 'My eyes were completely going mad, sitting down and not being able to move. Small brushes, fine canvas.

Caroline Blackwood, *c*.1953

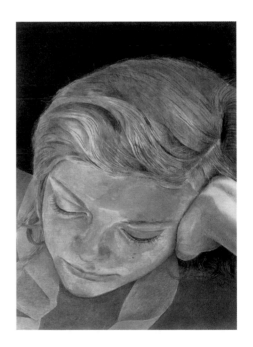

Girl Reading 1952 [no.37]

Sitting down used to drive me more and more agitated. I felt I wanted to free my-self from this way of working. *Hotel Bedroom* is the last painting where I was sitting down; when I stood up I never sat down again.'

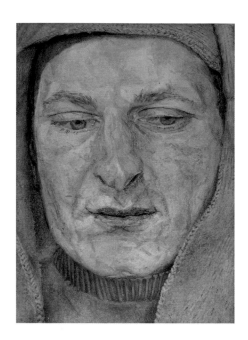

The Procurer (Man in a Headscarf) 1954 [no.41]

The Procurer (Man in a Headscarf) 1954 [no.41], a painting cut down from its original size, was a proxy self-portrait. The man was someone Freud came across in a bar where he had not been before. He saw him buy a drink and to his surprise heard his name. 'The barman said "is that on your bill, Mr Freud?" When I got to the bar, I said "Excuse me, who was that just buying a drink?" and the barman said "Oh, that's Mr Lucian Freud." Possibly the most revolting person that I had ever seen in my life. Repulsive. So then I took some trouble – though none was needed – to get to know this horrible man. And that was David Litvinov. I thought, well, I can do a self-portrait without all the bother of looking in the mirror.' The title varied. As *The Procurer* it referred to Litvinov's habit of bringing girls round to Delamere Terrace, which Freud rather resented.

With *The Procurer* and *A Woman Painter* Freud worked the paint, wet on wet, giving faces the look of enlarged miniatures. Gradually he amplified his touch. Hogshair replaced sable brushes. Between the painting of a bedraggled Caroline, *Girl by the Sea* 1956 [no.43], done shortly before she left him, and *Woman Smiling* 1958–9 [no.45], he tried for greater substantiality, this at a time when Francis Bacon was astonishing him with ectoplasmic wraiths and gagging Popes. Bacon was the spur. 'He talked about packing a lot of things into one single brushstroke, which amused and excited me, and I realised that it was a million miles away from anything I could ever do.'

The transition was awkward in that Freud could not bring himself to abandon exactitude for mere abandon. 'Sometimes when I've been staring too hard I've noticed that I could see the circumference of my own eye.' His instinct was to attend to every freckle and individual hair while still trying to strengthen his handling. John Berger described some of the results as 'painstaking naturalism somewhat reminiscent of the covers of *Time* magazine. Only they are more startling because they all emphasise decay – like touched up photographs of rotten apples.'[26]

'I felt more discontented than daring. It wasn't that I was abandoning something dear to me, more that I wanted to develop something unknown to me.'

'SHOCKING', 'VIOLENT', 'CRUEL', 'ROTTEN'. And 'affected'. The epithets so loosely attached to Freud's new work were not those applied to the 'Kitchen Sink' realism associated with Helen Lessore's Beaux Arts Gallery. Freud 'allowing the paint freer rein' had little or nothing in common with, for example, John Bratby, who painted everyday circumstances thickly and profusely in emulation of van Gogh. *Pregnant Girl* 1960–1 [no.46], a study of Bernardine Coverley who gave birth to Bella (*Baby on a Green Sofa* 1961 [no.47]), and *Head* 1962, of Jane Willoughby, a maid

of honour at the Coronation, were more sensuous than any Bratby yet more restrained than the heavily worked paintings of Leon Kossoff and Frank Auerbach, who also showed at the Beaux Arts Gallery in the late 1950s.

When Freud saw his first Auerbachs (in 1955) he was nonplussed. 'They looked like the most appalling threatening kind of mess.' He came to admire Auerbach, however, above all other living painters; for Auerbach proceeded to do what Bacon mainly talked of doing: he showed that emotional truth had a momentum to it. 'The space always the size of the idea, while the composition is as right as walking down the street,' Freud later wrote. 'Work brimming with information conveyed with an underlying delicacy and humour that puts me in mind of the last days of Socrates.'[27]

Such expression surpassed Expressionism, and Grosz and Dix with their 'medieval German drawing all slipped up'. Asked why, contrary to the perception that his painting stemmed from Germanic sources, he preferred to acknowledge a debt to French painting, Freud replied that he had a very simple answer. 'Because it happens to be better.'

IN THE EARLY 1960s Freud travelled abroad several times to see particular paintings. He went to Colmar in Alsace for Grünewald's Isenheim altarpiece and to the Hals exhibition in Haarlem in the summer of 1962. On one trip he saw the Musée Ingres at Montauban, the Goyas at Castres and the Courbets at Montpellier. 'Two days there. I looked at the Courbets (and those Géricault limbs) a lot: *Les Baigneuses*, that marvellous nude going into the forest, like a rugger player pushing off others, lots of foliage, and the woman beside her, one stocking off, one at her ankle. I like Courbet. His shamelessness. Since I hadn't his ability or facility, my paintings went wrong slowly.' His travelling companion on most of these expeditions sat for *Figure with Bare Arms* 1962 [no.49]. 'A very good sitter; had this amazing discipline over her hips.' She also sat, thirty years later, for *Woman in a Butterfly Jersey* 1990–1 [no.118].

In 1962 demolition gangs advanced along Delamere Terrace and Freud shifted to Clarendon Crescent, a condemned terrace further along the canal. He had an upstairs room at number 124, with an outside lavatory on a balcony overlooking the canal, a room so poky it affected his work, not cramping his style but provoking a more expansive manner. He painted himself in cusps and harsh downstrokes, a Paddington Hals willing himself to spontaneity. A sense of impulse, of fluent growth, was brilliantly achieved with *Cyclamen* 1964 [no.54]. Floating cyclamen petals and leafage had been the motif of murals he painted in a bathroom at Chatsworth and in the dining room at Coombe Priory, the house in Dorset where Freud had lived for a while during his second marriage. He saw cyclamens as divas. 'They die in such a dramatic way. It's as if they fill and run over. They crash down; their stems turn to jelly and their veins harden.'

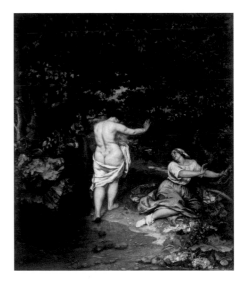

Gustave Courbet, *Les Baigneuses* 1853 (Musée Fabre, Montpellier, France)

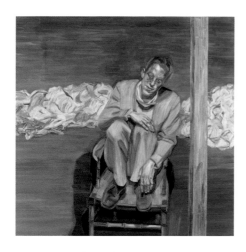

Red Haired Man on a Chair 1962–3 [no.51]

If flowers could have emotional lives, how much more so could human sitters, each unique. *Red Haired Man on a Chair* 1962–3 [no.51] is constriction exposed, balance disturbed. Tim Behrens, a Slade student and devotee of Freud, crouches on a chair, head and shoulder sagging towards a vertical strut left where the wall was knocked away to make extra room; behind him is a surf of heaped sheets from the rag and bone merchants under the canal bridge. Plenty of these were needed now that there were loaded brushes to be wiped clean after each dab.

Others whom Freud knew and used included Ted, a neighbour with compelling scars – 'he had a thick skin and was very well stitched up' – and his daughter, Sharon (*A Man and his Daughter* 1963–4, no.53), and John Deakin, the bitchy-tongued Soho figure, who photographed Bacon not only in the style of Bacon (photographs that Bacon then used) but also, as he himself acknowledged, in imitation of Freud's Bacon portrait.

'AT CLARENDON I WAS PAINTING 4am to lunch, then off gambling. Lots of playing, day and night, horses and dogs. I was completely broke.'

WHEN CLARENDON CRESCENT was demolished, in turn, Freud was rehoused on the other side of the Harrow Road, at 227 Gloucester Terrace, stucco-fronted and awaiting renovation. There he had an L-shaped room to work in with windows facing north and south. Among his sitters were Michael Andrews and June Keeley, guarded and mutually protective (*Michael Andrews and June* 1965–6, no.57), Harry Diamond, who was making a name for himself as a photographer (*Paddington Interior, Harry Diamond* 1970, no.67), John Deakin, a faintly rueful-looking Iago [no.52], and Bacon's friend George Dyer (*Man in a Blue Shirt* 1965, no.55), his face skewed with perplexity. Freud liked his company. 'He had been a lookout man, a very bad one and he saw a book of Hals, he looked at it and his face absolutely lit up. He said "what a marvellous idea, making people look like that." He thought they were modern. That's right really.'

Looking down at a mirror at his feet, Freud painted himself foreshortened, lights haloing above and spaciousness ('the air around me') laid in with a palette knife. The small figures in *Reflection with Two Children (Self-Portrait)* 1965 [no.56] were Rose and Ali, two of his children by Suzy Boyt (*Smiling Woman* 1959), introduced like latecomers in a cinema.[28] Still looking down, Freud began a series of nudes (*Naked Girl*, 1966, no.58), to be regarded as portraits of the whole person. 'I always started with the head; and then I realised that I wanted very deliberately not: the figure not to be strengthened by the head. The head is a limb, of course.'

Interior with Hand Mirror (Self-Portrait) 1967 [no.59] has the reflected head wedged at an angle in the sash window, daylight hitting the face, eyes narrowed in concentration on the shifts of focus. *Interior with Plant, Reflection Listening* 1967–8 [no.60] is Freud's satyr-like head and bare shoulders, slipped behind the saw-

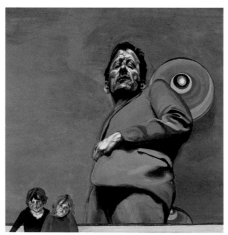

Reflection with Two Children (Self-Portrait) 1965 [no.56]

toothed *dracaena deremensis*, hand cupped to ear and nothing to hear but traffic hum. 'A night picture, but actually I did it in the day because the reflection was too dramatic at night.' For *Large Interior, Paddington* 1968–9 [no.64], Ib (Isobel), another Boyt daughter, laid herself down, as children do, in afternoon nap pose. Her father's jacket, a stiffness hung on the shutter, offsets the bright flutter of zimmelinde leaves.

During the 1960s Freud emerged from what can be termed his transitional phase. He could now realise in paint whatever he chose: buttercups, furs, the glint of light in a darkened window, the sheen on a ribcage, the mottling on a silk tie. *Wasteground with Houses, Paddington* 1970–2 [no.69], the larger of two views from back windows at Gloucester Terrace, is the grandest example of his command of detail. Coinciding as it did with the vogue for Photorealism – slavish transcriptions of projected colour slides of sex and shopping and holiday snap banalities – it tended to be seen as a related feat: if not photographic then akin to a Stanley Spencer 'pot-boiler' landscape, filled in down to the nettle stings. But *Wasteground* is neither systematic nor exhaustive. It is a subdued view, a facing outwards, rich in possibilities. Neither version stuck to the facts. Several garage doors and windows were omitted from the smaller painting, railings from the larger one, and figures came and went. 'I didn't want the garage doors to look like abstract art – like Ben Nicholson – so I had someone cycling through, but it didn't work.'

His father, Ernst Freud, died in 1970. They had not been close, but the painting was affected by the death. Elements were reworked, particularly the visible decay of stuff that just happened to be there. 'I felt the rubbish must be more exact; I felt somehow the rubbish was the life of the painting.' At one stage he almost had to pay two tramps to leave the mattresses where they were. 'I'm fascinated with the haphazard way it has come about, with the poignancy of the impermanency of it.'

In 1972 Freud began painting his mother. 'If my father hadn't died I'd never have painted her. I started working from her because she lost interest in me; I couldn't have, if she had been interested.' Her depression reduced her to passivity, so four or five days a week, on and off until the mid-1980s, he collected her and took her off to sit for him. 'She barely noticed, but I had to overcome a lifetime of avoiding her. From very early on she treated me, in a way, as an only child. I resented her interest; I felt it was threatening. She was so intuitive. And she liked forgiving me; she forgave me for things I never even did.'

'I USE PEOPLE TO MAKE MY PICTURES.'

The upstairs back room of a terrace house at 19 Thorngate Road, a cul-de-sac in Maida Vale where Freud worked for five years from 1972, was the scene of *Large Interior* W9 1973 [no.73]. The painting is not allegorical, not Youth and Age, but it does take its bearings from *La Tempesta*: the opposite ways the two figures face,

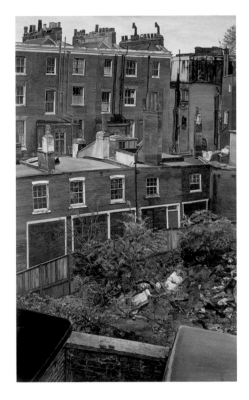

Wasteground with Houses, Paddington 1970–2 [no.69]

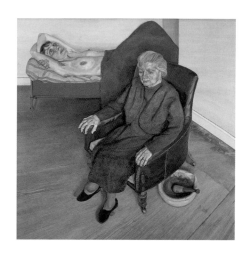

Large Interior W9 1973 [no.73]

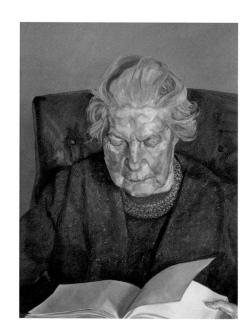

The Painter's Mother Reading 1975 [no.76]

the emotional distance between them and the sense of divide, with Giorgione's lightning flicker reduced to the glint in an eye. The women relate to Freud, not to each other. They never sat for him together, though his mother did once hear the girlfriend smashing things in the next room; as far as she is concerned the woman behind her, staring at the ceiling, is elsewhere. She is, however, grandmother to the other woman's son, Francis – 'Freddy' of *Freddy Standing* 2001 [no.147] – born in 1971.

Two perspectives clash in the painting and are secured by the mortar under the chair, the blackened bowl around which the composition turns, used by Freud for crushing the charcoal that he mixed into the paint. He wanted the colours 'as Londony as possible'. *Large Interior W9* [no.73] is *The Painter's Room*, as it were, thirty years on, Londony now, not surrealistic in the slightest, palm and zebra head replaced by people, schematic clarity superseded by the subtleties of human differences. The last painting that Freud completed before his Hayward retrospective in 1974, it has true awareness and presence. 'Be guided by feeling alone,' Corot wrote in a sketchbook. 'Reality is part of art: feeling completes it ... what we feel is real too.'[29]

'LUCIAN FREUD IN LIFE is a paragon of alertness and speed of response,' John Russell remarked in the catalogue essay for the Hayward exhibition, contrasting this with 'the ordered adagio of his working methods'. Freud himself recognised no such distinction between life and art. More alertness, less speed: he was working more intensively, his mother sitting most mornings and others later, into the small hours. 'I feel a bit hopeful about my work at the moment,' he said to me a few weeks before the exhibition opened. 'But then it varies terribly from day to day.' He added that he liked to leave pictures in a presentable state at the end of each session in case he didn't happen to survive the night.

Resuming where he had left off thirty years before, when he drew her in formidable half-profile, Freud examined his mother's bewilderment. Sitting was now an occupation for her and she did as she was told, picture by picture. *The Painter's Mother Reading* 1975 [no.76]: she stares down at a book, the blank pages reflecting up at her like the ruffs on Hals widows. 'I made her look at the Egyptian Book, but she's not registering.' Then, in *The Painter's Mother Resting I* 1976 [no.77], she lies back, babylike, hands cupped beside her head, a wary effigy. The paisley patterns on her dress were thinned out, to avoid tiresome repetition. 'I always felt that detail, where one was *conscious* of detail, was detrimental.'

Jacquetta Eliot, the other woman in *Large Interior W9*, brought overt emotional stress to the night-time sessions. Like Lorna Wishart earlier on, she submitted herself with some resentment, letting her thoughts roam and drift. In *Naked Portrait* 1972–3 [no.72], she tenses herself, staring past the palette knife and brushes laid out neatly on the daubed stool, one leg pulled up to her chest, the

other hooking the edge of the bed. *Last Portrait* 1976–7 [no.82] was stopped at a certain moment. So far so good: eyes realised, lips realised (and the mole on her neck), dispiritedness lapsing into exasperation, dark patches of hair and chair-back blocked in like cyclamen leaves above the wilting petals of the blouse.

'You are very conscious of the air going round people in different ways, to do with their particular vitality.' With Jacquetta Eliot there is threat and entreaty; around Katy McEwen in *Head of a Girl* 1975–6 [no.81], the air is sour with despair. Katy kept Japanese laboratory rats; hence *Naked Man with Rat* 1977–8, a painting in which the clutched rat, its warm tail draped over the man's thigh, plays phallic symbol.

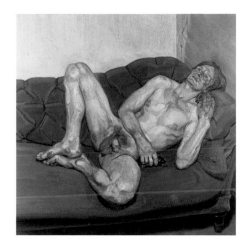

Naked Man with Rat 1977–8
(The Art Gallery of Western Australia)

A friend of Katy McEwen's at the Slade had been using Cremnitz white, she told Freud, a lead white so dense it was practically sculptural. Good for flesh, he decided: excellent for the solidity of flesh within aired spaces. (Moves to ban it, on health grounds, were to worry him some years later.) Cremnitz white formed the bulge of the neck and the dip of the upper lip in the magnificent *Head of the Big Man* 1975 [no.79], and the skin and bone beneath the springing hair in *Frank Auerbach* 1975–6 [no.80], a head clenched in thought.

'For me the painting *is* the person.'

BY THE MID-1970S AUERBACH was the living artist most admired by Freud. His portrait was thus to some degree a successor to the Bacon portrait, an expression of mutual esteem. Auerbach sat resolutely for Freud, regarding each three-hour session as little better than truancy. He was, he said, 'a good but reluctant sitter, always conscious that time and energy were leaking away. I don't think that I would have sat for anyone else by then. And given that sitting is inevitably a sort of chore, I cannot imagine working with – for – a more interesting person.'[30]

FREUD'S MOVE FROM THORNGATE ROAD ('his very austere Paddington room', as Auerbach described it) to a spacious and secure top-floor flat in Holland Park – his first proper studio – was gradual, beginning in 1977, and it took months for him to become confident enough to start working under the newly-installed skylight.

Foliage, he decided, would be a good under-the-skylight exploratory subject: 'lots of little portraits of leaves'. Masses of such portraits would amount to an indoor *Wasteground*, a small wilderness. 'I wanted it to have a real biological feeling of things growing and fading and leaves coming up and others dying.'

The painting *Two Plants* 1977–80 [no.85] gave him the idea for the cover for Lawrence Gowing's monograph on his work, published in 1982: leaves glazed with a transparent wrapper. 'Like dolmades: leaves wrapped round meat.' Gowing was unstinting in his exuberance. Freud, he wrote, had been able 'in portraits like *Frank Auerbach* to put more of the human forehead into pictures than

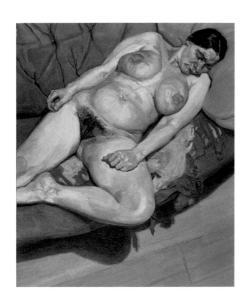

Naked Portrait II 1980–1 [no.89]

you could gather in the whole previous history of painting' and his description of *Naked Portrait II* 1980–1 [no.89] – completed the night before the sitter gave birth – rained Miltonic cadences. 'The pregnancy which has run full term, culminates in a ripeness with the veinous bloom of some great fruit, which is more *painted* than any other gamut of shot and broken colour in Freud's work.'[31]

Never in the whole previous history of painting, it could be said, had such an air of sumptuous broodiness been achieved as here with the body lodged on split and unravelling upholstery. Similarly, in *Rose* 1978–9 and *Esther* 1980 [nos.87, 90], *Naked Portrait with Reflection* 1980 and *Night Portrait* 1977–8 [nos.88, 84], a sweaty lustre embellishes the bodies; while the former *Naked Man with Rat*, Raymond Hall, poses with animal ease for *Naked Man with his Friend* 1978–80 [no.86], pushing one foot under the edge of the carpet and buttressing himself against the older man as though bracing himself to dream. So too the hardboiled egg, peeled, halved and unwinking in the white and yellow harmony of *Naked Girl with Egg* 1981, is a footnote to the upwards sequence of kneecaps, breasts and eyes. Here are balletic qualities, without the commotion.

IN 1982 FREUD made two etchings of Lawrence Gowing who, earnest, stammering, mildly cubistic (and speaking as a one-time pupil of William Coldstream, and Coldstream's successor at the Slade), confessed himself puzzled. 'He did not draw verifiably from a fixed position, which he could depend on returning to. He answered that for him it was more like aiming than copying … I had the impression of a process rather like echo-sounding.'[32] Glancing likenesses, they were not among the four etchings produced in editions of twenty-five for insertion in one hundred deluxe copies of Gowing's book, but they did suggest possibilities: etching as an alternative to painting, not echoing pictures but paralleling them and proliferating. Sustained by the printer's expertise, Freud's etchings became larger and bolder with lines bunched and feathered for emphasis and vim.

LORD GOODMAN *in his Yellow Pyjamas* 1987 [no.107], an etching enhanced with a watercolour wash, followed on from drawings of the rumpled *éminence grise* whose massive head was a repository of untold confidences, gossip and state secrets. Goodman was Freud's lawyer. He sat for Freud in bed, over breakfast. Other public figures who made themselves available when, from time to time, he found himself in urgent need of ready money included Charles Clore, the property tycoon, and Baron Thyssen (*Portrait of a Man* 1981–2 and *Man in a Chair* 1983–5, no.100); not that Freud chose to regard this as bespoke portrait painting. 'People go on about how to be commissioned is in some way to be trammelled or harnessed or limited. Auden said a very sensible thing about this. "In the end", he said, "it's a romantic idea. Whatever an artist does, they think they're commissioning themselves".'

34

Often Freud's sitters became friends; more often, when he asked them to pose, they were friends already, or otherwise close to him. 'And who closer than my children?' Annie and Annabel from his first marriage, Rose, Ib, Ali and Susie Boyt, Bella and Esther Freud, were named when he painted them. To name them was to acknowledge them; to paint them was to get to know them, intensively so, often after missing the childhood years. Freud has rationalised his sporadic fatherliness. 'If you're not there when they are in the nest you can be more there later.' *Portrait of Rose* [no.87], the 20-year-old Rose Boyt, her legs caught in a swathe of sheeting, a thumb pressed against an eye like an extra eyelid, confidently yields bodily sensation.

'When did you get the idea of working from your grown-up naked daughters?', Leigh Bowery asked in 1991.
'When I started painting naked people.'
'It must make things, well, slightly extreme.'
'My naked daughters have nothing to be ashamed of.'[33]

THE RELATIONSHIP OF PAINTER to sitter, practical, professional, necessarily exploitative, involves a conspiratorial intimacy, a familiarity that transfers to the painting as it becomes the third party in the relationship and the main concern: literally the love object.

'There is something about a person being naked in front of me that invokes consideration. You could even call it chivalry on my part: in the case of my children, a father's consideration as well as a painter's. They make it all right to paint them. I don't feel I'm under pressure from them.'

Tenderness in these circumstances is a dangerous impulse; it can become an excuse for sentimentality. 'I'm very conscious of, as it were, Titus disease: that Rembrandt loved Titus so much he couldn't do him quite straight. I mean, I love the Titus pictures but they aren't terribly good are they? There's a sort of Titusitis.'

Acute Titusitis is a common affliction in self-portraiture, resulting in top-lit heads graced with delusions of stature, and 'spiritual grandeur', where self-interest snuffs self-awareness. Well aware of this, Freud tried a sneak shot, as it were, with *Reflection (Self-Portrait)* 1981–2 [no.94], his image ricochetted into view through three mirrors. The conceit of catching himself unawares in sidelong appraisal suggests a chink in his self-possession. Could he be outwitting himself? Glassy halations streak the breathing space beyond his nose.

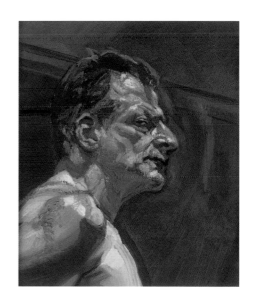

Reflection (Self-Portrait) 1981–2 [no.94]

'MY WORK IS PURELY AUTOBIOGRAPHICAL. It is about myself and my surroundings.' Freud's surroundings extend beyond the domain of the studio, the house and regular haunts, to places known to him only in paintings – 'art, after all, derives from art' – to Giorgione's backwater where the man looks on as the woman suckles her baby and lightning strikes, to Cézanne's dishevelled brothels, to the sturdy

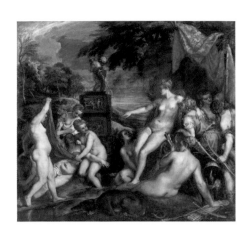

Titian, *Diana and Callisto* 1556–9
(Duke of Sutherland Collection, on loan to the
National Gallery of Scotland)

floorboards of van Gogh's bedroom, to the lashed-up decking of Géricault's *The Raft of the Medusa* with its human freight, dead and alive. Staying near Edinburgh in the late 1970s, Freud went again and again to the National Gallery of Scotland to see the two great Titians: *Diana and Callisto* (in which Callisto, having been made pregnant by Jupiter in the guise of Diana, is stripped naked by Diana's nymphs) and *Diana and Actaeon* (in which Diana decides to turn the hapless Actaeon into a stag and set her hounds on him as punishment for his having sighted her bathing). Freud was not particularly interested in the myths; what excited him was the splendour overall and the charged details, the lashings of cloth and leafage, flesh and stream, hounds, clouds, masonry and quiver, so entangled, so compounded and, edge to edge, so gorgeously resolved.

'Why is it as effortless as Matisse and yet it affects you more than any tragedy? It hardly matters what is going on: the water, the dogs. The people, though involved with each other, are there to please us.'[34] 'These are,' Freud declared, 'simply the two most beautiful pictures in the world.' When I reminded him that he had said the same of other paintings, Constable's *The Leaping Horse*, for one, he quickly agreed. 'If you say it, you'd say it more than once; like saying "you're the most beautiful girl in the world".'

'TITIAN DOES WONDERFULLY what is one of the most difficult things of all to do, which is to paint people together.'

Behind Baron Thyssen's shoulder in *Portrait of a Man*, Freud inserted *Pierrot Content*, a small Watteau belonging to Thyssen, and it occurred to him as he did so that he could make more of this.[35] He began *Large Interior W11 (after Watteau)* [no.95] in 1981 and it preoccupied him until 1983. An enormous painting by his standards, it was to be more than a modernised dalliance. Like *Interior in Paddington* in 1951 it was a challenge, but this time primarily a physical one, for his left arm had become too stiff to raise above his head and he feared that the scale might defeat him.

Portrait of Baron H.H. Thyssen-Bornemisza 1981–2
(Private Collection)

Large Interior W11 (after Watteau) 1981–3 [no.95]

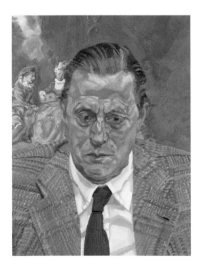

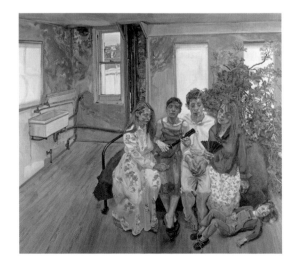

36

Pierrot Content was a prompt rather than an inspiration. 'I'm not so Watteau-mad (though "Gilles" is a great masterpiece). It took quite a lot of staging. Slightly costumy.' Seated on the bed were Celia Paul, painter, on the left, next to Bella Freud with a mandolin, and on the right Suzy Boyt and her son Kai, as Pierrot. 'He's the subject, not Suzy, not Bella, certainly not Celia. I'm the connection. The link is me.'

Painting these people together took some contriving. Freud wanted his grand-daughter May (daughter of Annie) for the small foreground figure but she became unavailable, so the sister of Ali Boyt's girlfriend, a child called Star, was intro-duced into the picture. 'Star was borrowed and bored.' Hardly an ensemble, the sitters came and went.

After Watteau is a makeshift tableau, a display of rivalry transformed into an undisguised charade conveniently set in the Holland Park studio. 'Watteau never had a studio; he was always borrowing rooms and stables.' Under the skylight mottled plaster, exposed pipes and a tangle of verbena substitute for woodland glade. 'Is the tap dripping too loud?' Freud asked me as the picture neared com-pletion. Like Courbet in 1855 assembling the constituents of *The Artist's Studio*, he was relieving the fantasy of pretence, showing instead the tentative gestures of people rehearsing themselves as themselves, more or less. 'A slight bit of role-playing, but I didn't try and forget who they were and in the end they are just *there*.'

'WHAT DO I ASK OF A PAINTING? I ask it to astonish, disturb, seduce, convince.'[36]

When Freud was invited in 1987 to make an 'Artist's Eye' selection of paintings from the National Gallery, London, he was rather surprised, he said, to find him-self choosing no Italian paintings, nothing indeed from southern Europe except Velázquez's *Rokeby Venus*. He included Hals (*Young Man holding a Skull (Vanitas)*) and Chardin (*The Young Schoolmistress*), Ingres (*Madame Moitessier*), Seurat (*Bathers at Asnières*), Cézanne (*The Painter's Father*) and Vuillard's *Madame André Wormser and her Children*, a drawing-room portrait rich in bobbed hair, gilt and parquet. Three paintings by Degas, three Constables and six Rembrandts provided the necessary imbalance. The choice celebrated the fact that great art connects – astonishingly, disturbingly, seductively, convincingly – across the ages.

Eleven years later Freud was asked to produce a painting inspired by a picture in the National Gallery for *Encounters*, the National Gallery's exhibition to mark the millennium. He decided to work from Chardin's *The Young Schoolmistress*, a painting of ardent make-believe in which an ingénue assumes the informative role, and made two copies, one smaller, the other full-size. He then made two etchings drawn on the plate in front of the picture: one of the ear of the 'school-mistress', the other large and densely chased. In doing so he moved the heads closer together and accentuated their features, his touch being more robust than Chardin's. 'On this scale a lot more happens; you see first one then another.' The

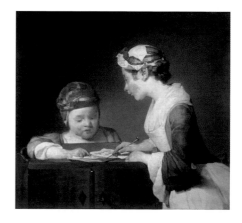

Jean-Simone Chardin, *The Young Schoolmistress* *c.*1735–6 (National Gallery, London)

child became less amenable and the girl, his sister presumably, more bossy. 'Such intellect as there was in her I left it out.'

After Chardin (Small) 1999 [no.144] is a cast of two, doubly intent, a different slant from most of Freud's other double portraits which, from *The Village Boys* in 1942, through *Hotel Bedroom, A Man and his Daughter* and *Large Interior* W9, to *Two Brothers from Ulster* (2001) [no.149] and *Daughter and Father* of 2002 [no.153], represent contrast and discrepancy. *Michael Andrews and June* – a couple with separate outlooks and differing uneasiness: an Adam and Eve – are more absorbing an occurrence than, say, the chance meeting of a zebra head and a sofa.

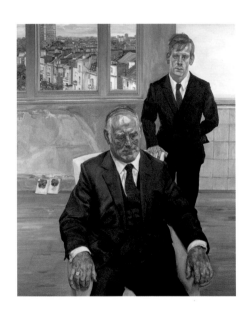

Two Irishmen in W11 1984–5 [no.103]

Two Irishmen in W11 [no.103] of 1984–5 is a painting of *The Big Man* of 1975, an Ulster businessman keen on horses and art, with his 19-year-old son in attendance. The suits, the comb-over, the glint of the signet ring on a heavy hand, have connotations, for the two feel out of place, a feeling endorsed by the two unfinished self-portraits of their overseer and host, installed like mousetraps at skirting-board level. Having arrived punctually, having settled in – facing away from the view over West London, over the lilacs of early summer and the backs of grand Holland Park houses – they apply themselves to being exemplary sitters.

Pictures involving two figures or more ('one of the most difficult things to do') were rarely attempted by Francis Bacon. Being a painter of impulse, Bacon usually operated one-to-one, putting isolated figures in the separate compartments of triptychs. He is said to have complained that Freud's work was 'realistic without being real'.[37] To Freud, Bacon's later paintings were a let-down. 'Francis talked about harnessing the accident. That was a terribly bad idea; you think of Degas saying "I don't know the meaning of inspiration: everything in my work is manipulated, is to do with awareness and artistry and tricks", Francis felt that these things were sent to him somehow. I noticed, for instance, he always gave me his legs when he painted me.'

Where Bacon seized on photographic characteristics and operated without sitters, Freud has needed an immediate presence to keep him on the *qui vive*. Reality entertains the unexpected, whereas surreality, or 'inspiration', tends to draw on imaginative habit. Bacon, for example, made a regular feature of the nape of George Dyer's (defenceless) neck as photographed by Deakin; he kept on with it after Dyer's suicide, by which time, apparently, anything more testing than this fixed memory was beyond him. Compared to that, the hardened yet vulnerable soles of the feet in *Annabel Sleeping* 1987–9 [no.108], Freud's painting of his second daughter in a blue dressing gown ('my quietest picture'), are as personal as a face and as tangible as a Chardin loaf of bread.

'I'm never inhibited by working from life. On the contrary I feel more free. Their being here is important from a nature-study point of view. Imagine going to the airport every day to study them …'

CELIA PAUL, who was a student at the Slade in the late 1970s when Freud, at Lawrence Gowing's invitation, became a visiting tutor once again, sat for a number of paintings, among them *Naked Girl with Eggs, Girl in Striped Nightshirt* [no.99], *After Watteau* and *Painter and Model* 1986–7 [no.106] in which, initially, an easel stood between her and Angus Cook – film-maker – sprawling on the leather sofa. Freud decided that the easel made the picture too busy; the cleared space between the two – the gap between the tip of the brush and the tip of a toe – was more charged, so much so that, iconographically speaking, the painting almost qualifies as an 'Annunciation'. Celia Paul had been something of a prodigy at the Slade. Branded with painter's mess and standing to the side, her role here is meditative rather than submissive. The painting itself is a meditation on painting. Depicted flesh on depicted leather, and depicted creases and scuffmarks, are no less abstract than depicted shadow or the smears of paint-as-paint on the painter's smock. Or the tubes of paint (one of them trodden on: a footnote as literal grace-note) that, having been used up on themselves, lie mangled on the floor.

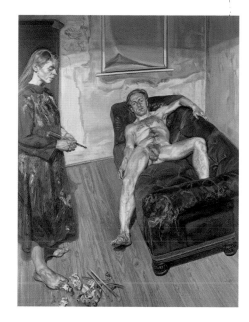

Painter and Model 1986–7 [no.106]

PAINTER AND MODEL was the most recent picture in the retrospective of 1987 at the Hirshhorn Museum in Washington. The exhibition established Freud's international reputation. 'Lucian Freud has become the greatest living realist painter,' Robert Hughes wrote in his catalogue essay. 'The strangeness of Freud's paintings comes in large part from the circumstances of their making: they bypass decorum while fiercely preserving respect.'[38]

Indecorous or not, the strangeness of *Two Men in the Studio* 1987–9 [no.111] derives from Watteau's *Gilles*, itself a commedia dell' arte version of *Ecce Homo*, the motif of the parading and mocking of Christ. Where Gilles in Pierrot costume, awaiting the curtain call, is attended by various heads and shoulders at knee level, Angus Cook stands naked on the bed, his arms braced against the beam beneath the skylight. If not Gilles or Christ, he could claim to be a potential St Sebastian or load-bearing caryatid.[39] The head of his companion, Cerith Wyn Evans, protrudes from under the bed, substituting maybe for the donkey head in the Watteau. (In 1986 Freud had played Louis XIV, momentarily, in Wyn Evans's short film *Look at Me*.) On an easel in the background is *Standing by the Rags* [no.114], the concurrent night picture, painting rags heaped beside it and shaped to form a perch on which Sophie de Stempel propped herself like a weary Madonna, the blood draining into her legs. 'She was always pressed. I quite like being a press.' De Stempel also posed for *Lying by the Rags* 1989–90 [no.115], a cliffhanger of naked contrasts in which the floorboards reminded Freud of the decks in Gustave Dore's grizzled illustrations to 'The Ancient Mariner'.

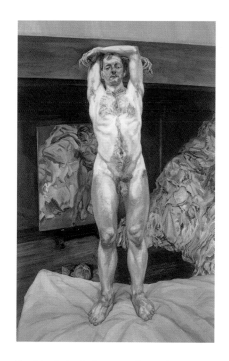

Two Men in the Studio 1987–9 [no.111]

'MY WORLD IS FAIRLY FLOORBOARDISH.'

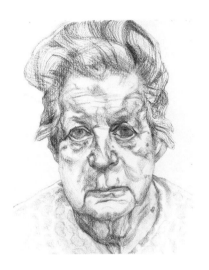

The Painter's Mother 1983 (Private Collection)

IN AUGUST 1989 Freud's mother died. She had sat for two paintings after he moved to the Holland Park flat. 'At over 90 she got up the four flights of stairs. "I'm glad it's not further," she said.' Since 1971 he had worked from her more or less uninterruptedly, ending with *The Painter's Mother Resting* 1982–4 [no.97], the most composed of the series in the true sense. He drew her finally the day after she died [no.113].

Lucie Freud's ambitions for her favourite son had always irked him. As a proud mother, she had asked Herbert Read to write a catalogue preface for his first show. (Read ducked out of it by saying that he only wrote introductions for refugees.) As a concerned mother she had tried to be understanding. 'It was being forgiven I didn't like. My mother always put nobler motives on my actions than those they were actually prompted by. She was so affectionately, insistently, maternal. And she preferred me.' The preference, Freud had always felt, was oppressive.

'MY MOTHER SAID that my first word was "alleine" which means alone.
Leave me alone.'

'FRESHLY FELT EMOTIONS can't be used in art without a filter. It's like people thinking manure is just shit, so they shit in a field and they think the shit will feed the plant. In fact it half-kills it.'[40]

Raw emotion is useless or, rather, it's like the used paint mantling the wall above the radiator in *Ib and Her Husband* 1992 [no.120], the accumulation of scrapings, removed from the canvas, wiped from brush and knife, added to the deposits on every wall within reach. These slugs of paint vented, as it were, from the work and mantling the walls, contrast with Freud's fixed intent, starting with the centre of interest, usually the face, and edging outwards, testing the ice. Nothing is tolerable or acceptable until it withstands scrutiny. Slowly the painting grows.

'My grandfather was adamant that to be an analyst you had to be a fully qualified medical doctor, and whenever he examined any of his patients –whatever desperate state they were in– he gave them a complete and thorough physical examination. That seems to me right and proper.'[41]

IN *MOSES AND MONOTHEISM* Sigmund Freud discussed 'the over-wide gap [that] human arrogance in former times created between man and beast'. Animal instincts, he said, correspond to the knowledge inherited by humans. 'They have preserved in their minds memories of what their ancestors experienced. In the human animal things should not be fundamentally different.'[42]

'You can't be aware enough. I've always thought that biology was a great help to me and perhaps even having worked with animals was a help. I thought through observation I could make something into my own that might not have been seen or noticed or noted in that way before.'

FREUD HAS ALWAYS preferred Géricault's horses to Stubbs's. 'Which all look cameo. I don't think Stubbs liked horses.'

Over and above his keen knowledge of racing form, the turf and, at one stage, the dog-track, Freud has always liked horses and dogs; he has an instinct for them, not to be confused with fellow-feeling ('Dogs like habit. I don't.') or senti-mental transfer of emotion. In Berlin there had been Billy the family greyhound and *Black Beauty* had been his favourite book; at Dartington he kept guinea pigs and commandeered Starlight the pony; during his first marriage there were the bull-terriers and during the second marriage horses and a red setter. When in 1970 he painted *A Filly* [no.68], which briefly belonged to him, his son Ali held the halter but was left out of the picture.

Animal ways impress Freud as virtues: their unselfconsciousness, their lack of arrogance, their ready eagerness, their animal pragmatism; and so, in the sense that they are at their most animal-like when resting or sleeping, those who sit for Freud trust him to bring out the animal in them. He quotes the lines from T. S. Eliot's 'Preludes':

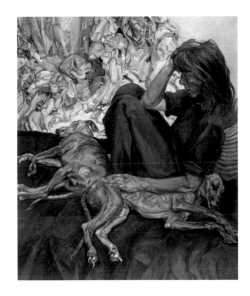

> I am moved by fancies that are curled
> Around these images, and cling:
> The notion of some infinitely gentle
> Infinitely suffering thing.[43]

A glint of complicity animates *Guy and Speck* 1980–1 [no.91], neither being pre-pared to trust Freud entirely, and *Guy Half Asleep* 1981–2 [no.92] suggests again that to sit is to be on guard; but in *Double Portrait* 1985–6 [no.105] sleep prevails, Joshua the whippet resting his muzzle in the palm of a relaxed hand. Its sequel, *Triple Portrait* 1987, has the owner awake and watchful and Joshua asleep with Pluto, the whippet bitch, bought by Freud for his daughter Bella and taken on by him when the demands of being a fashion designer meant that she could no longer look after her.

Triple Portrait 1987 (Private Collection)

Bella Freud label, designed by
Lucian Freud 1990

Pluto proved an excellent sitter. 'Sleeps well,' Freud said. Being there, in Walt Whitman's phrase, 'so placid and self-centred', a model of animal behaviour, guided by smell, recognising mood by tone and gesture, she acted as the painter would often wish to act or react himself. Talking on the phone one day in 1990, he drew a quick profile of Pluto for the Bella Freud label, an avid tongue and long grin: pure Fougasse.

'The dog isn't free, it can't do otherwise, it gets the scent and instinct does the rest.'[44] And to a dog, of course, names mean little and titles and reputation are nothing. The appetites so undisguised in a dog – hunger and lust, the desire for comfort, exercise, sleep and reassurance – are those most exposed when people take their clothes off and shed their facades.

'I'm really interested in people as animals. Part of my liking to work from them naked is for that reason. Because I can see more; and it's also very exciting to

see the forms repeating right through the body and often in the head as well. I like people to look as natural and as physically at ease as animals, as Pluto my whippet.'[45]

'IT BECOMES LESS autobiographical and, well, more ambitious, I suppose in a sense.'

Until Leigh Bowery came on the scene, Freud had rarely worked from professional models. Not that Bowery was a model exactly. He was a poser, a performer, whose every personal appearance in club or concert involved outrageous body transformations in costumes of tackily surreal splendour. Freud spotted him first outside Olympia. 'He was walking by a queue I was standing in. I noticed his legs and his feet: he was wearing clogs and his calves went right down to his feet, almost avoiding the whole business of ankles altogether.' Cerith Wyn Evans introduced him and he sat for Freud for a couple of years as often as five days a week. 'To begin with it was a bit of an ordeal,' Bowery told me. 'I assumed he was going to be painting me naked so I just started taking my clothes off.'[46]

Leigh Bowery (Seated) 1990 [no.116] is the sixteen-stone Australian-born performer divested of both his nondescript everyday clothing and the freak diva outfits. To Freud he bared himself, sloughing off his role as the modern Gilles, dropping what the singer Boy George described as 'his Benny Hill child molester look'.[47]

Freud had taken to having paintings enlarged when necessary as they developed, gaining elbow room and altering the proportions. *Leigh Bowery (Seated)* grew more than most, with strips added to the sides and a third as much again to the bottom. 'Enlarging is like stepping back over the edge because you know the terrace in your absence has been built a little bit further. It's to do with a diabolical

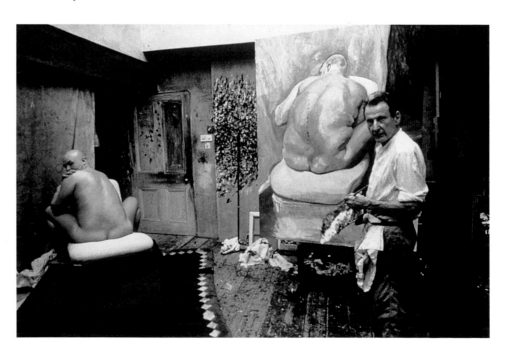

Leigh Bowery posing for *Naked Man, Back View* 1992
Photo: Bruce Bernard

liberty rather than a terrible risk.' Bowery's utter nakedness – he shaved himself all over for readier transfiguration – is that of a genie unbottled in the expanded picture space, a disarming figure, innocent of make-up. His skin, Freud found, was curiously translucent. 'Like being able to see underneath the carpet.'

Talking to John Richardson about Velázquez's *Mars*, a model too flabby to pass as anything but abjectly human, Freud said, 'I love his sadness and jokiness and the pointlessness of his strength. He's no god of war. He's a movie extra who just might get a walk-on part as Mars.'[48] Ungodlike himself, more a devotee of the Mars bar, Leigh Bowery regarded sitting for Freud as his chance to flaunt himself for posterity; and although he realised that, basically, he was a paid motif, he exerted himself to be a challenging and rewarding one. To recline outstretched between paint rags and bed for *Nude with Leg Up* 1992 [no.119] was physically taxing. 'I'm so aware of how Lucian manipulates things,' he said. 'That's what artworks are: elements being manipulated.'[49]

Freud recognised in Leigh Bowery a taunting quality; the very act of displaying himself was a sort of portrayal. 'The way he edits his body is amazingly aware and amazingly abandoned …' He posed him towering under the skylight and in a taffeta skirt; he put him on the bed with Nicola Bateman, Bowery's seamstress and occasional collaborator (in one performance he gave birth to her), lying Pluto-like beside him [no.124]. The working title, suggested by Bowery, was 'A Fag and His Hag', but Freud preferred *And the Bridegroom*, after A.E. Housman in 'A Shropshire Lad':

> And the bridegroom all night through
> Never turns him to the bride.

The following year the 'bridegroom' and 'bride' were married and seven months after that, on New Year's Eve 1994, Bowery died of AIDS. Freud was unaware until the last days that he had been HIV positive for some years. Death stimulated the Leigh Bowery cult. Memorial shows and books made a gay icon of him; an actor impersonated him in the musical *Taboo* in 2002, and his legacy of costumes was conserved and lent out to exhibitions by Nicola Bateman. She posed for Freud while Bowery was dying, and afterwards, for *Girl Sitting in the Attic Doorway* 1995 [no.128], a painting that can be taken to imply attic memories, not to say atavistic fears, but which actually exploited her willingness to climb onto the tall cupboard, and sit tearfully in the void, allowing Freud to put the remotest corner of the studio to use.

'YOU'RE LIVING and your relationships grow and mature or decay.'

PAINTING ABSORBS MEMORY and associations in ways that photography, in its various forms, cannot. Freud's two paintings of Bruce Bernard, and the earlier etching, were informed by forty years of acquaintance that grew into friendship. They

Diego Velázquez, *Mars, God of War* 1640 (Prado, Madrid)

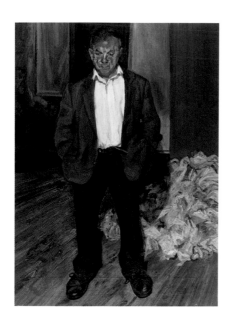

Bruce Bernard 1992 [no.121]

Unfinished Head 1991 (Private Collection)

had first met during the war, when Freud went with Lorna Wishart to visit her son Michael at his boarding-school and was introduced there to Bruce, who remembered being 'very impressed by Lucian's exotic and somewhat demonic aura'.[50] Working on the second painting, *Bruce Bernard (Seated)* 1996 [no.132], more than fifty years later, Freud remarked how recognisable the adolescent was in the ageing man. 'Bruce looked awkward, as if his clothes weren't right, as is very often the case with boys, especially when their mother's interested in other things. He was too big for them somehow, like when you come out of prison. In the paintings he has still got that look.'

By then Bruce Bernard had spent the best part of a lifetime as a Soho habitué. He had become a picture editor turned photographer and was editing *Lucian Freud*, the large picture-book published shortly after the second portrait was finished. In the first, *Bruce Bernard* 1992 [no.121], he stood before Freud, surly-looking (deceptively so: he was anxious, he told me, not to say anything that might endanger the painting) just as he stood most days in the French Pub or the Colony Room or lesser haunts.

'Bruce said that he kept his hands in his pockets because it would make it quicker. What he didn't realise is that hands in pockets is just as much a problem as hands.'

The writer Francis Wyndham, who also had known Freud since the early 1940s, told himself not to gossip too much while being painted, in 1993. 'My worry was not being meditative enough. Lucian's so interested in feeling and emotion; perhaps he's interested in that rather than what they – the sitters – really are. My idea of myself is unlike how I appear.'[51] Freud showed him observing a silence tinged with melancholy [no.126]. 'Lucian lives in a world of deep loyalties and friendships and antagonisms,' Wyndham said. 'It always interests me when he dislikes people. He produces brilliant, elaborate and slightly dotty explanations as to why. Everything acquires a sort of fascinating significance.'

In the early 1990s Freud began a painting of James Kirkman, his dealer since 1972. Their business relationship had become strained, and the portrait was intended to ease the situation but instead, as *Unfinished Head*, it heralded the split. An accumulation of work – principally the nude paintings of Leigh Bowery, unsold partly because of the 1989 recession – went off to the United States when, at the end of 1992, he arranged to be represented by William Acquavella in New York.

In December 1992 Freud turned 70. Three-score years and ten: time for a radical self-assessment. 'Now the very least I can do is paint myself naked,' he said. He had not tried this before, though he had done at least twenty self-portraits. 'It's more difficult than painting people, I find. Increasingly so. The psychological element is more difficult. I put all sort of expressions in and obscure them.'

Painter Working, Reflection [no.125], completed in the summer of 1993, is both challenge and submission, a reversal in the form of the full-length mirror image,

the right hand being actually the left hand, the palette knife a weapon brandished at shoulder height in waggishness or salute.

'The way you present yourself, you've got to try to paint yourself as another person. With self-portraits 'likeness' becomes a different thing. I have to do what I *feel* like without being an expressionist.'

He worked down to the laceless boots (protection against splinters) and then concentrated on the neck upwards, the paint thickening with each failed expression. 'The first day I reworked it it turned out to be my father.' As he worried away at his face, the theme song from *High Noon* came into his head. 'I do not know what fate awaits me … I only know I must be brave … And I must face the man who hates me … Or lie a coward … in my grave … '

After the painting was photographed for the catalogue of his 1993 exhibition at the Whitechapel, Freud finally altered the expression from intent, but fractionally unfocused, to intent and sharp.

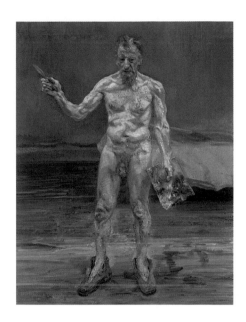

Painter Working, Reflection 1993 [no.125]

THE SUCCESSOR TO Leigh Bowery as prime model was his friend Sue Tilley, 'Big Sue', an official at the Department of Health and Social Security. She would arrive panting at the top of the stairs, her bulk an exotic quantity, a sort of aura. 'I have perhaps a predilection towards people of unusual or strange proportions, which I don't want to over-indulge,' Freud admitted after working from her for a while. 'Initially being very aware of all kinds of spectacular things to do with her size, like amazing craters and things one's never seen before, my eye was naturally drawn round to the sores and chafes made by weight and heat.' He recalled the clowns and dwarfs at the Spanish court treated with such perfect consideration by Velázquez. Nobody's victim and nobody's fool, Big Sue proved a vivid resource; her body, in *Benefits Supervisor Resting* 1994 [no.127], yields to nothing in its baroque loops and contortions. 'It's flesh without muscle and it has developed a different kind of texture through being such a weight-bearing thing.'[52]

Sleeping by the Lion Carpet in progress, 1996 [no.131]
Photo: William Feaver

Sleeping by the Lion Carpet 1996 [no.131] transforms body mass into resplendent monumentality, the folds and curves shining against the fuzzy half-light of the silken safari scene hung behind the chair. Big Sue could dream of being a Diana, or a Callisto, but no mythology is needed to sustain her, no glorifying allusion.

Freud's studio is a place of matter-of-fact contrivance employing whatever happens to be there: beds and chairs, cupboard and plan chest, rag piles and Pluto. *Sunny Morning – Eight Legs* 1997 [no.135], involving Pluto and the painter David Dawson (Freud's assistant), took shape gradually. Freud thought of them together and a woman, possibly, standing behind. But what to do with the space below the bed? Traditionally (most memorably in Wilhelm Busch's 'Max and Moritz') every bed has a chamber pot and slippers lurking underneath.

'The spare legs came about out of desperation, as things quite often do in my pictures. I thought I'd have some shoes or clothes under the bed but then realised

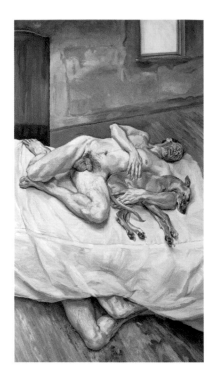

Sunny Morning – Eight Legs 1997 [no.135]

that I had to have something more organic there, something moving. And then I wanted a person under the bed, which I've used before, and which I've often sensed in pictures that I like. The reason I used David's legs rather than somebody else's was precisely because I don't want mystification. I thought by using his legs it would be rather like a hiccup or a stutter or a nervous repetition and therefore the legs would refer back to him.'[53] They could be a reflection of Actaeon's legs in a Titian forest pool. The idea was to have 'in some way caught a scene rather than composed it, so that you never questioned it. I felt that the way I put things looked – not in a romantic way, I'd like to think – awkward, in the way that life looks awkward.'

Every inch of *Sunny Morning – Eight Legs* works to advantage, one element played against another. 'In the big things especially, paint sometimes goes on almost all over the place, a bit like acupuncture, where you do something to the foot to change something in the neck.' So too in *The Pearce Family* 1998 [no.139], in which Rose Boyt and her husband, Mark, sit with Alex, his son by his first marriage, and their first baby together, Stella, and, as the painting proceeded, growing evidence of another on the way. To that extent the painting composed itself, each additional figure pressing forward and complicating the whole.

WORK ON *Garden, Notting Hill Gate* [no.137] was concentrated into three months, August onwards, in 1997. 'A race against autumn. I wanted to take on the garden because in the past I've either put the chunk indoors or done it from a distance. I was very conscious of where I was leading the eye. Where I wanted the eye to go but not to rest; that is, the eye shouldn't settle anywhere.' Here, unlike *Two Plants*, dusty under the skylight, colours ripened and dulled (Rowney's Transparent Brown mixed with green). 'I realised that I could sustain the drama that I wanted in the picture by – as I nearly always do – giving all the information that I can.'[54] The undersides of the buddleia leaves shivered silver and when the sun shone, picking out the horizontal shoots, there were flashes of late butterfly and wasp.

AFTER SEEING the Cézanne exhibition at the Tate in 1996, Freud said that what affected him particularly was his 'being able to do things which I thought were undoable. It's heartening.' Three years later Freud bought himself a small Cézanne, a brothel scene, *L'Après Midi à Naples*, and (as with the Watteau) embarked on his own much larger version: chair overturned, libido quenched – or failing – and a servant entering with refreshments.

After Cézanne 2000 [no.145] was not painted in the presence of the original. Freud had a reproduction to hand but kept the Cézanne itself elsewhere. The portable steps used when working on tall pictures served as a support for the man refusing to be coaxed or comforted by the woman. The man was Freddy Eliot, son of Jacquetta and himself ('very detached, curiously philosophical and

46

independent; a dancer and potter in Spain'); the woman was Julie, Big Sue's brother's girlfriend, a former hospital nurse and – Freud was pleased to discover – corpse washer.

Julie's friend Sarah acted as the servant with a tray, appearing in the extra space added at the top. Late on, he repainted her without her dress. 'A radical change: I've found Matisse sculptures have helped: to do with amazing proportions.' By then Pluto, his standby, had disappeared from the foreground. He decided against replacing her with oysters (too obvious) or a small fire. 'Earth, air, fire, water,' he murmured.

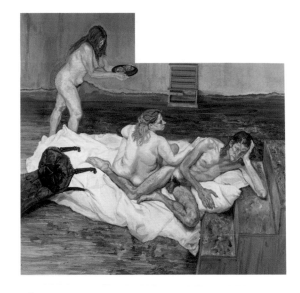

After Cézanne 2000 [no.145]

'TO MY MIND,' Cézanne said, 'one does not put oneself in place of the past, one only adds a new link.'[55]

To painters, precedents are immediate and alive, paintings being what they are – perpetual precedents – and studio circumstances being much the same from one generation to another. ('First learn your stovepipe,' Cézanne advised.) The links are practical and reassuring. When Freud, painting Leigh Bowery, was photographed by Bruce Bernard in a two-man tableau of Courbet's *Painter in his Studio,* they were catching at echoes. 'When I paint clothes I am really painting naked people who are covered in clothes. That's what I like so much about Ingres.' When he painted *Naked Portrait Standing* 1999–2000 [no.142], he consciously emulated Constable's *Study of the trunk of an elm tree* which, as a student in Dedham, he had tried to match. He failed then but sixty years later he placed himself as close to his model Nicki as Constable had been to the elm.[56] More obviously, *Armchair by the Fireplace* 1997 [no.136] connects with van Gogh. 'I love this chair. It may be to do with who sat in it. The life it's led. Slight feeling of sweat.' The chair sits there, scuffed, dented, castors askew, determinedly unsymbolic. 'Nothing ever stands in for anything (except with the Watteau and the Cézanne). Nobody is representing anything. Everything is autobiographical and everything is a portrait, even if it's a chair.'

Armchair by the Fireplace 1997 [no.136]

Freud's paintings have in abundance what E.H. Gombrich described as 'the pattern of living expression', as distinct from the 'hit' of a photograph. 'The consummate artist,' Gombrich added, 'conjures up the image of a human being that will live on in the richness of its emotional texture when the sitter and his vanities have long been forgotten.'[57]

Armchair, apples, painter, evacuee; landowner, monkey, actor, film maker, novelist, journalist, layabout, duchess, cyclamen, solicitor, performance artist, whippet; daughters, sons, grand-daughters, sixth-former, bookie, newspaper seller, man of letters, singer, procurer, ex-jockey, The Queen; John Richardson (Picasso's biographer), Aline Berlin (widow of Isaiah Berlin). Whoever or whatever: eventually the subjects of the paintings are relieved of everything but what Freud has made of them.

Still Life with Book 1993 [no.123] is *Geschichte Aegyptens,* dog-eared, thumbed,

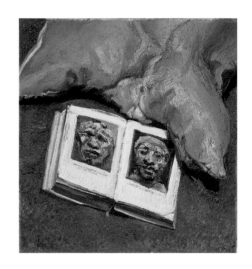

Still Life with Book 1993 [no.123]

opened at plates 120–1, resting against a pillow. Freud painted the image of the images from the page, of course, thereby coming his closest, perceptually, to Bacon and applying the paint as summarily, in effect, as Auerbach. The two heads have no names, no identities. Does it matter? Their gaze gives nothing away. Pharaohs be blowed. Philip IV of Spain is of no account now apart from being one of Velázquez's subjects, along with the man who was Mars and another who was Aesop. Which is the duke and which the scrounger? Was Moses Akhenaten?

Dryden said of poetry that it is 'moving the sleeping images of things towards the light'. We who spend a third of our lives asleep, and perhaps longer dreaming, are reawakened in art. Dated around 100 AD, almost too recent for inclusion in *Geschichte Aegyptens*, plates 274–5 are two Romano-Egyptian encaustic paintings from Faiyum, made to be attached like masks to mummy wrappings: 'Portrait of a Lady' and 'Portrait of a Boy', recognisable individuals, detached now from their corpses. Sigmund Freud owned several Faiyum paintings like these. 'Art is a way back to reality,' he once said.

Two Brothers from Ulster 2001 [no.149] – in which Paul, the 19-year-old in *Two Irishmen* who became the 33-year-old of *Head of an Irishman* 1999 [no.140], sits with his younger brother, Sam – is a painting tense with character. *Freddy Standing* 2000–1 could be a relaxed version of Rodin's *John the Baptist*. Freddy stands passive but self-possessed in the corner of the studio where Bruce Bernard had stood and where the Pearce family had sat, his father a wiped reflection in the dark window.

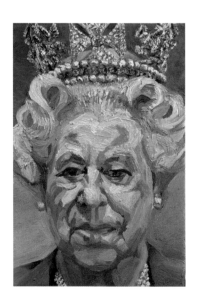

Portrait of The Queen 2001
(The Royal Collection)

IN HIS RECENT PAINTINGS, large and small, Lucian Freud has pressed on with the exploration of a world – the studio – as circumscribed and infinitely potential as Shakespeare's Globe, his 'wooden O'. There is no lack of subject matter here, no loss of purpose. Each painting, worked up from nothing, is another new reality. He has even validated that most ancient – pre-Dynastic – genre, the royal portrait.[58]

'Shows I do are punctuations.' This retrospective is a semi-colon, not a full stop; a pause to see what has been achieved before heading on.

'In art you take a risk. It's actually a deliberate thing. You are on the diving board. And in life it's even slightly difficult to define what is a risk. Unless you are playing, like I used to, Russian roulette with motor cars. You know: dashing across the road with your eyes shut to test your luck. In working, one of the things that makes you continue and is a stimulant is the difficulty surely?'

'THE THEME ITSELF carries you on.'

For years, among the phone numbers and paint smears on the studio walls, 'Art is Escape from Personality' was scrawled in charcoal;[59] also an exhortation: 'Urgent Subtle Concise'. Freud often talks about the need for emotion in a painting, not fervid expression but longing and risk and a sort of compassion. These paintings are begun in hope ('I love starting things'), worked through and through ('seeing how far I can go') until, penetratingly awkward as they often are, they become all we need to know.

'The harder you concentrate the more the things that are really in your head start coming out,' Freud said to me shortly before deciding that *After Cézanne* 2000 was ready for the framers. He looked intently at what he had made of the steps, the floor, one shoulder and another, the tideline along the skirting, the tilt of the coffee cups, and the spaces between them, opening up. What more could there be? 'I want to go on until there is nothing more to see.'

Studio, *c.*1992
Photo: William Feaver

1. All quotations, unless otherwise indicated, come from conversations with the artist over the past thirty years.

2. An English version of the book, *The Art of Ancient Egypt*, was published with a short text by Hermann Ranke and the same plates.

3. J. H. Breasted, *A History of Egypt*, New York 1905, p.355.

4. Breasted, *A History of Egypt*. See also Leonard Cottrell, *The Lost Pharaohs*, London 1956, 1999, pp.215–18.

5. *The Diary of Sigmund Freud, 1929–1939*, ed. Michael Molnar, London 1992, p.258.

6. Ibid. p. 220.

7. In *Moses: Pharaoh of Egypt*, London 1990, Ahmed Osman poses a theory that Moses was actually Akhenaten.

8. 'Thoughts on Painting', *Encounter*, July 1954.

9. Berlin, 1923. ('Im achten Manne ist ein Kind versteckt: das will spielen.')

10. *Punch*, 20 Jan. 1937.

11. See Fougasse / Kenneth Bird, *The Good Tempered Pencil*, London 1956, p.148.

12. Lawrence Gowing, *Lucian Freud*, London 1982.

13. Selected by W. H. Auden and John Garrett, London 1935.

14. London 1944. Christopher Isherwood was the anonymous author of the paper bag poem.

15. Valerie Grove, *Laurie Lee*, London 2000.

16. 'Islands of Scilly' in *Some Time After*, London 1972.

17. Watson and Roland Penrose backed the London Gallery which was run by the Belgian dealer–surrealist E. L. T. Mesens.

18. *Working for Lucian*, dir. Derek Smith, Border TV 1996.

19. Minton's long narrow face is reminiscent of the plaster mask of Akhenaten, plates 128–9 in *Geschichte Aegyptens*. He committed suicide in 1957.

20. *Portrait of Lucian Freud* (1951).

21. In the Tate Collection, but whereabouts unknown. Stolen from the Neue Nationalgalerie Berlin in May 1988. In 2001 Freud designed a 'Wanted' poster for display around Berlin in a campaign to recover the painting. The portrait was painted on a copper etching plate, as were *Still-life Squid and Sea Urchin* (1949), *Head of a Woman* (1950), *Portrait of a Girl* (1950) and *Girl Reading* (1952).

22. Initially a conversational lecture, 'Lightning Conductors', with David Sylvester, for the Oxford University Art Club in May 1953, revised with Sylvester's help and broadcast a year later on the BBC Third Programme and published in *Encounter*, July 1954.

23. *The Burlington Magazine*, October 1954.

24. *Lucian Freud: Early Works*, exh. cat., Robert Miller Gallery, New York 1993.

25. Unpublished catalogue introduction for Venice Biennale, British Council, 1954.

26. *New Statesman*, 5 Apr. 1958. In 1960 Freud went to Stockholm to draw Ingmar Bergman for a *Time* magazine cover. The portrait was not delivered: he needed the money and had calculated on being given the rejection fee only.

27. Foreword by Freud to *Frank Auerbach and the National Gallery*, exh. cat., National Gallery, London 1995.

28. Prompted by plate 74 in *Geschichte Aegyptens*: 'Group of the Dwarf Seneb and his Family'. Mother omitted.

29. *Corot raconte par lui-même*, ed. Etienne Moreau-Nelaton, Paris 1924, p.125.

30. Letter to author, 16 Jan. 1998. The term 'School of London' was exercised by R. B. Kitaj in his introduction to *The Human Clay*, 1976, an Arts Council exhibition of figure drawings selected by him. All those summarily enrolled – Andrews, Auerbach, Bacon, Freud, Kossoff and others (notably Uglow) – objected to the label which had been used previously by Gowing and by others at least thirty years before.

31. Gowing, *Lucian Freud*, p.190.

32. Ibid, p.60.

33. Leigh Bowery in conversation with Lucian Freud in *Lovely Jobly*, London 1991.

34. Quoted by Martin Gayford in 'Artists on Art', *Daily Telegraph*, 22 Dec. 2001.

35. Freud worked from a blown-up photograph of the illustration in the catalogue of the Thyssen Old Master collection.

36. *The Artist's Eye: Lucian Freud*, exh. cat., National Gallery, London 1987.

37. Daniel Farson, *The Gilded Gutter Life of Francis Bacon*, London 1993, p.203.

38. *Lucian Freud: Paintings*, exh. cat., London 1987, pp.7, 21. The exhibition, organised by the British Council, was subsequently shown at the Centre Pompidou, Paris, the Hayward Gallery, London and the Neue Nationalgalerie in Berlin.

39. He also stands comparison with Rodin's *Naked Balzac*, a cast of which stood for some years in the hallway of the Holland Park flat.

40. Quoted by Angus Cook in *Lucian Freud*, exh. cat., Rome and Milan 1991. Remark revised in conversation, 2002.

41. 'The Artist out of his Cage: William Feaver interviews Lucian Freud', *Observer Review*, 6 Dec. 1992.

42. *Moses and Monotheism*, p.161.

43. T. S. Eliot, *Collected Poems 1909–1935*, London 1936.

44. Freud quoted in Hughes, *Lucian Freud: Paintings*, p.19.

45. Conversation with author, Third Ear, BBC Radio 3, recorded 10 Dec. 1991.

46. Conversation with author in 'Body Language', *Observer Magazine*, 29 Aug. 1993.

47. Sue Tilley, *Leigh Bowery: The Life and Times of an Icon*, London 1997, p.140.

48. 'Paint Becomes Flesh', *New Yorker*, 13 Dec. 1993, p.143.

49. Conversation with author, 'Body Language', *Observer Magazine*, 29 Aug. 1993.

50. Bernard, 'Painter Friends' in *From London*, exh. cat., British Council, 1995, p.45.

51. Conversation with author, Aug. 1993, 'The Naked Truth', *Observer Magazine*, 29 May 1993.

52. 'The Artist out of his Cage'.

53. 'Body Language'.

54. Quoted by Feaver in *Observer Life*, 17 May 1998; fuller version in the leaflet accompanying 'Some New Paintings', Tate Gallery, 1998.

55. Cézanne to Roger Marx, 23 Jan. 1905, in *Letters*, ed. John Rewald, London 1941.

56. Freud selected the paintings and drawings for *John Constable* at the Grand Palais, Paris, Autumn 2002.

57. E. H. Gombrich, 'Portrait painting and portrait photography' in *Apropos* 5, London 1945, p.6.

58. *Portrait of The Queen* (2001), a gift to the Royal Collection.

59. 'Poetry is not the expression of personality but an escape from personality.' T. S. Eliot, 'Tradition and the Individual Talent' (1919) in *Selected Essays*, London 1953, p.21.

On Lucian Freud

I CAN ONLY PUT THIS APPROXIMATELY; I am not a writer.

When I think of artists, the first image that occurs has something to do with their manner. Matisse: shaped colour aspiring to transcendence; Michelangelo: twisted masses evoking (both in sculpture and in painting) a sort of muscular and organic sculpture; Dürer: a wiry lasso of a line capturing the quarry, etc., etc.

When I think of the work of Lucian Freud, I think of Lucian's attention to his subject. If his concentrated interest were to falter he would come off the tight-rope; he has no safety net of manner. Whenever his way of working threatens to become a style, he puts it aside like a blunted pencil and finds a procedure more suited to his needs.

I am never aware of the aesthetic paraphernalia. The subject is raw, not cooked to be more digestible as art, not covered in a gravy of ostentatious tone or colour, not arranged on the plate as a 'composition'.

The paintings live because their creator has been passionately attentive to their theme, and his attention has left something for us to look at. It seems a sort of miracle.

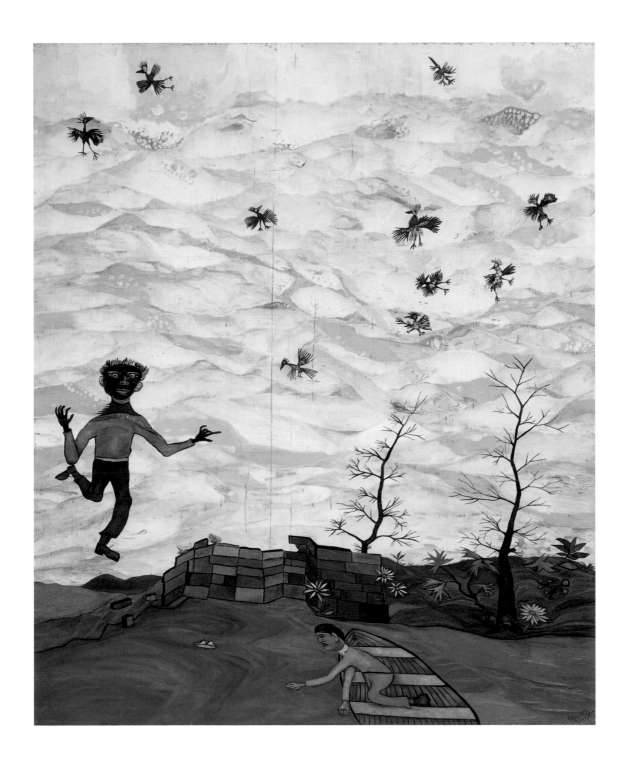

Landscape with Birds 1940 | no. 3

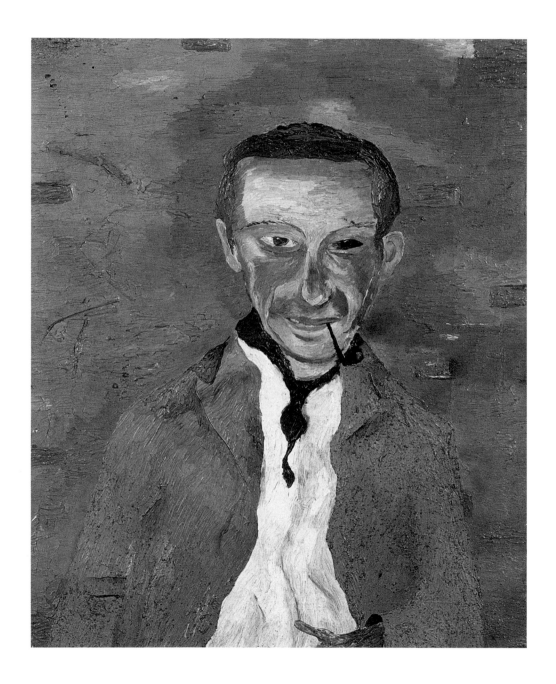

Cedric Morris 1940 | no.2

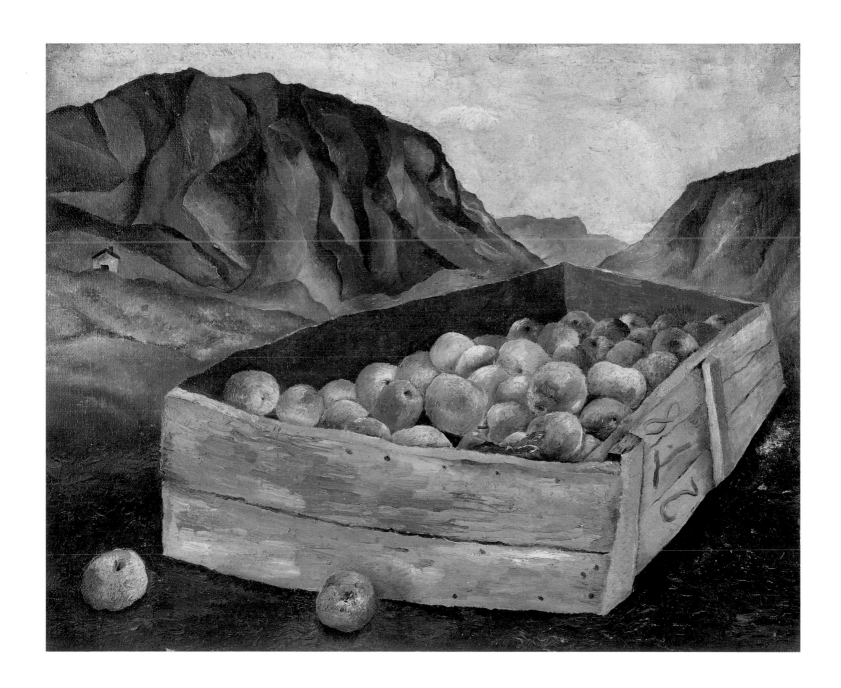

Box of Apples in Wales 1939 | no.1

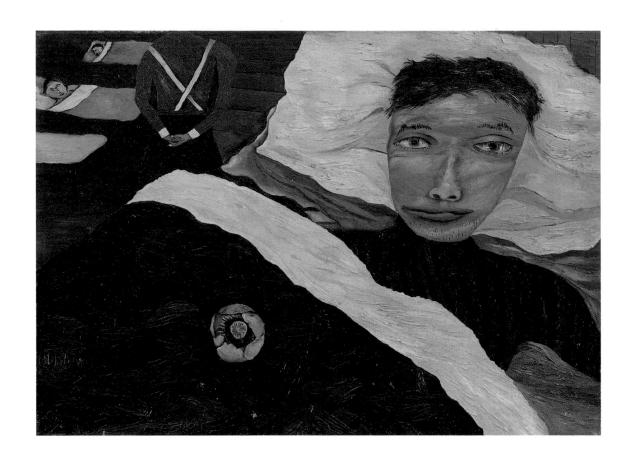

Hospital Ward 1941 | no.5

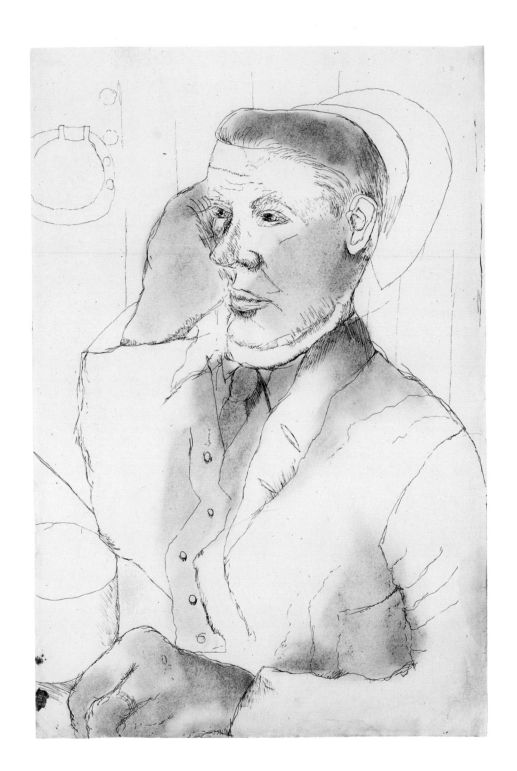

Able Seaman 1941 | no.4

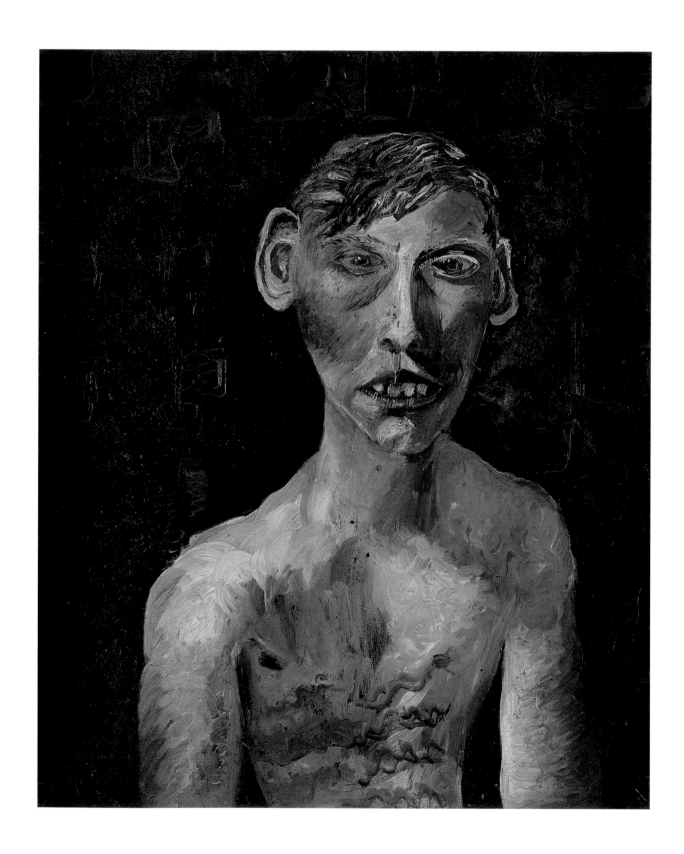

Evacuee Boy 1942 | no.6

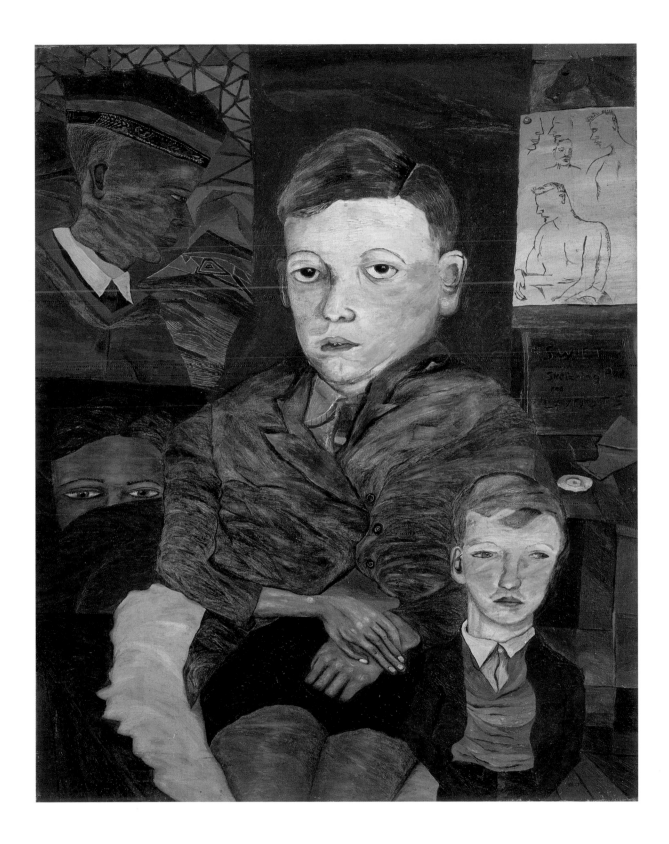

The Village Boys 1942 | no.7

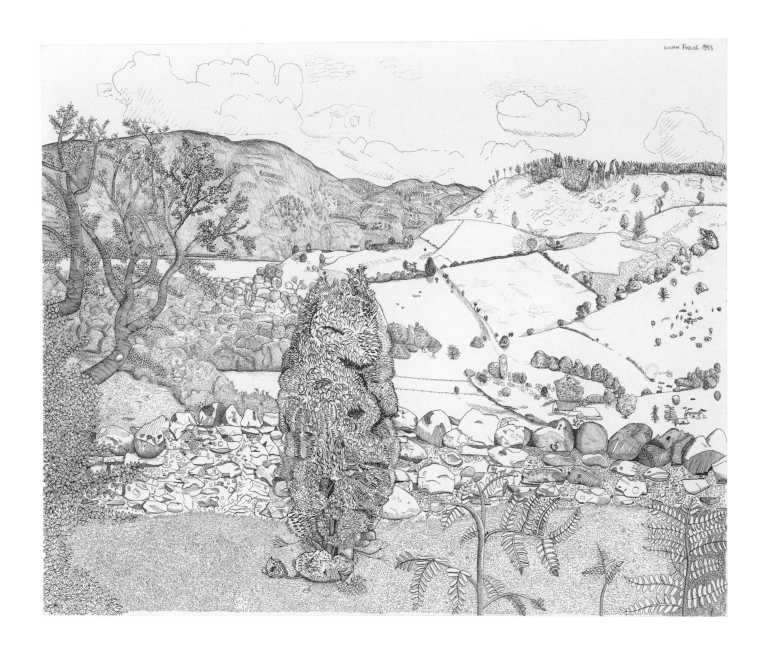

Loch Ness from Drumnadrochit 1943 | no.8

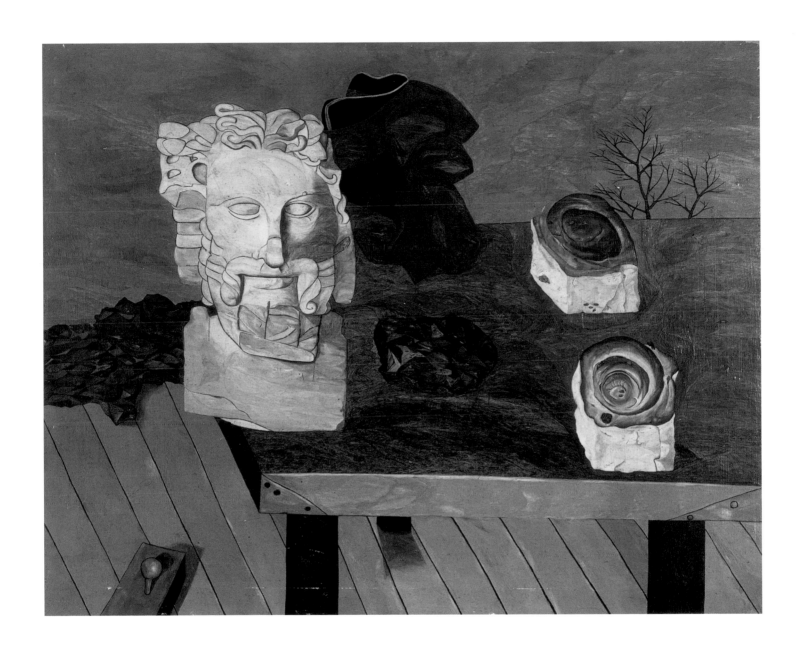

Still Life with Chelsea Buns 1943 | no.9

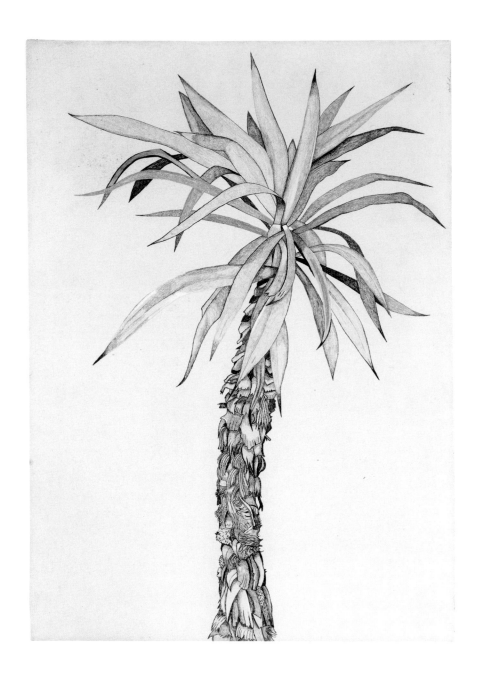

Palmtree 1944 | no.11

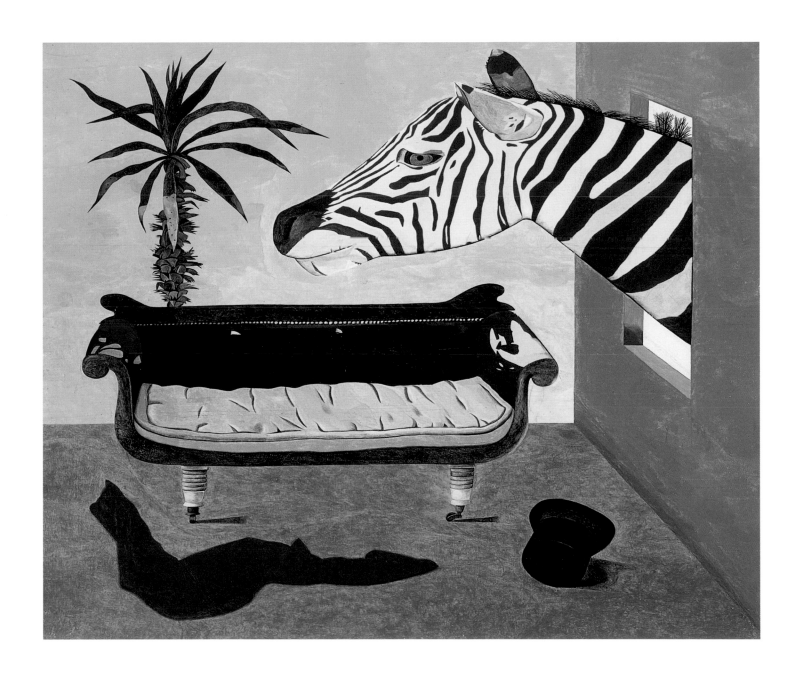

The Painter's Room 1943–4 | no.10

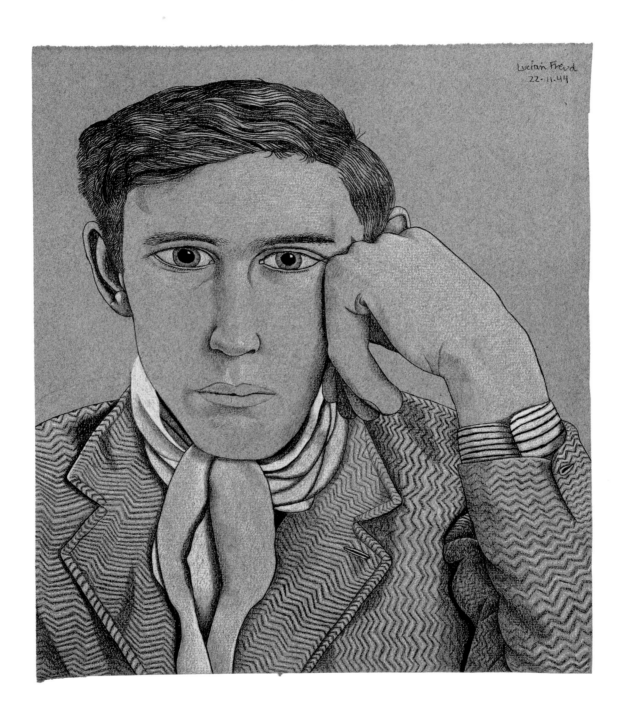

Portrait of a Young Man 1944 | no.13

Boy on a Balcony 1944 | no.12

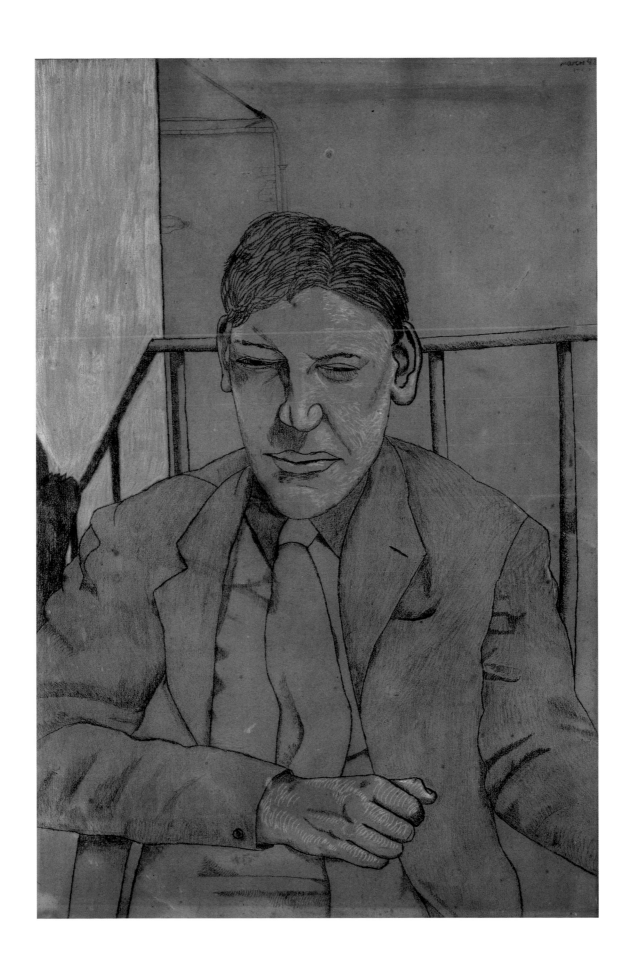

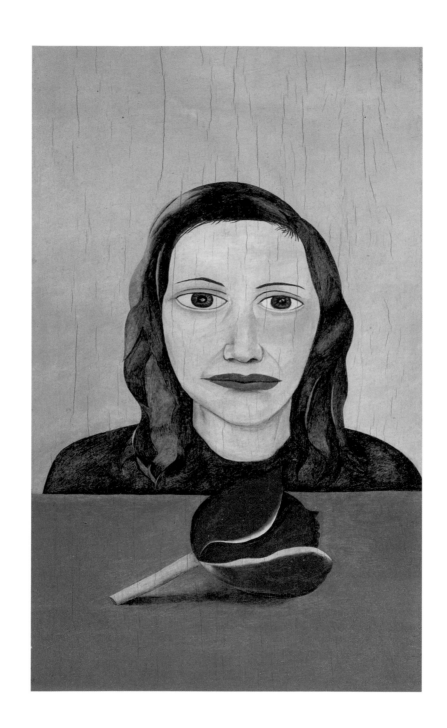

Woman with a Tulip 1945 | no.15

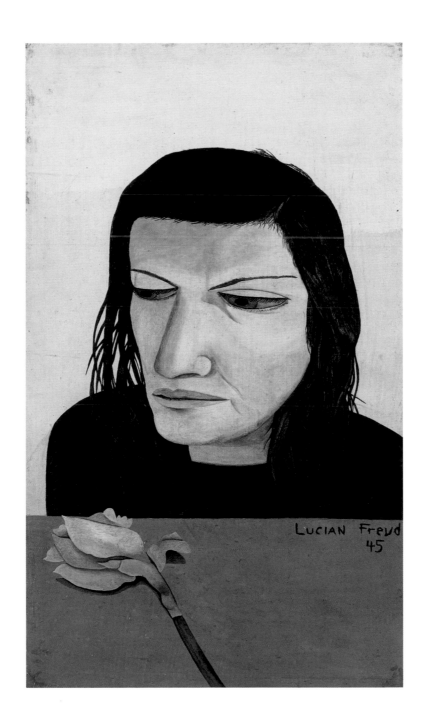

Woman with a Daffodil 1945 | no.14

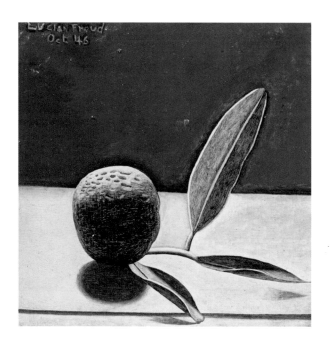

Unripe Tangerine 1946 | no.17

Dead Heron 1945 | no.16

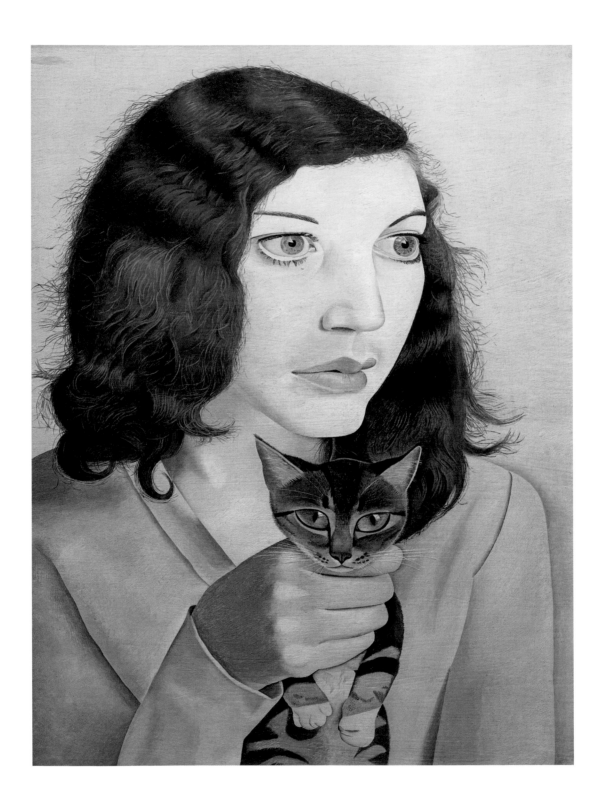

Girl with a Kitten 1947 | no.20

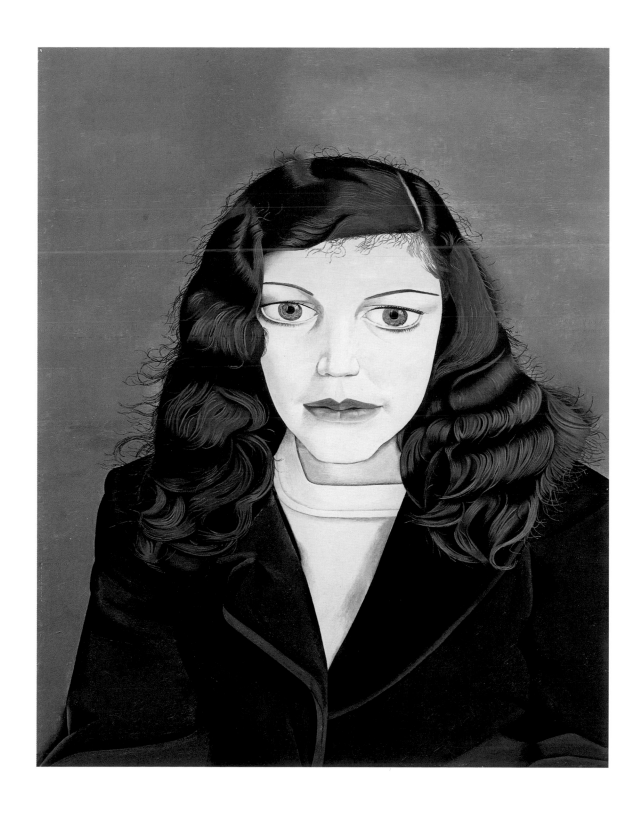

Girl in a Dark Jacket 1947 | no.19

Girl with Leaves 1948 | no.22

Girl with Roses 1947–8 | no.21

Girl with Fig Leaf 1948 | no.23

Ill in Paris 1948 | no.24

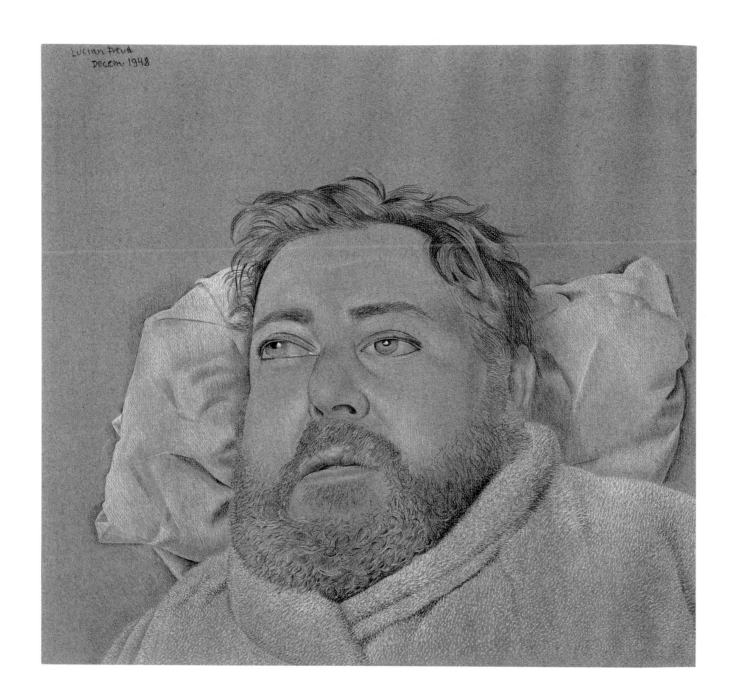

Christian Bérard 1948 | no.25

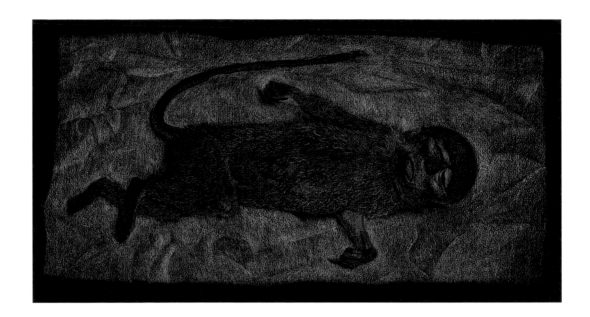

Dead Monkey 1950 | no.28

Still-life with Squid and
Sea Urchin 1949 | no.26

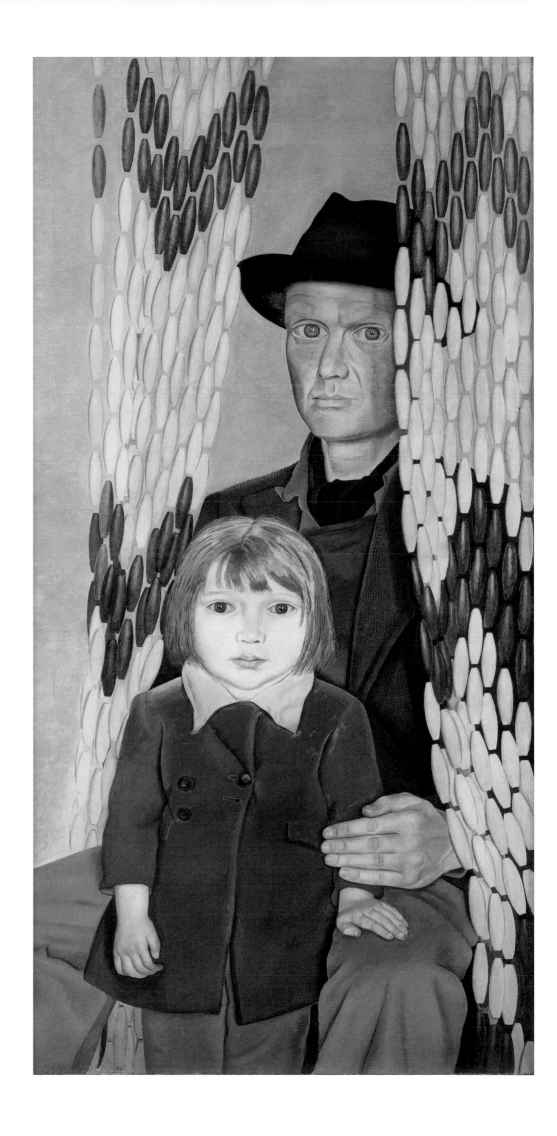

Father and Daughter 1949 | no.27

Girl with a White Dog 1950–1 | no.33

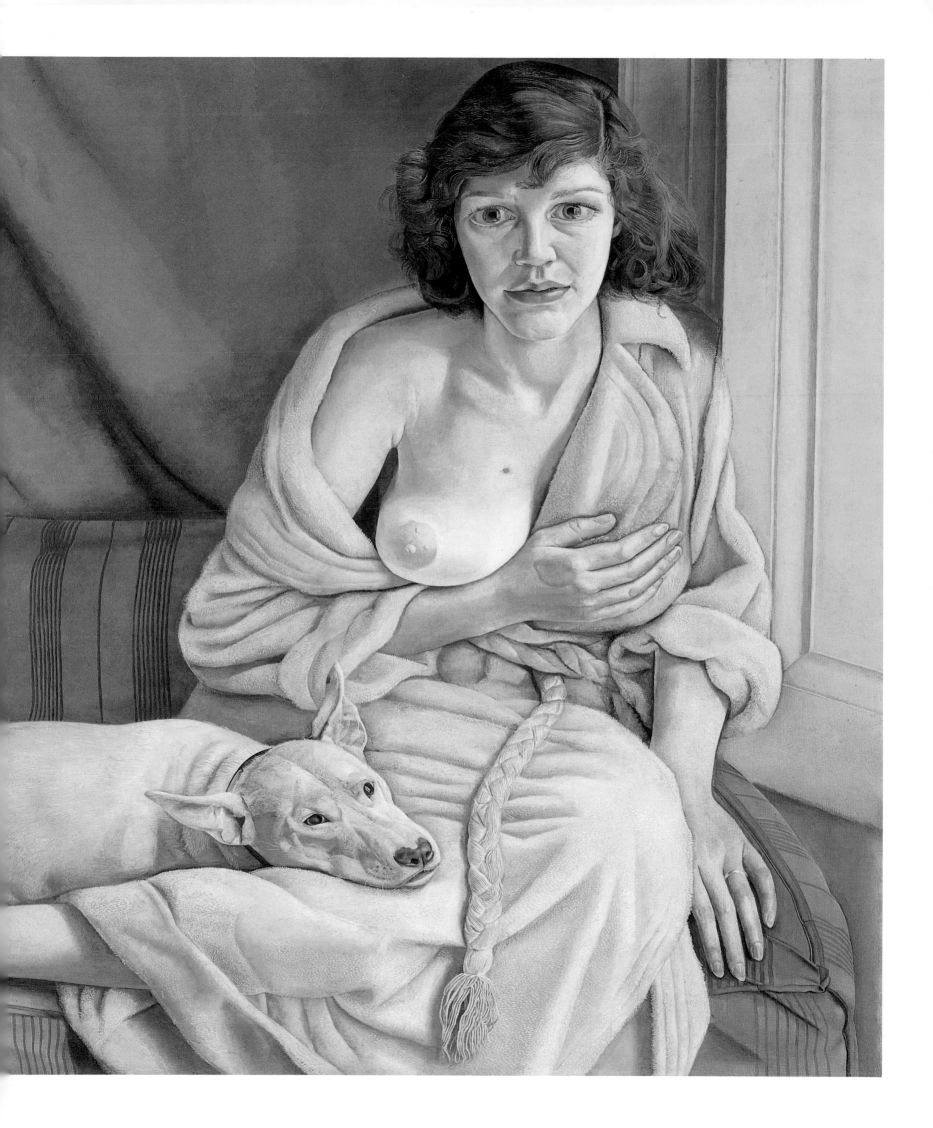

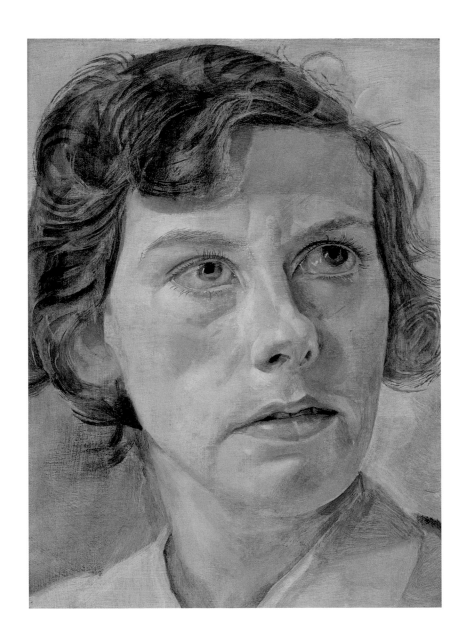

Head of a Woman 1950 | no.29

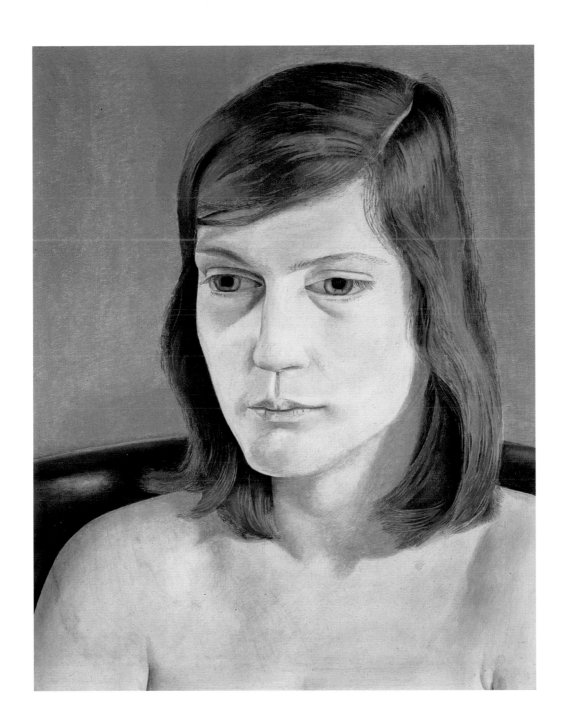

Portrait of a Girl 1950 | no.30

Interior in Paddington 1951 | no.31

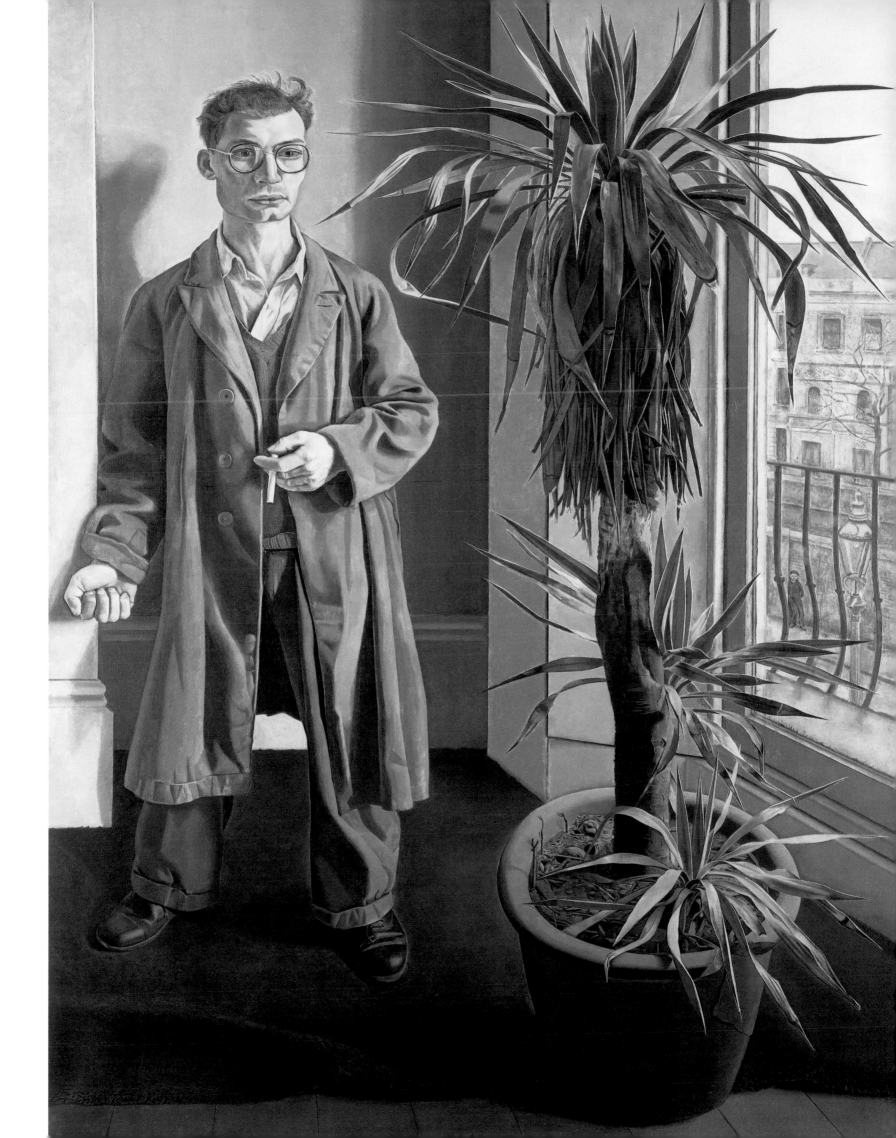

Francis Bacon 1951 | no.34

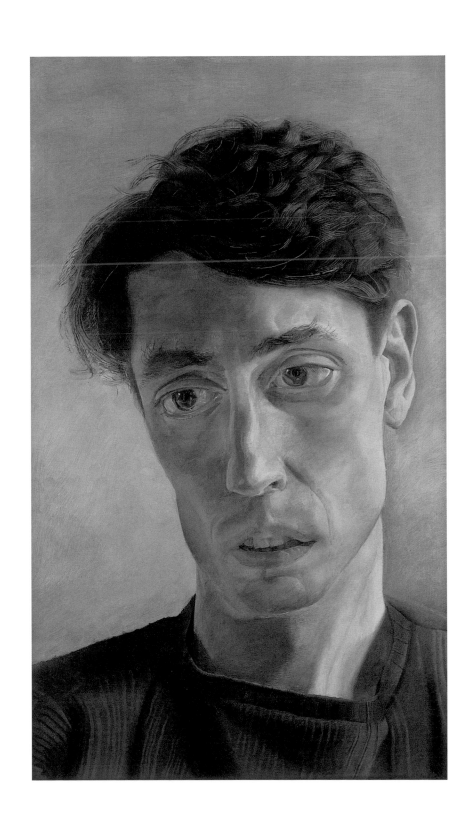

John Minton 1952 | no.35

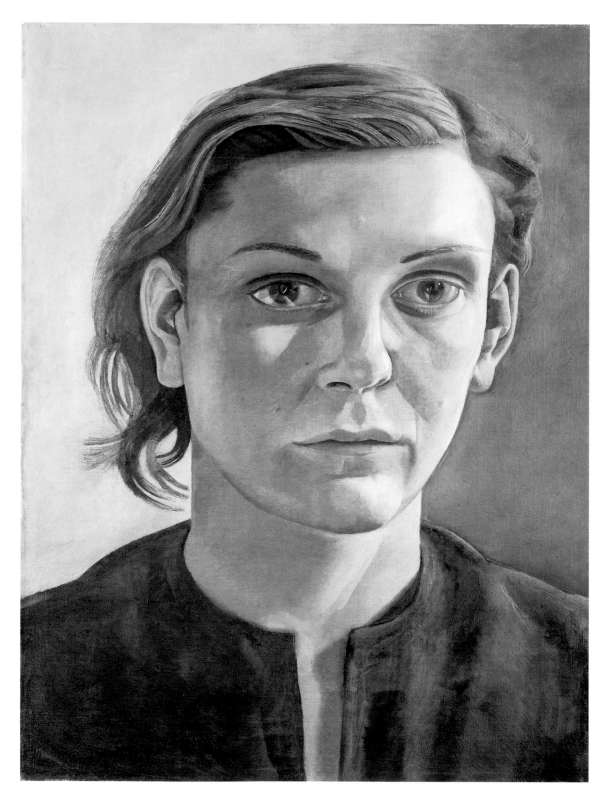

Girl in a Dark Dress 1951 | no.32

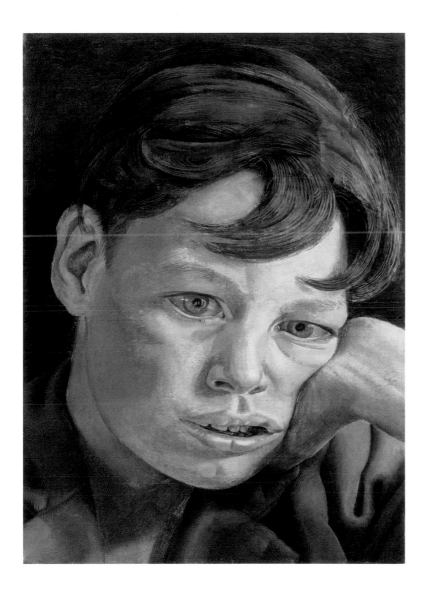

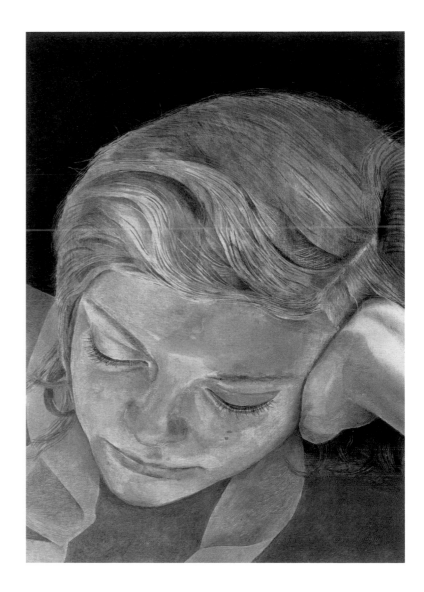

Boy's Head 1952 | no.36

Girl Reading 1952 | no.37

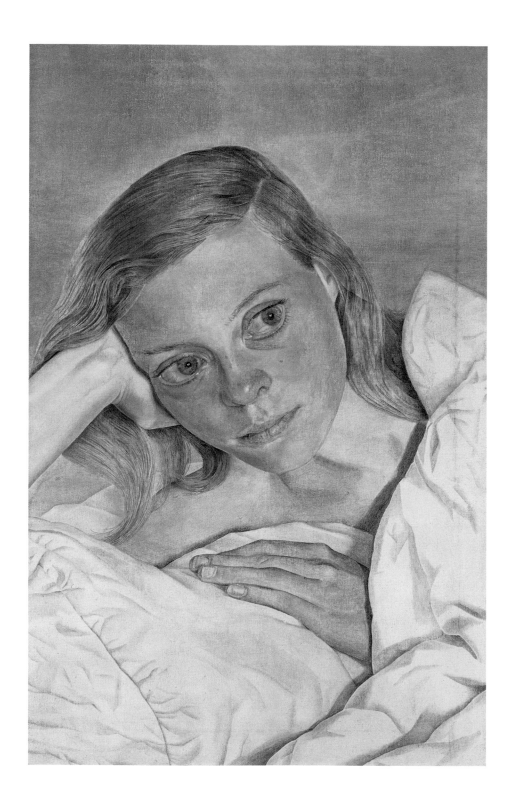

Girl in Bed 1952 | no.38

Hotel Bedroom 1954 | no.40

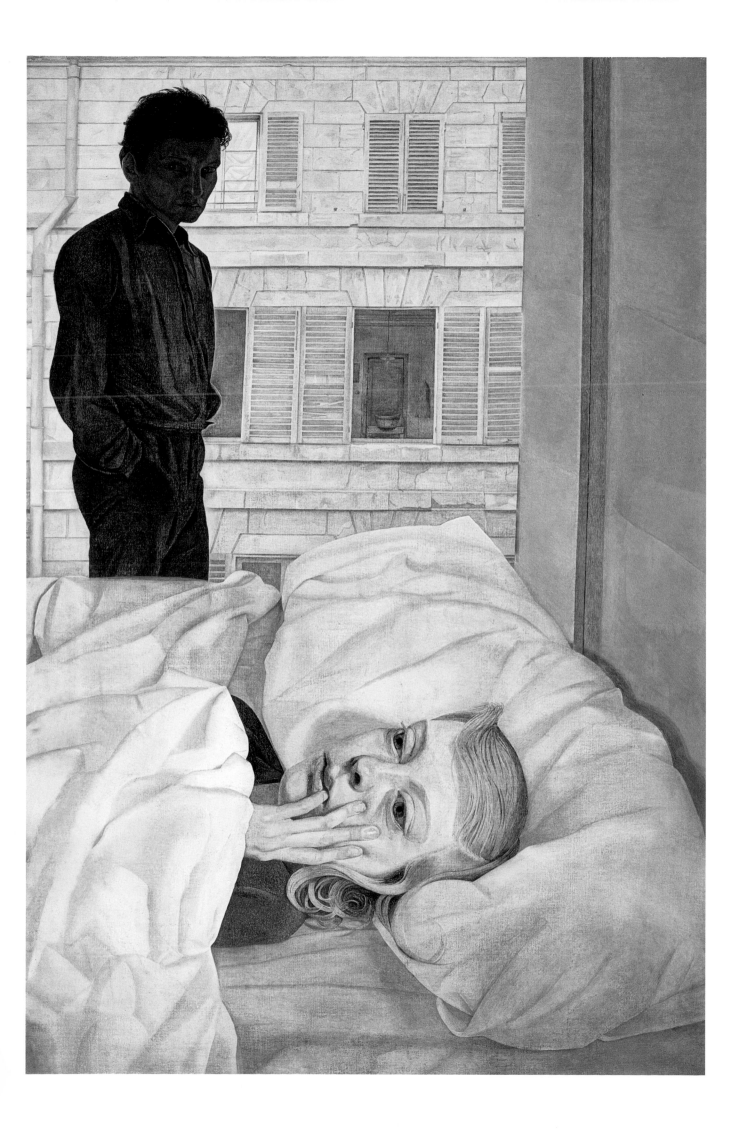

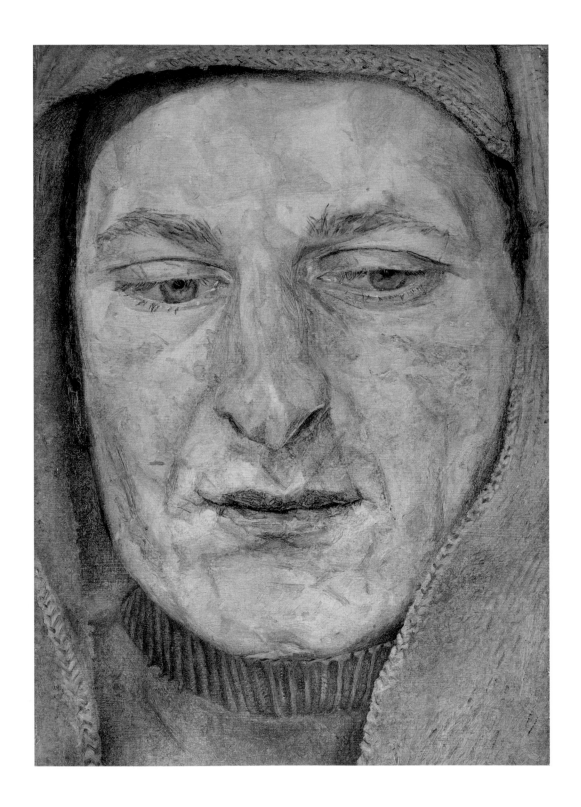

The Procurer (Man in a Headscarf) 1954 | no.41

A Woman Painter 1954 | no.42

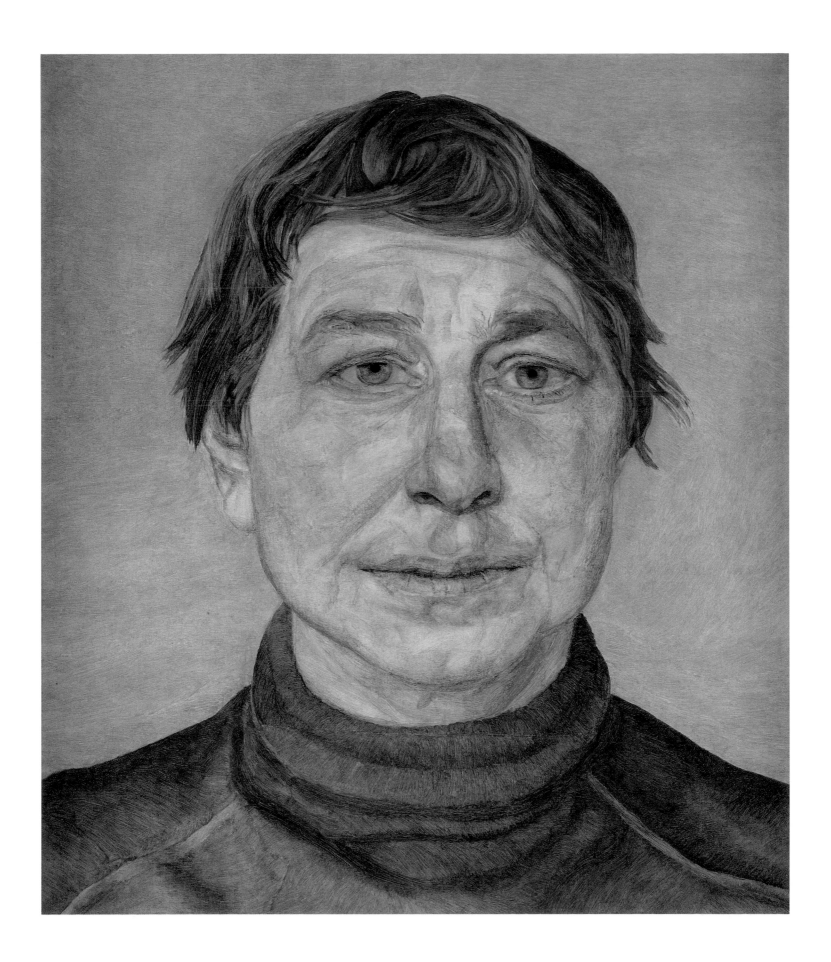

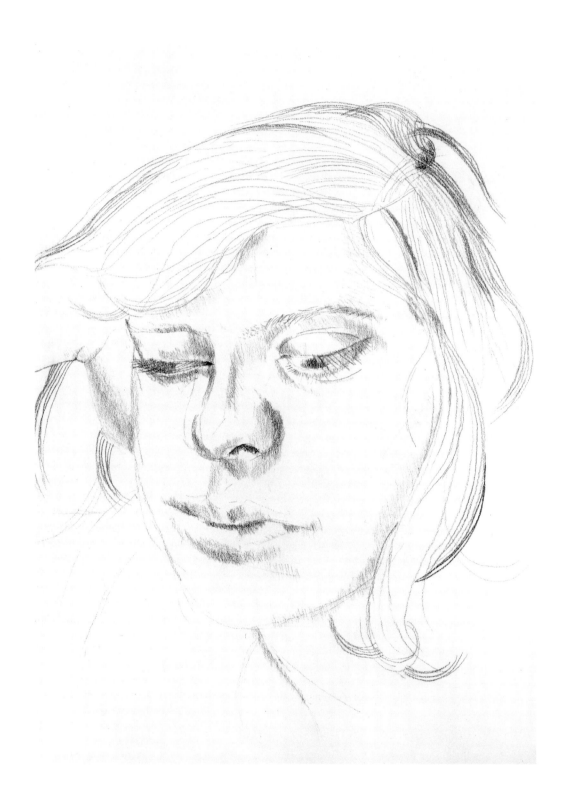

Girl's Head 1954 | no.39

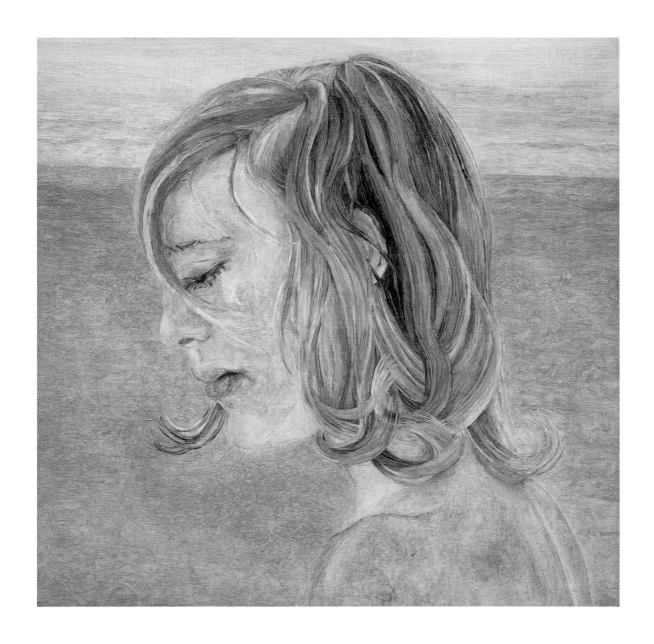

Girl by the Sea 1956 | no.43

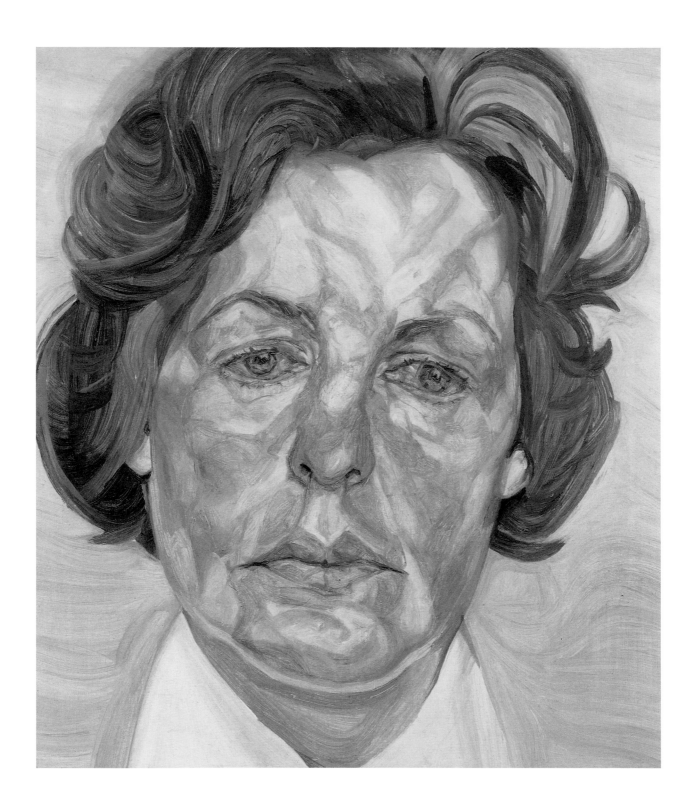

Woman in a White Shirt 1956–7 | no.44

Woman Smiling 1958–9 | no.45

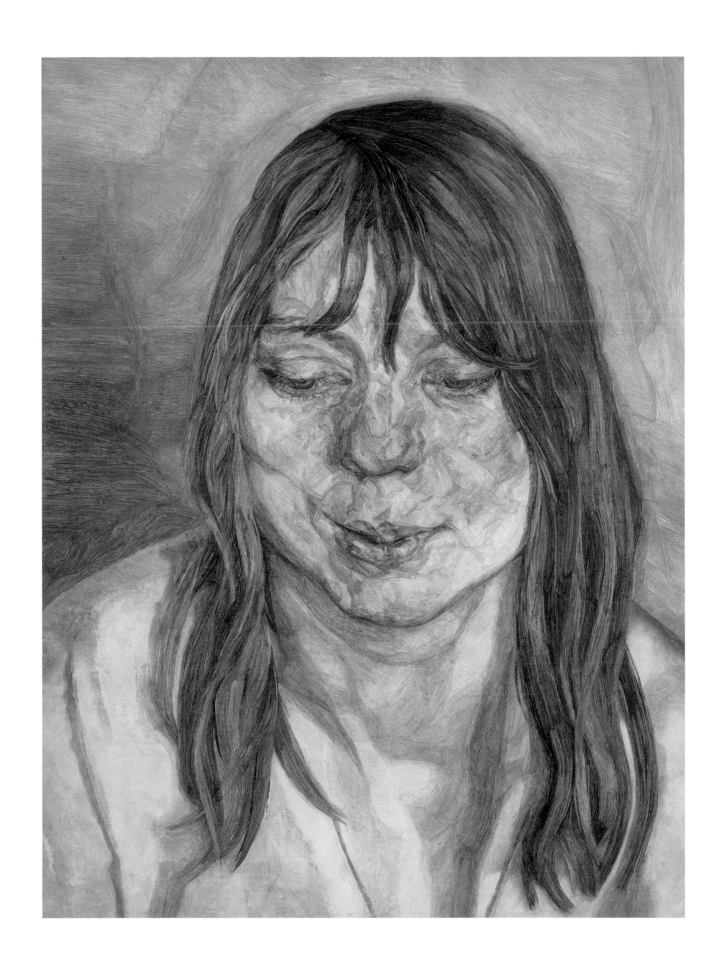

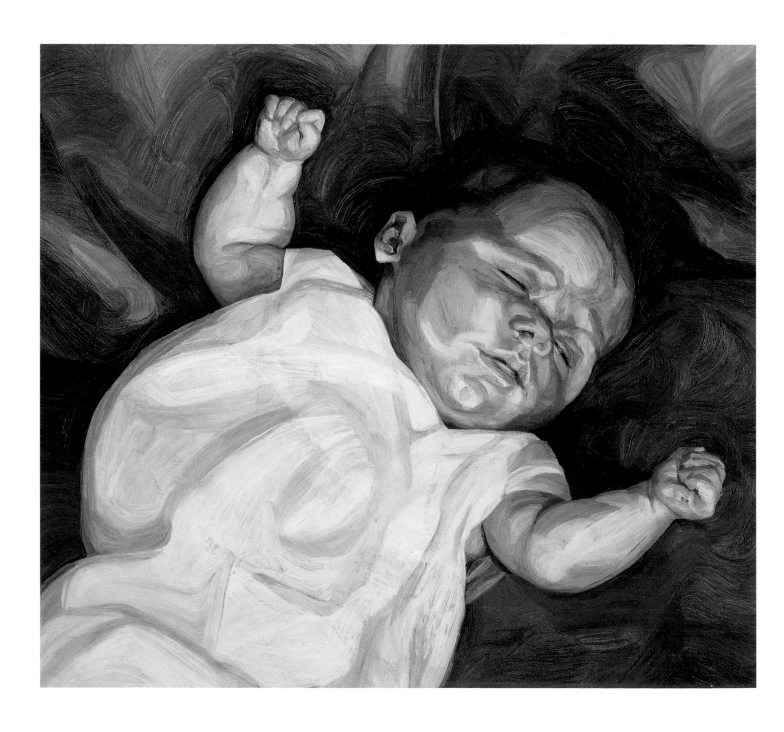

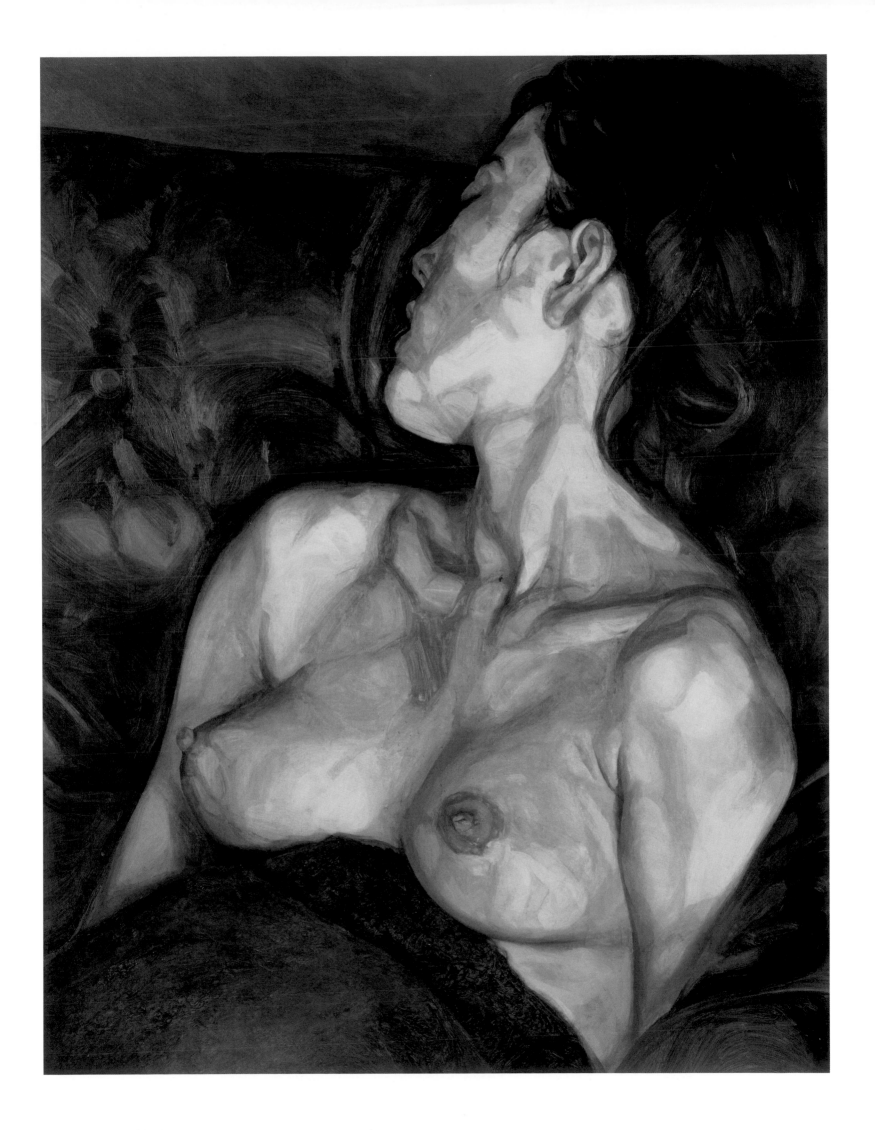

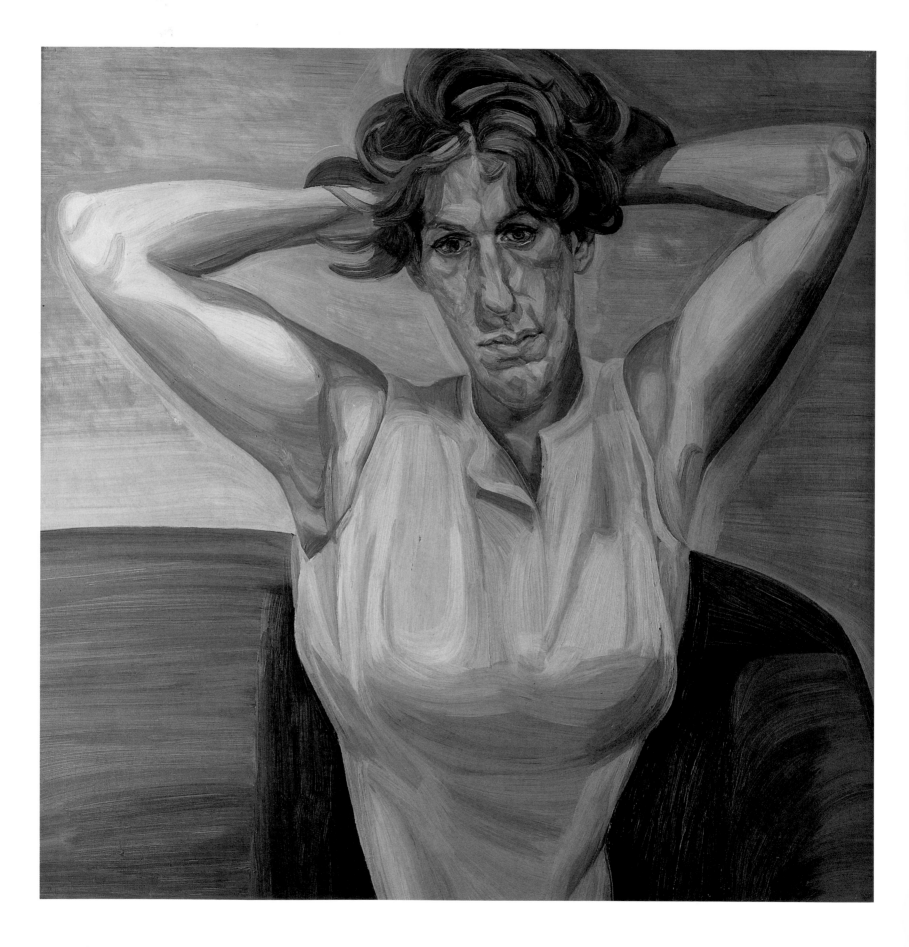

Figure with Bare Arms 1962 | no.49

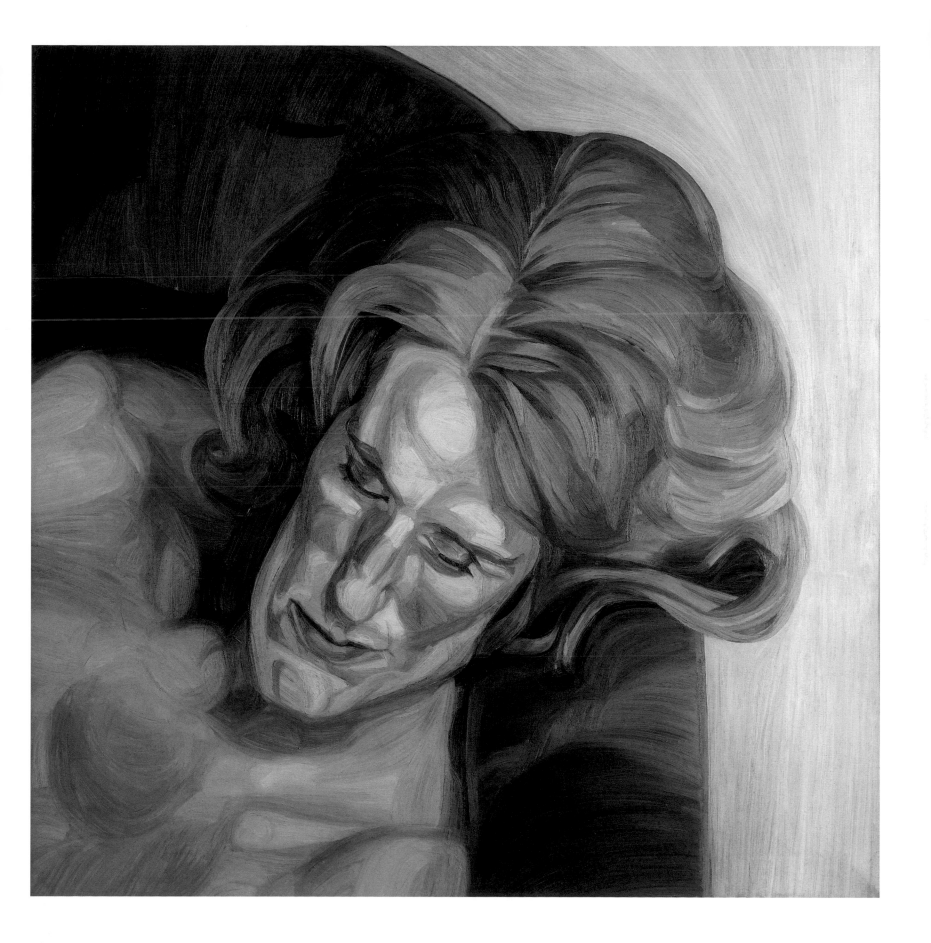

Head on a Green Sofa 1960–1 | no.48

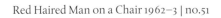
Red Haired Man on a Chair 1962–3 | no.51

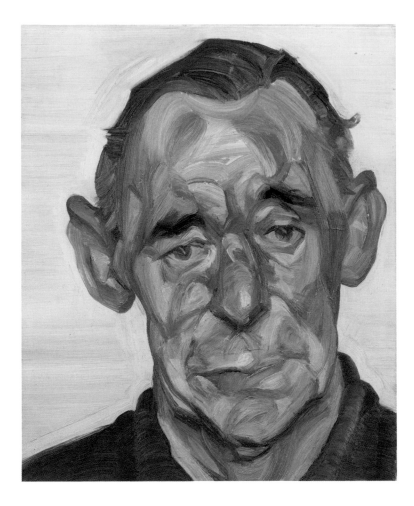

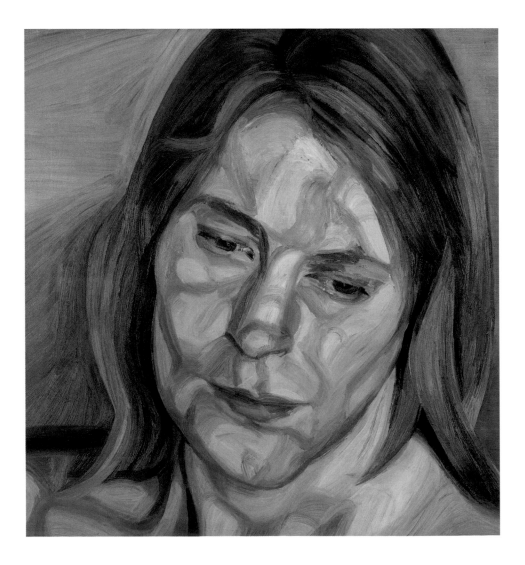

John Deakin 1963–4 | no.52

Head 1962 | no.50

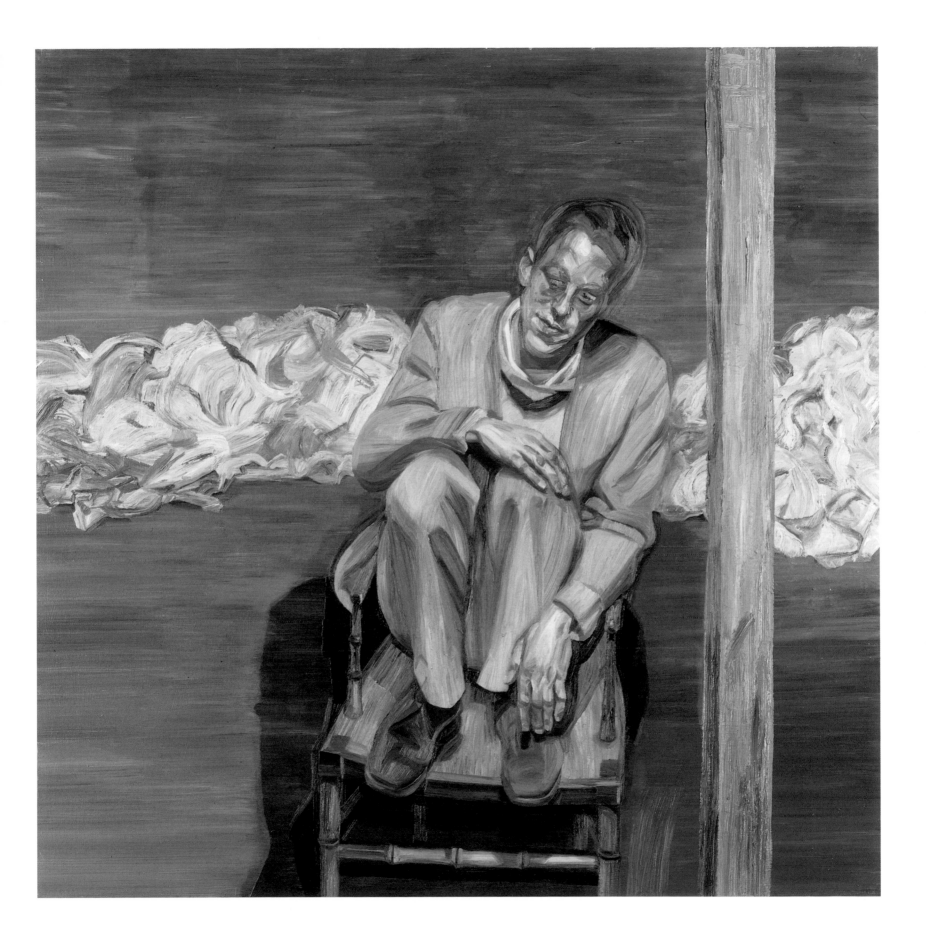

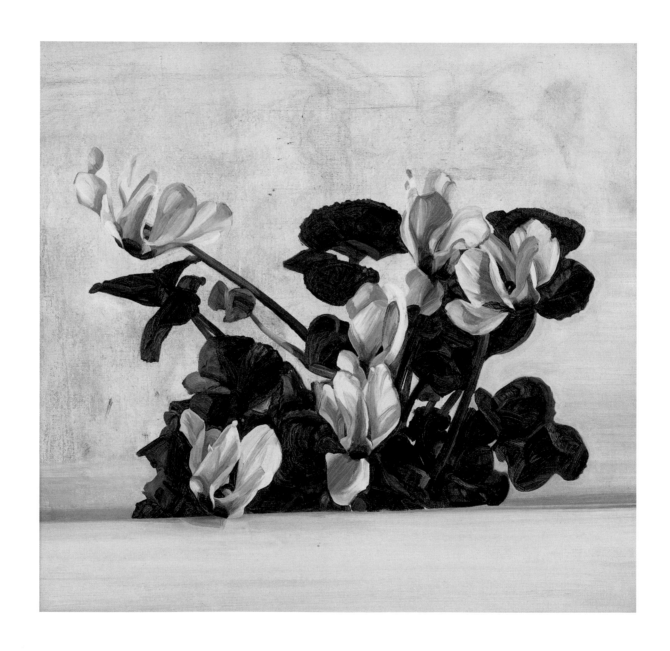

Cyclamen 1964 | no.54

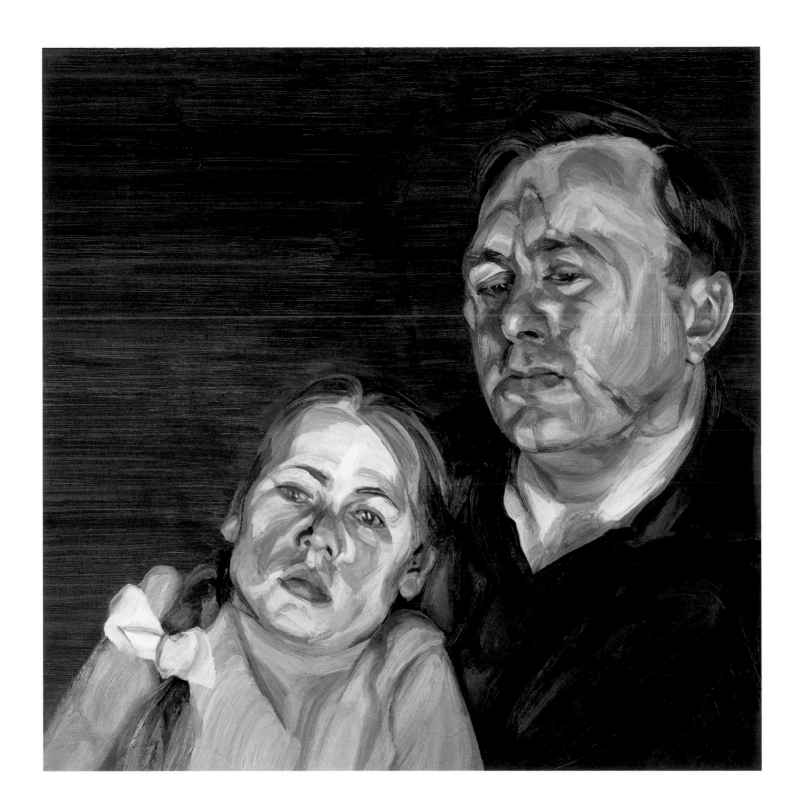

A Man and his Daughter 1963–4 | no.53

Reflection with Two Children (Self-Portrait) 1965 | no.56

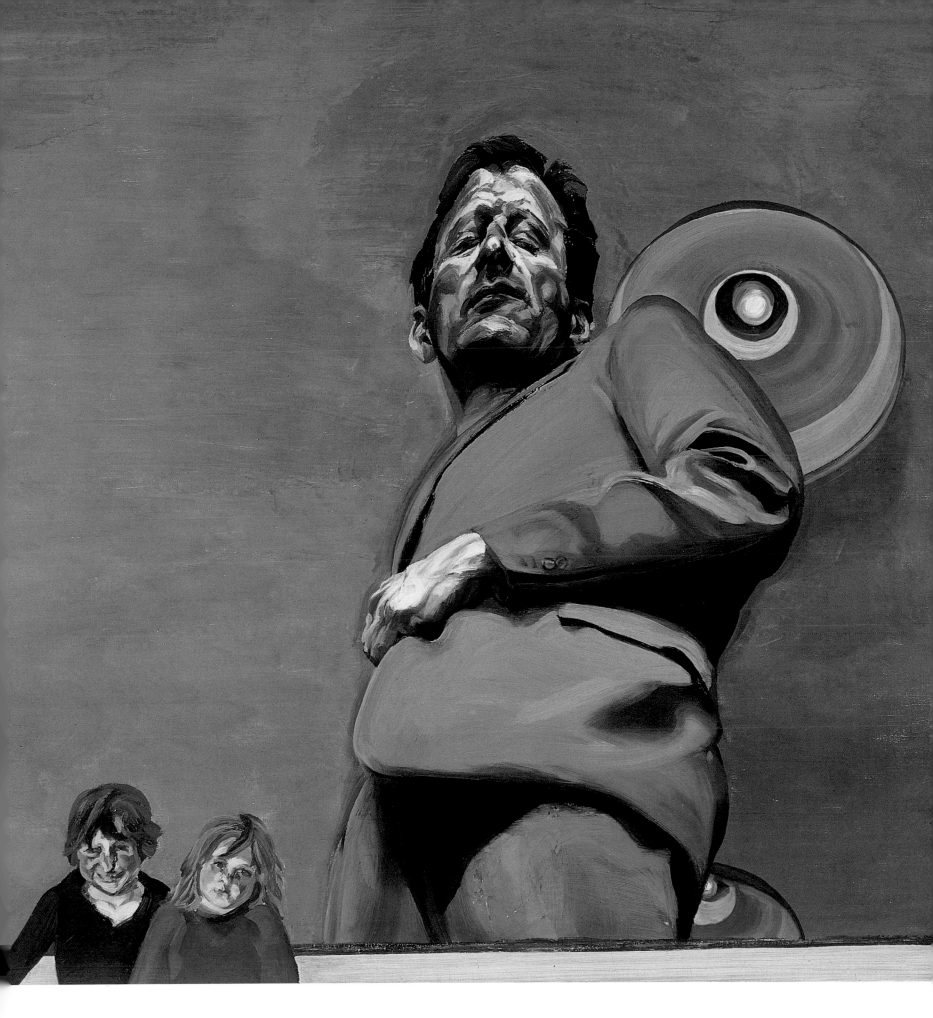

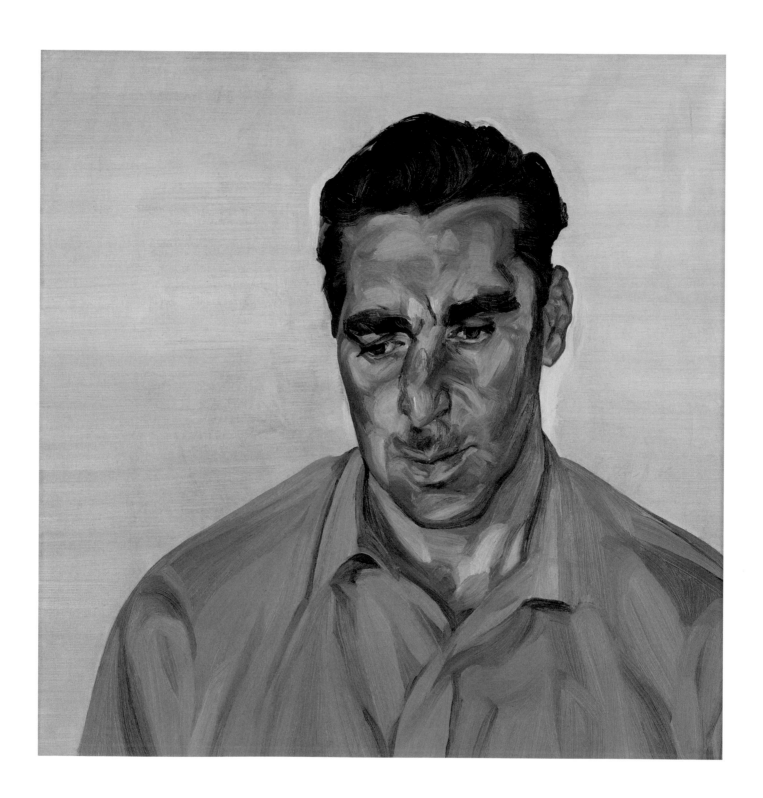

Man in a Blue Shirt 1965 | no.55

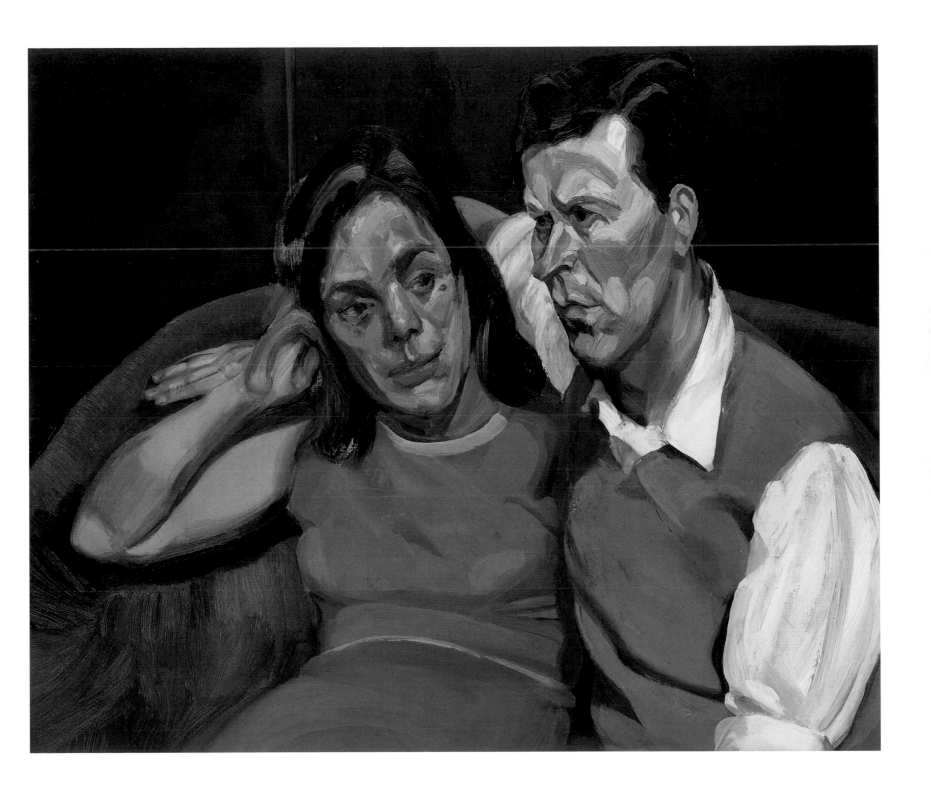

Michael Andrews and June 1965–6 | no.57

Naked Girl 1966 | no.58

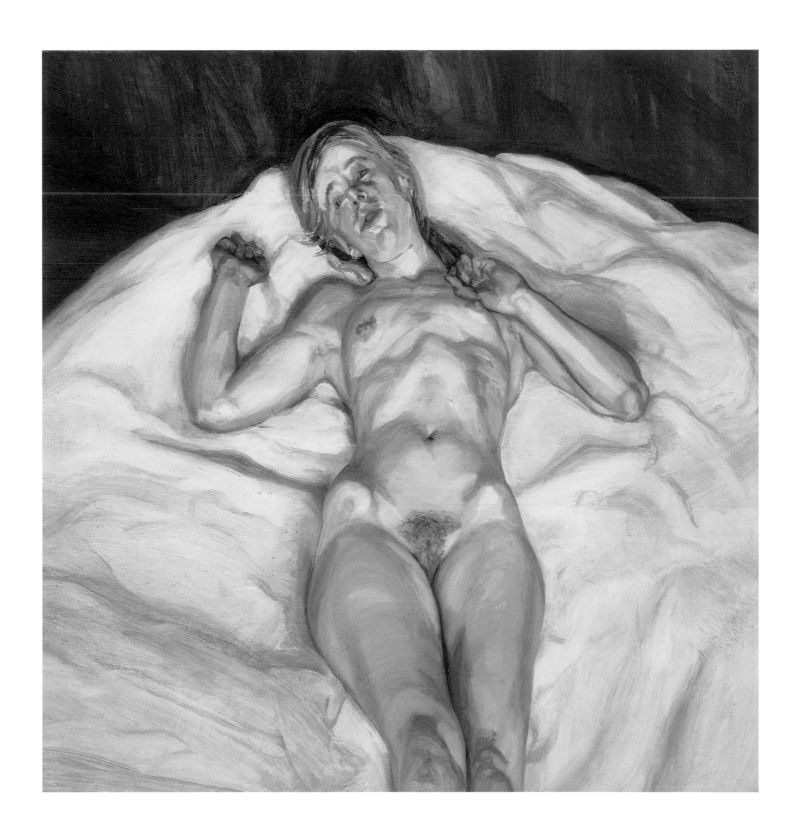

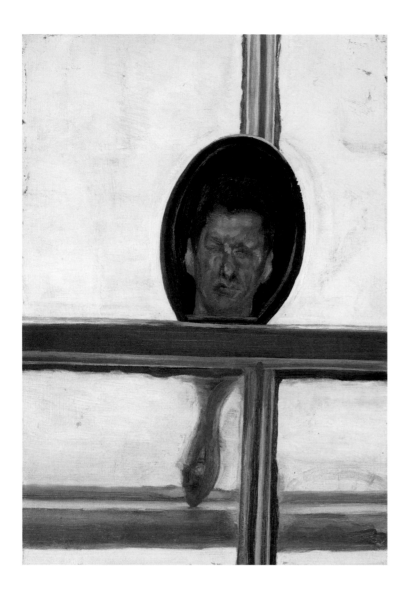

Interior with Hand Mirror (Self-Portrait) 1967 | no.59 Interior with Plant, Reflection Listening 1967–8 | no.60

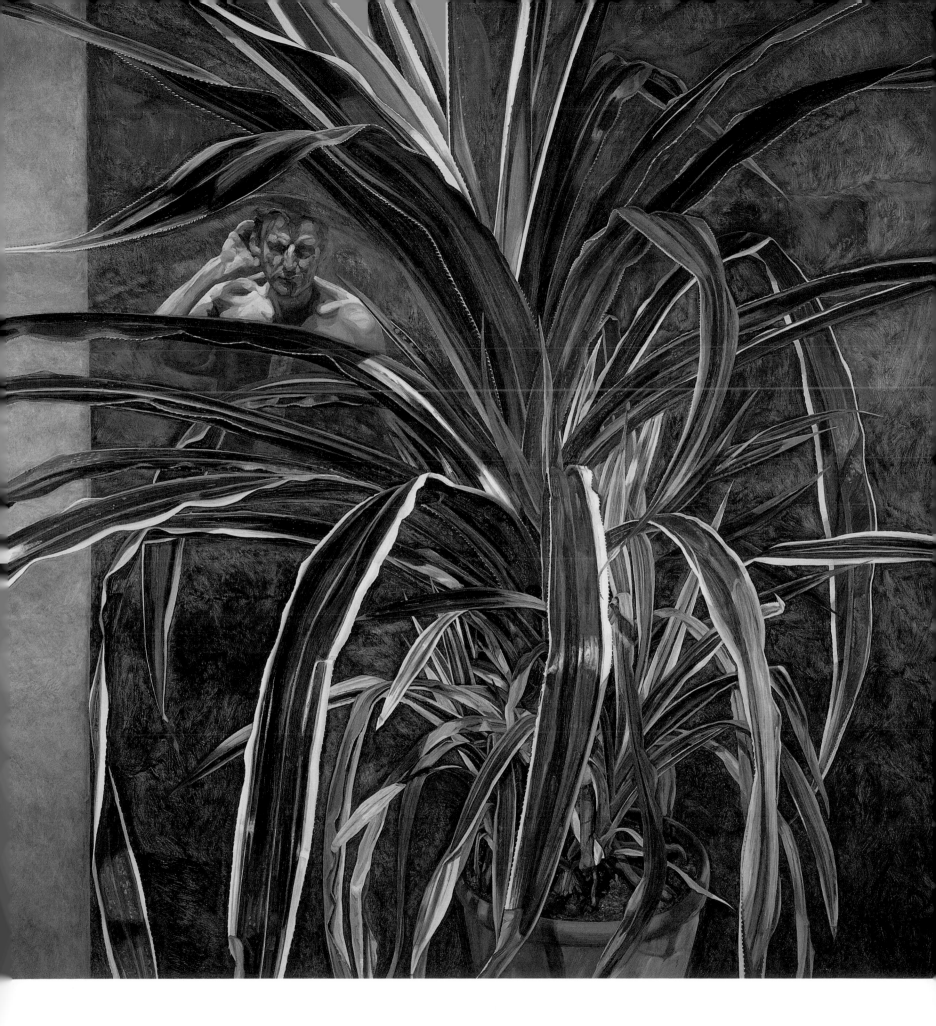

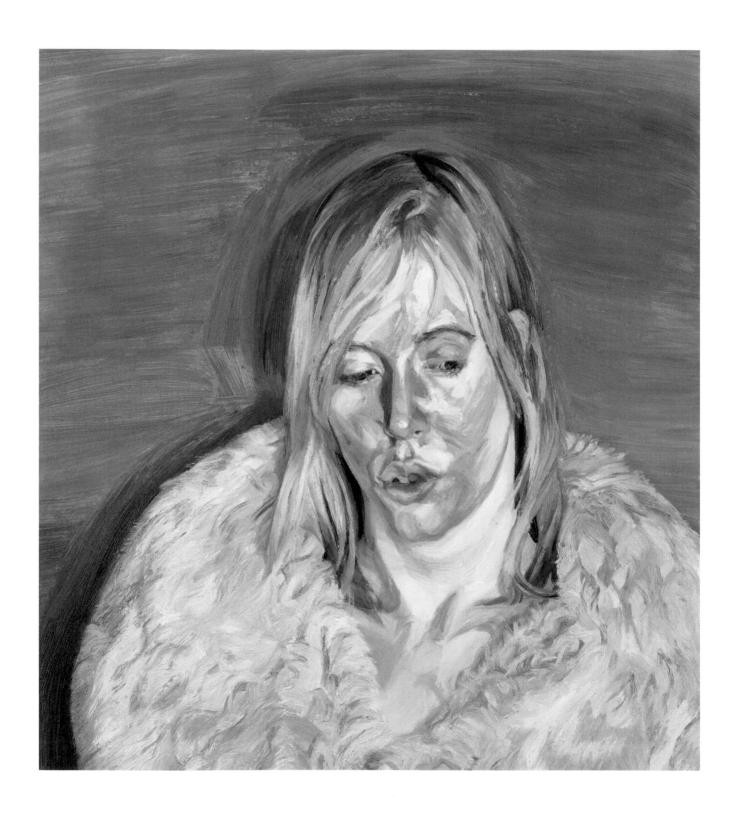

Woman in a Fur Coat 1967–8 | no.61

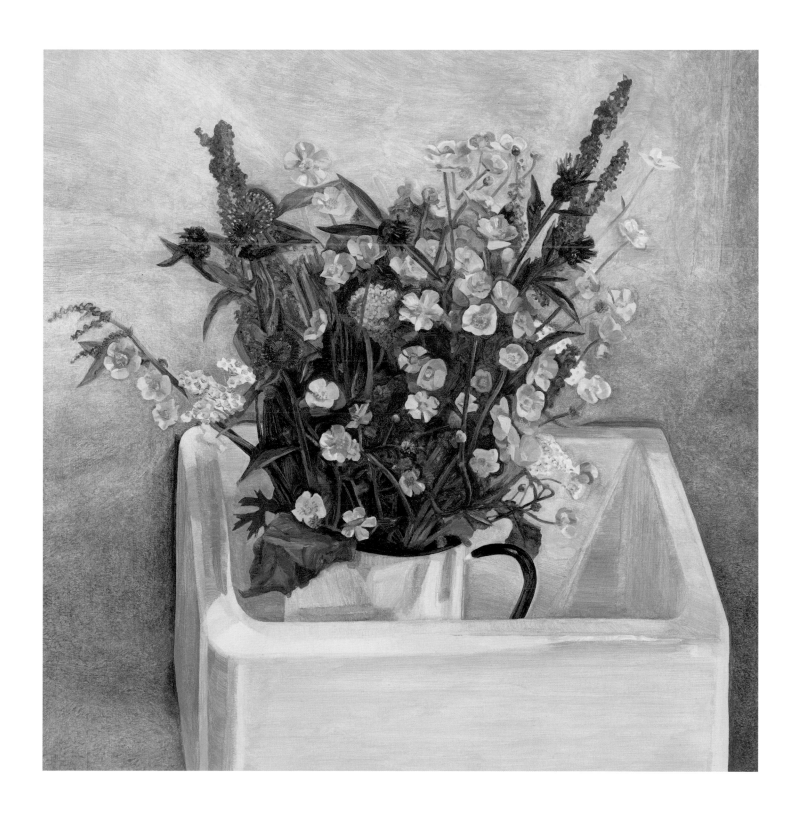

Buttercups 1968 | no.62

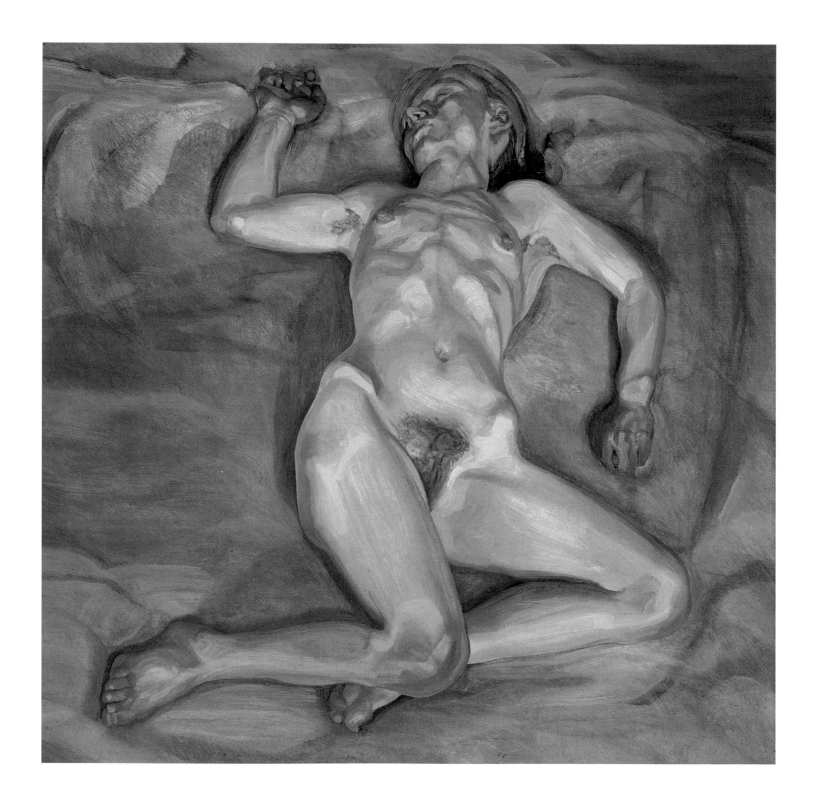

Naked Girl Asleep II 1968 | no.63

Paddington Interior, Harry Diamond 1970 | no.67

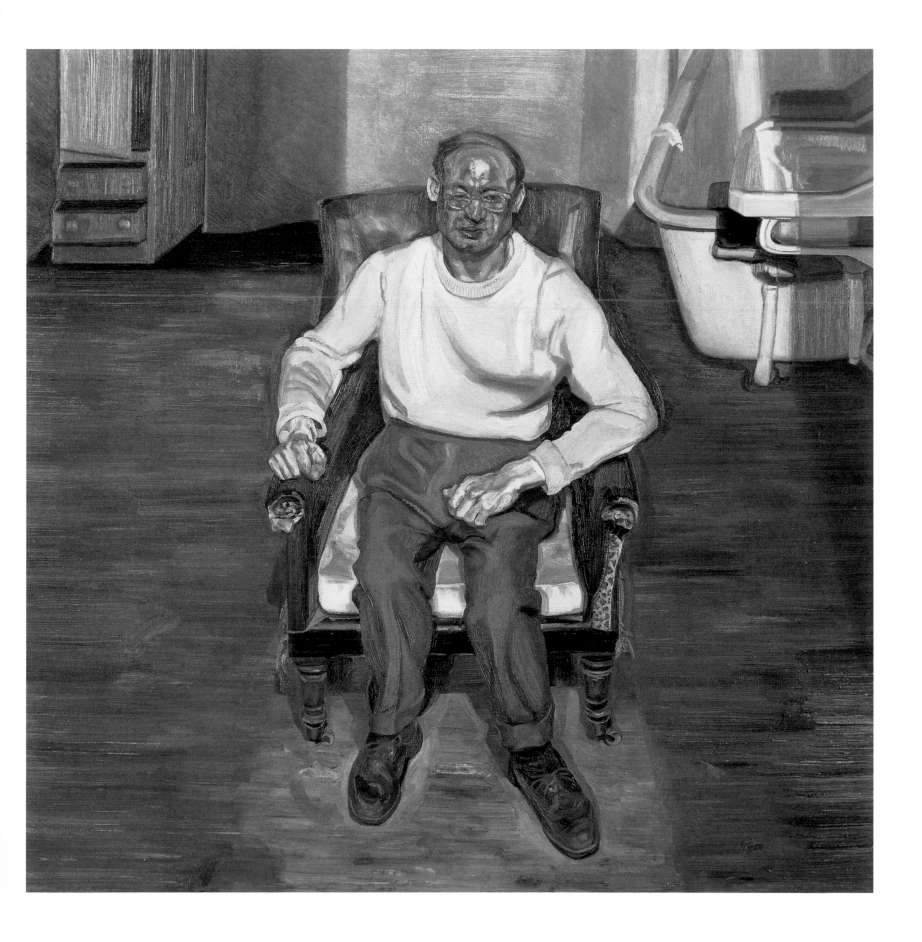

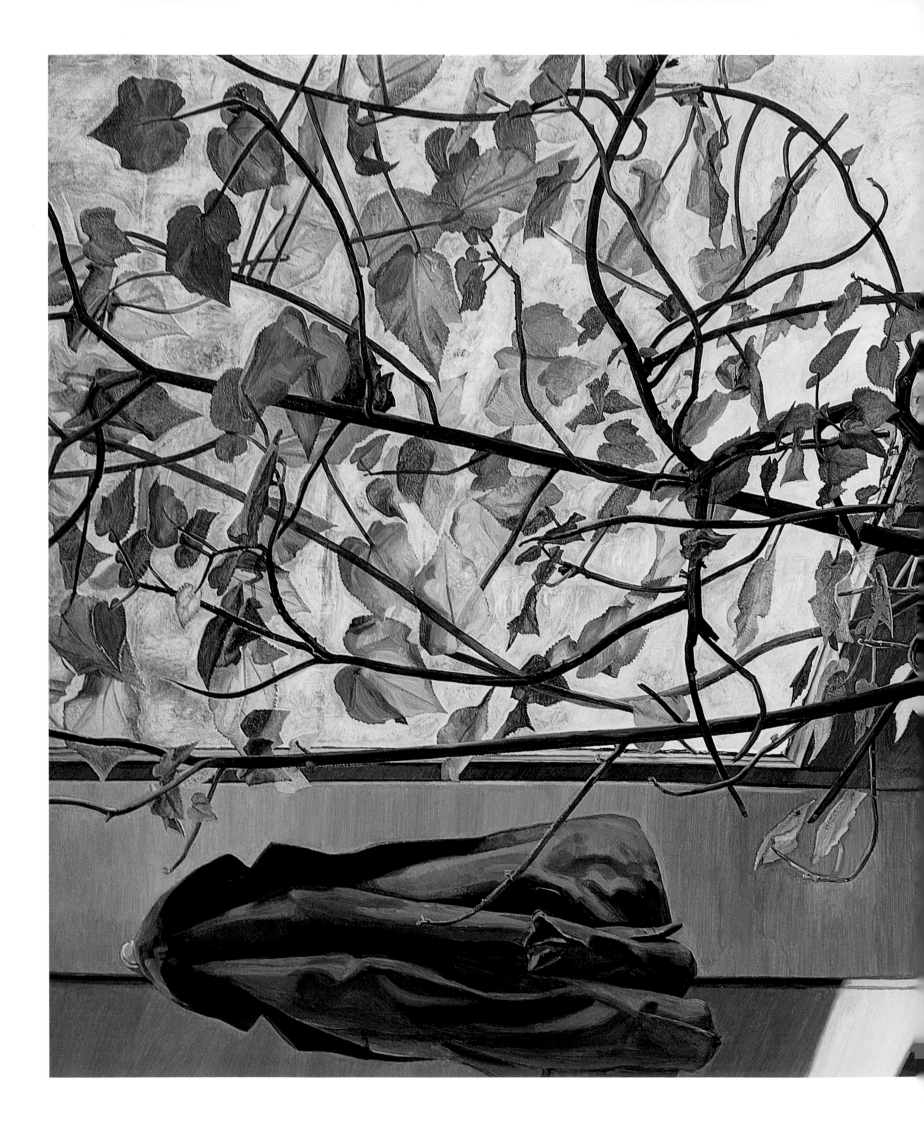

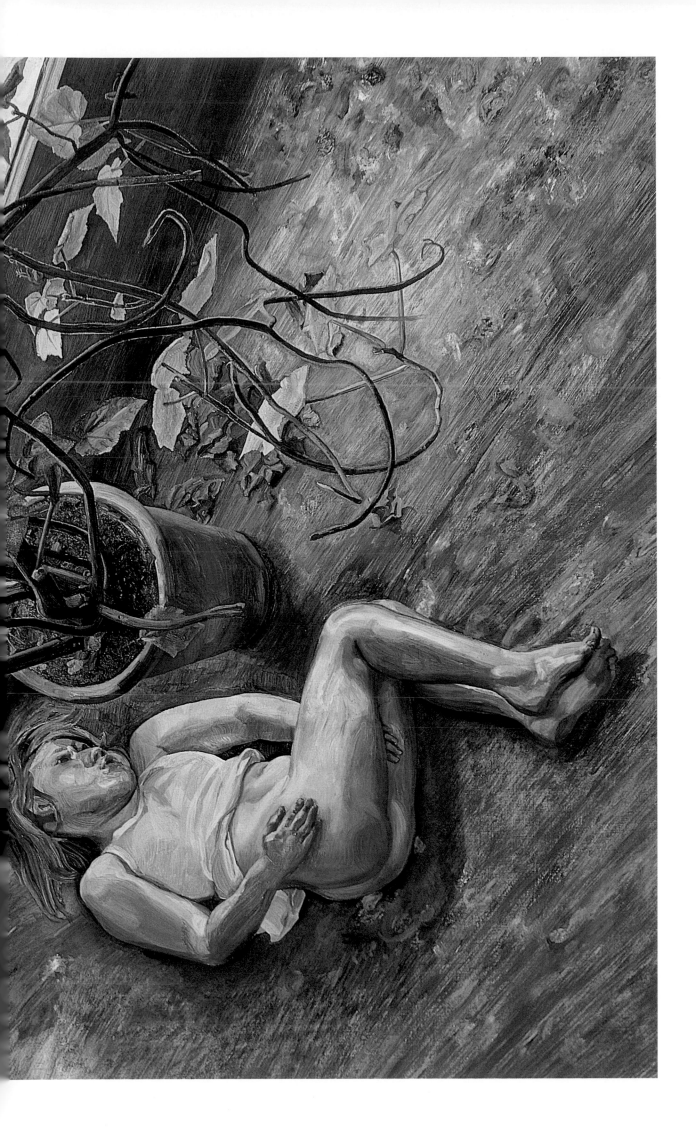

Wasteground with Houses, Paddinton 1970–2 | no.69

A Filly 1969 | no.65

A Filly 1970 | no.68

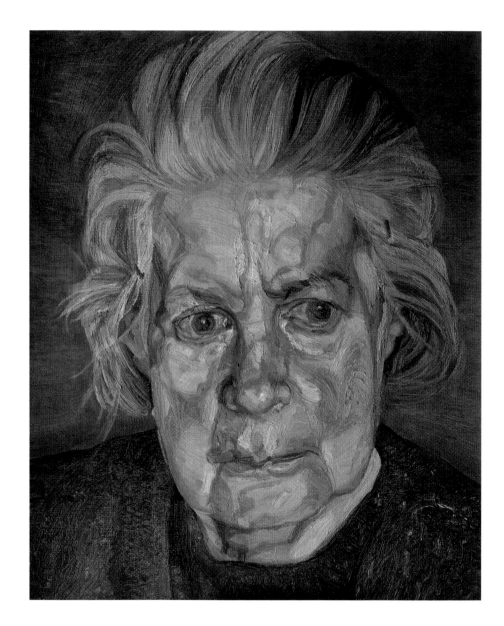

The Painter's Father 1970 | no.66 The Painter's Mother II 1972 | no.70

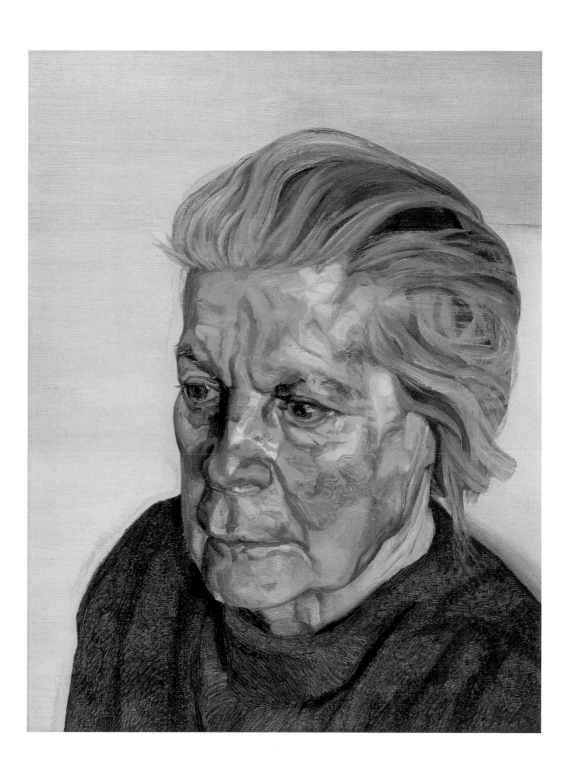

The Painter's Mother III 1972 | no.71

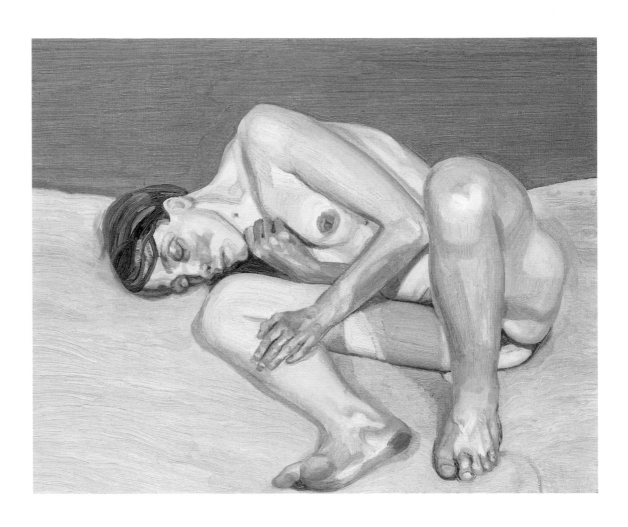

Small Naked Portrait 1973–4 | no.74

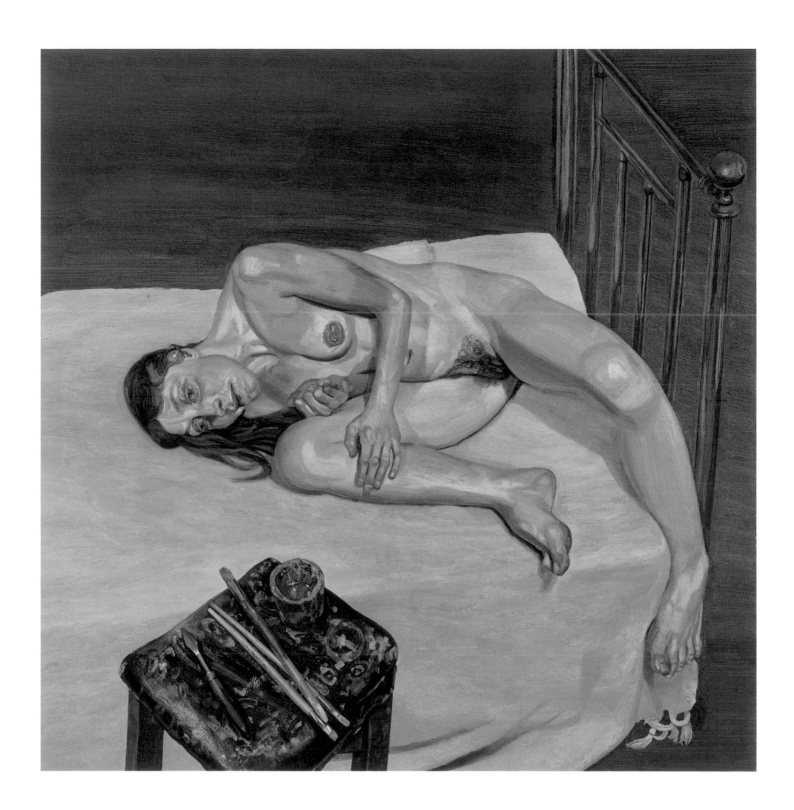

Naked Portrait 1972–3 | no.72

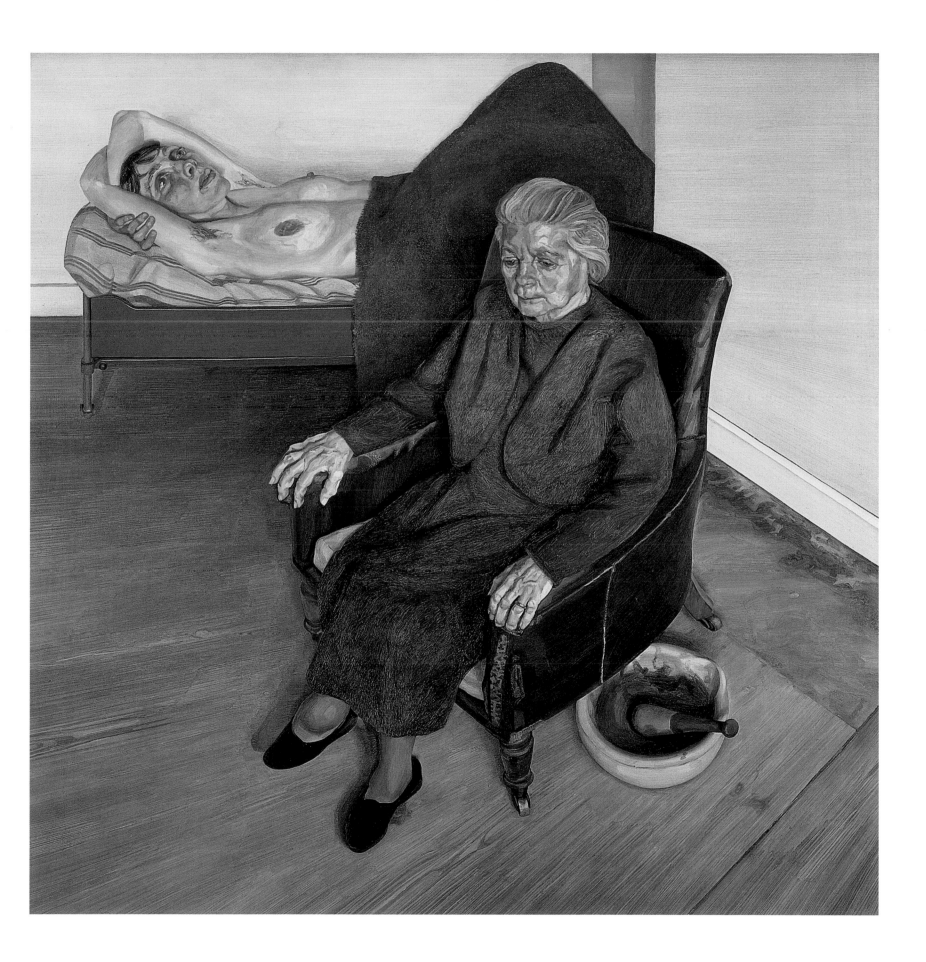

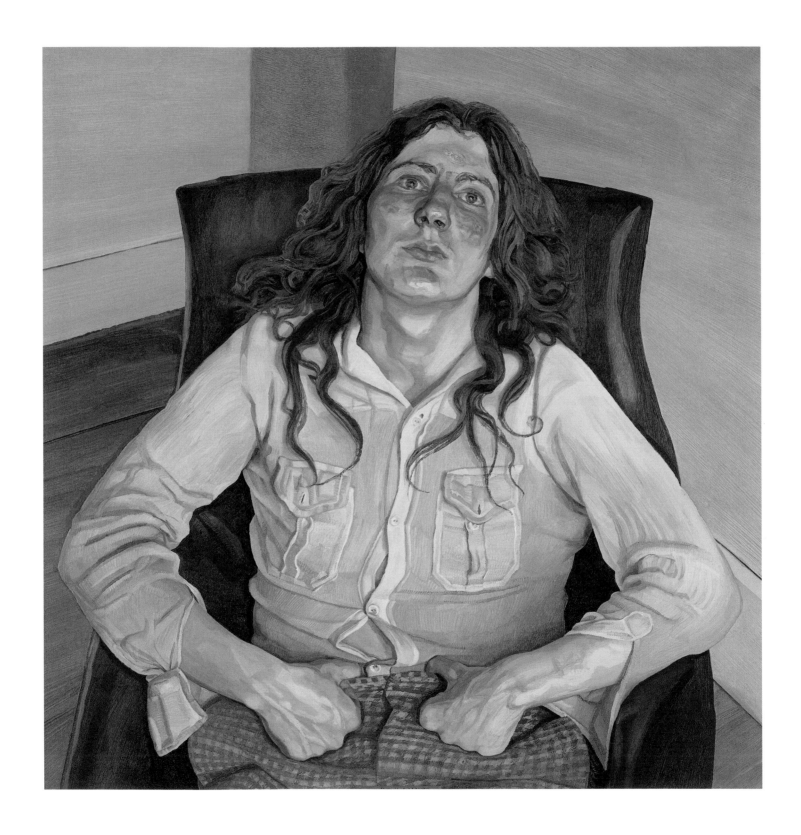

Ali 1974 | no.75

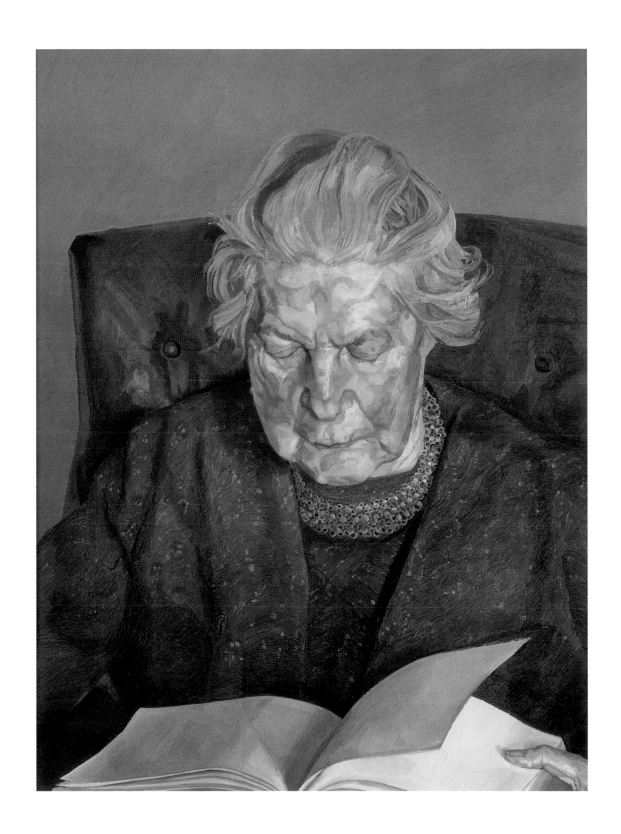

The Painter's Mother Reading 1975 | no.76

The Painter's Mother Resting I 1976 | no.77

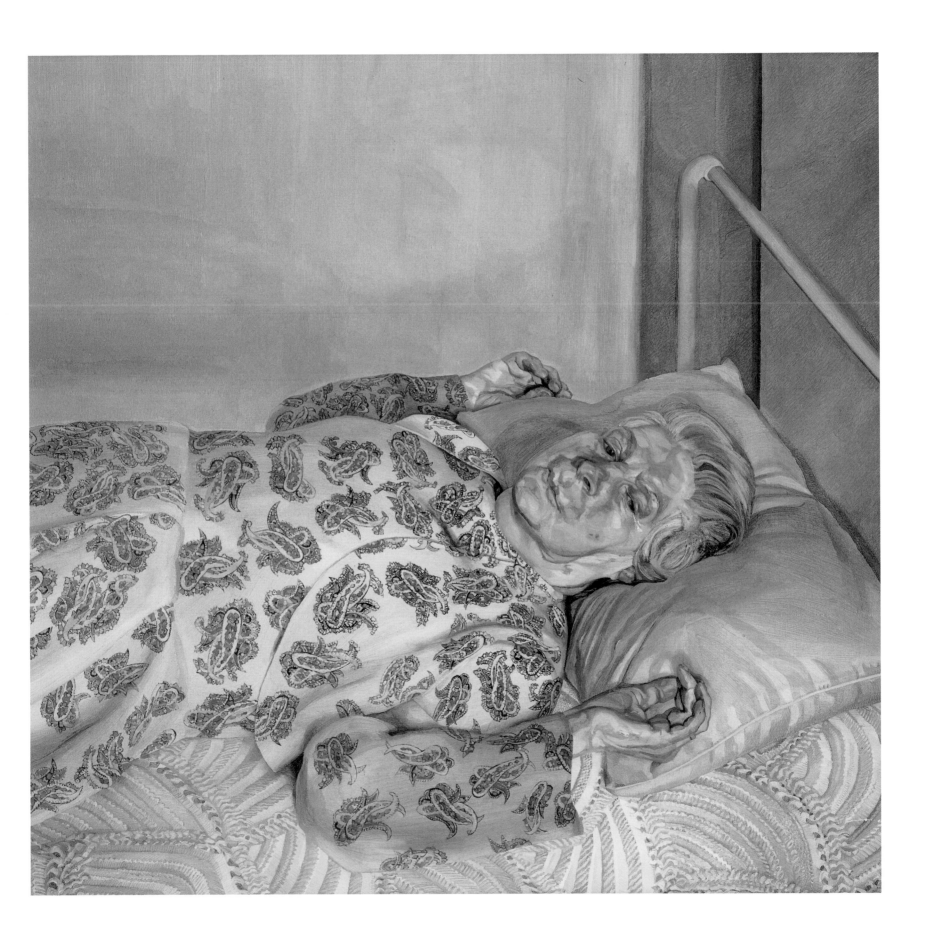

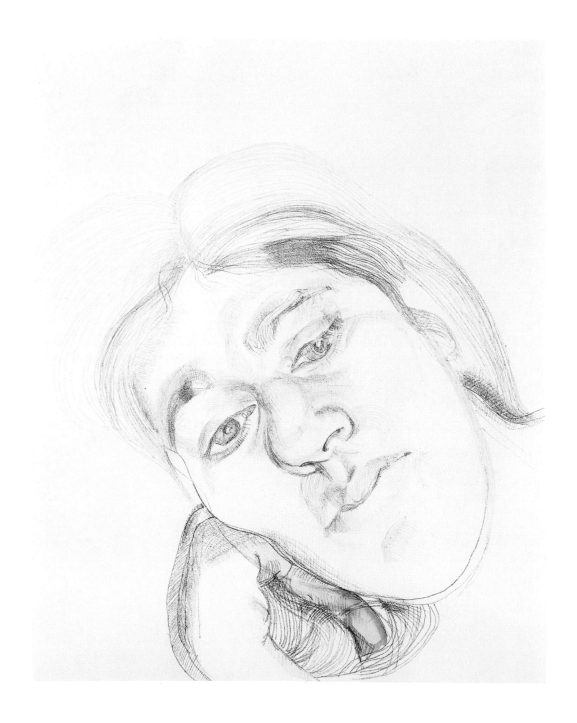

Annabel 1975 | no.78

Head of a Girl 1975–6 | no.81

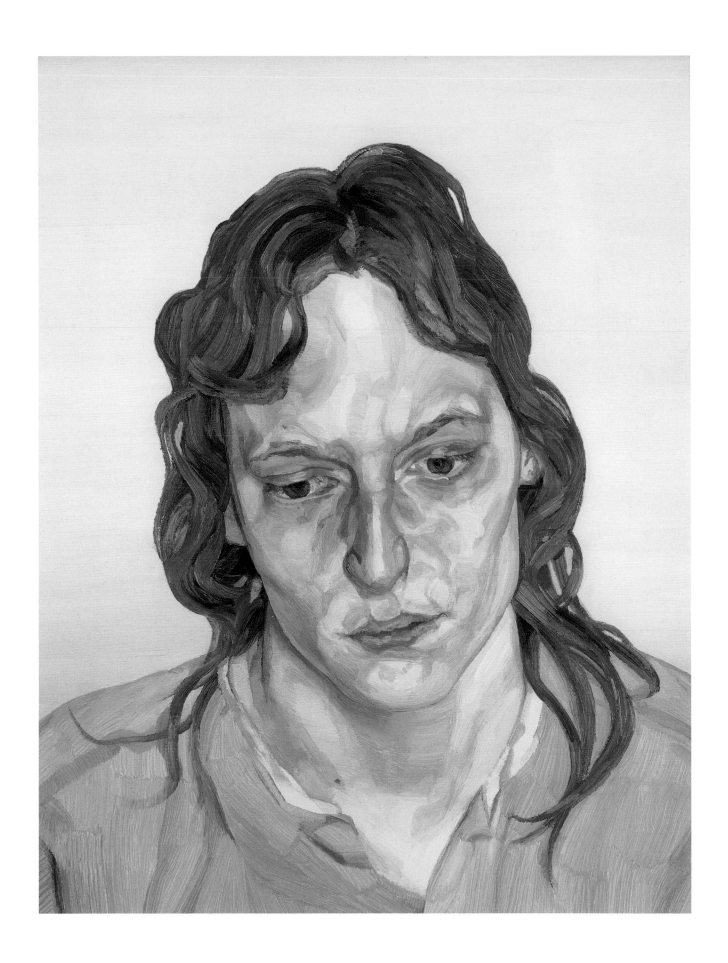

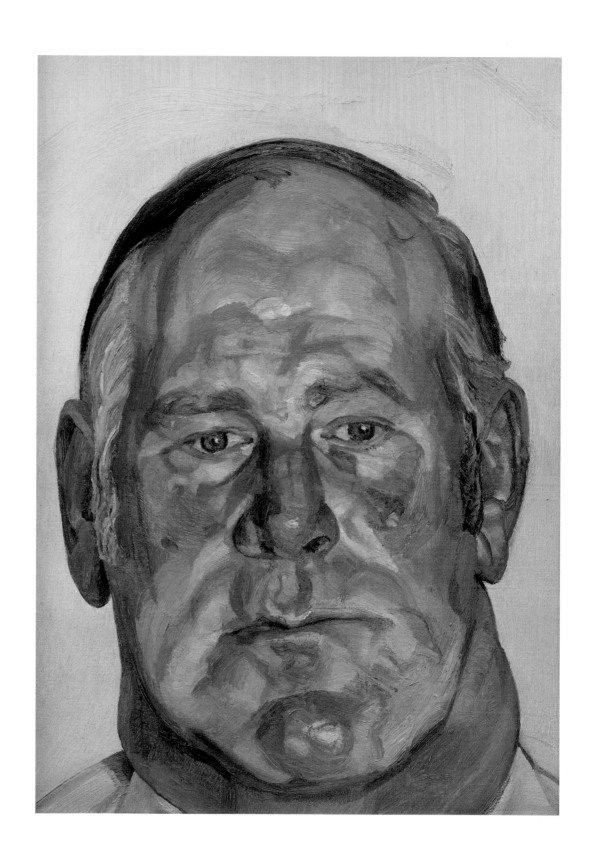

Head of the Big Man 1975 | no.79

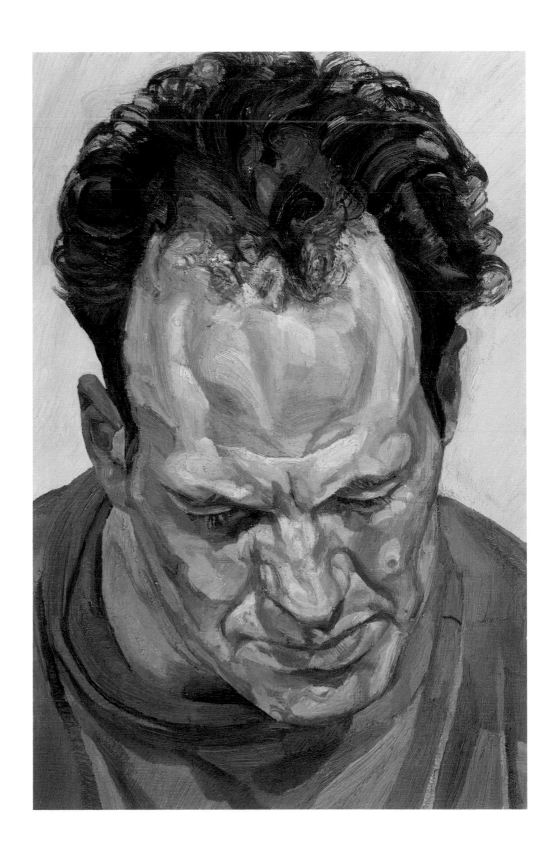

Frank Auerbach 1975–6 | no.80

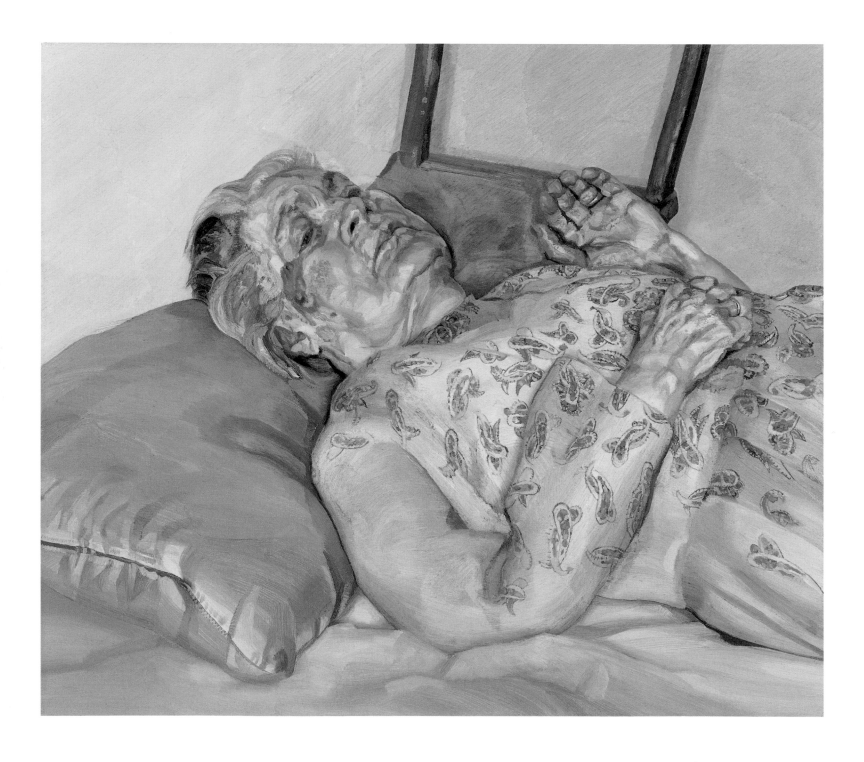

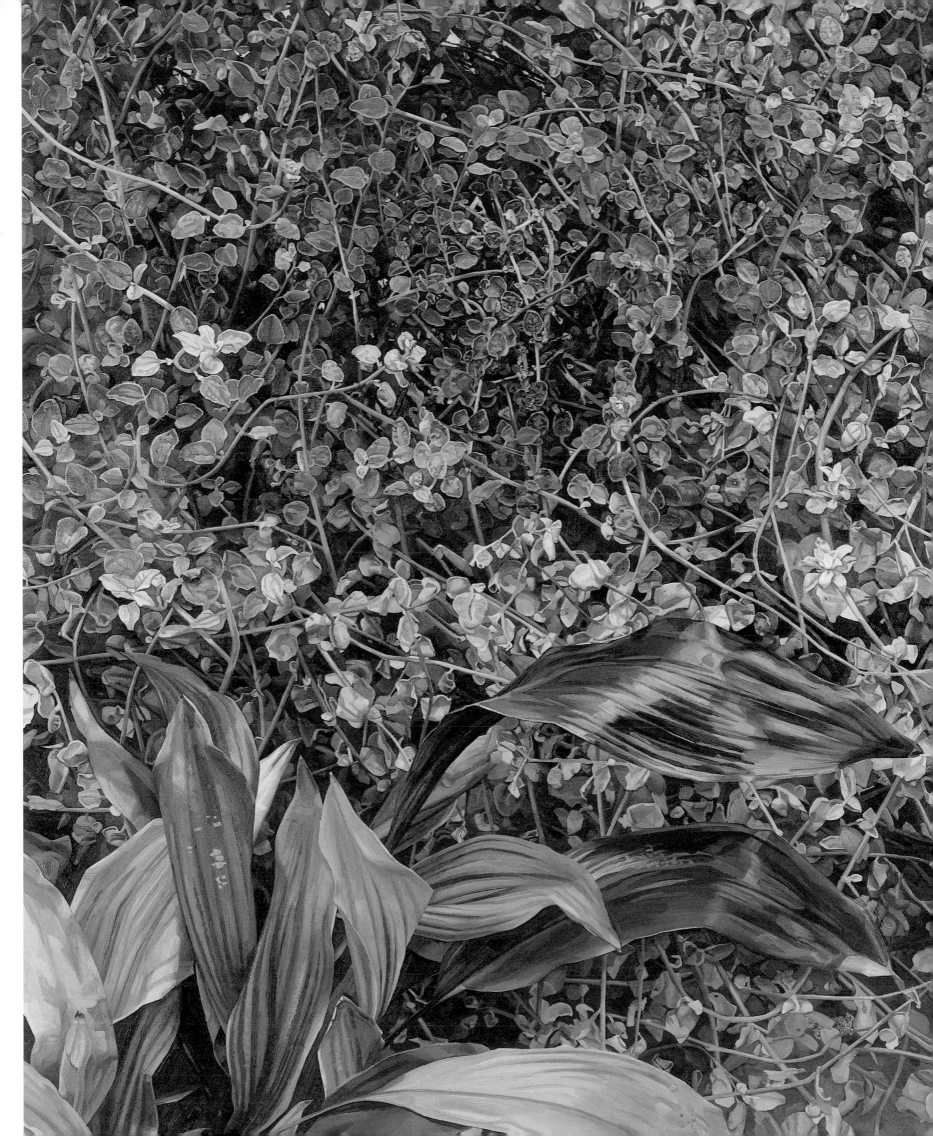

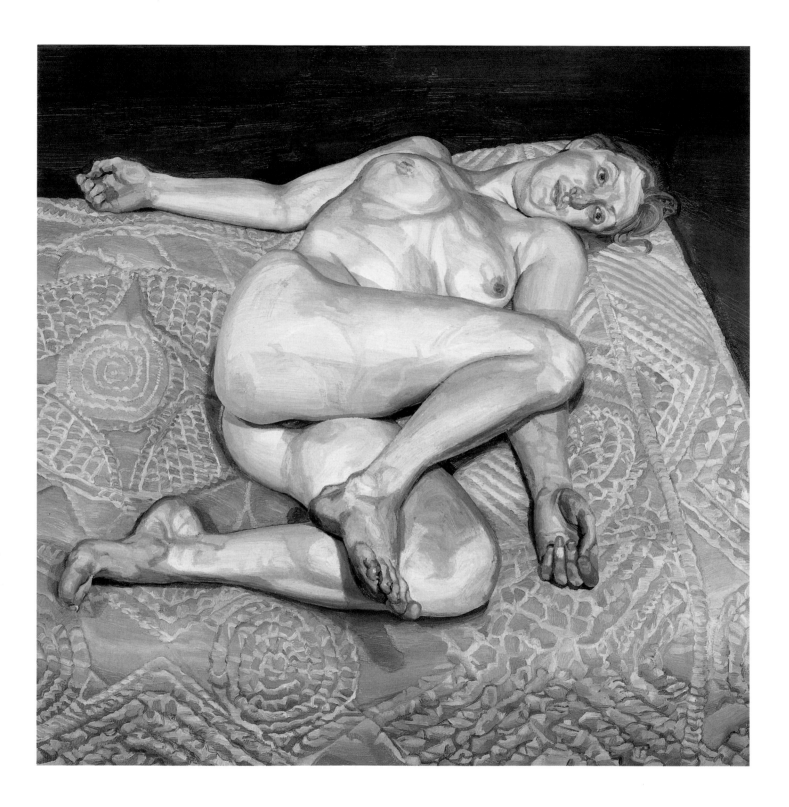

Night Portrait 1977–8 | no.84

Naked Man with his Friend 1978–80 | no.86

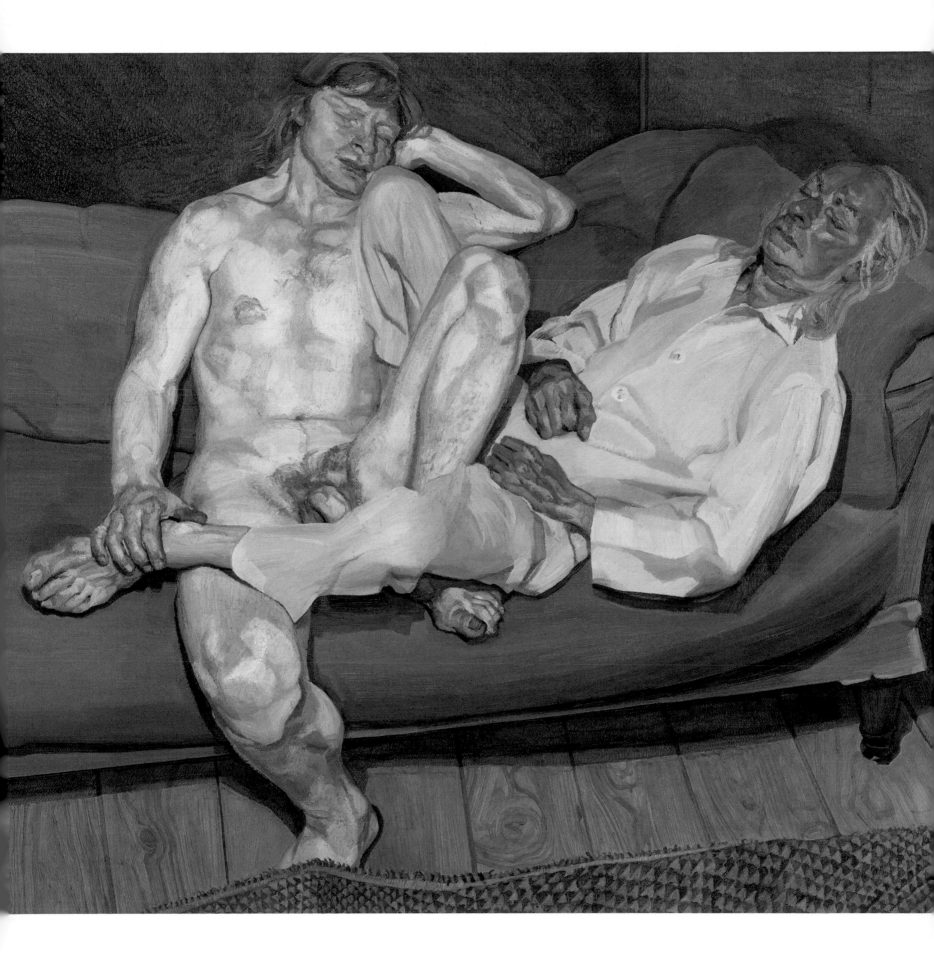

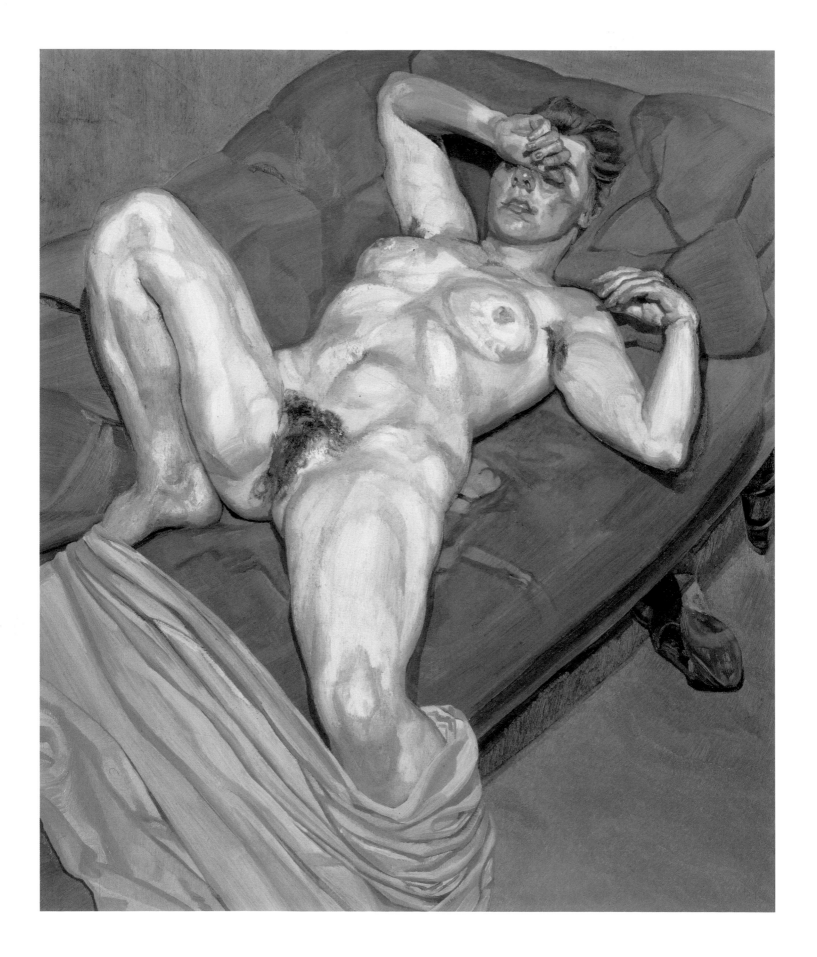

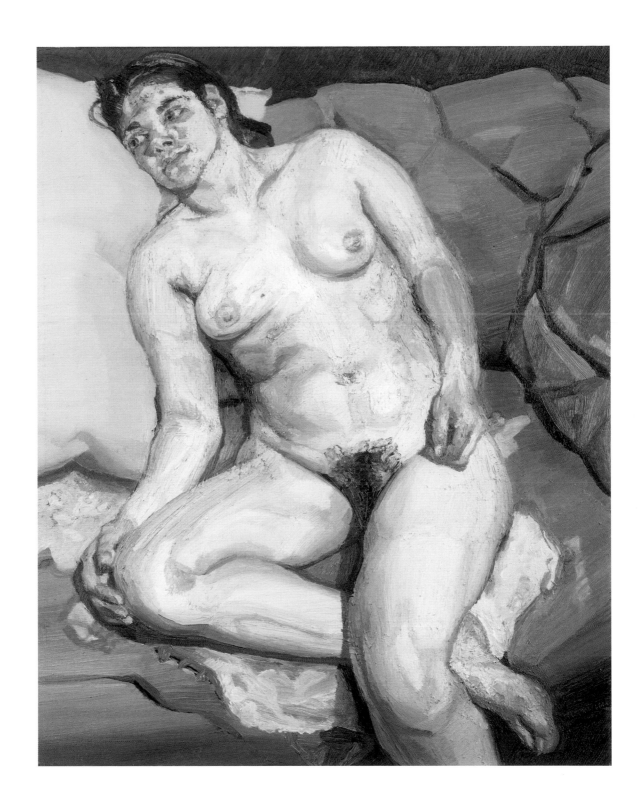

Portrait of Rose 1978–9 | no.87

Esther 1980 | no.90

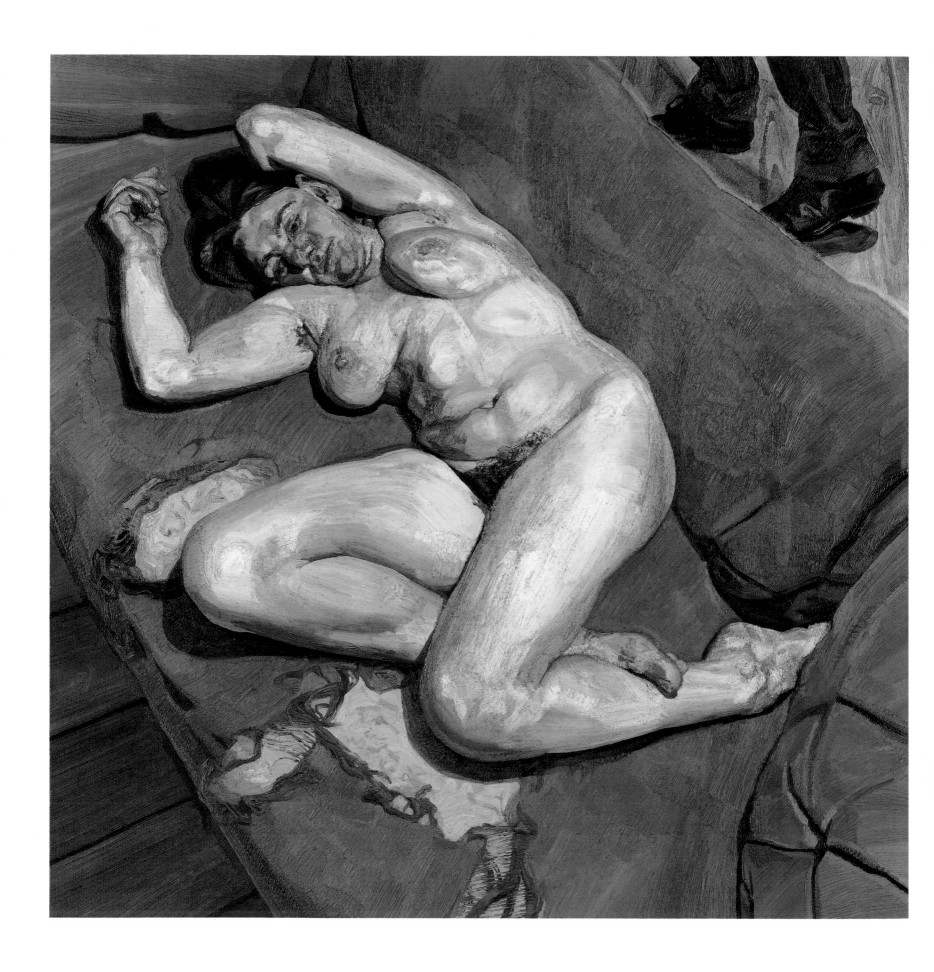

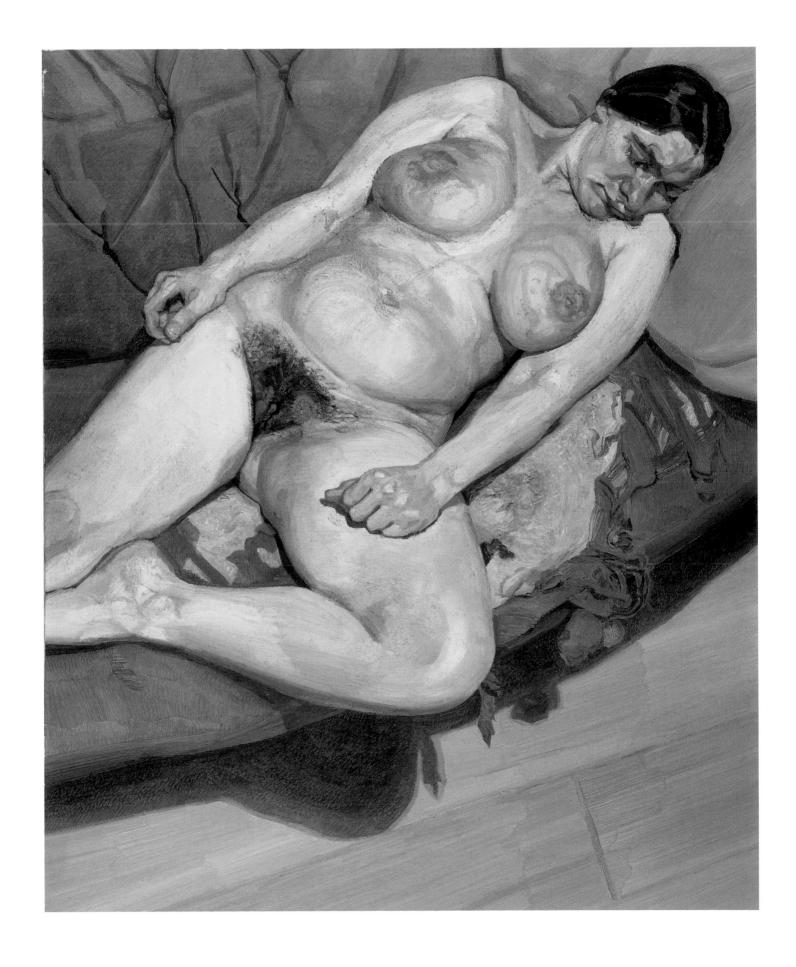

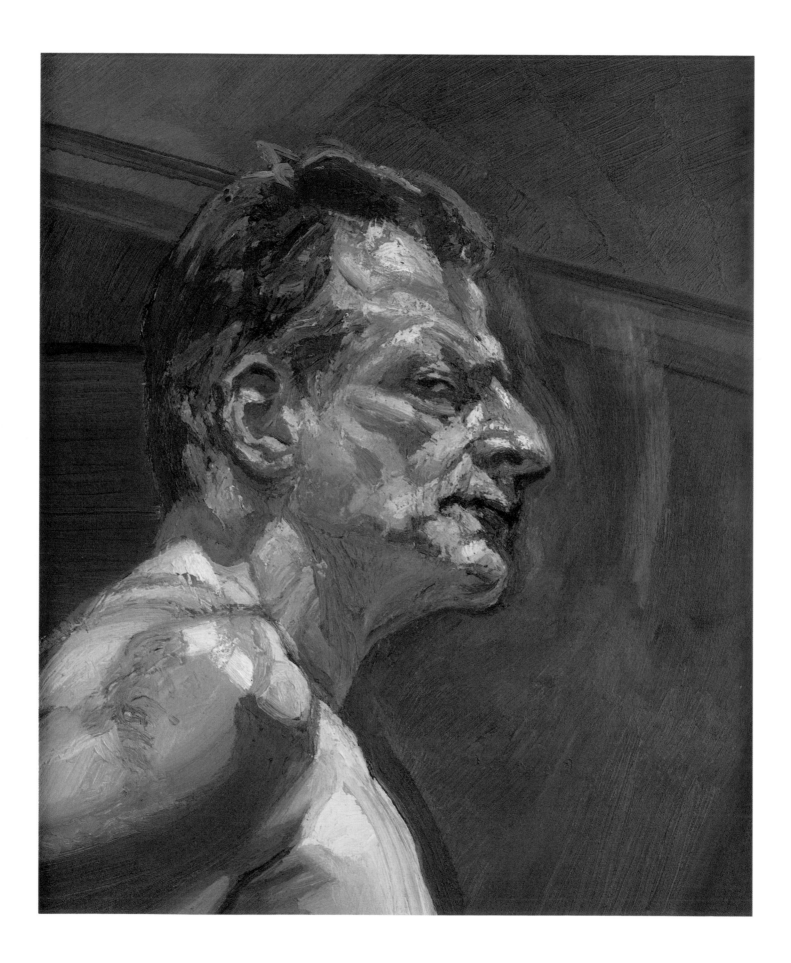

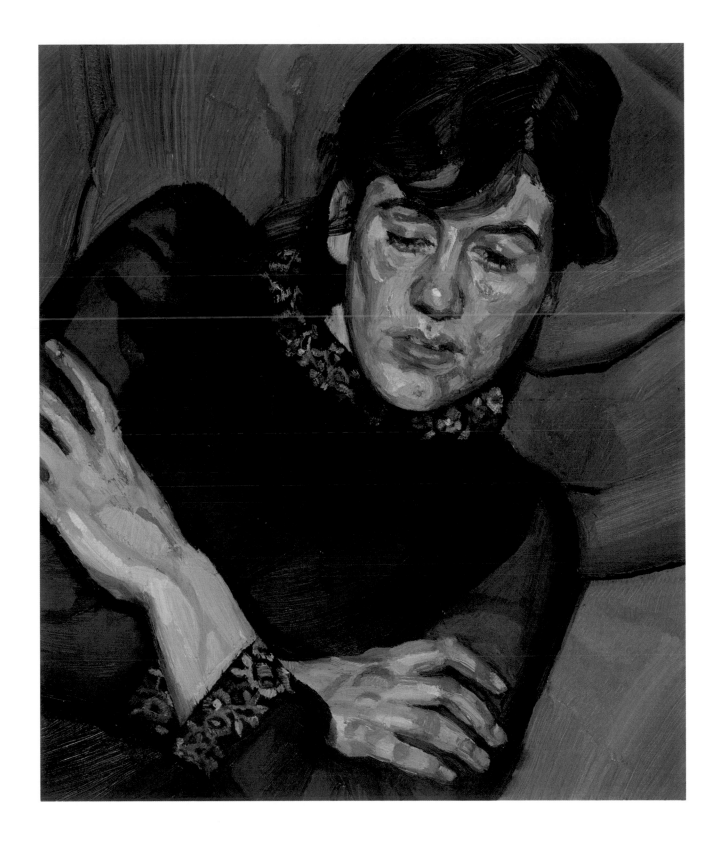

Reflection (Self-Portrait) 1981–2 | no.94

Bella 1981 | no.93

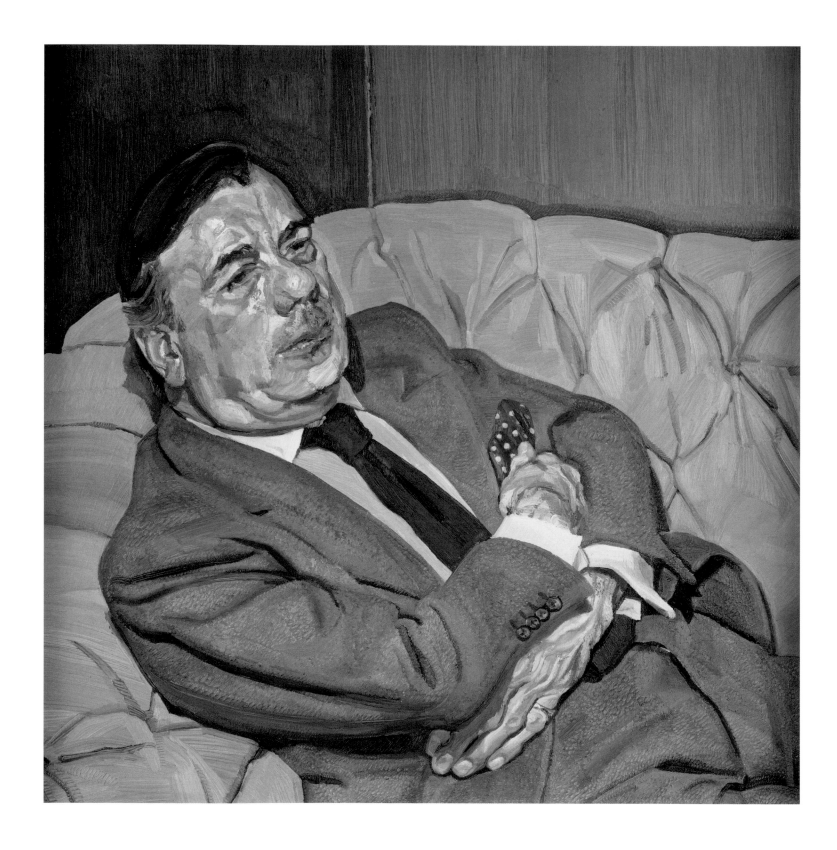

Guy Half Asleep 1981–2 | no.92

Guy and Speck 1980–1 | no.91

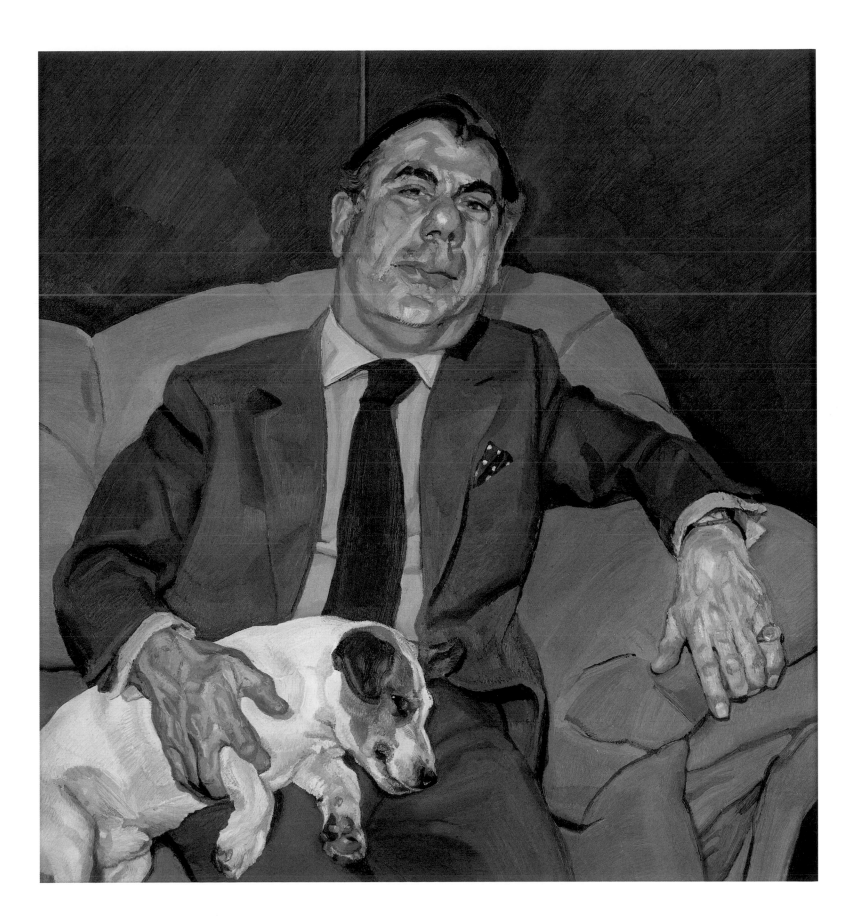

Large Interior w11 (after Watteau) 1981–3 | no.95

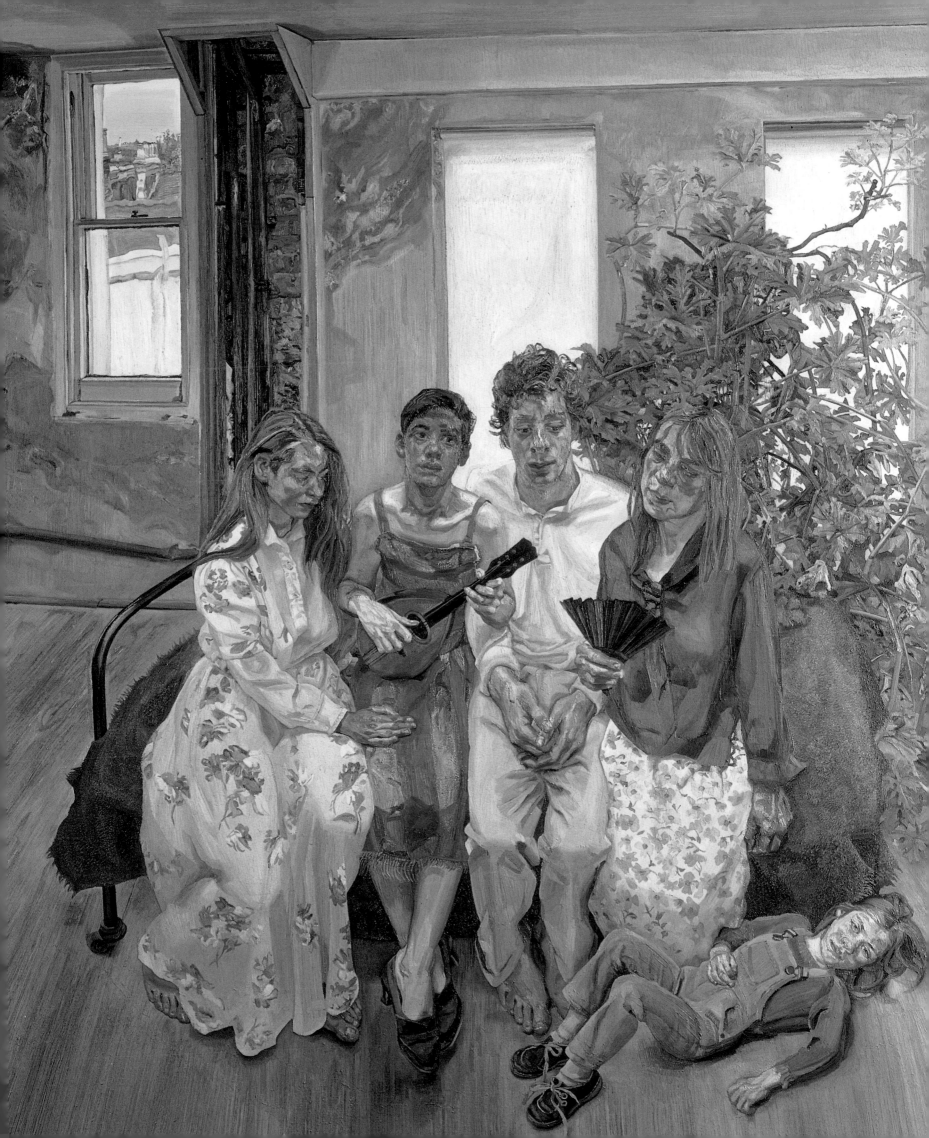

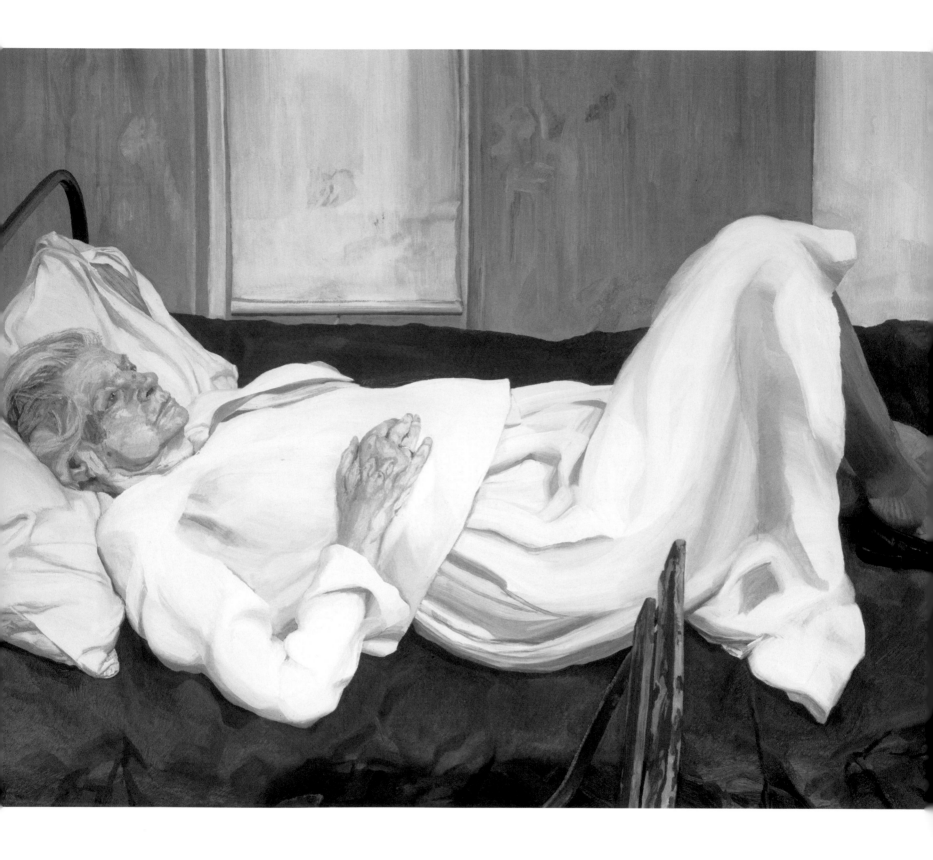

The Painter's Mother Resting 1982–4 | no.97

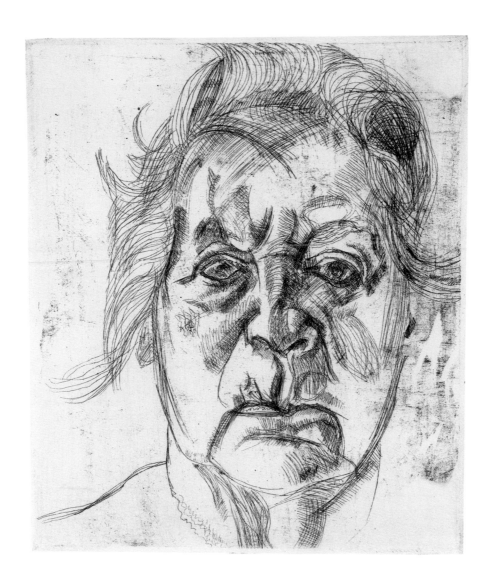

The Painter's Mother 1982 | no.96

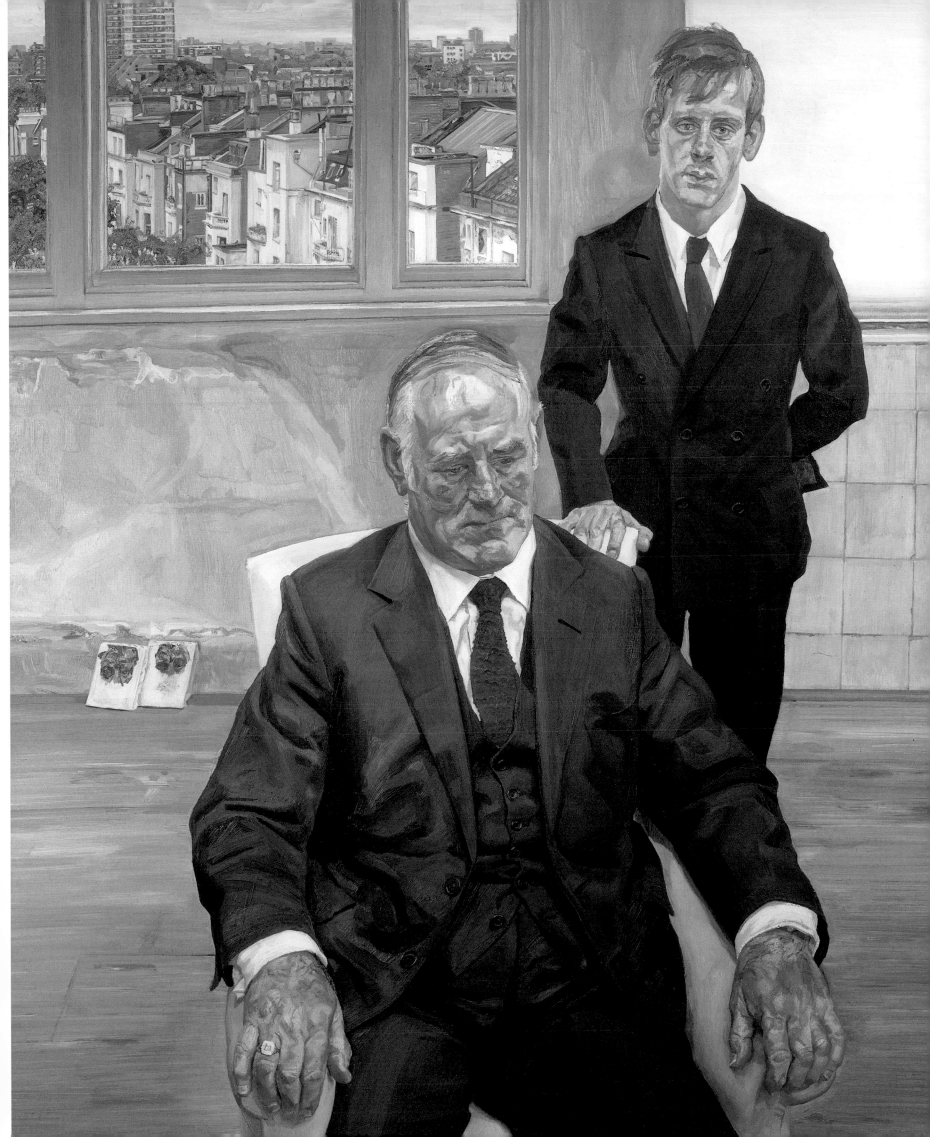

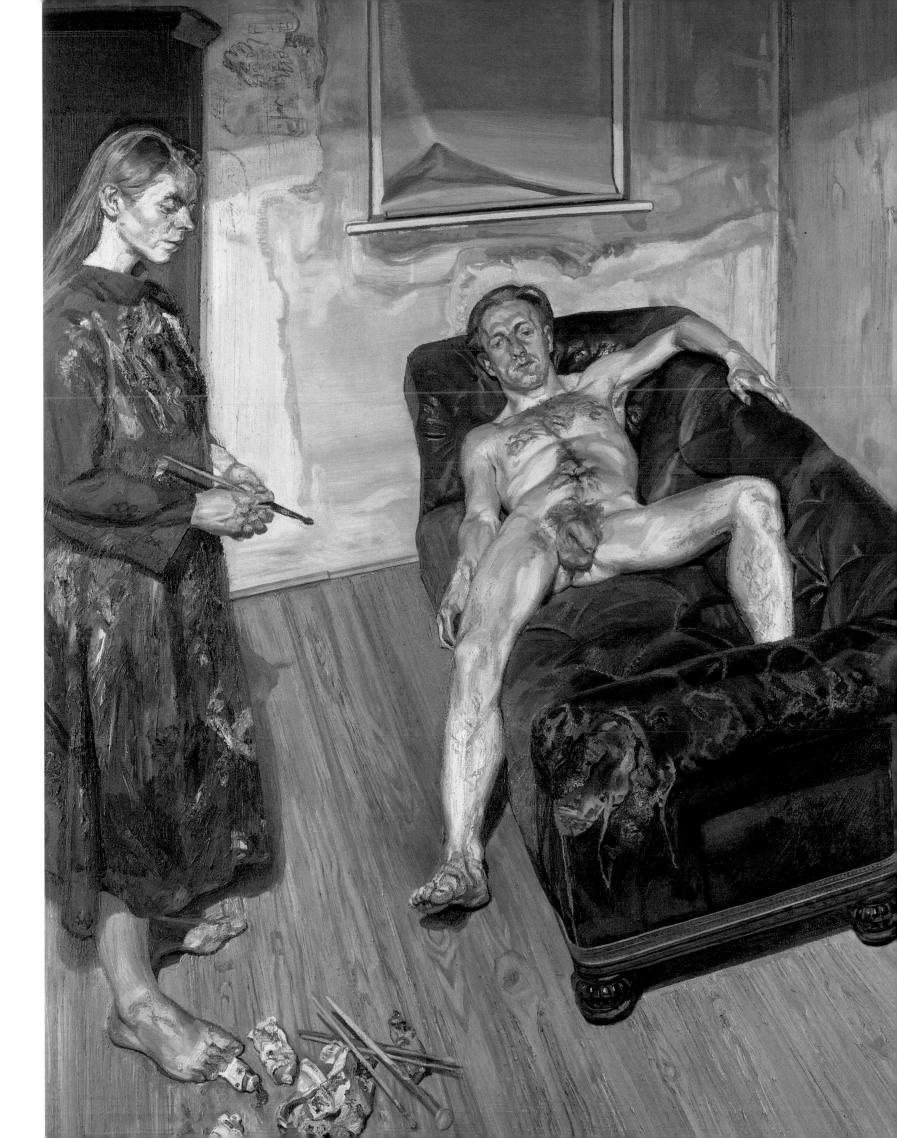

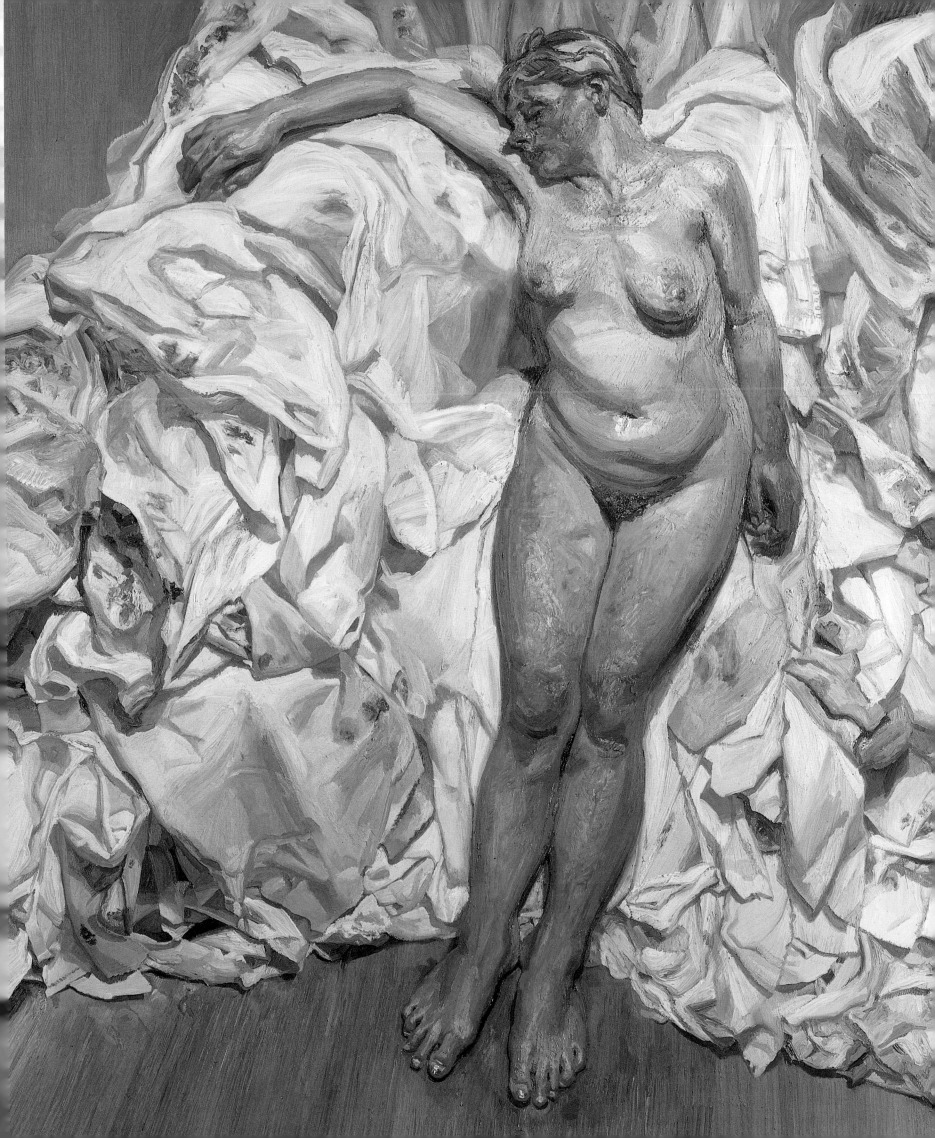

Lying by the Rags 1989–90 | no.115

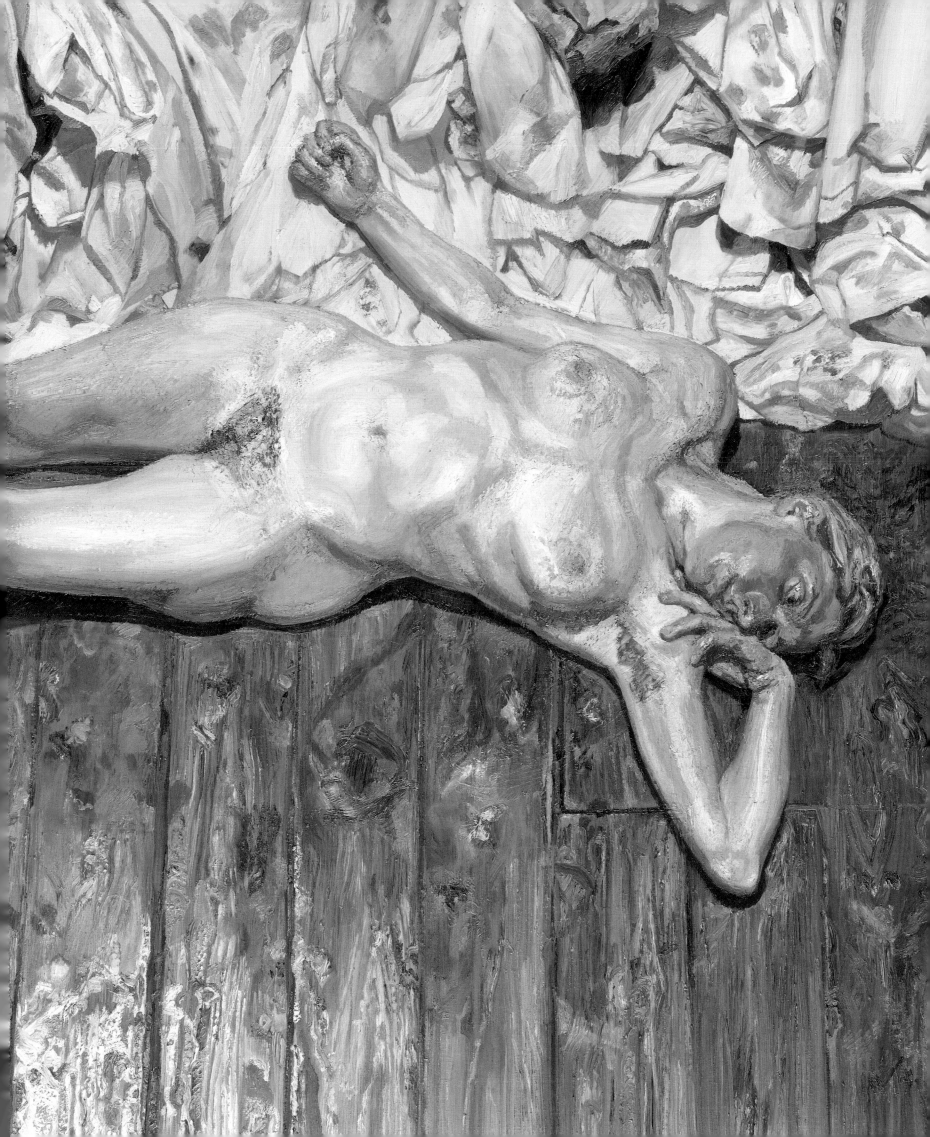

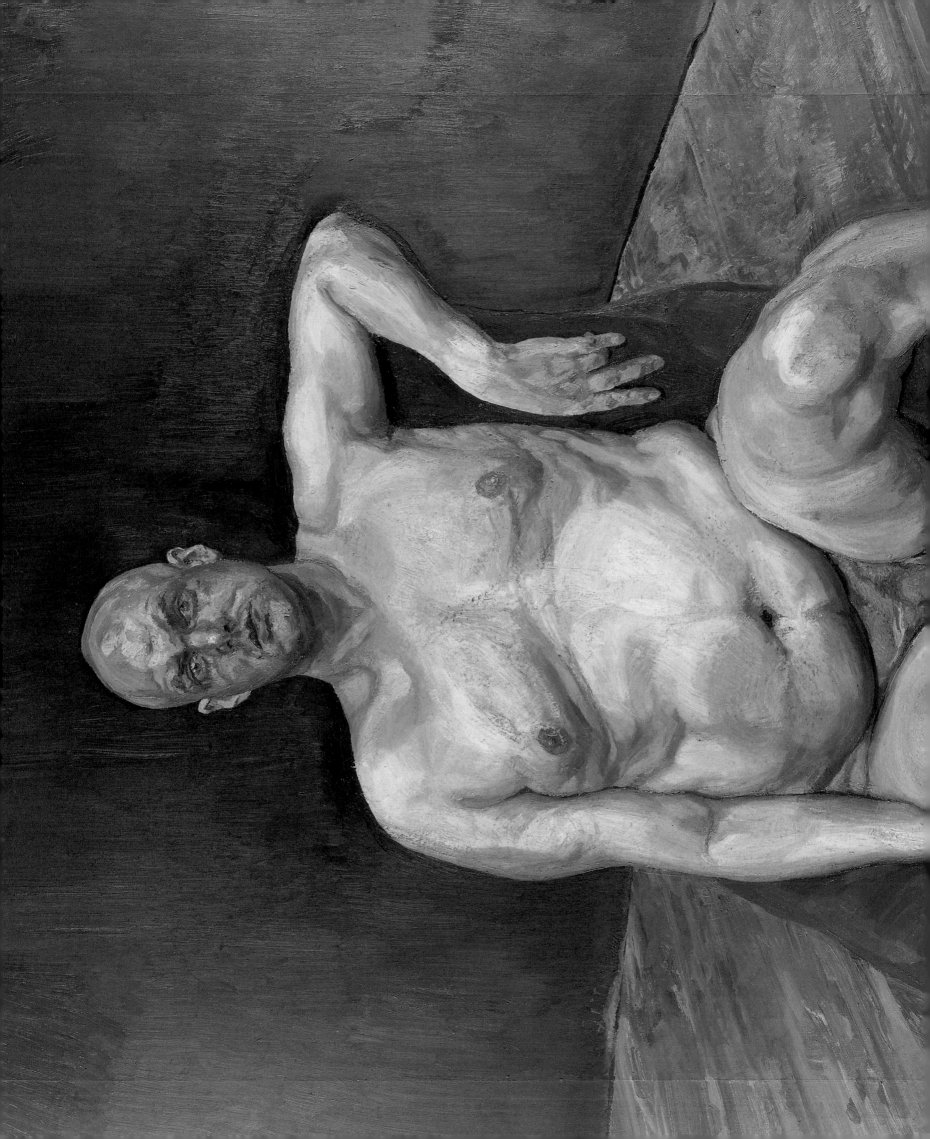

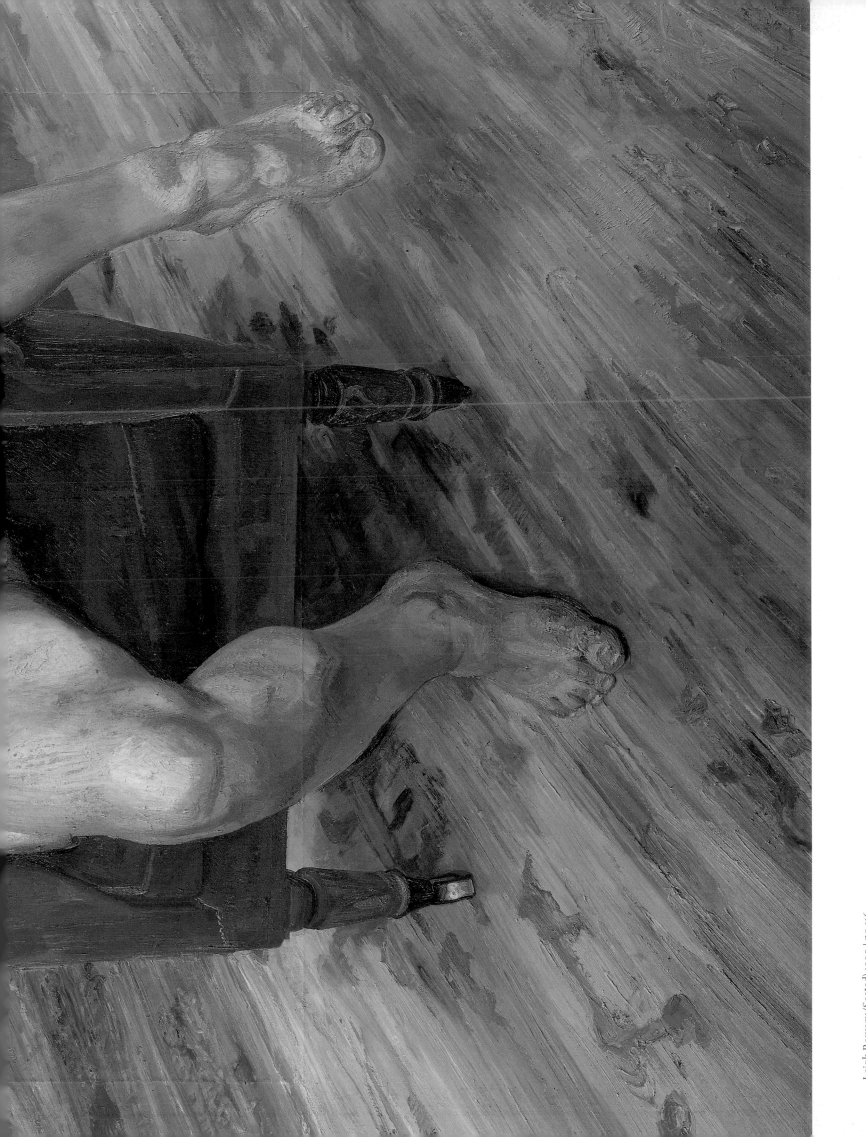

Nude with Leg Up 1992 | no.119

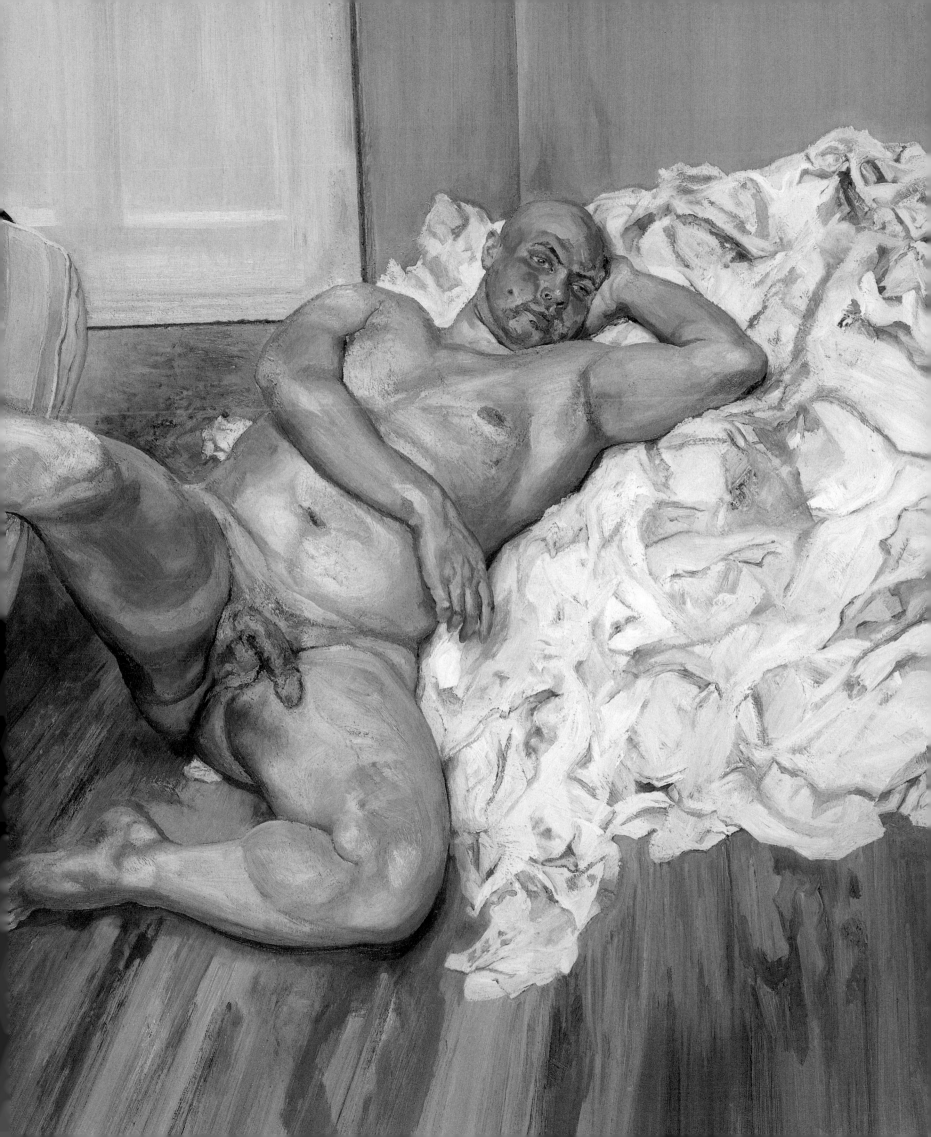

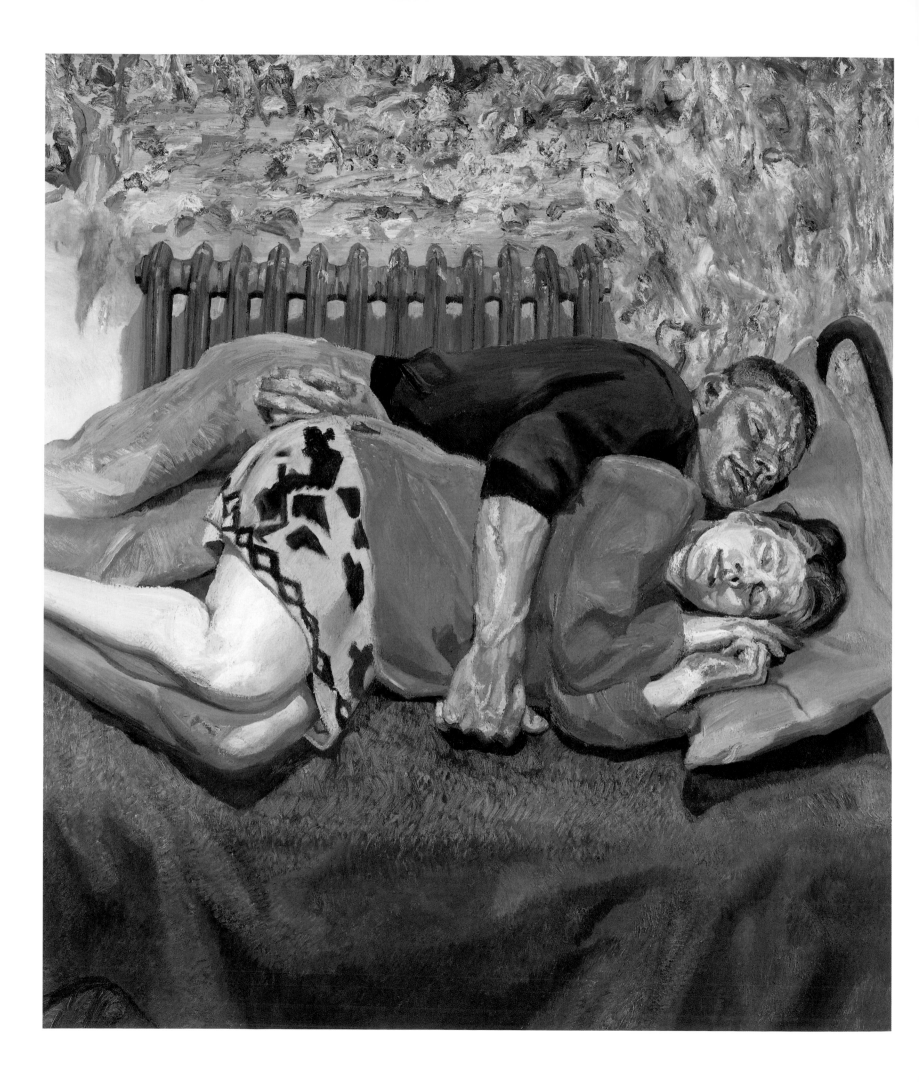

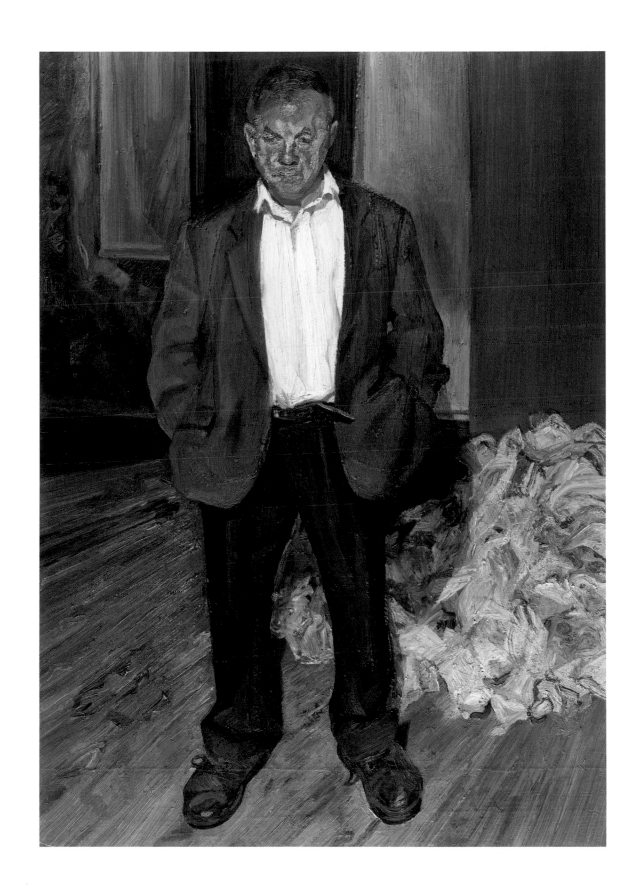

Ib and her Husband 1992 | no.120

Bruce Bernard 1992 | no.121

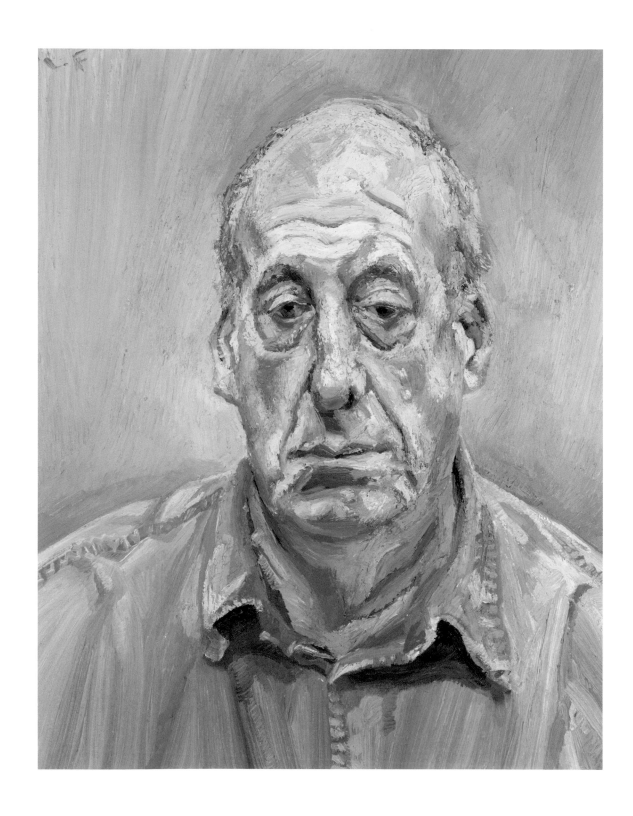

Francis Wyndham 1993 | no.126

Woman in a Butterfly Jersey 1990–1 | no.118

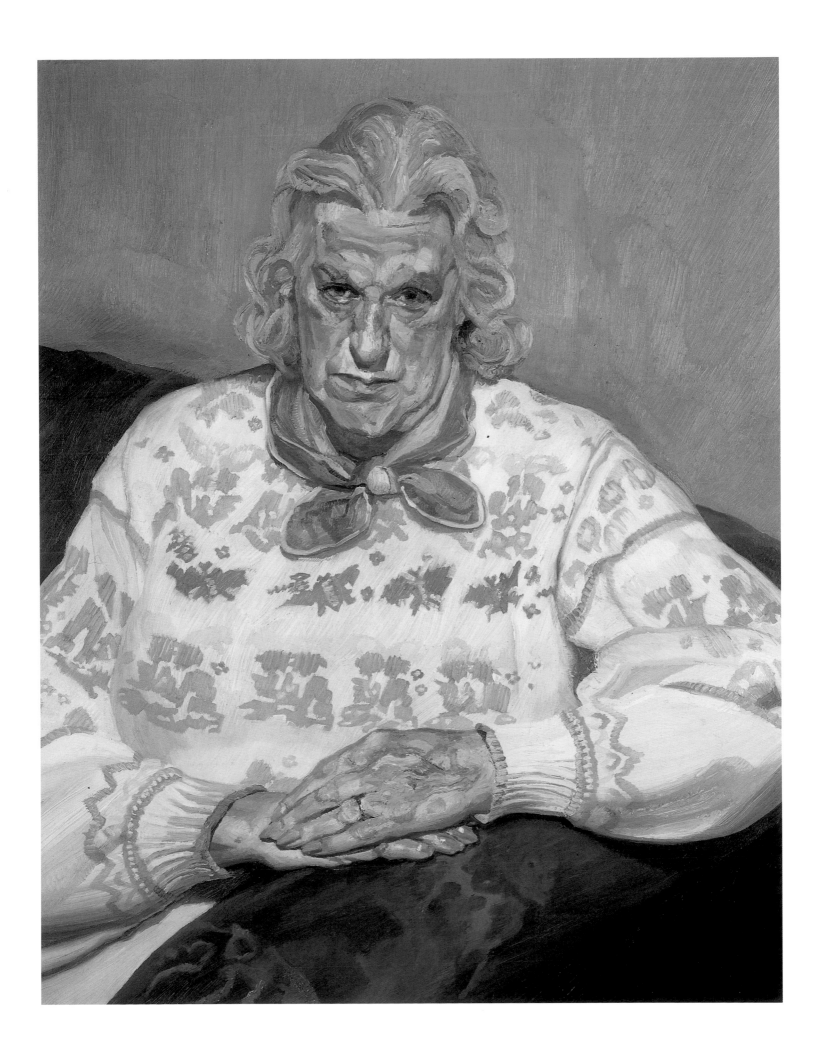

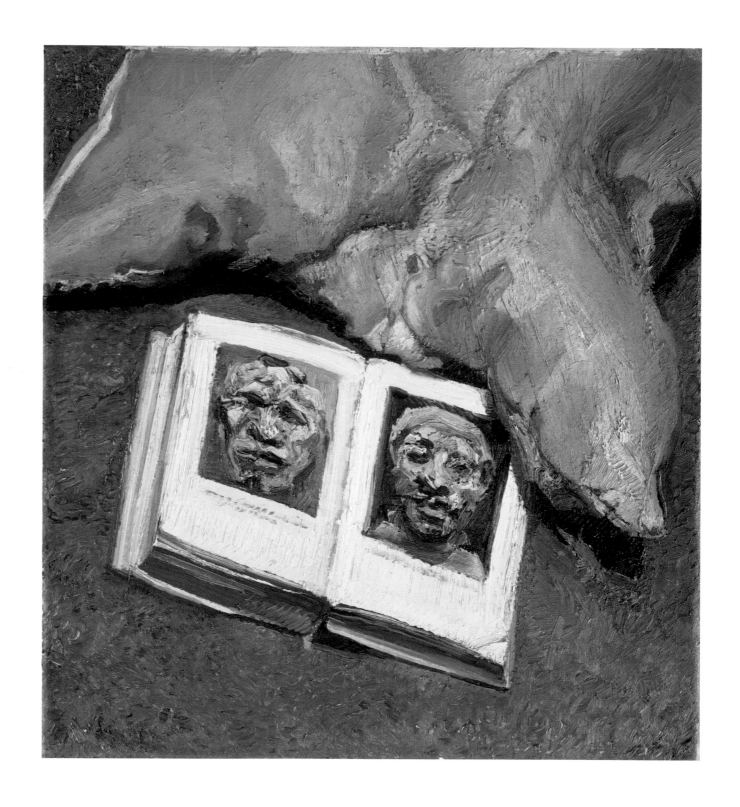

Still Life with Book 1993 | no.123

Large Head 1993 | no.122

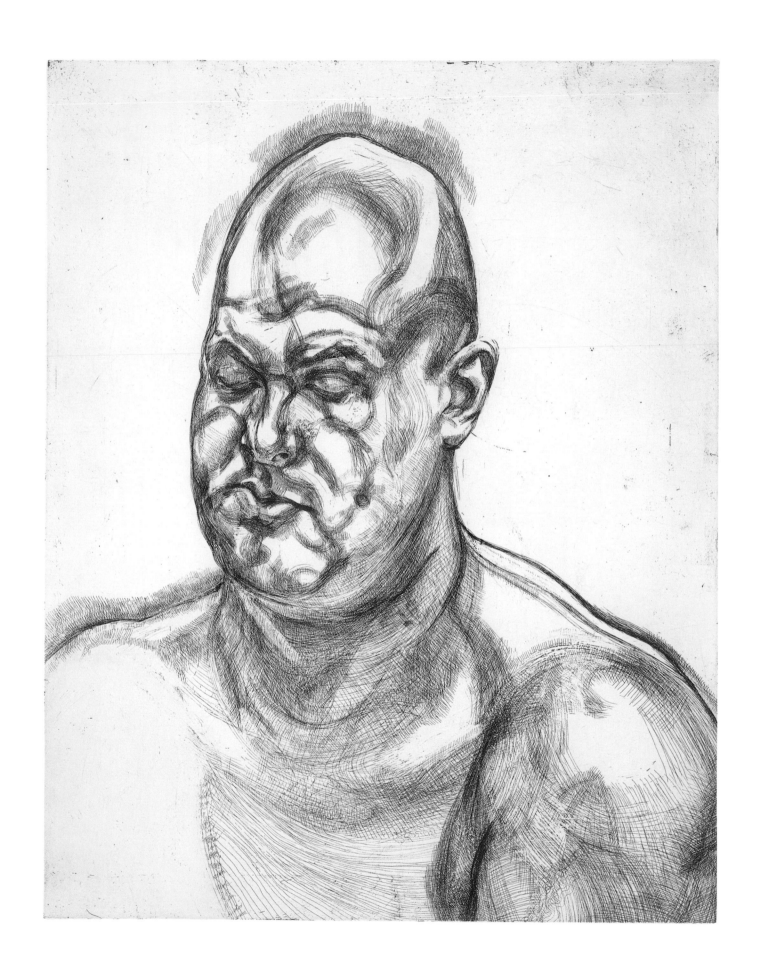

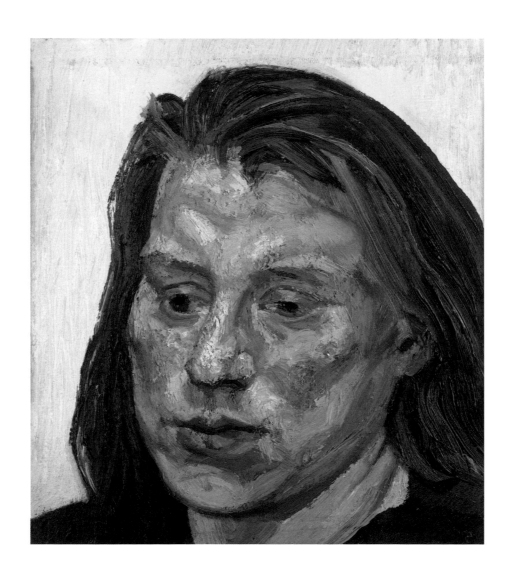

Ib 1990 | no.117 And the Bridegroom 1993 | no.124

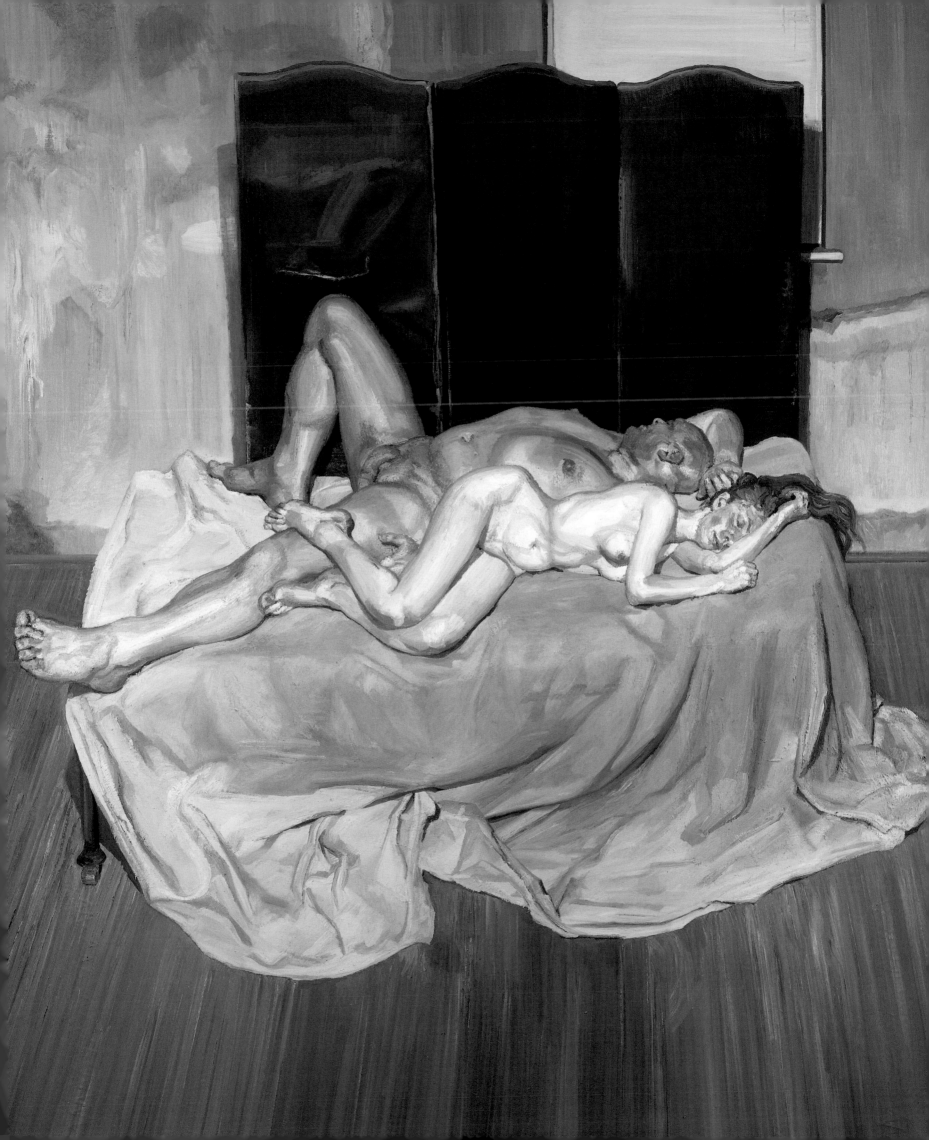

Painter Working, Reflection 1993 | no.125

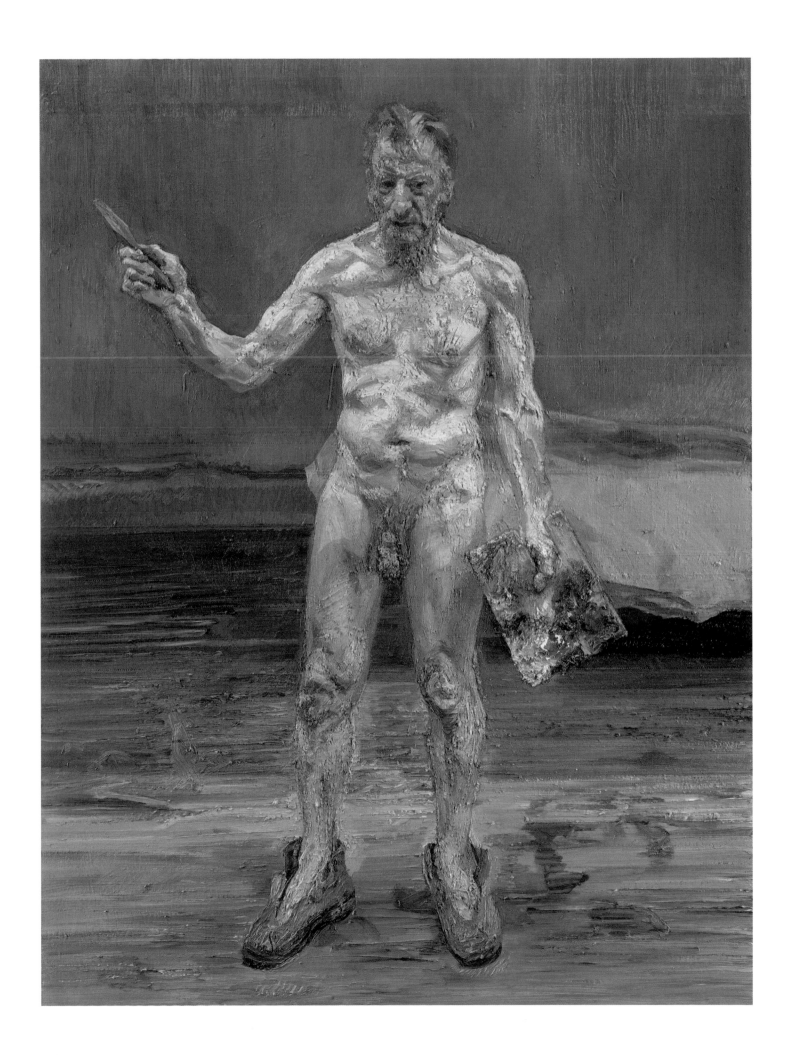

Benefits Supervisor Resting 1994 | no.127

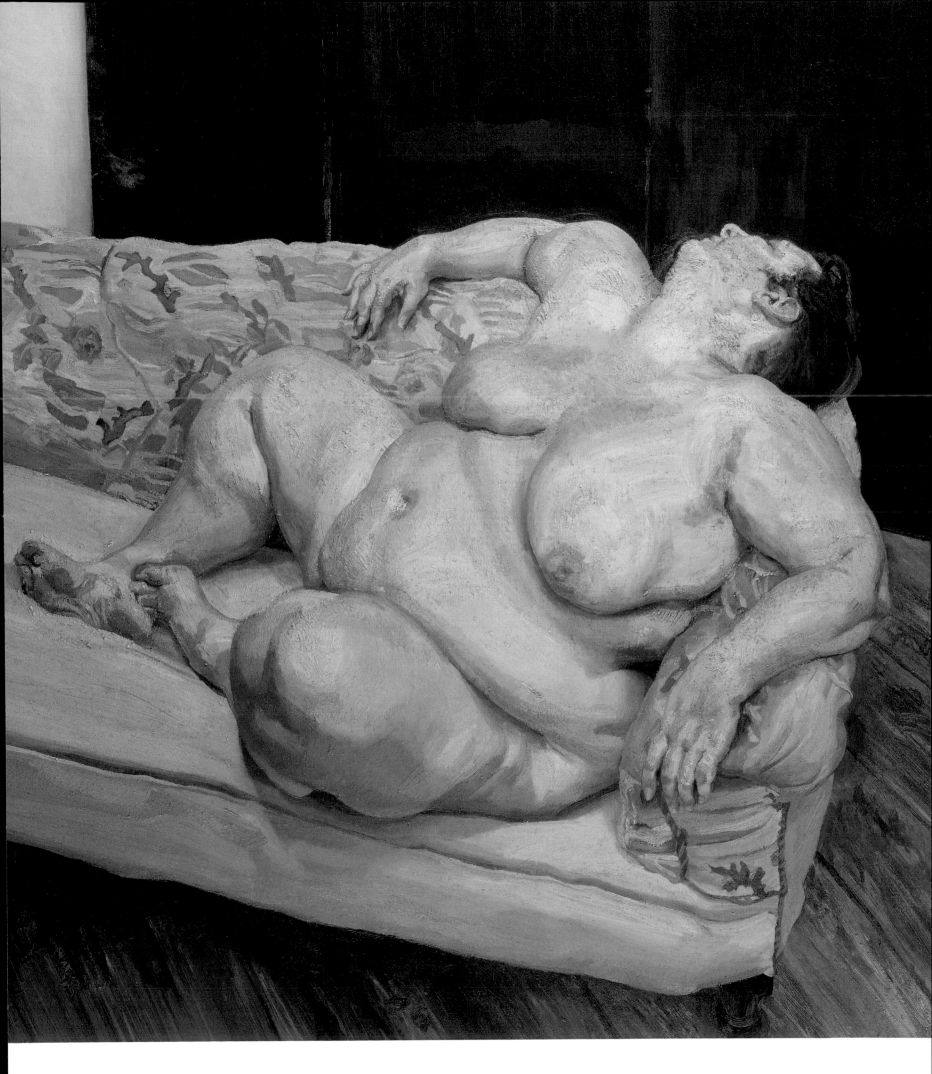

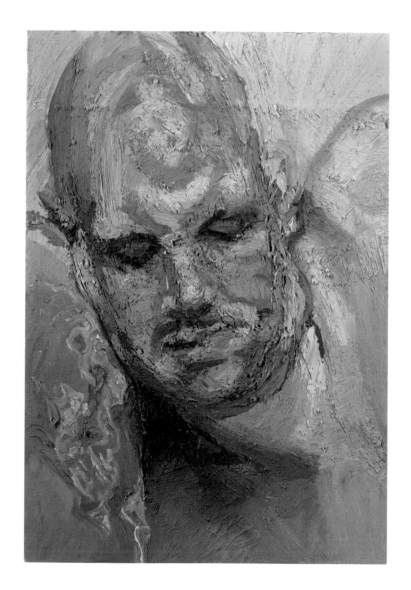

Last Portrait of Leigh 1995 | no.129

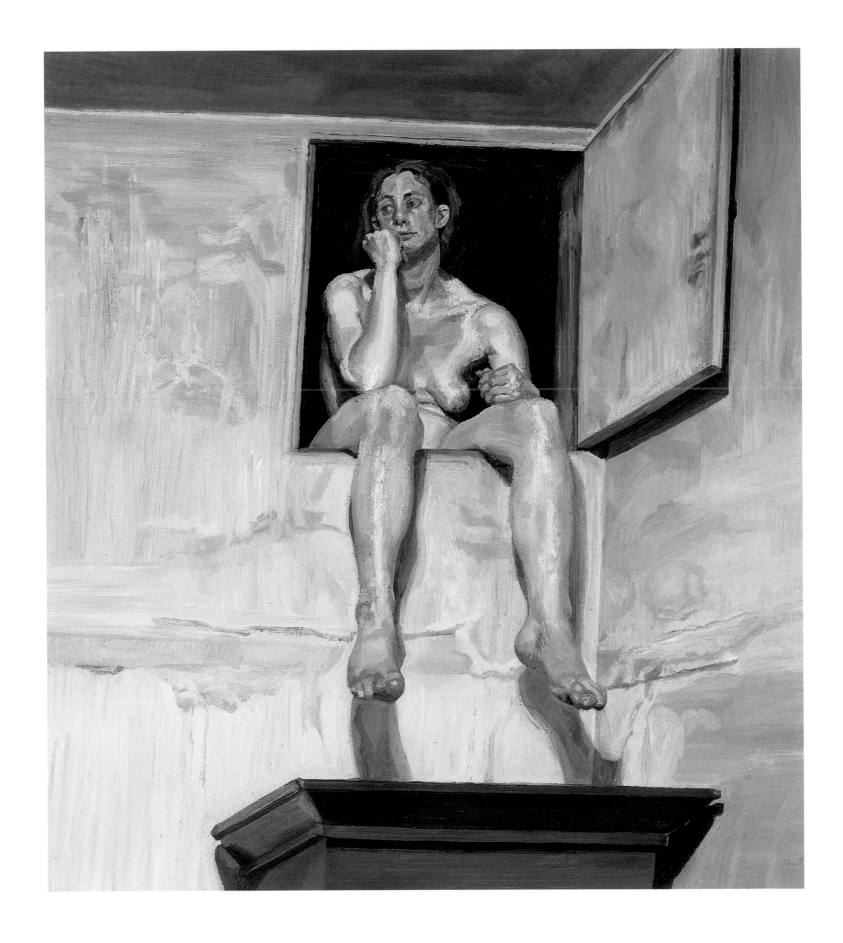

Girl Sitting in the Attic Doorway 1995 | no.128

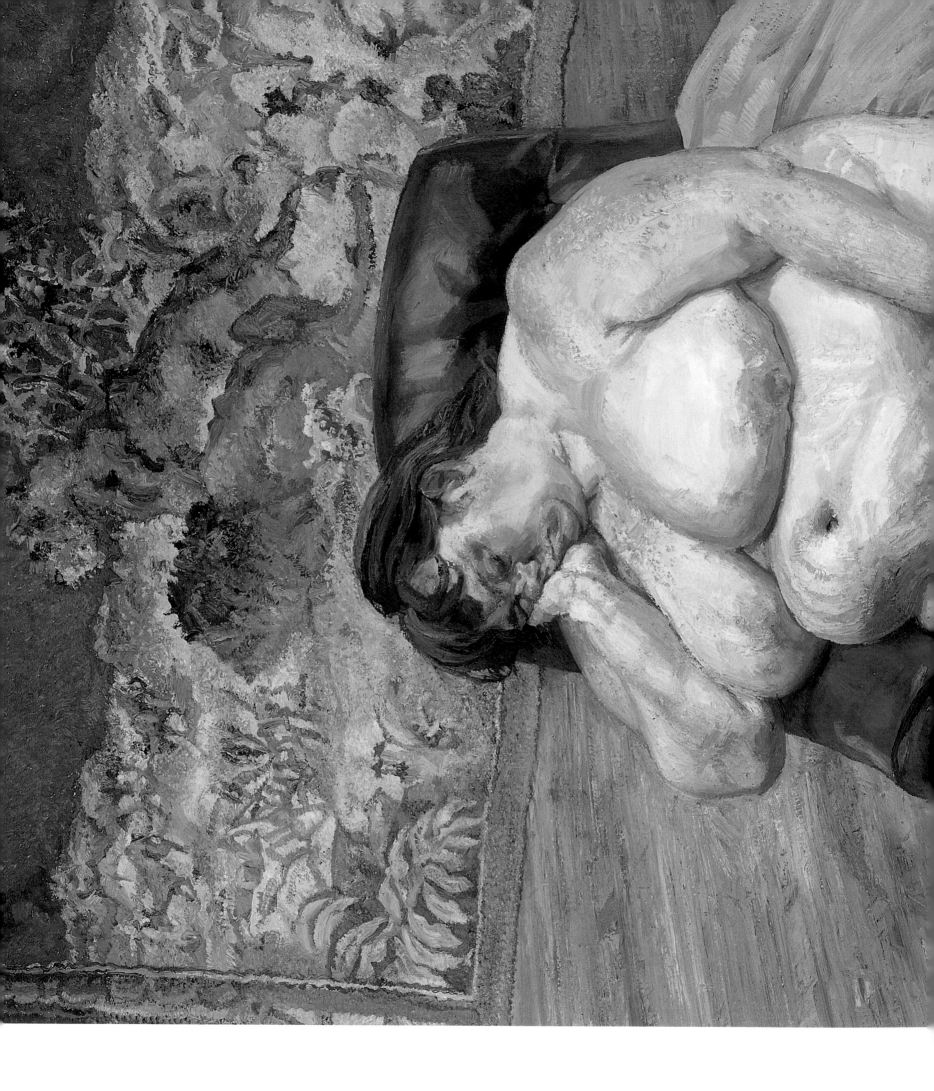

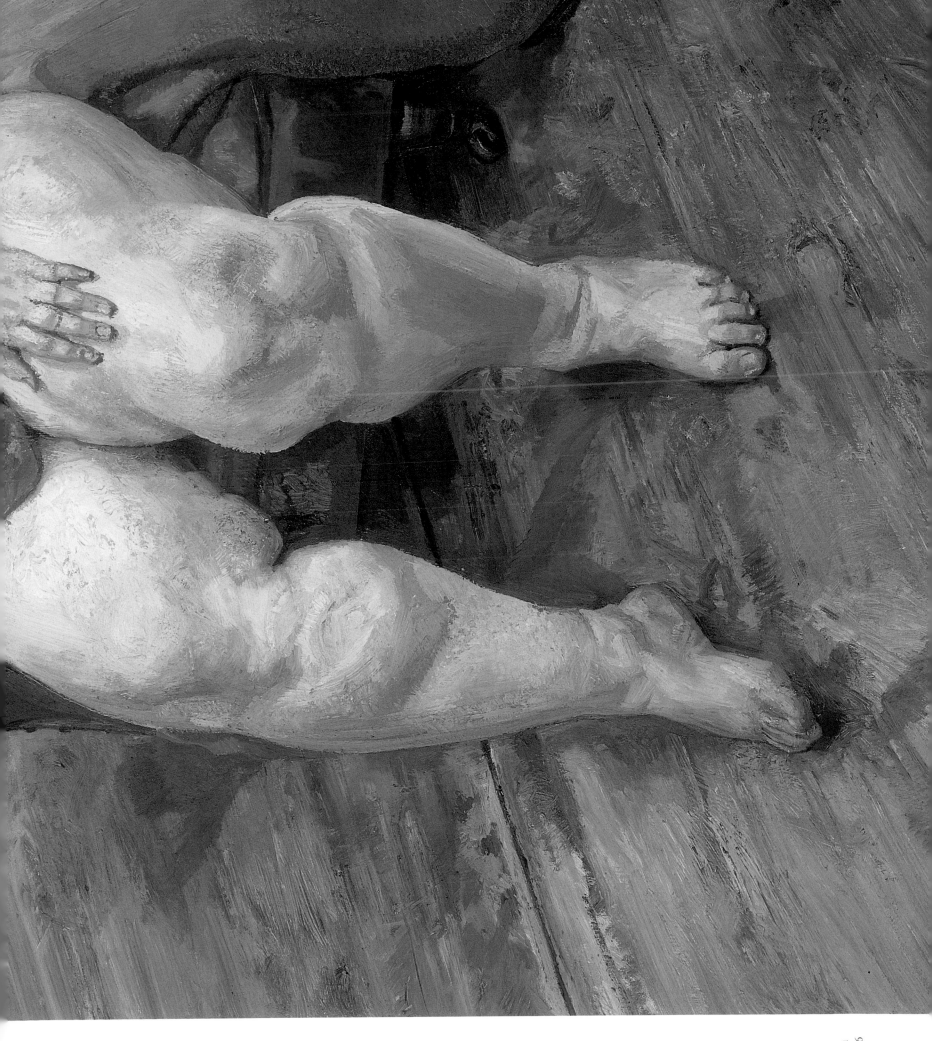

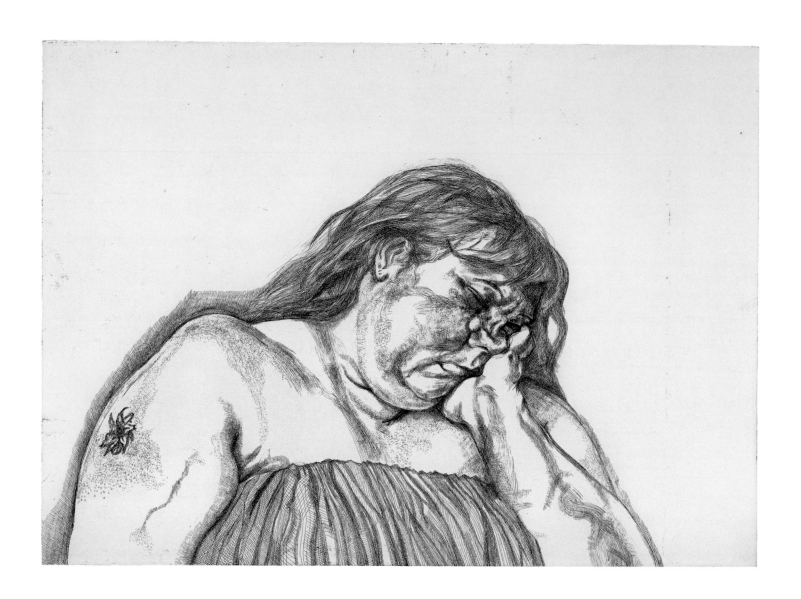

Woman with an Arm Tattoo 1996 | no.130

Bruce Bernard (Seated) 1996 | no.132

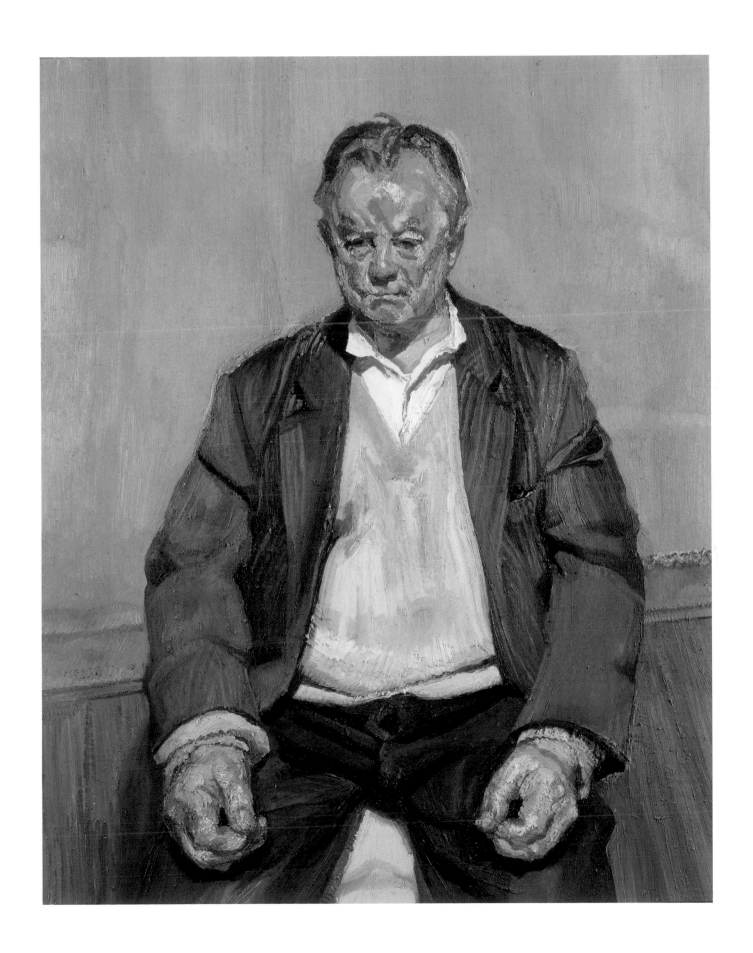

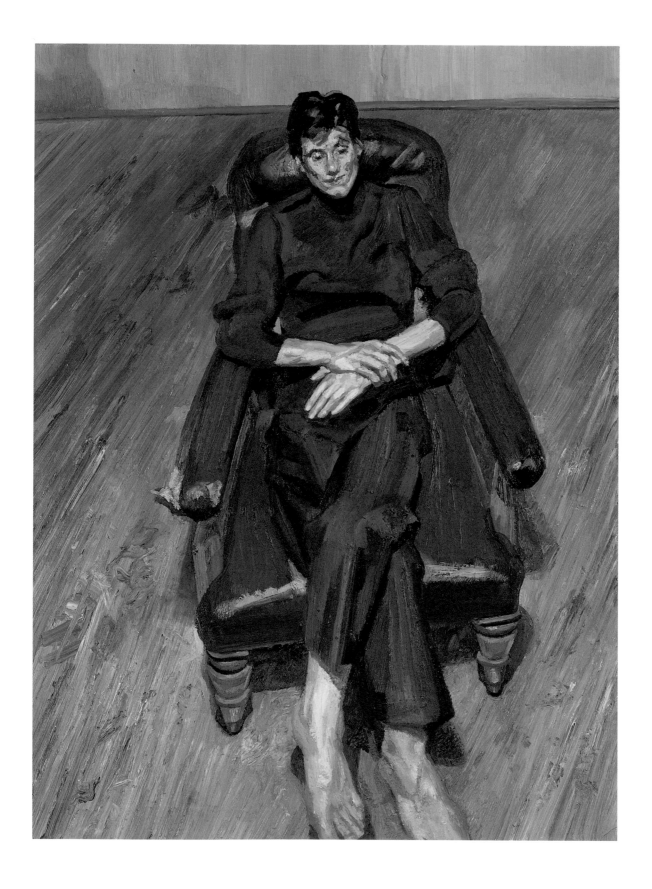

Bella 1996 | no.134

Pluto and the Bateman Sisters 1996 | no.133

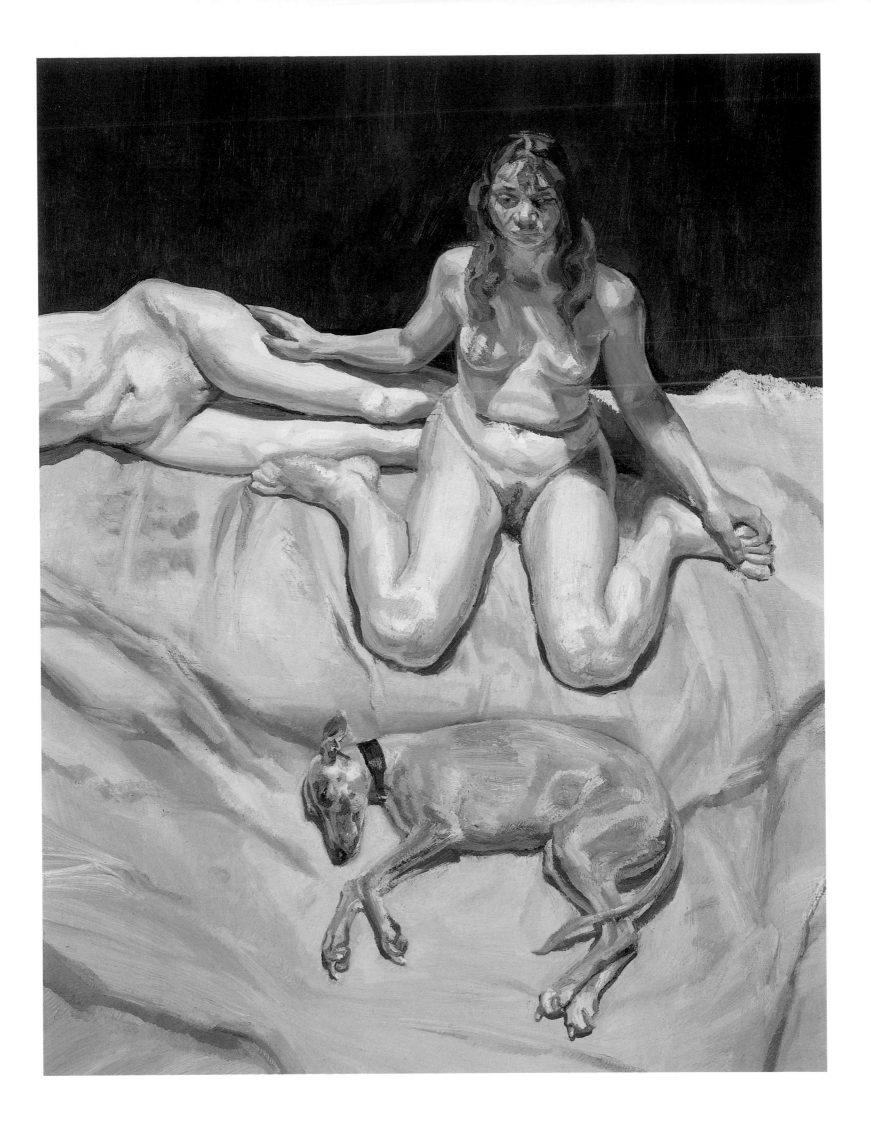

Armchair by the Fireplace 1997 | no.136

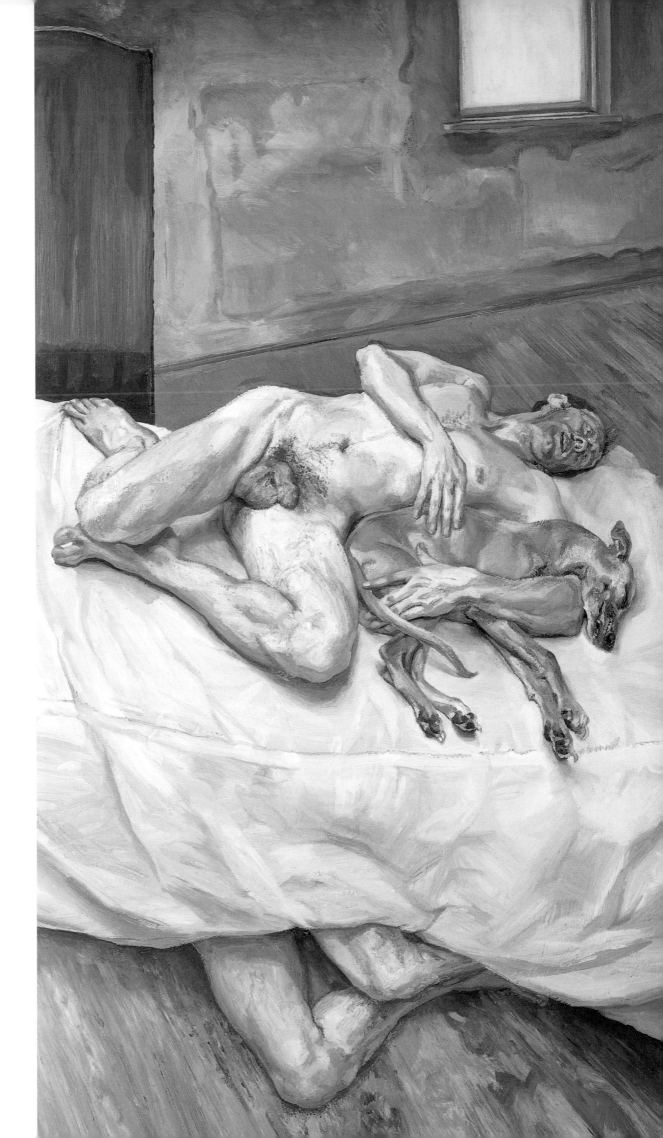

Sunny Morning – Eight Legs 1997 | no.135

Garden, Notting Hill Gate 1997 | no.137

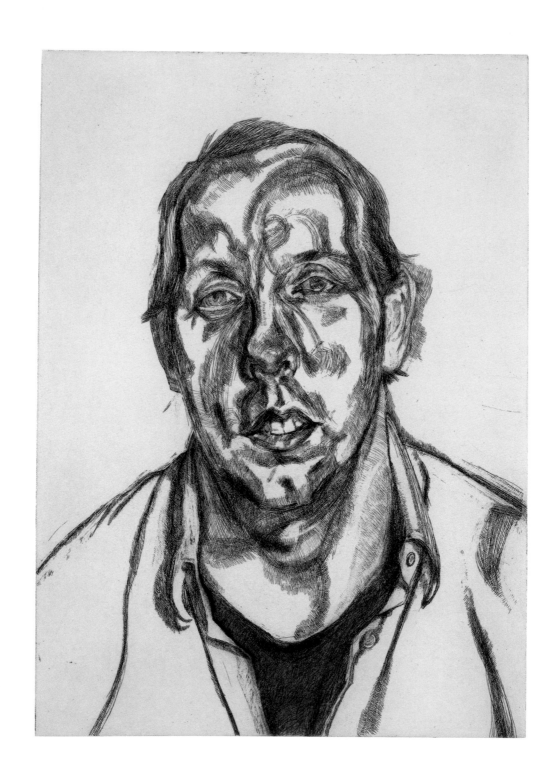

David Dawson 1998 | no.138

The Pearce Family 1998 | no.139

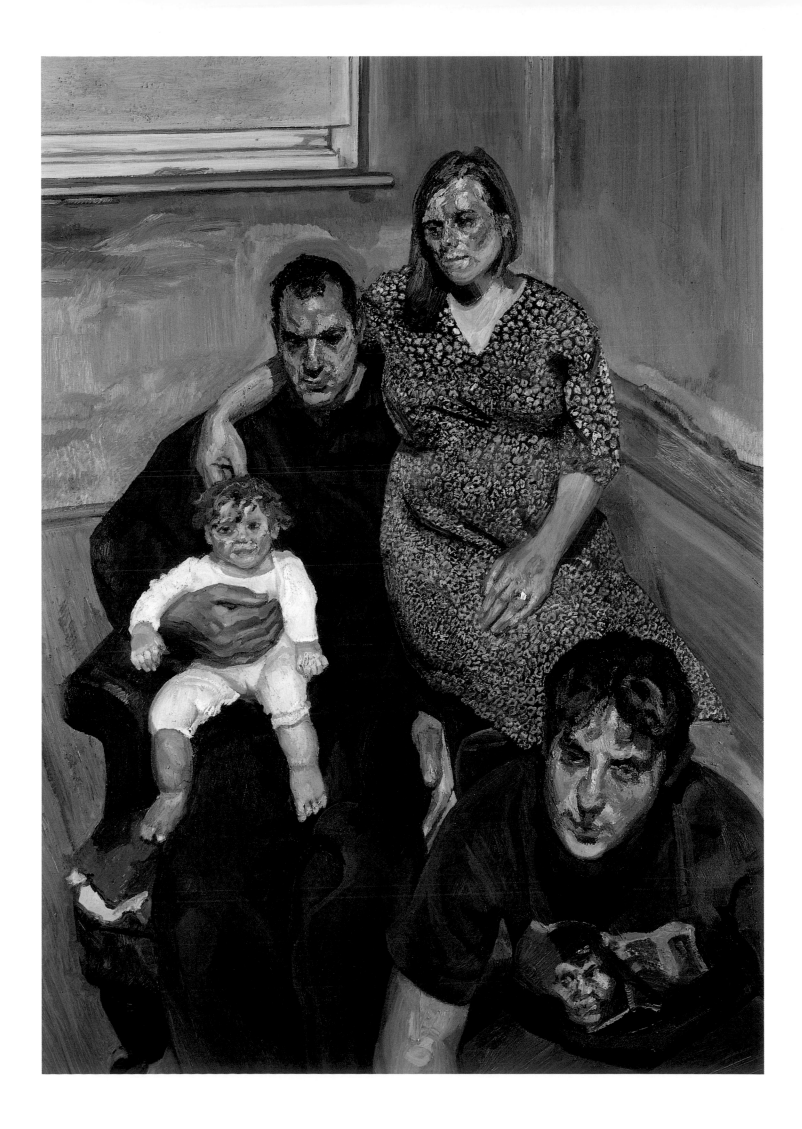

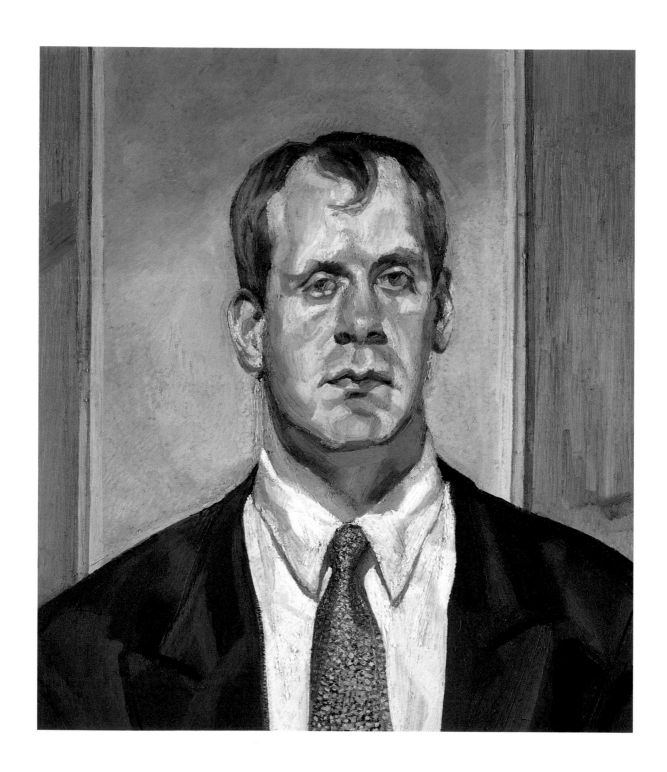

Head of an Irishman 1999 | no.140

After Chardin (Small) 1999 | no.144

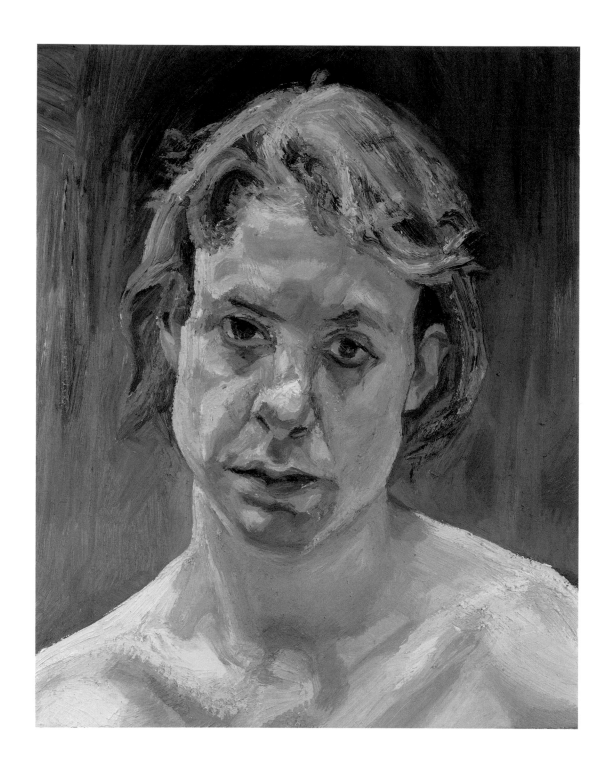

Head of a Naked Girl 1999–2000 | no.141 Naked Portrait Standing 1999–2000 | no.142

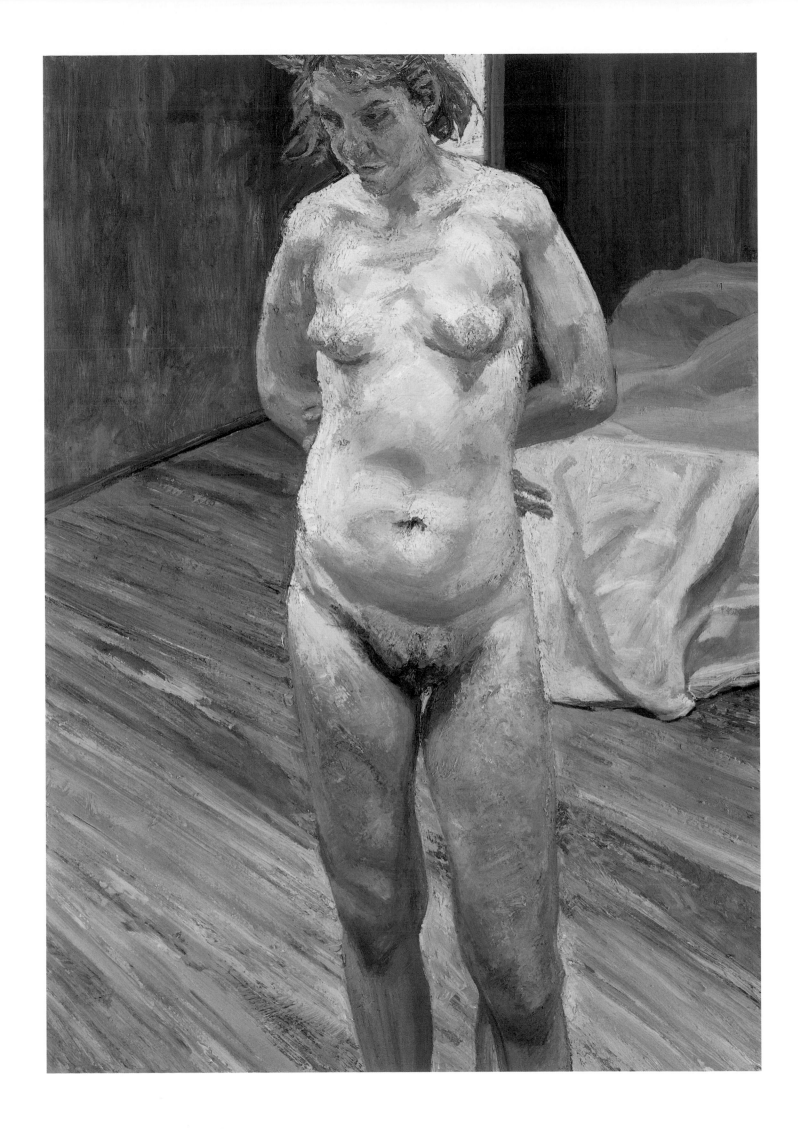

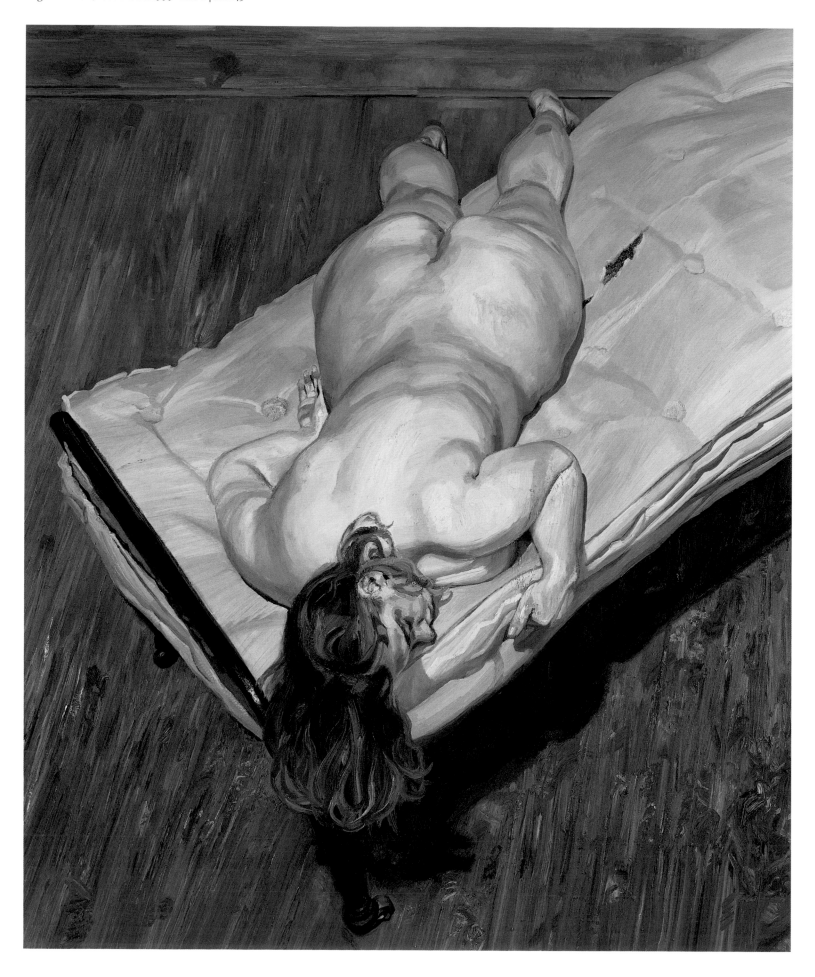

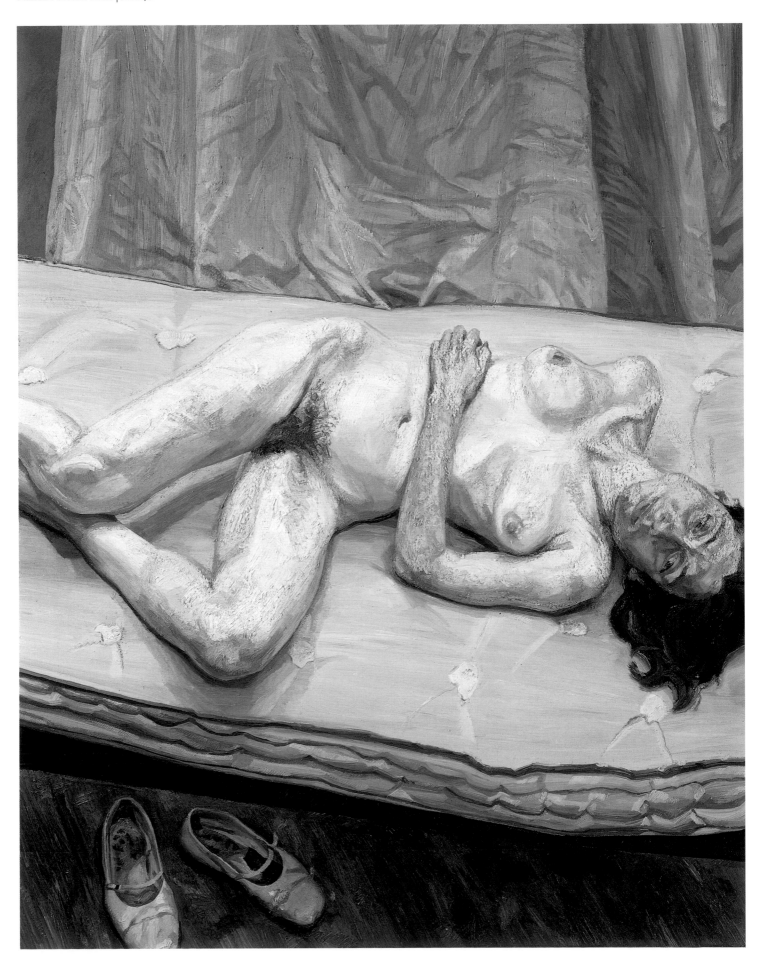

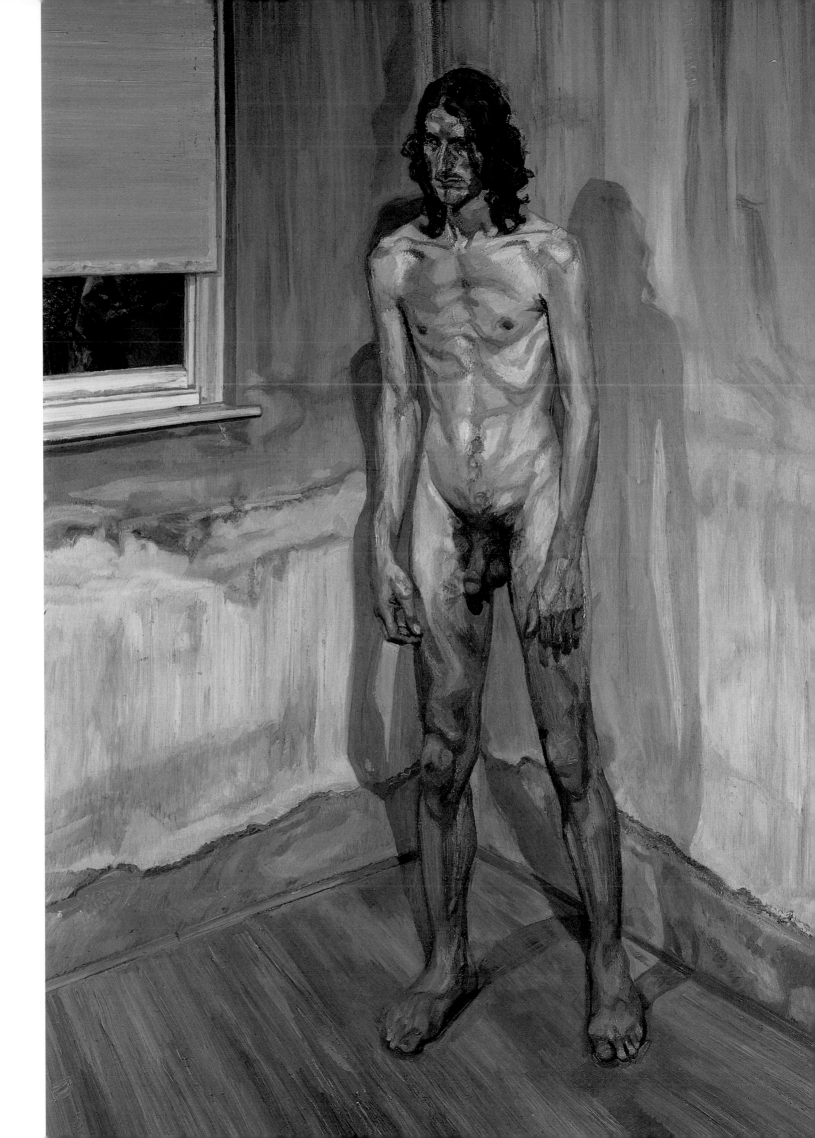

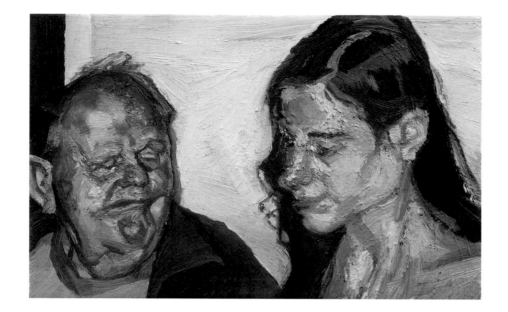

Daughter and Father 2002 | no.153

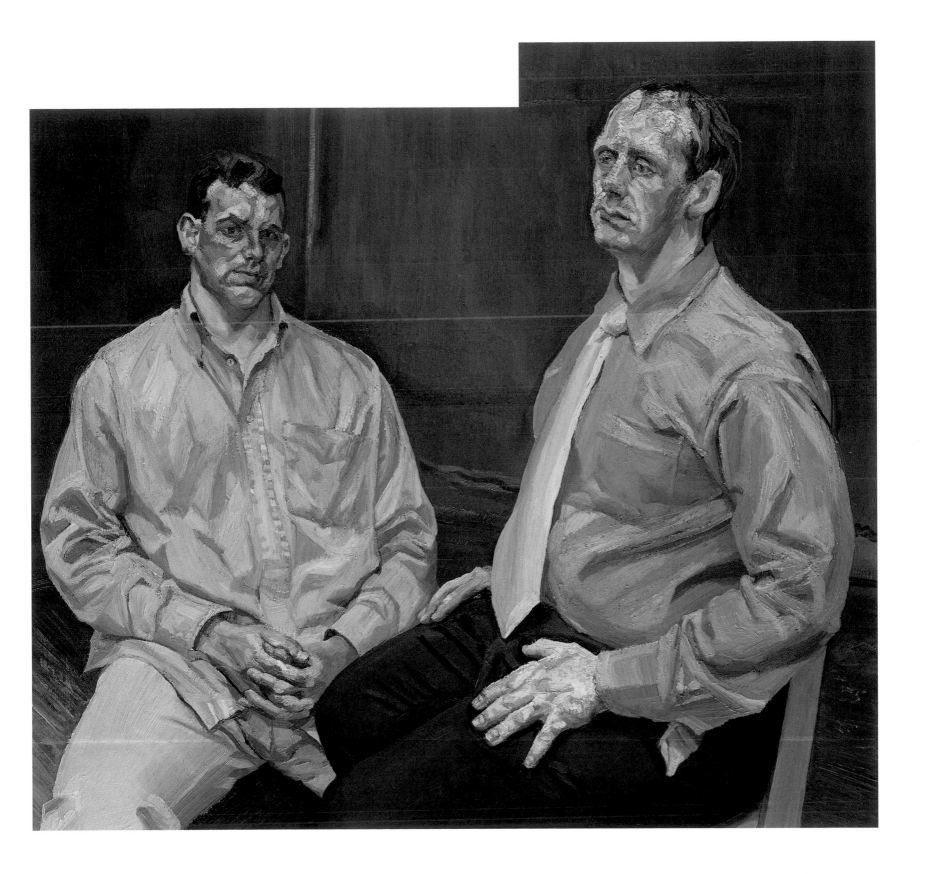

Two Brothers from Ulster 2001 | no.149

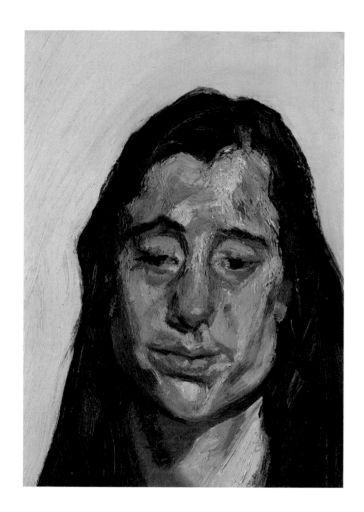

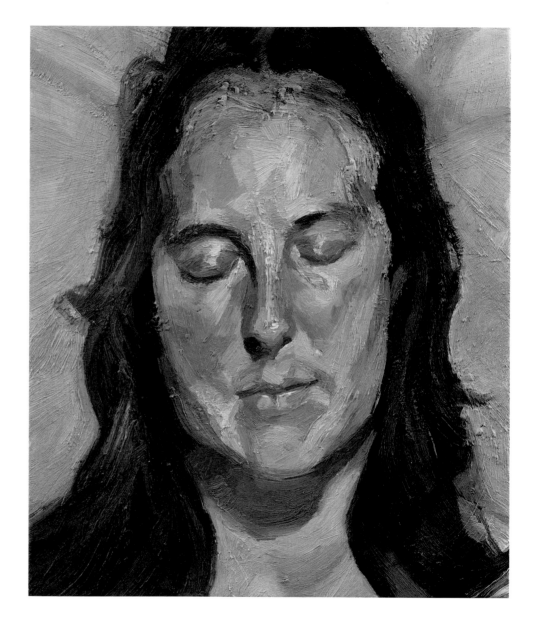

Small Portrait 2001 | no.152 Woman with Eyes Closed 2002 | no.154

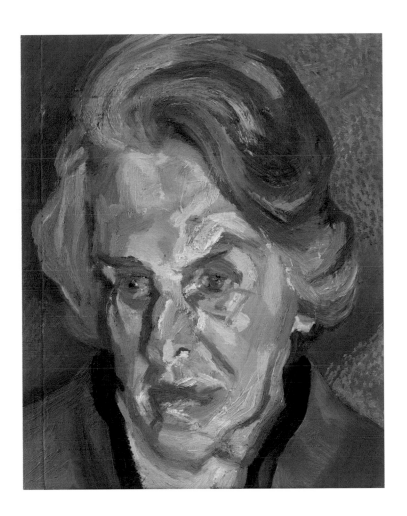

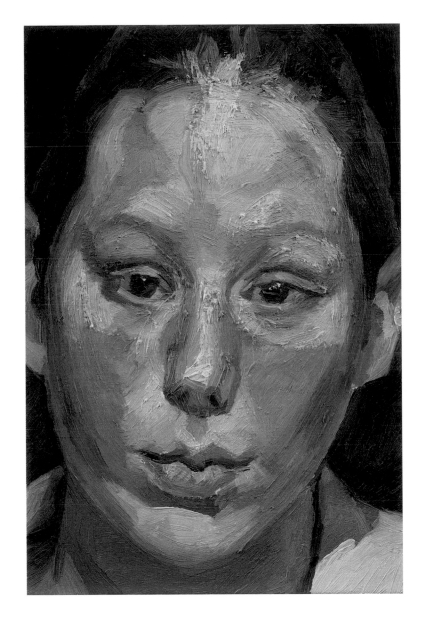

Aline 2000 | no.146

Frances Costelloe 2002 | no.155

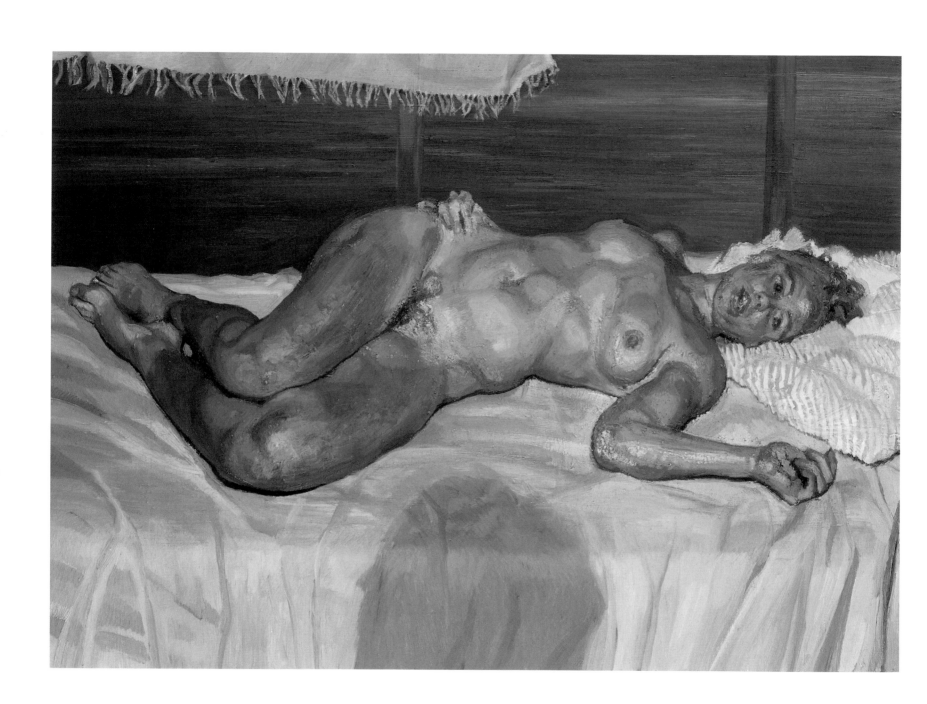

Flora with Blue Toe Nails 2000–1 | no.150

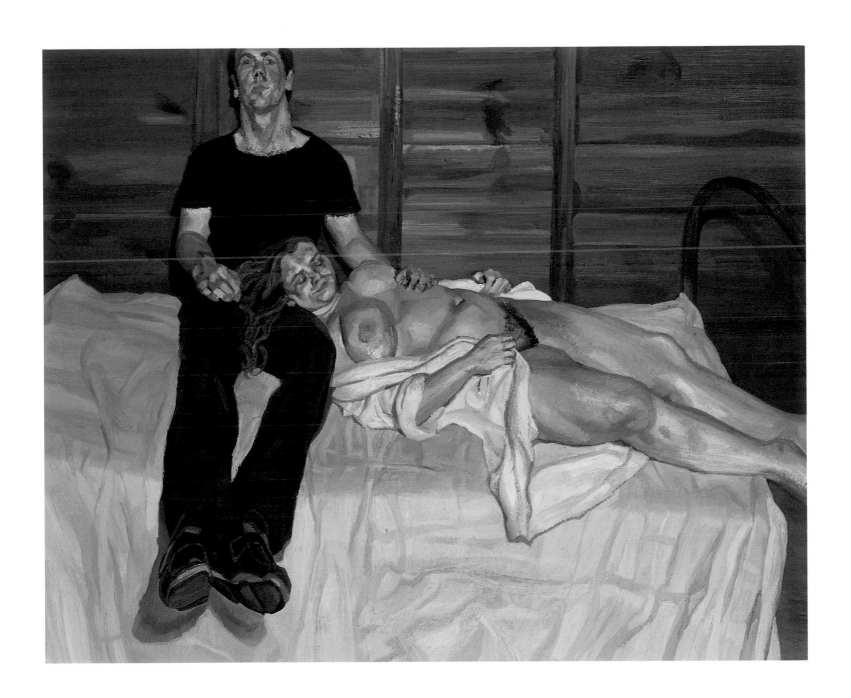

Julie and Martin 2001 | no.151

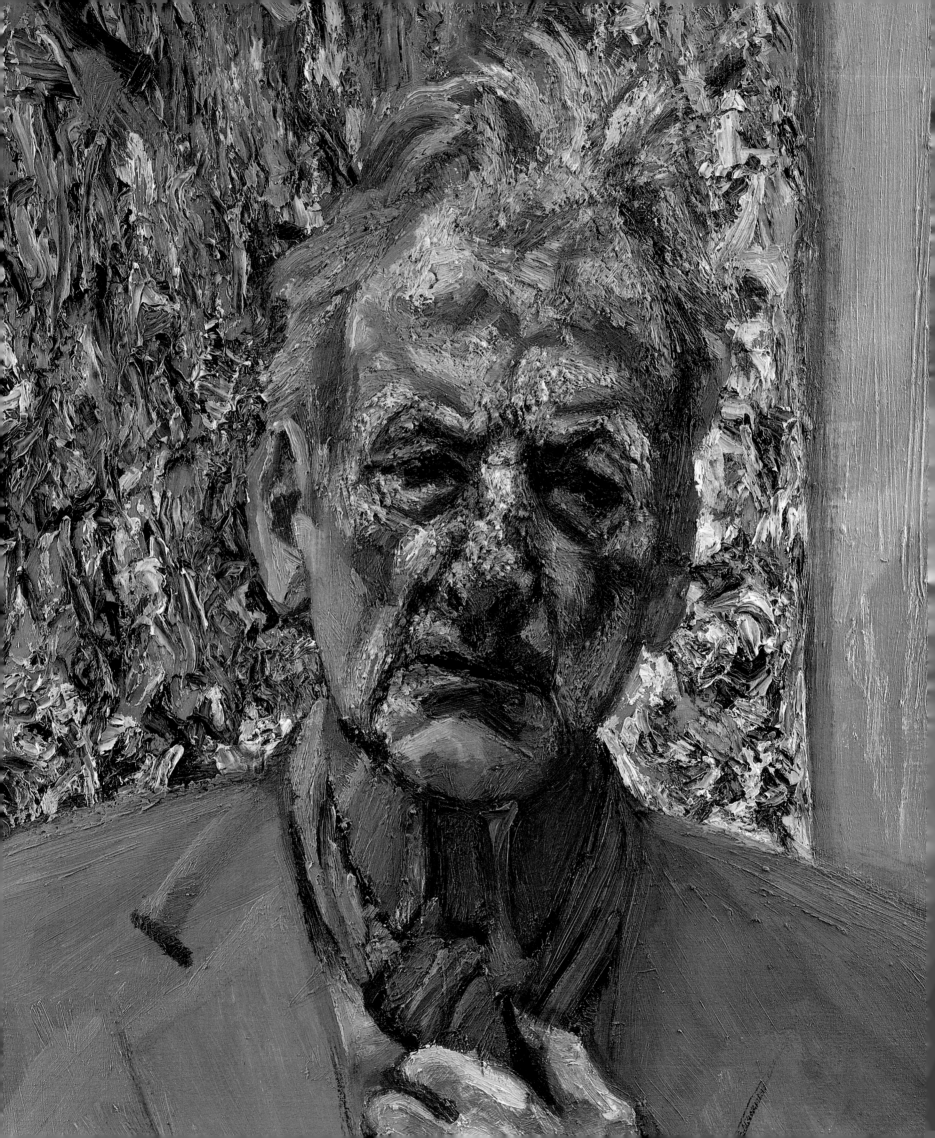

List of Exhibited Works

Self-Portrait, Reflection | no.156
Detail in unfinished state, April 2002

1
Box of Apples in Wales 1939
Oil on canvas · 59.7 × 74.9 (23½ × 29½)

2
Cedric Morris 1940*
Oil on canvas · 30.7 × 25.6 (12⅛ × 10⅛)
National Museums & Galleries of Wales
Allocated by HM Government in lieu of Inheritance
Tax and acquired with the assistance of the Derek
Williams Trust, 1998

3
Landscape with Birds 1940
Oil on panel · 39.5 × 32.3 (15½ × 12¾)

4
Able Seaman 1941
Black ink and oil on vellum · 38 × 25 (15 × 9⅞)
Vivian Horan Fine Art

5
Hospital Ward 1941
Oil on canvas · 24 × 34 (9½ × 13⅜)
The Duchess of Devonshire

6
Evacuee Boy 1942
Oil on canvas · 74.3 × 58.1 (29¼ × 22⅞)

7
The Village Boys 1942
Oil on canvas · 51 × 41 (20⅛ × 16⅛)

8
Loch Ness from Drumnadrochit 1943
Pen and ink on paper · 37.2 × 45.4 (14⅝ × 17⅞)

9
Still Life with Chelsea Buns 1943*
Oil on plywood · 40.3 × 50.8 (15⅞ × 20)
Carnegie Museum of Art, Pittsburgh; Gift of Mary
C. Hazard in honour of Leland Hazard (1893–1980),
1980

10
The Painter's Room 1943–4†
Oil on canvas · 63.1 × 76.1 (24¾ × 29⅞)

11
Palmtree 1944
Pastel, chalk and ink on paper · 61.5 × 43.5 (24¼ × 17⅛)
Freud Museum, London

12
Boy on a Balcony 1944*
Conté pencil and crayon, heightened with white on
buff paper · 53.3 × 35.5 (21 × 14)

13
Portrait of a Young Man 1944
Black crayon and white chalk on paper · 31.1 × 27.9
(12¼ × 11)

14
Woman with a Daffodil 1945*
Oil on canvas · 23.8 × 14.3 (9⅜ × 5⅜)
The Museum of Modern Art, New York
Purchase, 1953

15
Woman with a Tulip 1945
Oil on panel · 23 × 12.7 (9 × 5)

16
Dead Heron 1945
Oil on canvas · 49 × 74 (19¼ × 29⅛)

17
Unripe Tangerine 1946†
Oil on metal plate · 8.9 × 8.9 (3½ × 3½)
Colin St John Wilson

18
Still Life with Horns 1946–7
Oil on panel · 15.2 × 25.4 (6 × 10)

19
Girl in a Dark Jacket 1947
Oil on canvas · 47 × 38.1 (18½ × 15)

20
Girl with a Kitten 1947*
Oil on canvas · 39.4 × 29.5 (15½ × 11⅝)

21
Girl with Roses 1947–8
Oil on canvas · 106 × 75.6 (41¾ × 29¾)
The British Council

22

Girl with Leaves 1948*

Pastel on paper · 47.9 × 41.9 (18⅞ × 16½)
The Museum of Modern Art, New York.
Gift of Lincoln Kirstein

23

Girl with Fig Leaf 1948

Etching · 29 × 23 (11⅜ × 9)
Private Collection, Courtesy Matthew Marks Gallery,
New York

24

Ill in Paris 1948

Etching · 13 × 18 (5⅛ × 7⅛)
Private Collection, Courtesy Matthew Marks Gallery,
New York

25

Christian Bérard 1948

Black and white conté crayon on paper
40.5 × 42.5 (16 × 16¾)
Private Collection, Paris

26

Still-life with Squid and Sea Urchin
1949*

Oil on copper · 30 × 23 (11⅞ × 9⅛)
Harris Museum and Art Gallery, Preston

27

Father and Daughter 1949

Oil on canvas · 91.5 × 45.7 (36 × 18)
Marlborough Fine Art (London) Ltd.

28

Dead Monkey 1950*

Pastel and watercolour on paper
21.2 × 36.2 (8⅜ × 14¼)
The Museum of Modern Art, New York
Gift of Lincoln Kirstein

29

Head of a Woman 1950

Oil on copper · 19.5 × 14.5 (7⅝ × 5¾)
The Duke of Devonshire and the Chatsworth
Settlement Trustees

30

Portrait of a Girl 1950

Oil on copper · 29.5 × 23.5 (11⅝ × 9¼)

31

Interior in Paddington 1951

Oil on canvas · 152.4 × 114.3 (60 × 45)
Walker Art Gallery, National Museums and Galleries
on Merseyside

32

Girl in a Dark Dress 1951‡

Oil on canvas · 40.6 × 30.5 (16 × 12)

33

Girl with a White Dog 1950–1

Oil on canvas · 76.2 × 101.6 (30 × 40)
Tate. Purchased 1952

34

Francis Bacon 1951

Pencil and charcoal on paper · 54.7 × 42 (21½ × 16½)
R.B. Kitaj

35

John Minton 1952

Oil on canvas · 40 × 25.4 (15¾ × 10)
Royal College of Art Collection

36

Boy's Head 1952

Oil on canvas · 22 × 16 (8⅝ × 6¼)

37

Girl Reading 1952

Oil on copper · 21 × 16.5 (8¼ × 6½)

38

Girl in Bed 1952

Oil on canvas · 45.7 × 30.5 (18 × 12)

39

Girl's Head 1954†

Black and white conté pencil on paper
34.3 × 25.4 (13½ × 10)
Private Collection
Lent in memory of Dick and Mollie Mosse

40

Hotel Bedroom 1954

Oil on canvas · 91.1 × 61 (35⅞ × 24)
The Beaverbrook Foundation, The Beaverbrook Art
Gallery, Fredericton, NB Canada

41

The Procurer (Man in a Headscarf)
1954*

Oil on canvas · 32.5 × 22.3 (12¾ × 8¾)

42

A Woman Painter 1954

Oil on canvas · 40.6 × 35.5 (16 × 14)

43

Girl by the Sea 1956

Oil on canvas · 24.1 × 23.5 (9½ × 9¼)

44

Woman in a White Shirt 1956–7*

Oil on canvas · 45.7 × 40.6 (18 × 16)
The Duke of Devonshire and The Chatsworth
Settlement Trustees

45

Woman Smiling 1958–9

Oil on canvas · 71.1 × 55.9 (28 × 22)

46

Pregnant Girl 1960–1*

Oil on canvas · 91.5 × 71 (36 × 28)
Jacqueline Leland

47

Baby on a Green Sofa 1961

Oil on canvas · 56 × 62 (22 × 24⅜)
The Duchess of Devonshire

48

Head on a Green Sofa 1960–1

Oil on canvas · 91.5 × 91.5 (36 × 36)
Courtesy the Lambton Trustees

49

Figure with Bare Arms 1962

Oil on canvas · 91 × 91 (35⅞ × 35⅞)
Courtesy the Lambton Trustees

50

Head 1962

Oil on canvas · 56 × 51 (22 × 20⅛)
Private Collection, Paris

51

Red Haired Man on a Chair 1962–3

Oil on canvas · 91.5 × 91.5 (36 × 36)
Erich Sommer Holdings Ltd.

52

John Deakin 1963–4

Oil on canvas · 30.2 × 24.8 (11⅞ × 9¾)

53

A Man and his Daughter 1963–4

Oil on canvas · 61 × 61 (24 × 24)

54

Cyclamen 1964

Oil on canvas · 45.7 × 49.2 (18 × 19⅜)

55

Man in a Blue Shirt 1965

Oil on canvas · 59.7 × 59.7 (23½ × 23½)

56

Reflection with Two Children
(Self-Portrait) 1965†
Oil on canvas · 91.5 × 91.5 (36½ × 36½)
Museo Thyssen-Bornemisza, Madrid

57

Michael Andrews and June 1965–6
Oil on canvas · 60 × 70 (23⅝ × 27⅝)

58

Naked Girl 1966
Oil on canvas · 61 × 61 (24 × 24)

59

Interior with Hand Mirror
(Self-Portrait) 1967
Oil on canvas · 25.5 × 17.8 (9⅞ × 7)

60

Interior with Plant, Reflection
Listening 1967–8
Oil on canvas · 121.8 × 121.8 (48⅛ × 48⅛)

61

Woman in a Fur Coat 1967–8*
Oil on canvas · 60 × 60 (23⅝ × 23⅝)

62

Buttercups 1968*
Oil on canvas · 61 × 61 (24 × 24)

63

Naked Girl Asleep II 1968
Oil on canvas · 56 × 56 (22⅛ × 22⅛)
Private Collection, Courtesy Richard Nagy,
Dover Street Gallery

64

Large Interior, Paddington 1968–9†
Oil on canvas · 183 × 122 (72⅛ × 48⅛)
Museo Thyssen-Bornemisza, Madrid

65

A Filly 1969
Pencil and watercolour on paper · 34.5 × 24 (13⅝ × 9½)

66

The Painter's Father 1970*
Pencil on paper
22.9 × 16.5 (9 × 6½)

67

Paddington Interior, Harry Diamond
1970*
Oil on canvas · 71 × 71 (28 × 28)
University of Liverpool, Art Gallery and Collections

68

A Filly 1970
Oil on canvas · 19.1 × 26.7 (7½ × 10½)

69

Wasteground with Houses, Paddington
1970–2
Oil on canvas · 167 × 101 (65¾ × 39¾)

70

The Painter's Mother II 1972*
Oil on canvas · 25 × 21 (9⅞ × 8¼)
Private Collection, Courtesy James
Holland-Hibbert Ltd

71

The Painter's Mother III 1972
Oil on canvas · 32.4 × 23.5 (12¾ × 9¼)

72

Naked Portrait 1972–3
Oil on canvas · 61 × 61 (24 × 24)
Tate. Purchased 1975

73

Large Interior W9 1973*
Oil on canvas · 91.4 × 91.4 (36 × 36)
The Duke of Devonshire and the Chatsworth
Settlement Trustees

74

Small Naked Portrait 1973–4*
Oil on canvas · 22 × 27 (8⅝ × 10⅝)
Visitors of the Ashmolean Museum, Oxford

75

Ali 1974
Oil on canvas · 69.2 × 69.2 (27¼ × 27¼)

76

The Painter's Mother Reading 1975
Oil on canvas
65.4 × 50.2 (25¾ × 19¾)

77

The Painter's Mother Resting I 1976
Oil on canvas · 90.2 × 90.2 (35½ × 35½)

78

Annabel 1975
Pencil and watercolour on paper · 24.1 × 19.1
(9½ × 7½)
Collection of Matthew Marks

79

Head of the Big Man 1975
Oil on canvas · 41.3 × 26.7 (16¼ × 10½)

80

Frank Auerbach 1975–6
Oil on canvas · 40 × 26.5 (15¾ × 10½)
Private Collection, Courtesy Ivor Braka Ltd

81

Head of a Girl 1975–6
Oil on canvas · 50.8 × 40.6 (20 × 16)

82

Last Portrait 1976–7†
Oil on canvas · 61 × 61 (24 × 24)
Museo Thyssen-Bornemisza, Madrid

83

The Painter's Mother Resting III 1977
Oil on canvas · 59 × 69 (23¼ × 23¼)

84

Night Portrait 1977–8
Oil on canvas · 71 × 71 (28 × 28)

85

Two Plants 1977–80
Oil on canvas · 149.9 × 120 (59 × 47¼)
Tate. Purchased 1980

86

Naked Man with his Friend 1978–80
Oil on canvas · 90.2 × 105.4 (35½ × 41½)
Private Collection, Courtesy Ivor Braka Ltd

87

Portrait of Rose 1978–9†
Oil on canvas · 91.5 × 78.9 (36⅛ × 31⅛)

88

Naked Portrait with Reflection 1980*
Oil on canvas · 90.3 × 90.3 (35⅝ × 35⅝)

89

Naked Portrait II 1980–1
Oil on canvas · 90 × 75 (35½ × 29⅝)

90

Esther 1980

Oil on canvas · 48.9 × 38.3 (19¼ × 15⅛)

91

Guy and Speck 1980–1

Oil on canvas · 76.2 × 71.1 (30 × 28)

92

Guy Half Asleep 1981–2

Oil on canvas · 71.1 × 71.1 (28 × 28)
Private Collection, Courtesy Ivor Braka Ltd

93

Bella 1981

Oil on canvas · 35.5 × 30.5 (14 × 12)
Collection of Roy and Cecily Langdale Davis

94

Reflection (Self-Portrait) 1981–2

Oil on canvas · 55.9 × 50.8 (22 × 20)

95

Large Interior W11 (after Watteau)
1981–3

Oil on canvas · 186 × 198 (73¼ × 78)

96

The Painter's Mother 1982

Etching · 15 × 13 (6 × 5⅛)
Private Collection, Courtesy Matthew Marks Gallery,
New York

97

The Painter's Mother Resting 1982–4

Oil on canvas · 105.4 × 127.6 (41½ × 50¼)
Private Collection, Courtesy Richard Nagy,
Dover Street Gallery

98

Esther 1982–3

Oil on canvas · 35.6 × 30.5 (14 × 12)

99

Girl in a Striped Nightshirt 1983–5

Oil on canvas · 29.5 × 25 (11⅜ × 9⅞)

100

Man in a Chair 1983–5*

Oil on canvas · 120.5 × 100.5 (47½ × 39⅝)
Thyssen-Bornemisza Collection, Lugano

101

Two Japanese Wrestlers by a Sink
1983–7

Oil on canvas · 50.8 × 78.7 (20 × 31)
The Art Institute of Chicago, Restricted Gift of Mrs
Frederic G. Pick; through prior Gift of Mr and Mrs
Carter H. Harrison

102

Ib 1983–4

Oil on canvas · 35.6 × 30.5 (14 × 12)

103

Two Irishmen in W11 1984–5

Oil on canvas · 172.7 × 142.2 (68 × 56)

104

Bruce Bernard 1985

Etching · 29 × 29 (11½ × 11½)
Private Collection, Courtesy Matthew Marks Gallery,
New York

105

Double Portrait 1985–6

Oil on canvas · 78.7 × 88.9 (31 × 35)

106

Painter and Model 1986–7

Oil on canvas · 159.7 × 120.7 (62⅞ × 47½)

107

Lord Goodman in his Yellow Pyjamas
1987

Etching with watercolour on paper · 31 × 40.2
(12¼ × 15⅞)
The Whitworth Art Gallery, University of Manchester

108

Annabel Sleeping 1987–8*

Oil on canvas · 38.7 × 55.9 (15¼ × 22)

109

Bella and Esther 1988

Oil on canvas · 73.7 × 88.9 (29 × 35)

110

Woman in a Grey Sweater 1988

Oil on canvas · 56 × 45.7 (22 × 18)
Lewis Collection

111

Two Men in the Studio 1987–9

Oil on canvas · 185.5 × 120.7 (73 × 47½)
Lewis Collection

112

Susie 1988–9

Oil on canvas · 52 × 56.5 (20½ × 22¼)
Lewis Collection

113

The Painter's Mother Dead 1989*

Charcoal on paper · 33.3 × 24.4 (13 × 9⅝)
The Cleveland Museum of Art, Delia E. Holden Fund 1989

114

Standing by the Rags 1988–9

Oil on canvas · 168.9 × 138.4 (66½ × 54½)
Tate. Purchased with assistance from the National Art
Collections Fund, the Friends of the Tate Gallery and
anonymous donors 1990

115

Lying by the Rags 1989–90

Oil on canvas · 138.7 × 184.1 (54⅝ × 72½)
Astrup Fearnley Collection, Oslo, Norway

116

Leigh Bowery (Seated) 1990

Oil on canvas · 243.8 × 182.9 (96 × 72)
Mr and Mrs Richard C. Hedreen

117

Ib 1990†

Oil on canvas · 28 × 25.4 (11⅛ × 10)
Edward L. Gardner

118

Woman in a Butterfly Jersey 1990–1

Oil on canvas · 100.3 × 81.3 (39½ × 32)

119

Nude with Leg Up 1992

Oil on canvas · 183 × 228.5 (72 × 90)
Hirshhorn Museum and Sculpture Garden, Smithsonian
Institution. Joseph H. Hirshhorn Purchase Fund 1993

120

Ib and her Husband 1992

Oil on canvas · 168 × 147 (66⅛ × 57⅞)

121

Bruce Bernard 1992

Oil on canvas · 111.8 × 83.8 (44 × 33)
Collection of Elaine and Melvin Merians

122

Large Head 1993

Etching · 69 × 54 (27¼ × 21¼)
Private Collection, Courtesy Matthew Marks Gallery,
New York

123
Still Life with Book 1993
Oil on canvas · 42 × 38 (16½ × 15)

124
And the Bridegroom 1993
Oil on canvas · 231.8 × 196.2 (91¼ × 77¼)
Lewis Collection

125
Painter Working, Reflection 1993
Oil on canvas · 101.6 × 81.7 (40 × 32¼)

126
Francis Wyndham 1993
Oil on canvas · 64.8 × 50.8 (25½ × 20½)

127
Benefits Supervisor Resting 1994**
Oil on canvas · 160 × 150 (63 × 59⅛)

128
Girl Sitting in the Attic Doorway 1995*
Oil on canvas · 131.5 × 118.8 (51¾ × 46¾)

129
Last Portrait of Leigh 1995*
Oil on canvas · 29.5 × 20.3 (11⅝ × 8)

130
Woman with an Arm Tattoo 1996
Etching · 70 × 90 (27⅝ × 35½)
Private Collection, Courtesy Matthew Marks Gallery,
New York

131
Sleeping by the Lion Carpet 1996
Oil on canvas · 228 × 121 (89¾ × 47½)
Lewis Collection

132
Bruce Bernard (Seated) 1996
Oil on canvas · 101.6 × 81.3 (40 × 32)

133
Pluto and the Bateman Sisters 1996
Oil on canvas · 175 × 135 (68⅞ × 15⅜)
Colección Cisneros

134
Bella 1996
Oil on canvas · 102.9 × 76.2 (40½ × 30)

135
Sunny Morning – Eight Legs 1997
Oil on canvas · 234 × 132.1 (92⅛ × 52)
The Art Institute of Chicago, the Joseph
Winterbotham Collection

136
Armchair by the Fireplace 1997
Oil on canvas · 66 × 56 (26 × 22)

137
Garden, Notting Hill Gate 1997
Oil on canvas · 149 × 120 (69 × 57)

138
David Dawson 1998
Etching · 82 × 67 (32⅜ × 26⅜)
Private Collection, Courtesy Matthew Marks Gallery,
New York

139
The Pearce Family 1998
Oil on canvas · 142.2 × 101.6 (56 × 40)

140
Head of an Irishman 1999
Oil on canvas · 47 × 36.8 (18½ × 14½)

141
Head of a Naked Girl 1999–2000
Oil on canvas · 51.4 × 40.6 (20¼ × 16)
Collection UBS PaineWebber Inc.

142
Naked Portrait Standing 1999–2000*
Oil on canvas · 109.2 × 77.5 (43 × 30½)

143
Night Portrait, Face Down
1999–2000*
Oil on canvas · 151 × 156 (59½ × 61½)

144
After Chardin (Small) 1999
Oil on canvas · 15.2 × 20.3 (6 × 8)

145
After Cézanne 2000*
Oil on canvas · 214 × 215 (84¼ × 84⅝)
Collection: National Gallery of Australia, Canberra.
Purchased with assistance of members of the NGA
Foundation, including David Coe, John Schaeffer and
Kerry Stokes AO, 2001

146
Aline 2000
Oil on canvas · 24.8 × 18.4 (9¾ × 7¼)

147
Freddy Standing 2000–1
Oil on canvas · 248.9 × 172.7 (98 × 68)

148
Naked Portrait 2001*
Oil on canvas · 167.6 × 132.1 (66 × 52)

149
Two Brothers from Ulster 2001
Oil on canvas · 144.8 × 133.4 (57 × 52½)

150
Flora with Blue Toe Nails 2000–1
Oil on canvas · 91.4 × 127 (36 × 50)

151
Julie and Martin 2001
Oil on canvas · 137.2 × 167.6 (54 × 66)

152
Small Portrait 2001
Oil on canvas · 17.8 × 12.7 (7 × 5)

153
Daughter and Father 2002
Oil on canvas · 12.9 × 20.5 (5 × 8)

154
Woman with Eyes Closed 2002
Oil on canvas · 30.5 × 25.4 (12 × 10)

155
Frances Costelloe 2002
Oil on canvas · 30.5 × 20.3 (12 × 8)

156
Self-Portrait, Reflection 2002
Oil on canvas · 66 × 50.8 (26 × 20)

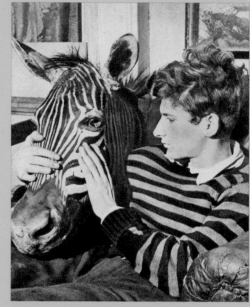

1

7

8

3

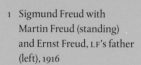

1 Sigmund Freud with
Martin Freud (standing)
and Ernst Freud, LF's father
(left), 1916

2 Drawing by LF, *c*.1928

3 LF with zebra head, *c*.1943
Photo: Ian Gibson Smith

4 Drawing published in *Ballet*
magazine, January 1948

5 LF by Jacob Epstein, 1948

6 LF at Benton End, 1940

7 LF working at Benton End,
1940, with David Carr
(foreground) and David
Kentish (left)

8 LF's mother, Lucie
Brasch, 1919

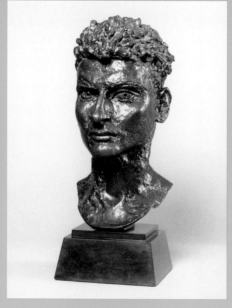

Bird in Cage *Drawing by Lucian Freud*

Ballet in Paris

LES BALLETS DES CHAMPS-ELYSEES have presented two new works this
winter, 15 *Danses*, by Roland Petit, and *Le Portrait de Don Quichotte*, by
Aurel Milloss. There was to have been a third production, *Ni Vu ni
Connu*, but this has been abandoned.
 15 *Danses* has an amusing history. Several months ago it was decided
to arrange new choreography for the Mozart–Tchaikovsky, Beaurepaire,

4

5

Chronology

1922

Born Lucian Michael on 8 December in Berlin, to Jewish parents. His father, the youngest son of Sigmund Freud, is an architect and his mother is the daughter of a grain merchant.

1933–8

Moves to Britain with family.

Studies at Dartington Hall, Devon; Dane Court; and Bryanston.

1938

Sigmund Freud arrives in London.

Drawings included in an exhibition of children's art at Guggenheim Jeune, Cork St.

1939

Becomes a naturalised British subject.

Death of Sigmund Freud.

1939–42

Studies at Central School of Arts and Crafts, London; then at East Anglian School of Painting and Drawing, Dedham (under Cedric Morris).

1940

Self-portrait drawing published in *Horizon*.

1941

Serves on North Atlantic convoy for three months.

Returns to Morris's school at Benton End, Hadleigh.

1942

Moves to Abercorn Place, St John's Wood.

Drawings included in an exhibition at Alex Reid and Lefevre Gallery, London.

1943

Drawings published in *Horizon*.

Moves to Delamere Terrace, W12.

1944

First one-man exhibition at Alex Reid and Lefevre Gallery, London.

Nicholas Moore's *The Glass Tower: Poems 1936–43* illustrated by Freud published by Editions Poetry London.

1945

Visits the Scilly Isles.

1946

Spends two months in Paris where he makes first two etchings, *The Bird* and *Chelsea Bun*.

Joins John Craxton on the Greek island of Poros where he remains for five months.

1947

London Gallery (with Craxton).

1948

Marries Kitty Garman, daughter of Kathleen Garman and Jacob Epstein. Moves to Clifton Hill, Maida Vale.

London Gallery.

1949–54

Visiting tutor, Slade School of Fine Art.

1950

Hanover Gallery, London.

1951

Purchase Prize from Arts Council of Great Britain for *Interior in Paddington* exhibited in *Sixty Paintings for '51*, part of the Festival of Britain.

1952

Hanover Gallery, London.

1953

Marries Caroline Blackwood.

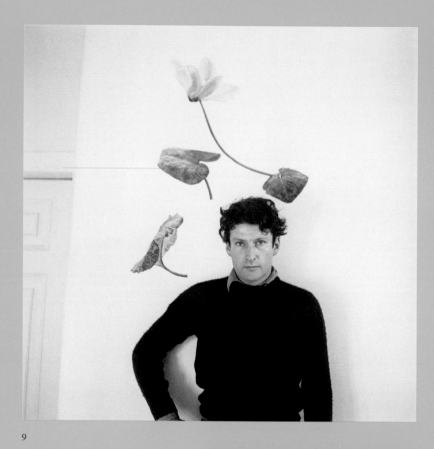

9

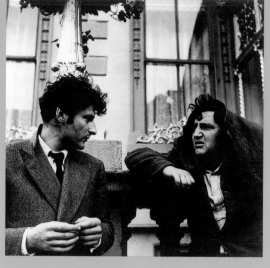

10

11

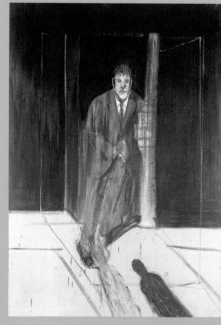

13

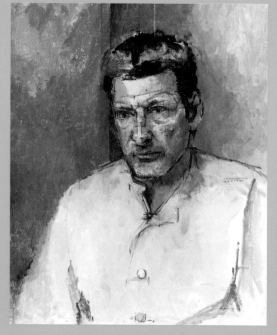

12

9 LF with cyclamen mural,
 Coombe, 1955. Photo: Cecil Beaton

10 LF and Brendan Behan, Dublin,
 1953. Photo: Dan Farson

11 *Sunny Morning – Eight Legs* [no.135]
 in progress. Photo: William Feaver

12 Portrait of LF by William
 Coldstream, 1971

13 Portrait of LF by Francis Bacon,
 1951

226

1954

Represents Britain at the 27th Venice Biennale of Art (with Ben Nicholson and Francis Bacon).

'Some Thoughts on Painting' published in *Encounter*.

1955

Second prize in the *Daily Express Young Artists' Exhibition* at the New Burlington Galleries, London, with *Hotel Bedroom*.

1958

Marlborough Fine Art, London.

1962

Moves to Clarendon Crescent, W11.

1963

Marlborough Fine Art, London.

1967

Moves to Gloucester Terrace, W2.

1968

Marlborough Fine Art, London.

1970

Death of Ernst Freud.

1972

Moves to Thorngate Road, Maida Vale.

Completes *The Painter's Mother*, the first in a series of paintings which continues until the mid-1980s.

Leaves Marlborough Fine Art. Anthony d'Offay Gallery, London.

1974

First retrospective, Hayward Gallery, London, and touring.

1977

Moves to Holland Park.

1978

Anthony d'Offay Gallery, London.

1979

Nishimura Gallery, Tokyo.

1981

A New Spirit in Painting, Royal Academy of Arts, London.

Eight Figurative Artists, Yale Center for British Art, New Haven.

1982

Lucian Freud, monograph by Lawrence Gowing, published by Thames and Hudson.

Anthony d'Offay Gallery, London.

1983

Created Companion of Honour.

Leaves Anthony d'Offay Gallery with James Kirkman continuing to act as his agent.

1984

The Hard Won Image, Tate Gallery, London.

The Proper Study, Lalit Akademi, Delhi, and Bombay.

1987

Selected *The Artist's Eye*, National Gallery, London.

1987–8

A School of London, organised by the British Council, at Kunstnernes Hus, Oslo. Tours to Louisiana (Denmark), Venice and Düsseldorf.

Retrospective organised by the British Council, at Hirschhorn Museum and Sculpture Garden, Washington DC, the first major representation of Freud's work shown outside Britain. Tours to Musée National d'Art Moderne, Paris, the Hayward Gallery, London, and the Neue Nationalgalerie, Berlin.

1989

Death of Lucie Freud.

1991–2

Lucian Freud, Paintings and Works on Paper 1940–1991 organised by the British Council at Palazzo Ruspoli, Rome. Tours to Tate Gallery Liverpool; Tochigi Prefectural Museum of Fine Arts; Otani Memorial Museum, Nishinomiya; Setagaya Art Museum, Tokyo and Art Gallery of New South Wales, Sydney.

James Kirkman ceases to act as Freud's agent. Arranges to be represented by William Acquavella, New York.

1993

Awarded the Order of Merit.

1993–4

Lucian Freud: Recent Work at Whitechapel Art Gallery, London. Tours to the Metropolitan Museum of Art, New York, and Museo Nacional Centro de Arte Reina Sofia, Madrid.

1994

Paintings hung at Dulwich Art Gallery.

1995

From London: Bacon, Freud, Kossoff, Andrews, Auerbach, Kitaj organised by the British Council at Scottish National Gallery of Modern Art, Edinburgh.

1996

Lucian Freud: Paintings and Etchings at Abbot Hall Art Gallery, Kendal.

Acquavella Galleries, New York.

Lucian Freud, ed. Bruce Bernard, published by Jonathan Cape, London.

1997

Lucian Freud: Early Works, Scottish National Gallery of Modern Art, Edinburgh.

1998

Lucian Freud: Some New Paintings, Tate Gallery, London.

2000

Lucian Freud, recent work, 1997–2000, Acquavella Galleries, New York.

2001

Donates *Portrait of The Queen* to the Royal Collection.

2002

Lucian Freud, Tate Britain, touring to Fundació "la Caixa", Barcelona and The Museum of Contemporary Art, Los Angeles.

Constable, selected by Freud, at the Grand Palais, Paris.

Bibliography

Compiled by Kryzsztof Cieszkowski of the Tate Library.

The items within each section are listed chronologically. Square brackets indicate information supplied from sources other than the item itself.

Items marked with an asterisk (*) are recommended by the compiler as particularly useful.

1 Writings by the artist

* 'Some thoughts on painting', in *Encounter*, July 1954, vol.3 no.1, pp.23–4 (+ 4pp of plates); Italian trans. publ. in 1991/2 Milan solo cat., pp.23–4.

[statement, titled 'A short text' in contents] in *Modern art in Britain*, ed. Michael Peppiatt, *Cambridge Opinion*, no.37 1963, p.47.

[statement] in *Carnegie International 1985*, exhib. cat., Museum of Art, Carnegie Institute, Pittsburgh, 1985, p.131.

[statement] in *The artist's eye: Lucian Freud: an exhibition of National Gallery paintings selected by the artist*, exhib. cat., National Gallery, London, 1987, p.[20].

'Frank Auerbach's paintings', in *Frank Auerbach at the National Gallery: after the masters*, exhib. cat., National Gallery, London, 1995, p.5.

2 Books and sections of books on the artist

Bryan Robertson, John Russell, Lord Snowdon: *Private view*. London: Nelson, 1965; pp.112–15 (text by John Russell).

John Rothenstein: 'Lucian Freud', in *Modern English painters III: Wood to Hockney*. London: Macdonald, 1974, pp.192–200; repr. in *Modern English painters III: Hennell to Hockney*. London: Macdonald, 1984, pp.179–85; (rev. version of essay previously publ. in *Art and Literature*, Spring 1967).

* Lawrence Gowing: *Lucian Freud*. London: Thames and Hudson, 1982; 230pp., 187 illus. (some col.).

Helen Lessore: *A partial testament: essays on some moderns in the great tradition*. London: Tate Gallery, 1986; pp.122–42.

Alistair Hicks: *New British art in the Saatchi Collection*. London: Thames and Hudson, 1989; pp.12–13, 38–45.

Alistair Hicks: *The School of London: the resurgence of contemporary painting*. Oxford: Phaidon, 1989; pp.46–9, 52–3, & passim.

Andrew Benjam in: 'Betraying faces: Lucian Freud's self-portraits', in *Art, mimesis and the avant-garde: aspects of a philosophy of difference*. London: Routledge, 1991, pp.61–74.

Craig Hartley: *The etchings of Lucian Freud: a catalogue raisonné 1946–1995*. London, New York: Marlborough Graphics; Bergamo: Galleria Ceribelli, 1995; 138pp., 58 illus.; rev. edn. *Lucian Freud: Rubenspreis der Stadt Siegen 1997: Award of the Rubenspreis of the City of Siegen 1997*; Bielefeld: Kerber Verlag, 1997; 78pp., 26 illus., with parallel German/English text by Andreas Franzke; biog.; bibl.

* Bruce Bernard & Derek Birdsall (eds.): *Lucian Freud*. London: Jonathan Cape, 1996; introd. by Bruce Bernard, bibl.; 360pp., 297 illus. (mostly col.).

Sue Tilley: *Leigh Bowery: the life and times of an icon*. London: Hodder & Stoughton, 1997.

Lucian Freud: 'After Cézanne'. Canberra: National Gallery of Australia, 2001; text by Brian Kennedy, *In search of Lucian Freud*, pp.3–8; Rolf Lauter, *Expert report*, pp.10–19; Catherine Lampert, pp.20–2; Jörg Zutter, p.23; 24pp., 19 col. illus.

John Richardson: 'Lucian Freud and his models', in *Sacred monsters, sacred masters: Beaton, Capote, Dalí, Picasso, Freud, Warhol, and more*. London: Jonathan Cape, 2001; pp.322–41 (rev. versions of articles previously publ. in *New Yorker*, Dec. 1993, & *Vanity Fair*, May 2000).

James Hyman: *The battle for realism: figurative art in Britain during the Cold War 1945–1960*. New Haven, London: Yale University Press, for the Paul Mellon Centre for Studies in British Art, 2001.

3 Selected articles, interviews, reviews

Michael Ayrton: 'Art' [incl. review of Lefevre exhib.], in *Spectator*, 1 Dec. 1944, no.6075, p.503.

'Perspex': 'Current shows and comments: Matters of opinion' [incl. review of Lefevre exhib.], in *Apollo*, Jan. 1945, vol.41 no.239, pp.1–3 (ref. pp.2–3).

Cora Gordon: 'London commentary' [incl. review of Lefevre exhib.], in *Studio*, Mar. 1945, vol.129 no.624, pp.88–91 (ref. pp.90–1).

M.H. Middleton: 'Art' [incl. review of London Gallery exhib.], in *Spectator*, 7 Nov. 1947, no.6228, pp.589–90.

Patrick Heron: 'Matthew Smith, Craxton and Freud' [incl. review of London Gallery exhib.], in *New Statesman and Nation*, 8 Nov. 1947, vol.34 no.870, p.368.

Maurice Collis: 'Current art survey' [incl. review of London Gallery exhib.], in *Time & Tide*, 8 Nov. 1947, vol.28 no.43, p.1188.

'New English paintings' [review of London Gallery exhib.], in *The Times*, 11 Nov. 1947, p.7.

Philip Hendy: 'Art – Three generations of painters' [review of British Council exhib.], in *Britain To-Day*, Feb. 1948, no.142, pp.29–32 (ref. p.32).

Geoffrey Grigson: 'Who paints now in England?', in *Harpers Bazaar*, Nov. 1948.

[LF: 'Kitty with Fig Leaves'], in *Painting and sculpture acquisitions from January 1, 1948 to July 1, 1949*, issue of *The Museum of Modern Art Bulletin* (New York), 1950, vol.17 no.2–3 (ref. p.15).

Philip Hendy: 'The New Burlington Galleries' [review of exhib.], in *Britain Today*, Feb. 1950.

'Exhibitions' [incl. review of Hanover Gallery exhib.], in *Architectural Review*, June 1950, vol.107 no.642, pp.427–8 (ref. p.428).

David Sylvester: 'Two painters', in *Britain Today*, June 1950.

David Sylvester: 'Portrait of the artist no.36: Lucian Freud', in *Art News and Review*, 17 June 1950, vol.2 no.10, pp.1–2.

[LF: 'Boy with White Scarf'], in *Bulletin of the National Gallery of South Australia* (Adelaide), Oct. 1950, vol.12 no.2, pp.1, 8.

Robert Melville: 'The exhibitions of the Institute of Contemporary Arts', in *Studio*, Apr. 1951, vol.141 no.697, pp.97–103 (ref. 102–3).

'Arts Council Festival purchases: contemporary British paintings', in *Illustrated London News*, 28 Apr. 1951, vol.218 no.5845, p.669 (illus.).

Philip James: 'Patronage for painters: 60 paintings for '51: the Arts Council selection discussed', in *Studio*, Aug. 1951, vol.142 no.701, pp.42–7 (ref. pp.42, 45).

David Sylvester: 'Freud and Pasmore' [incl. review of Hanover Gallery exhib.], in *Listener*, 8 May 1952, vol.47 no.1210, p.760.

Stephen Bone: 'Lucian Freud', in *Manchester Guardian*, 8 May 1952.

John Russell: 'Vasari to Steinberg' [incl. review of Hanover Gallery exhib.], in *Sunday Times*, 11 May 1952.

'Hanover Gallery: Mr. Lucian Freud' [review of exhib.], in *The Times*, 13 May 1952, p.8.

Pierre Rouve: 'Passport to Belgravia' [review of Hanover Gallery exhib.], in *Art News and Review*, 17 May 1952, vol.4 no.8, p.7.

Charles Spencer: 'Lucian Freud', in *Jewish Life*, 29 May 1952.

'Perspex': 'Current shows and comments: Institutions' [incl. review of Hanover Gallery exhib.], in *Apollo*, June 1952, vol.55 no.328, pp.157–9, 190 (ref. p.158).

Andrew Hammer: 'Exhibitions: paintings and sculpture' [incl. review of Hanover Gallery exhib.], in *Architectural Review*, July 1952, vol.112 no.667, pp.63–4.

A.M.F. [= Alfred M. Frankfurter]: 'Double drawing festival: the great tradition from France, a modern style in Chicago' [incl. review of Chicago exhib.], in *Art News*, Nov. 1952, vol.51 no.7 part 1, pp.16–23 (illus. on p.26).

Douglas Cooper: 'Reflections on the Venice Biennale', in *Burlington Magazine*, Oct. 1954, vol.96 no.619, pp.316–322 (ref. p.321).

Bernard Denvir: 'Masterpieces explained, IV: *The sisters*, by Mary Cassatt; *Girls with straw hats*, by Auguste Renoir', in *The Artist*, Jan. 1955, vol.47 no.4, pp.80–3 (ref. p.80).

D.L.A. Farr: 'London' [incl. review of Marlborough exhib.], in *Burlington Magazine*, Mar. 1958, vol.100 no.660, pp.186–7 (ref. p.186).

John Berger: *New Statesman*, Apr. 1958.

Stephen Bone: 'Lucian Freud's new style', in *Manchester Guardian*, 26 Mar. 1958.

'Mr. Lucian Freud's arresting portraits' [review of Marlborough exhib.], in *The Times*, 26 Mar. 1958, p.3.

Eric Newton: 'Caterpillar into moth' [review of Marlborough exhib.], in *Time & Tide*, 29 Mar. 1958, vol.39 no.13, p.405.

John Russell: 'Unsparing portraitist' [review of Marlborough exhib.], in *Sunday Times*, 30 Mar. 1958.

John Berger: 'Success and value' [incl. review of Marlborough exhib.], in *New Statesman*, 5 Apr. 1958, vol 55 no.1412, pp.434–5 (ref. p.434).

* Lawrence Alloway: 'Round the London galleries' [incl. review of Marlborough exhib.], in *Listener*, 10 Apr. 1958, vol.49 no.1515, p.626.

Pierre Rouve: 'By any other name' [review of Marlborough exhib.], in *Art News and Review*, 12 Apr. 1958, vol.10 no.6, p.3.

Jean Yves Mock: 'Notes from Paris and London' [incl. review of Marlborough exhib.], in *Apollo*, May 1958, vol.67 no.399, pp.176–8 (ref. p.176).

John Russell: 'Lucian Freud' [review of Marlborough exhib.], in *Art News*, May 1958, vol.57 no.3, p.46.

* Robert Melville: 'Exhibitions: paintings and sculpture' [incl. review of Marlborough exhib.], in *Architectural Review*, June 1958, vol.123 no.737, pp.418–20 (ref. p.419).

G.S. Whittet: 'London commentary' [incl. review of Marlborough exhib.], in *Studio*, June 1958, vol.155 no.783, pp.186–9 (ref. p.188).

Pierre Jeannerat: 'Brush that goes beyond the surface' [review of Marlborough exhib.], in *Daily Mail*, 4 Oct. 1963.

'Telling portrait heads' [incl. review of Marlborough exhib.], in *The Times*, 5 Oct. 1963, p.5.

* John Russell: 'The agony of painting' [review of Marlborough exhib.], in *Sunday Times*, 6 Oct. 1963.

Eric Newton: 'Lucian Freud' [review of Marlborough exhib.], in *Guardian*, 7 Oct. 1963.

Cottie Burland: 'Lucian Freud' [review of Marlborough exhib.], in *Arts Review*, 19 Oct.–2 Nov. 1963, vol.15 no.20, p.10.

Keith Roberts: 'London' [incl. review of Marlborough exhib.], in *Burlington Magazine*, Nov. 1963, vol.105 no.728, pp.516–22 (ref. pp.518, 521).

G.S. Whittet: 'Artists discover themselves: London commentary' [incl. review of Marlborough exhib.], in *Studio*, Dec. 1963, vol.166 no.848, pp.246–8 (ref. p.248).

John Rothenstein: 'Lucian Freud', in *Art and Literature*, Spring 1967, no.12, pp.107–20 (republ. in rev. form in *Modern English painters III*, 1974).

James Burr: 'London galleries: Poetic eloquence' [incl. review of Marlborough exhib.], in *Apollo*, Apr. 1968, vol.87 no.74 (n.s.), pp.296–8 (ref. pp.296–7).

Terence Mullaly: 'Lucian Freud's works of compelling nastiness' [review of Marlborough exhib.], in *Daily Telegraph*, 11 Apr. 1968.

John Russell: 'Lucian Freud' [review of Marlborough exhib.], in *Sunday Times*, 14 Apr. 1968.

Nigel Gosling: 'Lucian Freud' [review of Marlborough exhib.], in *Observer*, 21 Apr. 1968.

Norbert Lynton: 'Wrestling with Realism' [review of Marlborough exhib.], in *Guardian*, 26 Apr. 1968.

Robert Melville: 'Moviegoing', in *New Statesman*, 26 Apr. 1968.

Keith Roberts: 'London' [incl. review of Marlborough exhib.], in *Burlington Magazine*, May 1968, vol.110 no.782, pp.299–301 (ref. pp.300–1).

Paul Overy: 'Berliners' [incl. review of Marlborough exhib.], in *Listener*, 2 May 1968, vol.79 no.2040, pp.559, 583.

Keith Sutton: 'Art' [incl. review of Marlborough exhib.], in *Queen*, 8 May 1968, vol.430 no.5645, pp.26–7 (ref. p.26).

William Feaver: 'Stranded dinosaurs', in *London Magazine*, July–Aug. 1970, vol.10 no.4, pp.95–105 (ref. pp.101–2).

John Russell: 'Lucian Freud – clairvoyeur', in *Art in America*, Jan.–Feb. 1971, vol.59 no.1, pp.104–6.

James Burr: 'London galleries: Dustbin art' [incl. review of d'Offay exhib.], in *Apollo*, Oct. 1972, vol.96 no.128 (n.s.), pp.354–5 (ref. 355).

William Packer: 'London' [incl. review of d'Offay exhib.], in *Art and Artists*, Oct. 1972, vol.7 no.7 (issue no.79), pp.54–6 (ref. p.54).

Michael Shepherd: 'Beholder's eye' [review of d'Offay exhib.], in *Sunday Telegraph*, 15 Oct. 1972.

John Russell: 'Sights of London' [incl. review of d'Offay exhib.], in *Sunday Times*, 15 Oct. 1972.

Marina Vaizey: 'Lucian Freud' [review of d'Offay exhib.], in *Financial Times*, 18 Oct. 1972.

Guy Brett: 'Sensational no longer' [review of d'Offay exhib.], in *The Times*, 18 Oct. 1972, p.9.

Michael Shepherd: 'Lucian Freud' [review of d'Offay exhib.], in *Arts Review*, 21 Oct. 1972, vol.24 no.21, p.651.

Robert Melville: 'Gallery: The art of being literal' [incl. review of d'Offay exhib.], in *Architectural Review*, Dec. 1972, vol.152 no.910, pp.349–52 (ref. pp.351–2).

Keith Roberts: 'London' [incl. review of d'Offay exhib.], in *Burlington Magazine*, Dec. 1972, vol.114 no.837, pp.880–7 (ref. pp.882, 884).

William Feaver: 'London letter' [incl. review of d'Offay exhib.], in *Art International*, Jan. 1973, vol.16 no.1, pp.29–33 (ref. pp.30–1).

William Feaver: *New Realists* [incl. review of d'Offay/Hartlepool exhib.], in *London Magazine*, Feb.–Mar. 1973, vol.12 no.6, pp.122–31 (ref. pp.127–9).

John Russell: *Sights of London*, in *Sunday Times*, 15 Oct. 1973.

Nigel Gosling: 'From Watts to Freud' [incl. review of Hayward exhib.], in *Observer*, 27 Jan. 1974.

John Russell: 'The fascination of Freud' [review of Hayward exhib.] in *Sunday Times*, 27 Jan. 1974.

Paul Overy: 'Lucian Freud's visual autobiography' [review of Hayward exhib.], in *The Times*, 29 Jan. 1974, p.11.

Peter Stone: 'Freud's laughing child' [review of Hayward exhib.], in *Jewish Chronicle*, 1 Feb. 1974.

Robert Melville: 'Brief spell' [review of Hayward & d'Offay exhibs.], in *New Statesman*, 1 Feb. 1974, vol.87 no.2235, pp.161–2.

William Feaver: 'Lucian Freud: the analytical eye', in *Sunday Times Magazine*, 3 Feb. 1974, pp.48–57.

Peter Fuller: 'Lucian Freud' [review of Hayward & d'Offay exhibs.], in *Arts Review*, 6 Feb. 1974, vol.26 no.3, p.48.

Richard Cork: 'Closely observed strains' [review of Hayward exhib.], in *Evening Standard*, 7 Feb. 1974, p.12.

Terence Mullaly: 'Captivating realism of Freud' [review of Hayward exhib.], in *Daily Telegraph*, 13 Feb. 1974.

Marina Vaizey: 'Lucian Freud' [review of Hayward exhib.], in *Financial Times*, 14 Feb. 1974.

Michael McNay: 'Sides of Bacon' [review of Hayward exhib.], in *Guardian*, 19 Feb. 1974.

Robert Melville: 'Gallery: the Eve they have painted' [incl. review of Hayward exhib.], in *Architectural Review*, Mar. 1974, vol.155 no.925, pp.159–62 (ref. pp.161–2).

John Russell: 'Top light and tales' [incl. review of Hayward exhib.], in *Art News*, Mar. 1974, vol.73 no.3, pp.85–6 (ref. p.86).

Fenella Crichton: 'London letter' [incl. review of Hayward exhib.], in *Art International*, Apr. 1974, vol.18 no.4, pp.43–6, 72 (ref. 46, 72).

Peter Fuller: 'Lucian Freud' [review of Hayward exhib.], in *Connoisseur*, Apr. 1974, vol.185 no.746, p.320.

Charles Spencer: 'London' [incl. review of Hayward exhib.], in *Arts Magazine*, May 1974, vol.48 no.8, pp.46–7 (ref. p.47).

Maurice Tuchman: 'European painting in the Seventies', in *Art and Artists*, Nov. 1975, vol.10 no.8 (issue no.116), pp.44–9 (ref. p.47).

Elizabeth Perlmutter: 'European painting: masters and mavericks' [incl. review of Los Angeles County Museum of Art exhib.], in *Art News*, Dec. 1975, vol.74 no.10, pp.84–6 (ref. p.84).

Gerald Nordland: 'Los Angeles letter' [incl. review of Los Angeles County Museum of Art exhib.], in *Art International*, 20 Dec. 1975, vol.19 no.10, pp.29–37 (ref. p.32).

John Gruen: 'The relentlessly personal vision of Lucian Freud', in *Art News*, Apr. 1977, vol.76 no.4, pp.60–3; republ. in *The artist observed: 28 interviews with contemporary artists*, Pennington (NJ): acappella books, 1991, pp.315–24.

Lawrence Gowing: 'Mother, by Lucian Freud', in *Sunday Times Magazine*, 12 Feb. 1978, pp.48–53.

William Feaver: 'Spying on privacy' [review of d'Offay exhib.], in *Observer Review*, 19 Feb. 1978, p.34.

Edward Lucie-Smith: 'Freud and friends' [review of d'Offay exhib.], in *Evening Standard*, 23 Feb. 1978.

Michael Shepherd: 'Body language' [review of d'Offay exhib.], in *Sunday Telegraph*, 19 Feb. 1978.

Terence Mullaly: 'Thoughts about another Freud' [review of d'Offay exhib.], in *Daily Telegraph*, 25 Feb. 1978, p.9.

William Packer: 'Lucian Freud' [review of d'Offay exhib.], in *Financial Times*, 27 Feb. 1978, p.11.

Lynda Morris: 'Freud's images' [review of d'Offay exhib.], in *Listener*, 2 Mar. 1978, vol.99 no.2549, p.281

Paul Overy: 'Freudian analysis' [incl. review of d'Offay exhib.], in *The Times*, 2 Mar. 1978, p.8

John McEwen: 'Stripped bare' [incl. review of d'Offay exhib.], in *Spectator*, 11 Mar. 1978, vol.240 no.7810, p.26.

Keith Roberts: 'Current and forthcoming exhibitions: London' [incl. review of d'Offay exhib.] in *Burlington Magazine*, Apr. 1978, vol.120 no.901, pp.246, 248–51 (ref. pp.246, 251).

Edward Lucie-Smith: 'Lucian Freud' [review of d'Offay exhib.], in *Art and Artists*, May 1978, vol.12 no.12 (issue no.145), pp.18–21.

William Feaver: 'Closely observed humans' [review of d'Offay exhib.], in *Art News*, May 1978, vol.77 no.5, pp.165–6.

Noel Frackman: 'Lucian Freud' [review of Davis & Long exhib.], in *Arts Magazine*, June 1978, vol.52 no.10, pp.37–8.

Jeffrey Weiss: 'Eight figurative painters' [review of Los Angeles exhib.], in *Arts Magazine*, Feb. 1982, vol.56 no.6, p.9.

Henry Porter: 'Lucian the elusive', in *Sunday Times*, 10 Oct. 1982, p.37.

John McEwen: 'No more sugar-coating' [review of d'Offay exhib.], in *Spectator*, 16 Oct. 1982, vol.249 no.8049, pp.28–9.

William Feaver: 'Guernica back home', in *Observer*, 17 Oct. 1982.

William Feaver: 'Forty years of Freud', in *Observer Colour Magazine*, 17 Oct. 1982, p.47.

Marina Vaizey: 'When the subject matters' [review of d'Offay exhib.], in *Sunday Times*, 17 Oct. 1982, p.42.

William Packer: '"...the best painter in this country..."' [review of d'Offay exhib.], in *Financial Times*, 19 Oct. 1982, p.17.

Mary Rose Beaumont: 'Lucian Freud' [review of d'Offay exhib.], in *Arts Review*, 20 Oct. 1982, vol.34 no.22, pp.546–7.

Christopher Neve: 'Defences down' [review of Gowing book], in *Evening Standard*, 20 Oct. 1982, p.21.

Michael McNay: 'Lucian Freud' [review of d'Offay exhib. & Gowing book], in *Guardian*, 23 Oct. 1982, p.11.

Jeffrey Bernard: 'A star for me', in *The Times*, 23 Oct. 1982, p.8.

Christopher Neve: 'Night pictures: a scrutiny: Lucian Freud', in *Country Life*, 28 Oct. 1982, vol.172 no.4445, pp.1328–9.

Richard Cork: 'The night hunter' [review of d'Offay exhib.], in *Evening Standard*, 28 Oct. 1982, p.17.

Christopher Reid: 'Lucian Freud: chasing the inevitable' [review of d;Offay exhib. & Gowing book], in *Harpers and Queen*, Nov. 1982, p.320.

Paul Overy: 'The other Freud' [review of Gowing book], in *New Society*, 4 Nov. 1982, p.227.

* Richard Shone: 'Wonder-kid' [review of Gowing book], in *Spectator*, 13 Nov. 1982, vol.249 no.8053, p.21.

* Timothy Hyman: 'Lucian Freud at Anthony d'Offay' [review of exhib. & of Gowing book], in *Artscribe*, Dec. 1982, no.38, pp.46–7.

Edward B. Henning: 'New paintings by four artists from Britain' [incl. LF: *Portrait of Ib*], in *Bulletin of the Cleveland Museum of Art*, Dec. 1982, vol.69 no.10, pp.309–23 (ref. 313–15).

Michael Peppiatt: 'Lucian Freud' [review of Gowing book], in *Art International*, Jan.–Mar. 1983, vol.26 no.1, pp.101–6.

Catherine Lampert: 'The Ingres of existentialism' [review of Gowing book], in *Times Literary Supplement*, 7 Jan. 1983, no.4162, p.8.

John Russell: 'When one artist brings his insight to works of another', in *New York Times*, 16 Jan. 1983.

John McEwen: 'Report from London: art in the year of the Falklands' [incl. review of d'Offay exhib. and Gowing book], in *Art in America*, Feb. 1983, vol.71 no.2, pp.17–23 (ref. pp.19–21).

Andrew Brighton: 'Lucian Freud' [review of Gowing book], in *Art Monthly*, Feb. 1983, no.63, pp.25–7.

John Russell: 'Lucian Freud' [review of Gowing book], in *International Herald Tribune*, 17 Feb. 1983.

Jonathan Keates: 'Relics of delight' [review of Agnews exhib.], in *Harpers and Queen*, Oct. 1983, no.83/10, pp.252–3.

Geraldine Norman: 'Freud completes his masterpiece', in *The Times*, 13 Oct. 1983, p.28.

Lawrence Gowing: 'Lucian Freud: a little help from his friends', in *Sunday Times Magazine*, 6 Nov. 1983, pp.34–5.

William Feaver: 'Truth about Gaudier-Brzeska' [incl. review of Agnews exhib.], in *Observer*, 6 Nov. 1983.

William Packer: 'Perhaps a masterpiece', in *Financial Times*, 8 Nov. 1983, p.21.

Richard Cork: 'Analysing Freud', in *Evening Standard*, 10 Nov. 1983.

Terence Mullaly: 'An ugly group', in *Daily Telegraph*, 16 Nov. 1983, p.13.

Michael Peppiatt: 'Lucian Freud: à l'intérieur d'une oeuvre', in *Connaissance des Arts*, Mar. 1984, no.385, pp.44–51.

David Lee: 'Lucian Freud by Lawrence Gowing' [review of book], in *Arts Review*, 6 July 1984, vol.36 no.13, p.333.

* Arnold Goodman: 'Diary' [account of sitting for portrait by LF], in *London Review of Books*, 18 July 1985, vol.7 no.13, pp.1, 21.

Matthew Marks: 'The graphic work of Lucian Freud' [incl. cat. of graphic works 1936–82], in *Print Quarterly*, Dec. 1986, vol.3 no.4, pp.321–34.

Roger Bevan: 'Freud's latest etchings' [incl. cat. of graphic works 1984–86], in *Print Quarterly*, Dec. 1986, vol.3 no.4, pp.334–43.

Jean Clair: 'Lucian Freud: la question du nu en peinture et le destin du moderne', in *Nouvelle Revue de Psychanalyse*, 1987, no.35.

David Lee: [review of National Gallery exhib.], in *The Times*, 17 June 1987, p.27.

William Feaver: 'Lucian Freud' [review of National Gallery exhib.], in *Observer*, 21 June 1987.

Waldemar Januszczak: 'Freud's body language' [review of National Gallery exhib.], in *Guardian*, 27 June 1987, p.12.

Richard Dorment: 'A Freudian slip-up at the National?' [review of National Gallery exhib.], in *Daily Telegraph*, 26 June 1987, p.12.

William Packer: 'An eye for humanity' [review of National Gallery exhib.], in *Financial Times*, 30 June 1987, p.19.

William Feaver: 'Artist's dialogue: Lucian Freud', in *Architectural Digest*, July 1987.

Brian Sewell: 'Freudian dip' [review of National Gallery exhib.], in *Evening Standard*, 2 July 1987, p.29.

Richard Cork: 'Northern lights' [review of National Gallery exhib.], in *Listener*, 16 July 1987, vol.118 no.3020, p.31.

Robert Hughes: 'On Lucian Freud', in *New York Review of Books*, 13 Aug. 1987, pp.54–9; repr. in 1987 British Council solo cat.

Michael Peppiatt: 'Could there be a School of London?', in *Art International*, Autumn 1987, no.1, pp.7–20.

Jean Clair: 'Lucian Freud: restoring the paint-flesh ritual', in *Art International*, Autumn 1987, no.1, pp.39–50.

Florence Rubenfeld: 'Lucian Freud paintings' [review of Hirshhorn exhib.], in *Museum and Arts* (Washington), Sept.–Oct. 1987.

Jean Addam Allen: 'Lucian Freud and the frailties of the flesh' [review of Hirshhorn exhib.], in *Washington Times*, 17 Sept. 1987.

John Russell: 'A painter's insights into body and soul' [review of Hirshhorn exhib.], in *New York Times*, 27 Sept. 1987.

Kenneth Baker: 'A special kind of realism' [review of Hirshhorn exhib.], in *San Francisco Chronicle*, 27 Sept. 1987.

Sanda Miller: 'People by Lucian Freud', in *Artforum*, Oct. 1987, vol.26 no.2, pp.113–18.

Alistair Hicks: 'Freudian trips', in *Harpers and Queen*, Oct. 1987, no.87/10, pp.238, 386.

Edward Sozanski: 'Lucian Freud' [review of Hirshhorn exhib.], in *Philadelphia Enquirer*, 22 Oct. 1987.

James F. Cooper: 'The Freudian world of flesh and blood' [review of Hirshhorn exhib.], in *New York City Tribune*, 23 Oct. 1987.

Joe Shannon: 'Intentional awkwardness: the representation and retrospective of Lucian Freud' [review of Hirshhorn exhib.], in *Arts Magazine*, Nov. 1987, vol.62 no.3, pp.26–9.

Mark Stevens: 'The unblinking eye' [review of Hirshhorn exhib.], in *New Republic*, 9 Nov. 1987.

Alan G. Artner: 'Mind over matter' [review of Hirshhorn exhib.], in *Chicago Tribune*, 11 Nov. 1987.

Jack Flam: 'The real Lucian Freud' [review of Hirshhorn exhib.], in *Wall Street Journal*, 11 Nov. 1987.

Nancy Grimes: 'Washington DC: Lucian Freud: Hirshhorn Museum' [review of exhib.], in *Art News*, Dec. 1987, vol.86 no.10, p.164.

Jean Clair: 'Lucian Freud: de l'Ecole de Paris à l'Ecole de Londres', in *Connaissance des Arts*, Dec. 1987, no.430, pp.94–101.

Hervé Ganville: 'Freud, l'homme aux pinceaux' [review of Paris exhib.], in *Libération*, 21 Dec. 1987.

Philippe Dagen: 'Le pompier de la couperose' [review of Paris exhib.], in *Le Monde*, 23 Dec. 1987.

Michael Gibson: 'Sous le regard de Freud' [review of Paris exhib.], in *Beaux Arts*, Jan. 1988, no.53, pp.1, 54–7.

Andrew Brighton: 'Analysis of Freud: challenging Modernism', in *New Art Examiner*, Jan. 1988, vol.15 no.5, pp.38–41.

Allison Gamble: 'Reinforcing patriarchy', in *New Art Examiner*, Jan. 1988, vol.15 no.5.

Laurence Debecque-Michel: 'Lucian Freud au Centre Pompidou', in *Opus International*, Jan.–Feb. 1988, no.106, pp.55–6.

Giles Auty: 'Visible export' [review of Paris exhib.], in *Spectator*, 2 Jan. 1988, p.29.

Jean-Marie Tasser: 'Freud' [review of Paris exhib.], in *Figaro*, 5 Jan. 1988.

Geoffrey Wheatcroft: 'Portrait of the artist as a ladykiller', in *Sunday Telegraph*, 24 Jan. 1988, p.5.

Daniel Farson: 'The great seducer', in *Guardian*, 29 Jan. 1988, p.21.

David Lee: 'Sitting uncomfortably' [review of Hayward exhib.], in *The Times*, 30 Jan. 1988, p.22.

Bruce Bernard: 'Freudian analysis', in *Observer Magazine*, 31 Jan. 1988.

Jed Perl: 'From September to December' [incl. review of Hirshhorn exhib.], in *New Criterion*, Feb. 1988, vol.6 no.6, pp.43–54 (ref. pp.50–1).

Brian Sewell: 'Jung at art?' [review of Hayward exhib.], in *Tatler*, Feb. 1988, vol.283 no.2, p.20; repr. in Sewell, *The reviews that caused the rumpus, and other pieces*, London: Bloomsbury, 1994, pp.247–50.

Mark Boxer: 'Schadenfreud', in *Tatler*, Feb. 1988, vol.283 no.2, pp.80–3.

'Opportunity to analyse Freud' [review of Hayward exhib.], in *Independent*, 2 Feb. 1988, p.24.

Paddy Kitchen: 'All the way with flesh' [review of Hayward exhib.], in *Country Life*, 4 Feb. 1988, vol.182 no.5, pp.74–5.

Richard Dorment: 'The painful path of Freudian analysis' [review of Hayward exhib.], in *Daily Telegraph*, 5 Feb. 1988, p.12.

Waldemar Januszczak: 'Love in a cold climate' [review of Hayward exhib.], in *Guardian*, 5 Feb. 1988, p.19.

William Feaver: 'Sleeping dogs lie' [review of Hayward exhib.], in *Observer*, 7 Feb. 1988.

Michael Shepherd: 'Couchside manner' [review of Hayward exhib.], in *Sunday Telegraph*, 7 Feb. 1988, p.17.

Marina Vaizey: 'The plain face of genius' [review of Hayward exhib.], in *Sunday Times*, 7 Feb. 1988, p.7.

Andrew Graham-Dixon: 'The skulls beneath the skin' [review of Hayward exhib.], in *Independent*, 8 Feb. 1988, p.11.

William Packer: 'Frailties of the flesh exposed' [review of Hayward exhib.], in *Financial Times*, 9 Feb. 1988, p.15.

John Russell Taylor: 'An enigma defined' [incl. review of Hayward exhib.], in *The Times*, 9 Feb. 1988, p.15.

Richard Cork: 'Only the lonely' [review of Hayward exhib.], in *Listener*, 11 Feb. 1988, vol.119 no.3049, p.30.

Patrick Reyntiens: 'Galleries' [review of Hayward exhib.], in *Tablet*, 13 Feb. 1988, p.178.

Giles Auty: 'Giotto's mordant heir' [review of Hayward exhib.], in *Spectator*, 13 Feb. 1988, pp.42–3.

Tim Hilton: [incl. review of Hayward exhib.], in *Guardian*, 17 Feb. 1988, p.37.

Brian Sewell: 'Master of the myth' [review of Hayward exhib.], in *Evening Standard*, 18 Feb. 1988, p.29.

John Spurling: 'Have their carcases' [review of Hayward exhib.], in *New Statesman*, 19 Feb. 1988, vol.115 no.2969, pp.36–7.

Mary Rose Beaumont: 'Lucian Freud' [review of Hayward exhib.], in *Arts Review*, 26 Feb. 1988, vol.40 no.4, p.124.

James Burr: 'Fatal turning points' [incl. review of Hayward exhib.], in *Apollo*, Mar. 1988, vol.127 no.313 (n.s.), pp.214–15 (ref. p.215)

Robin Duthy: 'Investor's file: Lucian Freud: a ruthless master', in *Connoisseur*, Mar. 1988, pp.150–5.

Angus Stewart: 'Lucian Freud' [review of Hayward exhib.], in *RSA Journal*, Mar. 1988, vol.136 no.5380, pp.279–80.

Robert Snell: 'The intimacy of strangers' [review of Hayward exhib.], in *Times Literary Supplement*, 4–10 Mar. 1988, no.4431, p.249.

Grey Gowrie: 'The migration of Lucian Freud', in *Modern Painters*, Spring 1988, vol.1 no.1, pp.5–11.

* Nicholas Penny: 'Lucian Freud: plants, animals and litter', in *Burlington Magazine*, Apr. 1988, vol.130 no.1021, pp.290–5.

Grey Gowrie: 'Happy ending to a pictorial autobiography' [review of cat. of Hayward exhib.], in *Spectator*, 16 Apr. 1988, p.42.

Robert Storr: 'In the flesh: Lucian Freud', in *Art in America*, May 1988, vol.76 no.5, pp.128–37.

Peter Fuller: 'London, Hayward Gallery: Lucian Freud' [review of exhib.], in *Burlington Magazine*, May 1988, vol.130 no.1022, pp.386–8; repr. in *Peter Fuller's Modern Painters: reflections on British art*, ed. John McDonald, London: Methuen, 1993, pp.199–204.

Marjorie Allthorpe-Guyton: 'Lucian Freud: Freud exercises a terrible power over things and over paint itself' [review of Hayward exhib.], in *Flash Art*, May–June 1988, no.140, pp.126–7.

Michael Nungesser: 'Lucian Freud: Gemälde ohne Voyeurismus' {review of Berlin exhib.], in *Die Kunst*, 2 May 1988.

Bernhard Schultz: 'Die verrinnende Zeit' [review of Berlin exhib.], in *Der Tagespiel*, 7 May 1988.

William Holmes: 'Chill in the art air' [review of BBC television 'Omnibus' programme], in *The Times*, 21 May 1988, p.20.

Jane Norrie: 'Lucian Freud: works on paper' [review of Ashmolean exhib.], in *Arts Review*, 3 June 1988, vol.40 no.11, p.391.

Henry Clare: 'Freud invests the ordinary with an extraordinary power', in *Glasgow Herald*, 24 June 1988.

Malcolm Yorke: [review of cats. of Hayward & South Bank Centre exhibs.], in *RSA Journal*, Aug. 1988, pp.684–5.

Murdo Macdonald: 'Freudian images', in *Scotsman*, 4 July 1988.

Robert Flynn Johnson: 'Lucian Freud: works of art on paper', in *Triptych* (Museum Society of Fine Arts Museums of San Francisco), Nov.–Dec. 1988–Jan. 1989, vol.44 pp.22–3; repr. from 1988 South Bank cat.

Marina Warner: 'Lucian Freud: the unblinking eye', in *New York Times Magazine*, 4 Dec. 1988, pp.68–70, 110–11, 122, 130.

Kenneth Baker: 'Lucian Freud's drawings' [review of San Francisco exhib.], in *San Francisco Chronicle*, 10 Dec. 1988.

Sandra Lawall Lipschultz: 'A horror of the idyllic', in *Arts* (Minneapolis Institute of Arts), Mar. 1989.

John Russell: 'A wild card who is not for puny natures', in *New York Times*, 28 May 1989.

Tom Lubbock: 'Look upon these paper ligaments' [review of Thames & Hudson ed. of South Bank Centre cat.], in *The Times*, 17 June 1989, p.37.

Robin Duthy: 'Depression pays off', in *Financial Times*, 2 Dec. 1989.

Jeremy Lewison: 'Lucian Freud's "Standing by the rags"', in *National Art Collections Fund Review*, 1990, pp.91–3.

Ursula Hoff: 'Variation, transformation and interpretation: Watteau and Lucian Freud', in *Art Bulletin of Victoria*, 1990, no.31, pp.26–31.

Andrew Graham-Dixon: 'Naked truths', in *Independent Magazine*, 27 Jan. 1990, pp.1, 38–42.

Alfred Corn: 'Looking at art: Lucian Freud: Large interior, W.9', in *Art News*, Mar. 1990, vol.89 no.3, pp.117–18.

Richard Dorment: 'Two portraits in Freudian reality' [review of Saatchi Collection exhib.], in *Daily Telegraph*, 28 Mar. 1990, p.14.

Tim Hilton: 'Look back in patches' [review of Saatchi Collection exhib.], in *Guardian*, 28 Mar. 1990, p.45.

William Packer: 'British talent brought to the fore' [review of Saatchi Collection exhib.], in *Financial Times*, 3 Apr. 1990, p.19.

Marina Vaizey: 'The vital signs of a British reawakening' [review of Saatchi Collection exhib.], in *Sunday Times*, 8 Apr. 1990.

Richard Cork: 'Start studies' [review of Saatchi Gallery exhib.], in *Listener*, 12 Apr. 1990, vol.123 no.3160, p.34.

Martin Golding: '"Realism" and the real' [review of Barbican exhib.], in *Modern Painters*, Summer 1990, vol.3 no.2, pp.82–5 (ref. pp.84–5).

Max Rabino: 'I sei eremiti della Scuola di Londra', in *Arte*, June 1990, no.208, pp.68–75.

Bruce Bernard: 'Organic nude', in *Independent Magazine*, 1 Dec. 1990.

Leigh Bowery: 'Art and love' [interview], in *Lovely Jobly*, 1991; repr. in *Independent Magazine*, 11 Jan. 1992, pp.34–6, & in in 1993 Matthew Marks Gallery, New York, cat.).

Richard Cork: 'Le portrait moderne en Grande-Bretagne: innovation et tradition', in *Artstudio*, Summer 1991, no.21, pp.50-7.

Edward Lucie–Smith: 'The strange case of Charles Saatchi, Sotheby's and this painting by Lucian Freud', in *Mail on Sunday*, 16 June 1991, p.42.

Dalya Alberge: 'Etchings by Freud show his skill as draughtsman', in *Independent*, 17 June 1991, p.7.

William Packer: 'The head, hand and heart of Freud' [review of Thomas Gibson exhib.], in *Financial Times*, 25 June 1991.

Fabio Isman: 'Tre Grazie per Palazzo Ruspoli' [review of Milan exhib.], in *Il Messaggero*, 27 Sept. 1991.

Ludovico Pratesi: 'Volti del piccolo Freud umani, troppo umani' [review of Milan], in *La Reppublica*, 5 Oct. 1991; as 'Una mostra aiuta chi vuole guarire', in *Corriere della Sera*, 5 Oct. 1991.

Lorenza Trucchi: 'Realtà alla Freud' [review of Milan exhib.], in *Il Giornale*, 13 Oct. 1991.

Antonio Pinelli: 'La realtà è un'ossessione' [review of Milan exhib.}, in *Il Messaggero*, 14 Oct. 1991, p.15.

Cesare de Seta: 'C'è qualcosa di osceno nei corpi nudi di Freud' [review of Milan exhib.], in *Corriere della Sera*, 26 Oct. 1991.

Max Rabino: 'Freud: il pittore' [review of Rome exhib.], in *La Stampa*, 4 Nov. 1991.

Delfina Rattazzi: 'Così sgradevole e così pieno di talento' [review of Milan exhib.], in *Uomini e Business*, Dec. 1991, pp.124–8.

Giovanni Testori: 'Volti, corpi: il crudele principio di realtà' [review of Milan exhib.], in *Corriere della Sera*, 12 Jan. 1992.

Daniel Farson: 'A very private viewing' [interview], in *Mail on Sunday*, 2 Feb. 1992, p.49.

Martin Gayford: 'Interrogation on Freud's bed of scrutiny', in *Sunday Telegraph*, 2 Feb. 1992, p.xi.

Richard Cork: 'Intensity tinged with compassion' [review of Liverpool exhib.], in *Times: Life and Times*, 7 Feb. 1992, p.3.

Tom Lubbock: 'On the couch in Freud's truth room' [review of Liverpool exhib.], in *Independent on Sunday*, 9 Feb. 1992, p.18.

William Feaver: 'Flesh and bone fills out nicely' [review of Liverpool exhib.], in *Observer*, 9 Feb. 1992, p.61.

Marina Vaizey: 'Naked truth about Freud' [review of Liverpool exhib.], in *Sunday Times*, 9 Feb. 1992, pp.6, 11.

Richard Dorment: 'Dazzling school of Freudian analysis' [review of Liverpool exhib.], in *Daily Telegraph*, 12 Feb. 1992.

James Hamilton: 'Something on their minds' [review of Liverpool exhib.], in *Spectator*, 15 Feb. 1992, vol.268 no.8535, pp.38–40.

James Hall: 'Crash-landings in the studio' [review of Liverpool exhib.], in *Times Literary Supplement*, 28 Feb. 1992, no.4639, p.21.

Giles Auty: 'Leading talent: the phenomenon of Lucian Freud' [review of Liverpool exhib.], in *Apollo*, Mar. 1992, vol.135 no.361 (n.s.), pp.174–7.

Murdoch Lothian: 'Lucian Freud: paintings & works on paper 1940–1991' [review of Tate Liverpool exhib.], in *Arts Review*, Mar. 1992, vol.44, pp.88–9.

Craig Hartley: ' Freud and Auerbach: recent work' [incl. cat. of graphic work 1986 91], in *Print Quarterly*, Mar. 1992, vol.9 no.1, pp.2–30 (ref. p.2–19).

James Hyman: 'Lucian Freud' [review of Liverpool exhib.], in *Modern Painters*, Spring 1992, vol.5 no.1, pp.97–9.

Richard Kendall: 'Tate Gallery Liverpool: Lucian Freud' [review of exhib.], in *Burlington Magazine*, Apr. 1992, vol.134 no.1069, pp.263–4.

Elizabeth Fortescue: 'Freud analysis hits Feaver pitch', in *Daily Telegraph Magazine* (Australia), 7 Nov. 1992.

Felicity Fennor: [review of Sydney exhib.], in *Sydney Morning Herald*, 29 Nov. 1992.

* William Feaver: *The artist out of his cage* [interview], in *Observer Review*, 6 Dec. 1992, pp.45–6; repr. in 2001 Frankfurt solo cat., pp.285–95.

Jessica Berens: 'Lucian Freud's women', in *Vogue*, June 1993, pp.124–30.

David Cohen: 'Freud's naked ambition', in *Sunday Express*, 22 Aug. 1993, section 2 p.41.

Daniel Farson: 'Portraits of a naked passion: Freud and the stark beauty of the nude', in *Mail on Sunday*, 29 Aug. 1993, p.40.

* William Feaver: 'Body language', in *Observer Magazine*, 29 Aug. 1993, pp.14–19.

Martin Gayford (incorporating texts by Barney Bramham, Caroline Blackwood, Henry Diamond, The Duke of Devonshire, Lord Goodman & Leigh Bowery): 'The Duke, the photographer, his wife, and the male stripper', in *Modern Painters*, Autumn 1993, vol.6 no.3, pp.22–6.

William Feaver: 'Inside Freud's mind', in *Art News*, Sept. 1993, vol.92 no.7, pp.136–41.

Andrew Graham-Dixon: 'Lucian Freud' [review of Whitechapel exhib.], in *Independent*, 4 Sept. 1993; repr. in Andrew Graham-Dixon: *Paper museum: writings about painting, mostly*, London: HarperCollins, 1996, pp.260–4.

Bruce Bernard: 'The fugitive subject', in *Independent on Sunday: Sunday Review*, 5 Sept. 1993, pp.1, 10–14.

John McEwen: 'On the couch with Freud' in *Sunday Telegraph*, 5 Sept. 1993, p.3.

Daniel Farson: 'Beneath the skin', in *Guardian*, 6 Sept. 1993, pp.6–7.

Iain Gale: 'Group portrait', in *Independent*, 7 Sept. 1993.

Paul Johnson: 'Portrait of the artist who loathes mankind', in *Daily Mail*, 11 Sept. 1993.

William Feaver: 'How blessed to be painted by Lucian Freud' [review of Whitechapel exhib.], in *Observer*, 12 Sept. 1993, p.48.

John McEwen: 'Revealed, cornered in his lair, a master' [review of Whitechapel exhib.], in *Sunday Telegraph*, 12 Sept. 1993, review p.7.

Waldemar Januszczak: 'The way that's all flesh' [review of Whitechapel exhib.], in *Sunday Times*, 12 Sept. 1993, p.9:2.

Peter Blake: 'On Lucian Freud', in *Sunday Times*, 12 Sept. 1993, p.9:2.

James Hall: 'Horror of the hollow' [review of Whitechapel exhib.], in *Guardian*, 13 Sept. 1993.

William Packer: 'Figuring out Freud' [review of Whitechapel exhib.], in *Financial Times*, 14 Sept. 1993, p.15.

Andrew Graham-Dixon: 'Portrait of the tyrant as an old man' [review of Whitechapel exhib.], in *Independent*, 14 Sept. 1993, p.22.

Richard Cork: 'The naked and the living dead' [review of Whitechapel exhib.], in *The Times*, 15 Sept. 1993, p.39.

Brian Sewell: 'Greater than the sum of his parts' [review of Whitechapel exhib.], in *Evening Standard*, 16 Sept. 1993, pp.29–30; repr. in Sewell, *The reviews that caused the rumpus, and other pieces*, London: Bloomsbury, 1994, pp.250–4.

Bernard Kops: 'My choice', in *Daily Telegraph*, 17 Sept. 1993.

Sue Hubbard: 'The way of all flesh' [review of Whitechapel exhib.], in *New Statesman and Society*, 17 Sept. 1993, vol.122 no.4152, pp.32–3.

Giles Auty: 'Portrait of an ageing existentialist' [review of Whitechapel exhib.], in *Spectator*, 18 Sept. 1993, vol.271 no.8619, p.49.

Tim Hilton: 'The flesh is weak, the spirit is willing' [review of Whitechapel exhib.], in *Independent on Sunday*, 19 Sept. 1993, p.26.

Julian Bell: 'Weight, oddity and grace: Lucian Freud's vision of the human body' [review of Whitechapel exhib.], in *Times Literary Supplement*, 24 Sept. 1993, no.4721, pp.1, 16.

Sarah Kent: 'Nudes agent' [review of Whitechapel exhib.], in *Time Out*, 29 Sept. 1993.

Sister Wendy Beckett: 'The flaying of Freud' [review of Whitechapel exhib.], in *Modern Painters*, Winter 1993, vol.6 no.4, pp.24–7.

Alasdair Gray: 'Thoughts on Freud', in *Modern Painters*, Winter 1993, vol.6 no.4, pp.28–9.

Richard Kendall: 'London, New York and Madrid: Lucian Freud' [review of Whitechapel exhib.], in *Burlington Magazine*, Nov. 1993, vol.135 no.1088, pp.776–7.

Martin Filler: 'The naked Freud', in *Vanity Fair*, Nov. 1993, pp.110–115, 139–42.

* Mark Marvel: 'Lucian Freud: an exclusive interview', in *Interview*, Dec. 1993, vol.23 no.12, pp.104–11.

* John Richardson: 'Paint becomes flesh' [review of New York exhib.], in *New Yorker Magazine*, 13 Dec. 1993, Vol.69 no.42, pp.135–43; rev. version publ. in Richardson, *Sacred monsters, sacred masters: Beaton, Capote, Dalí, Picasso, Freud, Warhol, and more*, London: Jonathan Cape, 2001, pp.322–41.

* Michael Kimmelman: 'Lucian Freud: the self exposed' [review of New York exhib.], in *New York Times*, 17 Dec. 1993.

Paul Richard: 'The naked eye of Lucian Freud' [review of New York exhib.], in *Washington Post*, 19 Dec. 1993.

Robert Hughes: 'The fat lady sings' [review of New York exhib.], in *Time*, 27 Dec. 1993.

Hilton Kramer: 'Like most of his subjects, Emperor Freud has no clothes' [review of New York exhib.], in *New York Observer*, 27 Dec. 1993–3 Jan. 1994, pp.1, 27.

Hilton Kramer: 'The other Freud' [review of Whitechapel exhib.], in *Art & Antiques*, Jan. 1994, vol.16 no.1, pp.84–5.

Peter Schjeldahl: 'The psychopathology of everyday taste', in *Village Voice*, 4 Jan. 1994.

Robert Hughes: 'Freudian analysis', in *Time*, 17 Jan. 1994.

Donald Kuspit, Linda Nochlin: 'Flesh for phantasy' [reviews of Metropolitan exhib.], in *Artforum*, Mar. 1994, vol. 32 no.7, pp.54–9; parallel texts: Donald Kuspit: 'Fresh Freud'; Linda Nochlin: 'Frayed Freud'.

JH [James Hyman]: 'What the critics said' [on Whitechapel exhib.], in *tate: the art magazine*, Spring 1994, no.2, pp.9–10.

Enriqueta Antolin: 'Lucian Freud: magia negra' [review of Madrid exhib.], in *El Pais*, 16 Apr. 1994.

Fernando Huici: 'Intimidad revelada' [review of Madrid exhib.], in *El Pais*, 16 Apr. 1994.

Julia Luzan: 'Lucian Freud: el pintor del desnudo' [review of Madrid exhib.], in *El Pais*, 16 Apr. 1994.

Fernando Samaniego: 'Retratos y desnudos de Lucian Freud se exponen por primera vez en España' [review of Madrid exhib.], in *El Pais*, 19 Apr. 1994.

William Feaver: 'Freud's latest paintings', in *Observer*, 11 Sept. 1994.

Martin Gayford: 'Flesh in Dulwich' [review], in *Modern Painters*, Winter 1994, vol.7 no.4, p.100.

Geraldine Norman: 'Freud and Rubens trade naked ambitions' [review of Dulwich exhib.], in *Independent*, 28 Nov. 1994.

Rachel Barnes: 'Flesh points' [review of Dulwich exhib.], in *Guardian*, 15 Dec. 1994, pp.8–9.

William Packer: 'Freud among the big boys' [review of Dulwich exhib.], in *Financial Times*, 20 Dec. 1994, p.13.

Andrew Graham-Dixon: 'Turner in his grave', in *Independent*, 20 Dec. 1994.

Richard Cork: 'A brush with naked genius' [review of Dulwich exhib.], in *The Times*, 20 Dec. 1994, p.27.

Brian Sewell: 'A cold eye for grandeur' [review of Dulwich exhib.], in *Evening Standard*, 22 Dec. 1994, p.35.

John McEwen: 'Putting fat into frank perspective' {review of Dulwich exhib.], in *Sunday Telegraph Review*, 1 Jan. 1995, p.6.

Waldemar Januszczak: 'Freudian slip' [review of Dulwich exhib.], in *Sunday Times*, 1 Jan. 1995, p.28.

Michael Peppiatt: 'A school or not a school', in *Modern Painters*, Summer 1995, vol.8 no.2, pp.64–6.

Marc LeBot: 'Francis Bacon – Lucian Freud' [review of Saint-Paul exhib.], in *Cimaise*, June–Aug. 1995, vol.42 no.236, pp.26–34.

Richard Cork: 'The full picture', in *Times Magazine*, 17 June 1995, pp.18–21.

Robert Alstead: 'Live', in *Big Issue*, 23 June 1995.

Ithzak Goldberg: 'Freud – Bacon: rencontre avec des hommes remarquables' [review of Saint-Paul exhib.], in *Beaux-Arts Magazine*, July–Aug. 1995, no.136, pp.82–8.

Rafael Pic: 'Bacon – Freud: le silence de la chair' [review of Saint-Paul exhib.], in *Muséart*, July–Aug. 1995, no.52, pp.90–5.

Duncan Macmillan: 'London calling' [review of Edinburgh exhib.], in *Scotsman*, 3 July 1995.

William Feaver: 'In a class of their own' [review of Edinburgh exhib.], in *Sunday Observer*, 9 July 1995.

John McEwen: 'London label doesn't stick' [review of Edinburgh exhib.], in *Sunday Telegraph*, 9 July 1995.

Rachel Barnes: 'A range of loners' [review of Edinburgh exhib.], in *Guardian*, 11 July 1995.

Christiane Duparc: 'Le diable aux corps' [review of Saint-Paul exhib.], in *L'Express*, 3–9 Aug. 1995, pp.82, 84.

Michael Gibson: 'Bacon, Freud and human bodies' [review of Saint-Paul exhib.], in *International Herald Tribune*, 12–13 Aug. 1995.

Alan Riding: 'The School of London, mordantly messy as ever' [review of Saint-Paul exhib.], in *New York Times*, 25 Sept. 1995, pp.C11–C16; repr. as 'Name game: new look at 'School of London'' in *International Herald Tribune*, 28 Sept. 1995.

Philippe Mengue: 'Bacon – Freud et la Nouvelle Figuration' [review of Saint-Paul exhib.], in *Plak'Art*, Oct. 1995, no.3, pp.8–14.

Richard Cork: 'Written on the body' [review of Kendal exhib.], in *Times Magazine*, 15 June 1996.

William Feaver: 'The naked eye', in *Observer Life*, 23 June 1996, pp.1, 24–30.

Martin Gayford: 'Up close and personal' [review of Kendal exhib.], in *Daily Telegraph*, 26 June 1996, p.20.

Adrian Searle: 'Sacred and profane' [review of Kendal exhib.], in *Guardian*, 10 July 1996.

Maggie Gee: 'The skull beneath Freud's skin' [review of Kendal exhib.], in *New Statesman and Society*, 2 Aug. 1996, vol.125 no.4295, p.39.

John McEwen: 'Tenderness – not prurience [review of Kendal exhib.], in *Sunday Telegraph*, 4 Aug. 1996, p.9.

Martin Gayford: 'The brutality of fact' [incl. review of Kendal exhib.], in *Modern Painters*, Autumn 1996, vol.9 no.3, pp.43–9 (ref. pp.46–9).

William Feaver: 'I love Lucian' [review of Edinburgh exhib.], in *Observer Review*, 16 Feb. 1997, p.9.

Iain Gale: 'Two into one' [review of Edinburgh exhib.], in *Scotland on Sunday*, 11 Feb. 1997.

Martin Gayford: 'The unmistakable mark of young genius' [review of Edinburgh exhib.], in *Daily Telegraph*, 26 Mar. 1997, p.23.

William Feaver: 'Pin-up' [interview], in *Observer Life*, 17 May 1998, pp.18–23; expanded version publ. in cat. of 1998 Tate Gallery exhib.

Tim Hilton: 'Grand master flesh', in *Independent on Sunday*, 31 May 1998, pp.18–20.

Bruce Bernard: 'Brush with a friend', in *Independent on Sunday*, 31 May 1998, p.21.

William Packer: 'Painted with urgent strokes' [review of Tate & Theo Waddington exhibs.], in *Financial Times*, 9 June 1998, p.17.

Adrian Searle: 'Lucian Freud: at home: with friends' [review of Tate exhibs.], in *Guardian*, 9 June 1998, p.10.

Richard Cork: 'Hidden truth revealed in the flesh' [review of Tate exhib.], in *Independent*, 9 June 1998, p.11.

Tom Lubbock: 'It's life, but not as we know it' [review of Tate exhib.], in *Independent*, 9 June 1998.

Brian Sewell: 'Long live the muddled genius' [review of Tate exhib.], in *Evening Standard*, 11 June 1998.

Martin Gayford: 'What is he up to?' [review of Tate exhib.], in *Spectator*, 13 June 1998, vol.280 no.8862, pp.46–7.

Richard Dorment: 'Worthy of the old masters' [review of Tate exhib.], in *Daily Telegraph*, 17 June 1998, p.25.

Oliver Reynolds: 'Presence, feeling, mystery' [review of Tate exhib.], in *Times Literary Supplement*, 10 July 1998, no.4971, p.19.

John Spurling: 'Portrait of the artist as a happy man', in *Independent on Sunday*, 13 Dec. 1998, p.26.

Richard Cork: 'The family way', in *Times Magazine*, 27 Mar. 1999, pp.34–40.

Martin Gayford: 'Paintings by Lucian Freud', in *Daily Telegraph*, 4 Sept. 1999.

Martin Gayford: 'A master copy', in *Daily Telegraph*, 22 Jan. 2000.

Dalya Alberge: 'Sotheby's crushes Freud painting', in *The Times*, 28 Apr. 2000, p.4.

Dalya Alberge: 'Crushed Freud was to star in Tate exhibition', in *The Times*, 29 Apr. 2000, p.3.

John Richardson: 'Shock of the nude', in *Vanity Fair*, May 2000, pp.119–29; rev. version publ. in *Sacred monsters, sacred masters: Beaton, Capote, Dalí, Picasso, Freud, Warhol, and more*, London: Jonathan Cape, 2001, pp.322–41.

Martin Gayford: 'A physical truth: what Lucian Freud sees in Chardin', in *Modern Painters*, Summer 2000, vol.13 no.2, pp.24–7.

Martin Gayford: ''It's all about 'cheering up''', in *Sunday Telegraph*, 13 Aug. 2000, p.9.

'Lucian Freud poster campaign', on *British Council* website, 22 June 2001.

'Wanted! Lucian Freud: Francis Bacon, Portrait', on *British Council (Germany)* website, 22 June 2001.

Jonathan Jones: 'Bringing home the Bacon', in *Guardian*, 23 June 2001.

'Freud unveils his royal portrait', on *BBC News* website, 20 Dec. 2001.

Luke Leitch: 'Queen Grumpy', in *Evening Standard*, 20 Dec. 2001, p.1.

'Freud royal portrait divides critics', on *BBC News* website, 21 Dec. 2001, p.1.

Nigel Reynolds: 'Freud's stark view of Queen', in *Daily Telegraph*, 21 Dec. 2001, p.1.

Maev Kennedy: 'Palace unveils Freud's gift to Queen', in *Guardian*, 21 Dec. 2001, p.1.

Adrian Searle: 'Beneath the skin of a painted lady: the best royal portrait for 150 years', in *Guardian*, 21 Dec. 2001.

Charles Rae: 'It's a travesty, your Majesty', in *Sun*, 21 Dec. 2001, pp.2, 32–3.

Richard Morrison: 'Unflattering, unsmiling', in *The Times*, 21 Dec. 2001, p.1.

4 Radio and television material

'Listen to Lucian Freud' [interviewed by William Feaver on 7 Feb. 1988 for BBC2, on the occasion of his Hayward exhib.], on *BBC Online: Voices from the Archive*, at www.bbc.co.uk/voices/pages/profilepages/freud1.shtml

[interview with William Feaver], in 'Third Ear' (Radio 3, produced by Judith Bumpus), recorded 10 Dec. 1991.

5 Solo and other major exhibitions and catalogues

Exhibition with Felix Kelly & Julian Trevelyan (27 works). London, Lefevre Gallery, Nov.–Dec. 1944.

Recent paintings by Ben Nicholson, Graham Sutherland and Francis Bacon, Robert Colquhoun, John Craxton, Lucian Freud, Robert MacBryde, Julian Trevelyan (5 works). London, Lefevre Gallery, Feb. 1946.

Recent paintings and drawings by John Craxton and Lucian Freud. London, London Gallery, 28 Oct.–29 Nov. 1947; 4p.

Lucian Freud (18 works). London, London Gallery, 9 Nov.–4 Dec. 1948; 4p.

Lucian Freud: recent works; Roger Vieillard: engravings (17 works). London, Hanover Gallery, 18 Apr.–27 May 1950; 4p.

Lucian Freud: new paintings; Martin Froy: first exhibition (13 works). London, Hanover Gallery, 6 May–14 June 1952; 3p.

Exhibition of works by Nicholson, Bacon, Freud; 'The unknown political prisoner': prize-winning maquette and related studies and Butler; recent artists' lithographs (22 works). Venice, 27th Biennale, British Pavilion, 19 June–17 Oct. 1954; text by John Rothenstein.

Lucian Freud: paintings (24 works). London, Marlborough Fine Art, Mar.–Apr. 1958; biog.; 12pp., 4 illus.

Lucian Freud: recent work (24 works). London, Marlborough Fine Art, Oct. 1963; 20pp., 16 illus.

Lucian Freud: recent work (23 works). London, Marlborough Fine Art, Apr. 1968; 20pp., 18 illus.

Lucian Freud: recent paintings (18 works). London, Anthony d'Offay, 10 Oct.–3 Nov. 1972; travelling to Gray Art Gallery, Hartlepool; 44pp., 19 illus.

Lucian Freud. London, Arts Council of Great Britain, at Hayward Gallery, London, 25 Jan.–3 Mar. 1974; Bristol City Art Gallery, 6–28 Apr. 1974; Birmingham City Museum and Art Gallery, 4–26 May 1974; Leeds City Museum and Art Gallery, 1–23 June 1974; text by John Russell; 55pp., 40 illus.

Lucian Freud: Pages from a sketchbook of 1941 (22 works). London, Anthony d'Offay, 25 Jan.–20 Feb. 1974; 4pp., col. illus.

Lucian Freud: recent paintings (17 works). London, Anthony d'Offay, 16 Feb.–18 Mar. 1978; travelling to Davis & Long Company, New York, 4–29 Apr. 1978; 41pp., 18 illus.

Tokyo, Nishimura Gallery, 1979; text by Seiji Oshima.

Lucian Freud (21 works). London, Anthony d'Offay, 8 Oct.–6 Nov. 1982; 3pp., col. Illus.

London, Thomas Agnew & Sons, 1983 [one painting and some graphic works].

Lucian Freud, Frank Auerbach (19 works). London, Bernard Jacobson, 1–23 Nov. 1983; 4p. dupl. typescript.

John Craxton and Lucian Freud (40 works). London, Christopher Hull Gallery, 27 Apr.–21 May 1984; 2p. dupl. typescript.

Lucian Freud: a painting and etchings. Tokyo, Nishimura Gallery, 1984.

The artist's eye: Lucian Freud: an exhibition of National Gallery paintings selected by the artist (2 works by LF). London, National Gallery, 17 June–16 Aug. 1987; 40pp., illus.; incl. text by the artist, p.20.

Lucian Freud: paintings (139 works). London, British Council, 1987, at Hirshhorn Museum and Sculpture Garden, Smithsonian Institution, Washington, 15 Sept.–29 Nov. 1987; Musée National d'Art Moderne, Paris, 16 Dec. 1987–24 Jan. 1988; Hayward Gallery, London (with additional paintings and prints), 4 Feb.–17 Apr. 1988; Neue Nationalgalerie, Staatliche Museen Stiftung Preussischer Kulturbesitz, Berlin, 6 May–12 June 1988; text by Robert Hughes, *On Lucian Freud* (repr. in *New York Review of Books*, 13 Aug. 1988). 136pp., 113 illus. (mostly col.).

Lucian Freud: etchings 1982–88. Sydney, Rex Irwin Gallery, 1988.

Lucian Freud: works on paper (95 works). London, South Bank Centre, at Ashmolean Museum, Oxford, 3 May–12 June 1988; Fruitmarket Gallery, Edinburgh, 18 June–24 July 1988; Ferens Art Gallery, Hull, 30 July–28 Aug. 1988; Walker Art Gallery, Liverpool, 8 Sept.–9 Oct. 1988; Royal Albert Memorial Museum, Exeter, 22 Oct.–20 Nov. 1988; Fine Arts Museums of San Francisco, California Palace of the Legion of Honor, 3 Dec. 1988–5 Feb. 1989; Minneapolis Institute of Art; Brooke Alexander Gallery, New York; Cleveland Museum of Art; Saint Louis Art Museum; texts by Nicholas Penny, *The early works 1938–1954*, & Robert Flynn Johnson, *The later works 1961–1987* (repr. in *Triptych*, Nov. 1988–Jan. 1989); biog., bibl.; 128pp., 117 illus. (some col).

Lucian Freud: paintings 1947–87 (37 works). Edinburgh, Scottish National Gallery of Modern Art, 2 July–16 Oct. 1988; reduced version of 1987/8 British Council touring exhib.; 2pp. dupl. typescript.

Lucian Freud: early works. Edinburgh, Fruitmarket Gallery, 1989.

Lucian Freud: etchings (18 works). London, Bernard Jacobson Gallery, 21 Mar.–15 Apr. 1989; 34pp., 18 illus.

Lucian Freud: l'oeuvre gravé (34 works). Paris, Galerie Berggruen, 1990; text by Michael Peppiatt (parallel English/French text); 56pp., 35 illus. (some col.).

Lucian Freud, Frank Auerbach, Richard Deacon. London, Saatchi Gallery, 1990.

Lucian Freud: etchings 1946–90. Tokyo, Nishimura Gallery, 1991; text by Craig Hartley.

Lucian Freud: the complete etchings 1946–1991. London, Thomas Gibson Fine Art, 4 June–12 July 1991; text by Craig Hartley, *Freud as an etcher*; biog, bibl.; 77pp., 41 illus. (some col.).

Lucian Freud: dipinti e opere su carta 1940–1991 (78 works). Milan, Arnaldo Mondadori Arte, organised by British Council, London, at Fondazione Memmo, Palazzo Ruspoli, Rome, 4 Oct.–17 Nov. 1991; Sala Viscontea, Castello Sforzesco, Milan, 11 Dec. 1991–19 Jan. 1992; Tate Gallery, Liverpool, 4 Feb.–22 Mar. 1992; Tochigi Prefectural Museum of Fine Arts, 19 Apr.–15 June 1992; Otani Memorial Art Museum, Nishinomiya, 4 July–2 Aug. 1992; Setagaya Art Museum, Tokyo, 15 Aug.–30 Sept. 1992; biog., bibl.; texts by Bruno Mantura, *Freud*, & Angus Cook, *Quanto segue…*; incl. 1954 *Encounter* text by the artist. Japanese ed. incl. text by William Feaver, *Beyond feeling*, replacing text by Angus Cook.

Lucian Freud: the complete etchings, 1946–1992. New York, Mary Ryan Gallery, 1992.

Lucian Freud (67 works). Sydney, Art Gallery of New South Wales, 31 Oct. 1992–10 Jan. 1993; travelling to Art Gallery of Western Australia, Perth, 1 Feb.–14 Mar. 1993; organised by British Council; text by William Feaver, *Beyond feeling* (previously publ. in Japanese ed. of 1992 British Council exhib.); biog., bibl.; 96pp., 95 illus. (mostly col.).

Lucian Freud: recent work. London, Whitechapel Art Gallery, 10 Sept.–21 Nov. 1993; Metropolitan Museum of Art, New York, 16 Dec. 1993–13 Mar. 1994; Museo Centro Nacional de Arte Reina Sofía, Madrid, 6 Apr.–13 June 1994; text by Catherine Lampert; biog.; 192pp., 100 col. illus.

Lucian Freud: early works (52 works). New York, Robert Miller Gallery, 23 Nov. 1993–8 Jan. 1994; texts by Caroline Blackwood, Anne Dunn, Robert Hughes, (excerpt from introd. to 1987 British Council cat.), John Russell (excerpt from introd. to 1974 Arts Council cat.) & 'A note from an old friend' (pp.45–7); 55pp., 1 illus.

Lucian Freud: recent drawings and etchings (22 works). New York, Matthew Marks Gallery, 11 Dec. 1993–29 Jan. 1994; incl. interview between LF & Leigh Bowery, *Art and love* (repr. in *Lovely Jobly*, 1991, & *Independent Magazine*, 11 Jan. 1992), & text by Angus Cook, *Seeing things*; 73pp., 26 illus. (some col.).

Lucian Freud at Dulwich Art Gallery (4 works). London, Dulwich Picture Gallery, Dec. 1994–22 Jan. 1995.

Lucian Freud: etchings 1946–1995. London, Marlborough Graphics, 1995 (book by Craig Hartley published).

Bacon–Freud: expressions (45 works). St. Paul, Fondation Maeght, 4 July–15 Oct. 1995; text by Jean-Louis Prat; biog.; bibl.; 213pp., 51 illus. (mostly col.).

Lucian Freud: a selection of etchings 1948–1995. New York, Marlborough Graphics, 1996 (1995 book by Craig Hartley published).

Lucian Freud: a selection: paintings and works on paper. New York, Davis and Langdale, 1996.

Lucian Freud paintings and etchings. Kendal, Abbot Hall Art Gallery, 25 June–8 Sept. 1996; text by William Feaver; bibl.; 88pp., 41 col. illus.

Lucian Freud. New York, Acquavella Gallery, Autumn 1996.

Early works: Lucian Freud (31 works). Edinburgh, Scottish National Gallery of Modern Art, 18 Jan.–13 Apr. 1997; biog.; bibl.; text by Richard Calvocoressi; 59pp., 38 illus. (mostly col.).

Lucian Freud: some new paintings (27 works). London, Tate Gallery, 3 June–26 July 1998; text of interview between the artist & William Feaver (Apr. 1998; previously publ. in *Observer*, 17 May 1998); folded sheet, 10pp.

Lucian Freud: paintings and drawings. London, Theo Waddington Fine Art, 1998.

Lucian Freud: etchings from the Paine Webber Art Collection (44 works). New Haven (CT), Yale Center for British Art, 23 Jan.–21 Mar. 1999; travelling to San Diego, Seattle, Houston, Palo Alto (CA) & Pittsburgh; texts by David Cohen, *Freud's probity*, & Scott Wilcox, *Between fact and truth: Lucian Freud's printmaking*; 81pp., 47 illus. (some col.).

Lucian Freud: recent work, 1997–2000 (35 works). New York, Acquavella Gallery, 10 Apr.–19 May 2000; 64pp., 38 illus. (mostly col.).

Lucian Freud: etchings. New York, Matthew Marks Gallery, 11 Nov.–23 Dec. 2001; text by Esther Freud, *Ode to Pluto*; 64pp., 45 illus. (mostly col.).

Lucian Freud: Naked portraits: Werke der 40er bis 90er Jahre / Works from the 1940s to the 1990s (47 works). Frankfurt am Main, Museum für Moderne Kunst, 2001 (publ. Hatje Cantz Verlag, Ostfildern-Ruit); biog., bibl.; ed. by Rolf Lauter, texts by Rolf Lauter, *Thoughts on Lucian Freud*; Jean-Christophe Ammann, *Maker of Golems – painter of gravity*; Craig Hartley, *Beyond description: Freud as an etcher*; 327pp., 190 illus. (some col.).

Constable. Paris, Grand Palais, 10 Oct. 2002–13 Jan. 2003; exhib. curated by LF.

6 Selected group exhibition catalogues

New Year exhibition: modern French pictures (from an English private collection), contemporary English art (1 work). London, Leicester Galleries, Jan. 1942.

Imaginative art since the War (1 work). London, Leicester Galleries, Apr.–May 1942.

Contemporary British paintings [etc.] (1 work). London, Lefevre Gallery, 9 Sept.–3 Oct. 1942.

New Year exhibition: paintings, drawings and sculpture (1 work). London, Leicester Galleries, Jan. 1943.

Quindici pittori inglesi (2 works). Rome, Studio d'Arte Palma, Dec. 1947; organised by British Council, London.

Exposition de la jeune peinture en Grande Bretagne (2 works). Paris, Galerie René Drouin, 23 Jan.–21 Feb. 1948; organised with British Council, London.

Forty years of modern art 1907–1947: a selection from British collections (1 work). London, Institute of Contemporary Art, at Academy Hall, London, 10 Feb.–6 Mar. 1948.

London–Paris: new trends in painting and sculpture (4 works). London, Institute of Contemporary Art, at New Burlington Galleries, 7 Mar.–4 Apr. 1950.

Oeuvres choisies. (2 works). London, Hanover Galleries, 4 July–11 Aug. 1950.

Sixty paintings for '51 (1 work). London, Arts Council of Great Britain, for the Festival of Britain, 1951.

British painting 1925–1950: first anthology (3 works). London, Arts Council of Great Britain, & Manchester City Art Gallery, for Festival of Britain, 1951.

21 modern British painters (1 work). London, British Council, at Vancouver Art Gallery, 1951; touring to venues in USA.

Some recent purchases of the Contemporary Art Society (2 works). London, Arts Council of Great Britain, 1951; touring exhib.

Three young collectors (1 work, in collection of Peter Meyer). London, Arts Council of Great Britain, 1952.

Recent trends in realist painting (2 works). London, Institute of Contemporary Art, 1952.

Contemporary drawings from 12 countries. Art Institute of Chicago, Nov. 1952.

Portraits by contemporary British artists. London, Marlborough Fine Art, 1953.

Recent British drawings (3 works). London, ICA Gallery, 10 Feb.–27 Mar. 1954

Daily Express young artists' exhibition (3 works). London, New Burlington Galleries, 21 Apr.–21 May 1955.

British painting in the Sixties (3 works). London, Tate Gallery & Whitechapel Art Gallery, 1–30 June 1963.

Dunn International (1 work). Fredericton (NB), Beaverbrook Art Gallery, Sept. 1963; London, Arts Council, at Tate Gallery, 18 Nov.–22 Dec. 1963.

English paintings 1951–1967 (7 works). Norwich Castle Museum, 31 May–2 July 1967.

XX century drawings and watercolours (3 works). London, Marlborough Fine Art, Sept.–Oct. 1974.

La ricerca dell'idenitità (3 works). Milan, Palazzo Reale, 16 Nov. 1974–15 Jan. 1975.

Drawings of people: an exhibition of drawings selected for the Arts Council by Patrick George (2 works). London, Arts Council of Great Britain, 1975.

European painting in the Seventies: new work by sixteen artists (1 work). Los Angeles County Museum of Art, 30 Sept.–23 Nov. 1975; travelling to Saint Louis & Madison (WI).

The human clay: an exhibition selected by R.B. Kitaj (6 works). London, Arts Council of Great Britain, at Hayward Gallery, London, 5–30 Aug. 1976, and touring.

Peter Moores Liverpool Project 4: Real life (5 works). Liverpool, Walker Art Gallery, 2 June–6 Sept. 1977; selected by Edward Lucie-Smith.

British painting 1952–1977 (3 works). London, Royal Academy of Arts, 24 Sept.–20 Nov. 1977.

25 from 51: paintings for the Festival of Britain (1 work). Sheffield, Mappin Art Gallery, 17 May–2 July 1978; travelling to Birmingham.

Treasures from Chatsworth: the Devonshire inheritance (3 works). Virginia Museum of Fine Arts, Richmond (VA), organised by International Exhibitions Foundation, Washington; travelling to other venues in USA & London.

The British art show (3 works). London, Arts Council of Great Britain, at Mappin Art Gallery, Sheffield, 1 Dec. 1979–27 Jan. 1980; travelling to Newcastle & Bristol.

This knot of life: paintings and drawings by British artists (8 works). Venice (CA), L.A. Louver Gallery, 23 Oct.–17 Nov. 1979.

Eight figurative painters (9 works). New Haven (CT), Yale Center for British Art, 14 Oct. 1981–3 Jan. 1982; travelling to Santa Barbara; text by Andrew Forge, Lawrence Gowing.

A new spirit in painting (8 works). London, Royal Academy of Arts, 15 Jan.–18 Mar. 1981.

Aspects of British art today (4 works). Tokyo Metropolitan Art Museum 1982.; travelling to Tochigi, Osaka, Fukuoka & Hokkaido.

Britain salutes New York: paintings and sculptures by contemporary British artists (3 works). New York, Marlborough Gallery, 9 Apr.–3 May 1983.

Peter Moores Liverpool Project 7: As of now: an exhibition selected by William Feaver (4 works). Liverpool, Walker Art Gallery, 24 Nov. 1983–19 Feb. 1984.

In honor of de Kooning (1 work). New York, Xavier Fourcade, 8 Dec. 1983–21 Jan. 1984.

Frank Auerbach, Francis Bacon, Lucian Freud, Leon Kossoff. Sydney, Rex Irwin Gallery, 1984.

A circle: portraits and self-portraits by Arikha, Auerbach, Kitaj, Freud (5 works). London, Marlborough Graphics Gallery, Apr.–May 1984.

The hard-won image: traditional method and subject in recent British art (5 works). London, Tate Gallery, 4 July–9 Sept. 1984; text by Richard Morphet.

The proper study: contemporary figurative paintings from Britain (5 works). Delhi, Lalit Kala Akademi, 1–31 Dec. 1984; travelling to Bombay; organised by British Council, London.

The British show. London, British Council, at Art Gallery of New South Wales, Sydney, 1985.

Carnegie International 1985 (6 works). Museum of Art, Carnegie Institute, Pittsburgh, 9 Nov. 1985–5 Jan. 1986.

Forty years of modern art (1 work). London, Tate Gallery, 19 Feb.–27 Aug. 1986; text by Ronald Alley.

Artist and model (5 works). Manchester, Whitworth Art Gallery, 23 May–19 July 1986.

Studies of the nude (2 works). London, Marlborough Fine Art, 19 Mar.–2 May 1986.

British art of the 20th century: the modern movement (8 works). London, Royal Academy of Arts, 15 Jan.–5 Apr. 1987; incl. text by Dawn Ades, *The School of London*, pp.308–11.

A paradise lost: the Neo-Romantic imagination in Britain 1935–55 [2 works]. London, Barbican Art Gallery, 21 May–19 July 1987; text ed. David Mellor.

A School of London: six figurative painters. Oslo, Kunstnernes Hus, 9 May–14 June 1987; travelling to Humlebaek, Venice & Düsseldorf; organised by British Council; text by Michael Peppiatt.

The British picture (1 work). Venice (CA), L.A. Louver, 5 Feb.–5 Mar. 1988.

Works on paper by contemporary artists (3 works). London, Marlborough Fine Art, 16 Mar.–22 Apr. 1988.

Contemporary graphics (2 works). London, Marlborough Fine Art, Graphics Gallery, Spring 1988.

Die Spur des Anderen: fünf jüdische Künstler aus London mit fünf deutschen Künstlern aus Hamburg im Dialog (2 works). Hamburg, Haine-Haus, 30 Sept.–22 Oct. 1988; text by Martin Roman Deppner.

Monet to Freud. London, Sotheby's, 31 Dec. 1988–25 Jan. 1989.

The pursuit of the real: British figurative painting from Sickert to Bacon (7 works). Manchester, City Art Galleries, 10 Mar.–22 Apr. 1990; travelling to London & Glasgow; text by Tim Wilcox, Andrew Causey, Lynda Checketts, Michael Peppiatt.

Frank Auerbach, Richard Deacon, Lucian Freud. London, Saatchi Collection, 1990.

The transformation of appearance: Andrews, Auerbach, Bacon, Freud, Kossoff (4 works). Norwich, Sainsbury Centre for Visual Arts, 24 Sept.–8 Dec. 1991; organised by Tate Gallery, London; text by Paul Moorhouse.

Da Bacon a oggi: l'outsider nella figurazione britannica (4 works). Florence, Palazzo Vecchio, 7 Dec. 1991–16 Feb. 1992.

Seven British painters: selected masters of postwar British art. London, Marlborough Fine Art, 18 June–4 Sept. 1993.

Dobbel virkelighet / Double reality: "The School of London" (7 works). Oslo, Astrup Fearnley Museet for Moderne Kunst, 16 Apr.–9 Oct. 1994; text by Jutta Nestegard.

Biennale. Venice, Biennale di Venezia, 1995.

From London: Bacon, Freud, Kossoff, Andrews, Auerbach, Kitaj (16 works). Edinburgh, Scottish National Gallery of Modern Art, 1 July–5 Sept. 1995; travelling to Luxembourg, Lausanne & Barcelona; organised by British Council, London; texts by Richard Calvocoressi, David Cohen.

Sargent to Freud: modern British paintings and drawings in the Beaverbrook Collection (1 work). Fredericton (NB), Beaverbrook Art Gallery, 24 May–13 Sept. 1998; travelling to Philadelphia, Halifax (NS), Saskatoon, London, Sheffield & London (Ont.); text by Ian G. Lumsden.

L'Ecole de Londres: de Bacon à Bevan (8 works). Paris, Fondation Dina Vierny-Musée Maillol, 10 Oct. 1998–20 Jan. 1999; travelling to Santiago de Compostella & Vienna; texts by Michael Peppiatt, Jean Clair.

Regarding beauty. Washington, Hirshhorn Museum and Sculpture Garden, 7 Oct. 1999–17 Jan.2000. Text by Neal Benezra, Ola M. Viso; travelling to Munich, Haus der Kunst.

Auerbach, Bacon, Freud, Kossoff (4 works). London, Blains Fine Art, 11 May–22 July 2000.

Encounters: new art from old (2 works). London, National Gallery, 14 June–17 Sept. 2000; text by Richard Morphet.

The School of London and their friends: the collection of Elaine and Melvin Merians (3 works). New Haven (CT), Yale Center for British Art, 11 Oct. 2000–14 Jan. 2001; travelling to Purchase (NY); text by Richard Cork, Patrick McCaughey.

La mirada fuerte: pintura figurativa de Londres. Mexico (DF), Museo de Arte Moderno, 2000.

236

Lenders to the Exhibition

Photographic Credits

Supporting Tate

Tate relies on a large number of supporters – individuals, foundations, companies and public sector sources – to enable it to deliver its programme of activities, both on and off its gallery sites. This support is essential in order to acquire works of art for the Collection, run education, outreach and exhibition programmes, care for the Collection in storage and enable art to be displayed, both digitally and physically, inside and outside Tate. Your donation will make a real difference and enable others to enjoy Tate and its Collections both now and in the future. There are a variety of ways in which you can help support the Tate and also benefit as a UK or US taxpayer. Please contact us at:

The Development Office
Tate · Millbank · London SW1P 4RG

Telephone 020 7887 8942
Fax 020 7887 8738

Tate American Fund
1285 Avenue of the Americas (35th floor)
New York NY 10019

Telephone 001 212 713 8497

Fax 001 212 713 8655

DONATIONS
Donations, of whatever size, from individuals, companies and trusts are welcome, either to support particular areas of interest, or to contribute to general running costs.

GIFTS OF SHARES
Since April 2000, we can accept gifts of quoted shares and securities. These are not subject to capital gains tax. For higher rate taxpayers, a gift of shares saves income tax as well as capital gains tax. For further information please contact the Campaigns Section of the Development Office.

TATE ANNUAL FUND
A donation to the Annual Fund at Tate benefits a variety of projects throughout the organisation, from the development of new conservation techniques to education programmes for people of all ages.

GIFT AID
Through Gift Aid, you can provide significant additional revenue to Tate. Gift Aid applies to gifts of any size, whether regular or one-off, since we can claim back the tax on your charitable donation. Higher rate taxpayers are also able to claim additional personal tax relief. Contact us for further information and a Gift-Aid Declaration.

LEGACIES AND BEQUESTS
A legacy to Tate may take the form of a residual share of an estate, a specific cash sum or item of property such as a work of art. Legacies to Tate are free of Inheritance Tax.

OFFERS IN LIEU OF TAX
Inheritance Tax can be satisfied by transferring to the Government a work of art of outstanding importance. In this case the rate of tax is reduced, and it can be made a condition of the offer that the work of art is allocated to Tate. Please contact us for details.

TATE AMERICAN FUND AND TATE AMERICAN PATRONS
The American Fund for the Tate Gallery was formed in 1986 to facilitate gifts of works of art, donations and bequests to Tate from United States residents. United States taxpayers who wish to support Tate on an annual basis can join the American Patrons of the Tate Gallery and enjoy membership benefits and events in the United States and United Kingdom (single membership $1000 and double $1500). Both organisations receive full tax exempt status from the IRS. Please contact the Tate American Fund for further details.

MEMBERSHIP PROGRAMMES
Tate Members enjoy unlimited free admission throughout the year to all exhibitions at Tate Britain, Tate Liverpool, Tate Modern and Tate St Ives, as well as a number of other benefits such as exclusive use of our Members' Rooms and a free annual subscription to *Tate: The Art Magazine*.

Whilst enjoying the exclusive privileges of membership, you are also helping secure Tate's position at the very heart of British and modern art. Your support actively contributes to new purchases of important art, ensuring that the Tate's Collection continues to be relevant and comprehensive, as well as funding projects in London, Liverpool and St Ives that increase access and understanding for everyone.

PATRONS
Tate Patrons are people who share a keen interest in art and are committed to giving significant financial support to the Tate on an annual basis, specifically to support acquisitions. There are four levels of Patron, including Associate Patron (£250) Patrons of New Art (£500), Patrons of British Art (£500) and Patrons Circle (£1000). Benefits include opportunities to sit on acquisition committees, special access to the Collection and entry with a family member to all Tate exhibitions.

CORPORATE MEMBERSHIP
Corporate Membership at Tate Liverpool and Tate Britain, and support for the Business Circle at Tate St Ives, offer companies opportunities for corporate entertaining and the chance for a wide variety of employee benefits. These include special private views, special access to paying exhibitions, out-of-hours visits and tours, invitations to VIP events and talks at members' offices.

CORPORATE INVESTMENT
Tate has developed a range of imaginative partnerships with the corporate sector, ranging from international interpretation and exhibition programmes to local outreach and staff development programmes. We are particularly known for high-profile business to business marketing initiatives and employee benefit packages. Please contact the Corporate Fundraising team for further details.

CHARITY DETAILS
The Tate Gallery is an exempt charity; the Museums & Galleries Act 1992 added the Tate Gallery to the list of exempt charities defined in the 1960 Charities Act. The Friends of the Tate Gallery is a registered charity (number 313021). Tate Foundation is a registered charity (number 1085314).

TATE BRITAIN DONORS
TO THE CENTENARY DEVELOPMENT CAMPAIGN

FOUNDER
The Heritage Lottery Fund

FOUNDING BENEFACTORS
Sir Harry and Lady Djanogly
The Kresge Foundation
Sir Edwin and Lady Manton
Lord and Lady Sainsbury of Preston Candover
The Wolfson Foundation

MAJOR DONORS
The Annenberg Foundation
Ron Beller and Jennifer Moses
Alex and Angela Bernstein
Ivor Braka
Lauren and Mark Booth
The Clore Duffield Foundation
Maurice and Janet Dwek
Bob and Kate Gavron
Sir Paul Getty KBE
Nicholas and Judith Goodison
Mr and Mrs Karpidas
Peter and Maria Kellner
Catherine and Pierre Lagrange
Ruth and Stuart Lipton
William A. Palmer
John and Jill Ritblat
Barric and Emmanuel Roman
Charlotte Stevenson
Tate Gallery Centenary Gala
The Trusthouse Charitable Foundation
David and Emma Verey
Clodagh and Leslie Waddington
Mr and Mrs Anthony Weldon
Sam Whitbread

DONORS
The Asprey Family Charitable Foundation
The Charlotte Bonham Carter Charitable Trust
The CHK Charities Limited
Sadie Coles
Giles and Sonia Coode-Adams
Alan Cristea
Thomas Dane
The D'Oyly Carte Charitable Trust
The Dulverton Trust
Tate Friends
Alan Gibbs
Mr and Mrs Edward Gilhuly
Helyn and Ralph Goldenberg
Richard and Odile Grogan
Pehr and Christina Gyllenhammar
Jay Jopling
Howard and Lynda Karshan
Madeleine Kleinwort
Brian and Lesley Knox
Mr and Mrs Ulf G. Linden
Anders and Ulla Ljungh
Lloyds TSB Foundation for England and Wales
David and Pauline Mann-Vogelpoel
Nick and Annette Mason
Viviane and James Mayor
Anthony and Deidre Montague
Sir Peter and Lady Osborne
Maureen Paley
Mr Frederik Paulsen

The Pet Shop Boys
The P F Charitable Trust
The Polizzi Charitable Trust
Mrs Coral Samuel CBE
David and Sophie Shalit
Mr and Mrs Sven Skarendahl
Pauline Denyer-Smith and Paul Smith
Mr and Mrs Nicholas Stanley
The Jack Steinberg Charitable Trust
Carter and Mary Thacher
Mr and Mrs John Thornton
Dinah Verey
Gordon D. Watson
The Duke of Westminster OBE TD DL
Mr and Mrs Stephen Wilberding
Michael S. Wilson

and those donors who wish to remain anonymous

TATE COLLECTION

FOUNDERS
Sir Henry Tate
Sir Joseph Duveen
Lord Duveen
The Clore Duffield Foundation
Heritage Lottery Fund
National Art Collections Fund

FOUNDING BENEFACTORS
Sir Edwin and Lady Manton
The Kreitman Foundation
The American Fund for the Tate Gallery
The Nomura Securities Co Ltd

BENEFACTORS
Gilbert and Janet de Botton
The Deborah Loeb Brice Foundation
National Heritage Memorial Fund
Patrons of British Art
Patrons of New Art
Dr Mortimer and Theresa Sackler Foundation
Tate Members

MAJOR DONORS
Edwin C Cohen
Hartley Neel
Richard Neel

DONORS
Howard and Roberta Ahmanson
Lord and Lady Attenborough
The Charlotte Bonham-Carter Charitable Trust
Mrs John Chandris
Brooke Hayward Duchin
GABO TRUST for Sculpture Conservation
The Gapper Charitable Trust
The Getty Grant Program
Calouste Gulbenkian Foundation
HSBC Artscard
The Samuel H Kress Foundation
Leche Trust
Robert Lehman Foundation
The Leverhulme Trust
William Louis-Dreyfus
The Henry Moore Foundation
Friends of the Newfoundland Dog and Members
 of the Newfoundland Dog Club of America

Peter and Eileen Norton,
 The Peter Norton Family Foundation
New Opportunites Fund
The Radcliffe Trust
The Rayne Foundation
Mr Simon Robertson
Lord and Lady Rothschild
Mrs Jean Sainsbury
The Foundation for Sports and the Arts
Stanley Foundation Limited
Mr and Mrs A Alfred Taubman

and those donors who wish to remain anonymous

TATE COLLECTORS FORUM

Lord Attenborough Kt CBE
Ricki Gail Conway
Madeleine, Lady Kleinwort
George Loudon
Anders and Ulla Ljungh
Jonathan Marland
Keir McGuinness
Tineke Pugh
Roland and Sophie Rudd
Andrew and Belinda Scott
Dennis and Charlotte Stevenson
Mr and Mrs John L Thornton

and those donors who wish to remain anonymous

COLLECTION SPONSOR

Carillion plc
Paintings Conservation (1995–2000)

TATE BRITAIN DONORS

MAJOR DONORS

The Bowland Charitable Trust
Mr and Mrs James Brice
The Henry Luce Foundation
The Henry Moore Foundation
The Horace W Goldsmith Foundation

DONORS

Howard and Roberta Ahmanson
Blackwall Green
Mr and Mrs Robert Bransten
The Calouste Gulbenkian Foundation
Ricki and Robert Conway
ICAP plc
ICI
The Stanley Thomas Johnson Foundation
John Lyon's Charity
Kiers Foundation
The Kirby Laing Foundation
London Arts
The Paul Mellon Centre for Sudies in British Art
The Mercers' Company
The Peter Moores Foundation
Judith Rothschild Foundation
Keith and Kathy Sachs
The Wates Foundation

TATE FOUNDING CORPORATE PARTNERS

AMP
Avaya UK
BNP Paribas
CGNU plc
Clifford Chance
Dresdner Kleinwort Wasserstein
Energis plc
Freshfields Bruckhaus Deringer
GLG Partners
Goldman Sachs International
J Sainsbury plc
Lazard
Lehman Brothers
London & Cambridge Properties Ltd
London Electricity Group plc and EDF Group
Mayer, Brown, Rowe & Maw
Pearson
Prudential
Railtrack PLC
Reuters
Rolls-Royce plc
Schroders
UBS PaineWebber Inc.
UBS Warburg
Whitehead Mann

TATE BRITAIN CORPORATE MEMBERS

Drivers Jonas
Global Asset Management
Hugo Boss
Linklaters
Merrill Lynch
Nomura International plc
Oracle
Simmons & Simmons
EMI
Tishman Speyer Properties

TATE BRITAIN SPONSORS

FOUNDING SPONSORS

BP
Campaign for the creation of Tate Britain (1998–2000)
BP Displays at Tate Britain (1990–2002)
Tate Britain Launch (2000)

BT
Tate Online (2001–2003)

Channel 4
The Turner Prize (1991–2002)

Ernst & Young
Cézanne (1996)
Bonnard (1998)

BENEFACTOR SPONSORS

GlaxoSmithKline plc
Turner on the Seine (1999)
William Blake (2000)
American Sublime: Landscape Painting in the United States,
1820–1880 (2002)

Prudential plc
The Age of Rossetti, Burne-Jones and Watts:
Symbolism in Britain 1860–1910 (1997)
The Art of Bloomsbury (1999)
Stanley Spencer (2001)

MAJOR SPONSORS

The Independent Newspapers
Media Partner for William Blake (2000)
Media Partner for Stanley Spencer (2001)
Media Partner for Exposed: The Victorian Nude (2001)

Morgan Stanley
Visual Paths: Teaching Literacy in the Gallery (1999–
2002)

Sun Life and Provincial Holdings plc
Ruskin, Turner & the Pre-Raphaelites (2000)

Tate & Lyle plc
Tate Members (1991–2000)
Tate Britain Community Education (2001–2002)

Tate Members
Exposed: The Victorian Nude (2001)

SPONSORS

B&Q
Michael Andrews (2001)

The Economist
James Gilray: The Art of Caricature (2001)

The Guardian / The Observer
Jackson Pollock (1999)
Media Partner for the Tate 2000 launch (2000)

Hiscox plc
Tate Britain Members Room (1995–2001)

The Telegraph
Media Partner for American Sublime (2002)